Adobe
Photoshop
Lightroom Classic
2020 release

CLASSROOM IN A BOOK®
The official training workbook from Adobe

RC Concepcion

ISBN-13: 978-0-13-662379-3

ISBN-10: 0-13-662379-4

1 2020

WHERE ARE THE LESSON FILES?

Purchase of this Classroom in a Book in any format gives you access to the lesson files you'll need to complete the exercises in the book.

1　Go to www.adobepress.com/LRClassicCIB2020.

2　Sign in or create a new account.

3　Click Submit.

Note: If you encounter problems registering your product or accessing the lesson files or web edition, go to www.adobepress.com/support for assistance.

4　Answer the questions as proof of purchase.

5　The lesson files can be accessed through the Registered Products tab on your Account page.

6　Click the Access Bonus Content link below the title of your product to proceed to the download page. Click the lesson file links to download them to your computer.

Note: If you purchased a digital product directly from www.adobepress.com or www.peachpit.com, your product will already be registered. However, you still need to follow the registration steps and answer the proof of purchase question before the Access Bonus Content link will appear under the product on your Registered Products tab.

CONTENTS

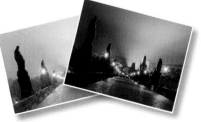

GETTING STARTED

Adobe® Photoshop® Lightroom® Classic is the gold standard workflow solution for the digital photographer—from importing, reviewing, organizing, and enhancing images to publishing photos, producing client presentations, creating photo books and web galleries, and outputting high-quality prints.

One of the benefits of using Lightroom Classic is that you get all of the power you've come to know and love from Adobe in an interface that is easy to use, getting you up to speed in no time.

Whether you're a home user, a professional photographer, a hobbyist, or a business user, Lightroom Classic enables you to stay in control of your growing photo library and to produce good-looking pictures and polished presentations for both web and print with little effort.

About Classroom in a Book

Adobe Photoshop Lightroom Classic Classroom in a Book is part of the official training series for Adobe graphics and publishing software developed with the support of Adobe product experts.

Each lesson in this book consists of a series of self-paced projects that give you hands-on experience using Adobe Photoshop Lightroom Classic.

If you're new to Lightroom, you'll learn the fundamental concepts and skills that will help you master the application; if you've used earlier versions of Lightroom, you'll find that this Classroom in a Book® teaches advanced tips and techniques, and covers the many new features and enhancements that Adobe Systems has introduced in the latest version.

What's new in this edition

This edition covers the many new and enhanced features in Adobe Photoshop Lightroom Classic, from deleting an image's history above a specific step, to new ways to filter your folders and collections, and batch exporting images from your photo library using more than one Export preset.

You'll also discover enhancements to many of your favorite tools, including the automatic filling in of uneven edges on your panoramic images, the ability to export your custom presets, alone or in a group, and the new Texture slider.

You'll learn new ways to organize your image library and streamline your workflow by creating collections and collection sets from folders and subfolders, and keep yourself organized by developing a solid workflow structure. This edition also introduces you to guest photographers, offering you advice from seasoned professionals as well as inspiration from those on an amazing photographic journey.

Prerequisites

Before starting on the lessons in this book, make sure that you and your computer are ready by following the tips and instructions on the next few pages.

Requirements on your computer

You'll need about 4.68 GB of free space on your hard disk for all the downloaded lesson files (see "Accessing the lesson files and Web Edition" on the facing page) and the work files that you'll create as you work through the exercises.

Required skills

The lessons in this book assume that you have a working knowledge of your computer and its operating system.

Make sure that you know how to use the mouse and the standard menus and commands, and also how to open, save, and close files. Can you scroll (vertically and horizontally) within a window to see content that may not be visible in the displayed area? Do you know how to use context menus, which open when you right-click items?

If you need to review these basic and generic computer skills, see the documentation included with your Apple macOS or Microsoft Windows software.

Installing Lightroom Classic

● **Note:** This book describes and illustrates Lightroom Classic release 9.0.

Before you begin the lessons in *Adobe Photoshop Lightroom Classic Classroom in a Book*, make sure that your system is set up correctly and that you've installed the required software and hardware.

You must purchase the Adobe Photoshop Lightroom Classic software separately. For system requirements and detailed instructions for downloading, installing, and setting up the software, see the topics listed on the Get Started link at https://helpx. adobe.com/support/lightroom.html.

Online content

Your purchase of this Classroom in a Book includes online materials provided by way of your Account page at adobepress.com. These include a useful bonus lesson called "Publishing Your Photos," as well as:

Lesson files

To work through the projects in this book, you will need to download the lesson files by following the instructions below.

Web Edition

The Web Edition is an online interactive version of the book, providing an enhanced learning experience. Your Web Edition can be accessed from any device with a connection to the internet, and it contains:

- The complete text of the book
- Hours of instructional video keyed to the text
- Interactive quizzes

Accessing the lesson files and Web Edition

⬤ **Note:** If you encounter problems registering your product or accessing the lesson files or web edition, go to www.adobepress.com/support for assistance.

You must register your purchase on adobepress.com in order to access the online content.

1 Go to www.adobepress.com/LRClassicCIB2020.

2 Sign in or create a new account.

3 Click Submit.

4 Answer the questions as proof of purchase.

5 The lesson files can be accessed from the Registered Products tab on your Account page. Click the Access Bonus Content link below the title of your product to proceed to the download page. Click the lesson file link(s) to download them to your computer.

 The Web Edition can be accessed from the Digital Purchases tab on your Account page. Click the Launch link to access the product.

⬤ **Note:** If you purchased a digital product directly from www.adobepress.com or www.peachpit .com, your product will already be registered. However, you still need to follow the registration steps and answer the proof of purchase question before the Access Bonus Content link will appear under the product on your Registered Products tab.

6 Create a new folder inside the Users/username/Documents folder on your computer, and then name the new folder **LRClassicCIB**.

7 If you downloaded the entire Lessons folder, drag that Lessons folder into the LRClassicCIB folder you created in step 6. Alternatively, if you downloaded folders for one or more individual lessons, first create a Lessons folder inside your LRClassicCIB folder, then drag the individual lesson folder(s) into your LRClassicCIB/Lessons folder.

8 Keep the lesson files on your computer until you've completed all the exercises.

The downloadable sample images are practice files, provided for your personal use in these lessons. It is illegal to use them commercially or to publish or distribute them in any way without written permission from Adobe Systems Inc. *and* the individual photographers who took the pictures.

Understanding Lightroom catalog files

The catalog file is the master digital notebook for all the photos in your library. This digital notebook includes the location of the master files, any metadata you've added in the process of organizing your images, and a record of every adjustment or edit you've made. Most users will keep all their photos in a single catalog, which can easily manage thousands of files. Some might want to create separate catalogs for different purposes, such as personal photos and business photos. Although you can create multiple catalogs, keep in mind that you can only open one catalog at a time in Lightroom Classic.

For the purposes of working with this book, you'll create a new catalog to manage the image files that you'll use in the lessons. This will allow you to leave the default catalog untouched while working through the lessons, and to keep your lesson files together in one easy-to-remember location.

Creating a catalog file for working with this book

When Lightroom Classic starts for the first time, a catalog file named Lightroom Catalog.lrcat is automatically created on your hard disk. This default catalog file is created inside the folder *username*/Pictures/Lightroom.

● **Note:** In this book, the forward arrow character (>) is used to denote submenus and commands found in the menu bar at the top of the workspace or in context menus; for example, Menu > Submenu > Command.

You'll create your new work catalog file inside your LRClassicCIB folder, right beside the Lessons folder containing your downloaded work files.

1 Launch Lightroom Classic.

2 From the Lightroom menu bar, choose File > New Catalog.

3 Navigate to the LRClassicCIB folder you created on your hard disk.

4 Type **LRClassicCIB Catalog** in the File Name text box on Windows or the Save As text box on macOS, then click Create.

5 If you see a notification about backing up the current catalog before loading your new catalog, choose your preferred option to dismiss the message.

To be sure that you're always aware of which catalog you're working with as you progress through the exercises in this book, you'll next set the preferences so that you'll be prompted to specify your LRClassicCIB catalog each time you launch Lightroom Classic. It is recommended that you keep this preference set as long as you're working through the lessons in this book.

6 Choose Lightroom Classic > Preferences (macOS) or Edit > Preferences (Windows).

7 In the Preferences dialog box, click the General tab. From the Default Catalog menu, choose Prompt Me When Starting Lightroom.

● **Note:** In the remainder of this book, instructions that differ for Macintosh users and those working on Windows systems are given in a compact format as follows: the forward slash character (/) is used to separate equivalent terms and commands for macOS/Windows, in the order shown here.

8 Click Close (macOS) or OK (Windows) to close the Preferences dialog box.

Next time you start Lightroom Classic, the Select Catalog dialog box will appear, giving you the opportunity to make sure that your LRClassicCIB Catalog is selected before clicking Open to launch Lightroom.

	Adobe Photoshop Lightroom Classic - Select Catalog	
Select a recent catalog to open		
LRClassicCIB Catalog.lrcat	/Users/rc/Pictures/LRClassicCIB Catalog	
LPCIB Catalog.lrcat	/Users/rc/Documents/LPCIB/LPCIB Catalog	
RC Main Catalog-2.lrcat	/ - Personal/ - Lightroom Area	
Lightwork Show LR Catalog.lrcat	/ - Syracuse/- Completed Projects/Lightwork Show LR Catalog	
South Africa Print Show.lrcat	/ - Syracuse/ - Open Projects/South Africa Print Show	
VIS Event Catalog.lrcat	/ - Syracuse/Resources/Vis Event/VIS Event Catalog	
324.lrcat	/Users/rc/324	

☐ Always load this catalog on startup ☐ Test integrity of this catalog

Note: Lightroom Catalogs cannot be on network volumes or in read-only folders.

▶ **Tip:** Even if you've set Lightroom to load the most recent catalog by default, you can open the Select Catalog dialog box by holding down the Control+Option/ Ctrl+Alt keys immediately after you launch Lightroom.

Getting ready to go mobile

Adobe Photoshop Lightroom Classic is integrated through Adobe Creative Cloud with Lightroom for mobile and Lightroom on the web, enabling you to sync photo collections between your desktop computer and a companion app on your mobile device, so that you can review, organize, and even edit your photos anywhere, anytime, and then share them online.

Whether you're working in Lightroom Classic on your desktop (or laptop) or Lightroom on your handheld device, any modifications made to a synced collection or the photos it contains will be updated on the other device. Lightroom syncs high-resolution Smart Previews to your mobile device, rather than your original photos. At a small fraction of the original file size, these Smart Previews won't take long to sync, or use up all your storage space, which means that you can even work with raw images while you're away from your desktop computer.

Edits you make on the mobile device are synced back to the full-size originals in your Lightroom Classic catalog. Photos captured on your handheld device and added to a synced collection are downloaded to your desktop at full size. You can share your photos from your device to social media or via Lightroom on the web. Here's how to set this up:

1 Download and install Lightroom on your mobile device. You can download the app free from the Apple App Store (for iPad and iPhone), or from Google Play (for Android), on a trial basis; then, choose a subscription plan later.

2 Once you've installed Lightroom on your handheld device, see the section "Taking your collections on the road" in Lesson 4, "Managing Your Photo Library," for details on getting started with Lightroom.

Editing photos in Lightroom on the web is covered in Lesson 4, in the "Editing on the Lightroom.adobe.com site" section. Sharing collections from Lightroom Classic via Lightroom on the web is explained in the "Syncing photos from Lightroom Classic" section in Lesson 4.

Subscription to Lightroom for mobile is free with either a full Creative Cloud subscription or the Photography plan. For subscription details, go to www.adobe.com/creativecloud/plans.html.

Getting help

Help is available from several sources, each one useful to you in different circumstances.

Module-specific tips

The first time you enter any of the Lightroom Classic modules, you'll see module-specific tips that will help you get started by identifying the components of the Lightroom Classic workspace and stepping you through the workflow.

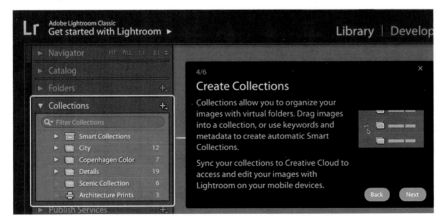

You can dismiss the tips if you wish by clicking the Close button (x) in the upper-right corner of the floating tips window. You can call up the module tips at any time by choosing Help > [*Module name*] Tips.

In the Help menu, you can also access a list of keyboard shortcuts applicable to the current module.

Navigating Help in the application

The complete user documentation for Adobe Photoshop Lightroom Classic is available from the Help menu.

● **Note:** You need to be connected to the internet to view Help in Lightroom.

1 Choose Help > Lightroom Classic Help or press the F1 key on your keyboard. Lightroom takes you to the online Help landing page. To search for a particular topic in the online Help, use the search bar at the upper right of the page. Enter a search term and press Return/Enter.

2 For quick access to Help documentation specific to the module in which you are working, press Command+Option+/ on macOS or Ctrl+Alt+/ on Windows.

3 Press Command+/ on macOS or Ctrl+/ on Windows to see a list of keyboard shortcuts for the current module. Press any key to hide it.

Accessing Help and support on the web

You can access Lightroom Classic Help, tutorials, support, and other useful resources on the web, even if Lightroom Classic is not currently running.

• If the application is running, choose Help > Lightroom Classic Online.

- If Lightroom Classic is not currently running, point your default web browser to https://helpx.adobe.com/support/lightroom.html, where you can find and browse Lightroom Classic content on adobe.com.

Additional resources

Adobe Photoshop Lightroom Classic Classroom in a Book is not intended to replace the documentation that comes with the application, or to be a comprehensive reference for every feature. Only the commands and options used in the lessons are explained in this book. For comprehensive information about program features and tutorials, please refer to these resources:

Adobe Photoshop Lightroom Classic Help and Support
You can search and browse Help and Support content from Adobe at https://helpx.adobe.com/support/lightroom.html.

Adobe Support Community
Tap into peer-to-peer discussions, advice, and questions and answers on Adobe products at https://community.adobe.com/.

Adobe Creative Cloud Learn
For inspiration, key techniques, cross-product workflows, and updates on new features, go to https://helpx.adobe.com/lightroom-classic/tutorials.html.

Adobe Photoshop Lightroom Classic product home page
https://www.adobe.com/products/photoshop-lightroom.html.

Adobe Create Magazine
https://create.adobe.com offers articles on design and design issues, a gallery showcasing the work of top-notch designers, tutorials, and more.

1 A QUICK TOUR OF LIGHTROOM CLASSIC

Lesson overview

This lesson starts with a quick look behind the scenes to show you how Lightroom Classic makes it easy to navigate, search, and manage your ever-growing image library and frees you to work on your photos without damaging the original files. The exercises then provide a hands-on introduction to Lightroom, familiarizing you with the workspace as they guide you through a typical workflow:

- Bringing photos into Lightroom Classic.

- Reviewing and comparing photos.

- Sorting and organizing your image library.

- Adjusting and enhancing photos.

- Sharing your work.

 This lesson will take about 1 to 2 hours to complete. To get the lesson files used in this chapter, download them from the web page for this book at www.adobepress.com/LRClassicCIB2020. For more information, see "Accessing the lesson files and Web Edition" in the Getting Started section at the beginning of this book.

Note: The downloaded lesson images won't appear in Lightroom until you've imported them into the library catalog file; you'll do that in the exercise "Importing photos," after the overview that begins this lesson.

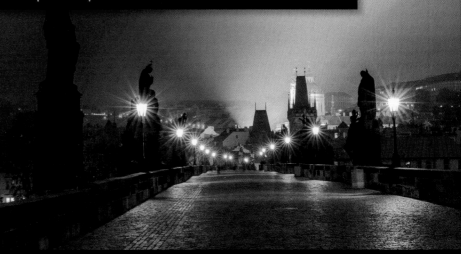

Library | Develop | Map | **Book** | Slideshow | Print | Web

Whether you're a beginner or a professional, Lightroom Classic delivers a complete desktop-based workflow solution for today's digital photographer, allowing you to work more efficiently and bring out the very best in your images.

Understanding how Lightroom works

Working with Lightroom Classic will be easier and more productive if you have an overview of how Lightroom works—and how it differs from other image processing applications in the way it handles your pictures.

About catalog files

In order to work with a photo in Lightroom Classic you must first bring it into your library catalog by importing it.

Think of the Lightroom catalog as a master notebook that keeps track of the location of your pictures (hard drive, external drives, network-attached storage device), as well as what you've done to these pictures (rank, sort, pick, develop, etc.). This digital notebook keeps track of all of the changes you make inside the catalog file, and never touches the original images. This allows you to work with images more quickly and offers you better ways to organize and sort your growing photographic library.

A single catalog can easily manage thousands of files (my catalog file manages more than 350,000 images), but you're free to create as many catalogs as you wish and switch between them. The one thing to consider is that you will not be able to work with or search for images across multiple catalogs. Because of this, I recommend that you keep all of your images in one catalog.

Managing the photos in your catalog

Lightroom Classic lets you organize your photos right from the point of import; you can choose to add photos to your catalog without moving the image files from where they live on a hard drive, copy them to a new location leaving the originals intact, or move them and delete the originals to avoid duplicating files. If you choose to copy or move your files during the import process, you have the option to select how folders are structured in your new location.

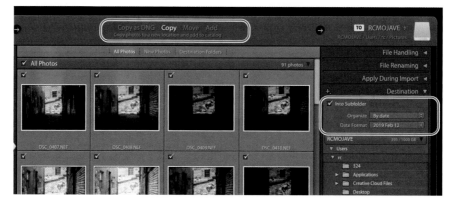

During this import process, Lightroom can rename your images, create backup duplicates (your digital negatives), attach keywords and other metadata, and even apply develop presets—all before you've opened a single image!

● **Note:** You'll learn more about setting up import options in Lesson 2, "Bringing Photos into Lightroom Classic."

The Library module will let you organize your images, and attach keywords and captions. Additionally, you can separate and organize your images by using pick flags, and star and color ratings—both on single images or on a group of images—in no time at all. Lightroom even gives you the option to sort images by places on a map or to sort by face. All of this information goes into your digital notebook, giving you access to it whenever you need it.

Managing files and folders

While all of this is quite useful, I'll add a word of caution. If you wish to rename or move an image file or folder that you've already imported into your catalog or any folder containing photos from your library, you should always do so from within Lightroom so that the changes can be tracked in the catalog. If you make these changes outside of Lightroom, it will no longer be able to find them (we'll talk about how to recover them later).

Non-destructive editing

While storing information about your images in a central catalog makes it easy to navigate, search, and manage your photo library, the greatest benefit of this catalog file is that your edits are *non-destructive*. When you modify or edit a photo, Lightroom makes a record of each step you take in the catalog file, rather than saving changes directly to the image. This ensures that the original raw data is always safe. I like to think of it like this: the raw data is my ingredients, but the recipe is what I save in my notebook (catalog file).

Non-destructive editing not only frees you to experiment with your photos without fear of losing information from the original files, but also makes Lightroom a very powerful editing environment. All of your edits remain "live," so you can return at any time to undo, redo, or tweak any modification that you've made; Lightroom applies your edits permanently only to output copies—and it does that quickly.

Editing photos in another application

Should you wish to edit an image from your catalog using an external program, always launch the process from within Lightroom so that Lightroom can keep track of changes made to the file. For a JPEG, TIFF, or PSD image, you have the option to edit the original file or a copy—either with or without the adjustments that you've already applied in Lightroom. For other file formats, you can edit a copy to which your Lightroom adjustments have already been applied. The edited copy will automatically be added to your catalog.

▶ **Tip:** You can specify your favorite external editors in the External Editing preferences; your choices will appear in the Photo > Edit In menu. If you have Photoshop installed on your computer, it will be listed by default.

The Lightroom Classic workspace

Lightroom is split into seven main panels. At the center of the program is the preview and work area, and panel groups appear to the left and right of it. Directly above the work area and to the left is the identity plate. The Module Picker sits above and to the right. Finally, the area beneath the work area is the Toolbar, and below that, across the bottom of the workspace, the Filmstrip.

● **Note:** The illustration at the right shows the macOS version of Lightroom. On Windows, the workspace is the same, except for minor differences between the two operating systems; on Windows, for example, the menu bar is located under the title bar, whereas on macOS it's anchored at the top of the screen.

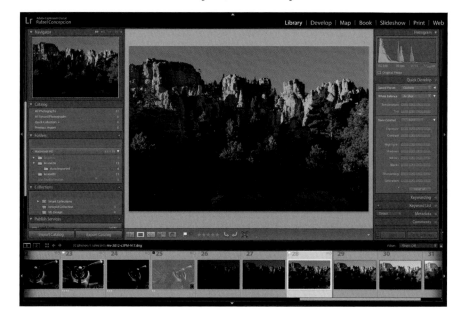

This visual arrangement of panels is identical in all of the seven modules. Only the contents of the panels vary from module to module.

The top panel

The top panel displays an identity plate on the left and the Module Picker on the right. This identity plate can be customized to feature your own company name or logo and will be temporarily replaced by a progress bar whenever Lightroom is performing a background process (clicking the progress bar brings up a menu that shows you the processes Lightroom is working on). To the right, you'll use the Module Picker to move between the different modules by clicking their names. Finally, the name of the currently active module is always highlighted in the Module Picker.

▶ **Tip:** The first time you enter any of the Lightroom modules, you'll see module tips that will help you get started by identifying the components of the Lightroom workspace and stepping you through the workflow. Dismiss the tips by clicking the Close button. To reactivate the tips for any module, choose [*Module name*] Tips from the Help menu.

The work area

The main preview and work area sits at the center of Lightroom—you'll spend most of your time here. This is where you select, review, sort, compare, and apply

adjustments to your images, and where you preview the work in progress. This center window will change as you move across modules, showing you book designs, slideshow presentations, web galleries, and print layouts as needed.

The Toolbar

Underneath the work area is the Toolbar. This toolbar will offer a different set of tools and controls for each of the modules. You can customize the Toolbar for each module independently to suit your needs, choosing from a variety of tools and controls for switching viewing modes; setting ratings, flags, or labels; adding text; and navigating through preview pages. You can show or hide individual controls, or hide the Toolbar altogether until you need it.

▶ **Tip:** You can show and hide the Toolbar by pressing the T key.

Here, we see the Toolbar for the Library module, with the view mode buttons at the left, and a selection of task-specific tools and controls that can be customized by choosing from the menu at the far right of the Toolbar.

Tools and controls that are currently visible in the Toolbar have a check mark beside their names in the Select Toolbar Content menu. The order of the tools and controls from left to right in the Toolbar corresponds to their order from top to bottom in the menu. Most of the options presented in the Toolbar are also available as menu commands or keyboard shortcuts.

The Filmstrip

The Filmstrip gives you access to all of the images in your catalog or collection at any stage in your workflow. You can use the Filmstrip to quickly navigate through a selection of images, or to switch between different sets of images without returning to the Library module.

▶ **Tip:** If you don't see the Filmstrip across the base of the workspace, choose Show Filmstrip from the Window > Panels menu, or press the F6 key.

You can work directly with the thumbnails in the Filmstrip—just as you do in the Library module's Grid view—to assign ratings, flags, and color labels, apply metadata and develop presets, and rotate, move, or delete photos.

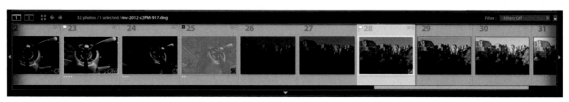

By default, the Filmstrip displays the same set of images as the Grid view in the Library module; it can show every image in the library, the contents of a selected source folder or collection, or a selection filtered by a range of search criteria.

The side panels

As you move from module to module, the content of the side panels will change, offering you tools specific to that module. A quick way to think of this layout is that the panels in the left group of any module help you navigate to, preview, find, and select images, while panels in the right group allow you to edit or customize the settings for your selected photo.

In the Library module, for example, you'll use the panels on the left, below the Navigator preview (Catalog, Folders, Collections, and Publish Services), to locate and group the images you want to work with or share, and the panels on the right, below the Histogram panel (Quick Develop, Keywording, Keyword List, Metadata, and Comments), to apply changes to your selected photo.

In the Develop module, you'll choose develop presets on the left, and fine-tune their settings on the right. In the Slideshow, Print, and Web modules, you'll select a layout template on the left, and customize its appearance on the right.

Left panels, Develop module. Right panels, Develop module. Left panels, Web module. Right panels, Web module.

Customizing the workspace

As you spend more time working through Lightroom, you'll notice that you won't work with every single panel. Thankfully, you have the option to quickly modify the layout of each of the panels to your specific workflow. Keep in mind that the configuration of each of the layouts is on a module-by-module basis. This is a good thing, as your needs will vary as you move across the modules.

Click the outer margin at the top, sides, and bottom of the workspace (the black bar with the gray triangle at its center), or use the commands and shortcuts listed in the Window > Panels menu, to show or hide any of the panels that surround the work area. Right-click the side and bottom margins, and in the menu, you can set the side panels or the Filmstrip to show and hide in response to your pointer movements so that information, tools, and controls appear only when you need them. You can also drag to adjust the width of the side panel groups or the height of the Filmstrip panel as needed.

You can expand any of the panels on the right and left sides by clicking the triangle beside its name. Right-click any panel header to access a menu where you can hide panels you seldom use, creating more space for those you access more often, or reduce clutter by choosing Solo Mode so that all the panels other than the one you're working with close automatically.

The View > Grid View Style menu and the Library View Options dialog box (View > View Options) allow you to customize the appearance of the thumbnail image cells in the Grid view. You can have thumbnails displayed in either compact or expanded cells, and specify how much information about the images will be shown for each view style.

Tip: Make sure you check out the downloadable content to see a video on how to customize your workspace. See the "Getting Started" section at the beginning of the book for how to access it.

Note: Lightroom Classic allows you to reorganize the panels in the Develop module. We'll cover how (and why) to set up your own configuration in the Develop module lesson (Lesson 5).

If you use a second monitor, click the Second Window button (the rectangle with a "2" inside, located at the upper left of the Filmstrip) to set up an additional view that is independent of the module and view mode on your main monitor. You can use the view picker at the top of secondary display, or right-click the Second Window button to access its menu, to customize the view and the way it responds to your actions in the main workspace.

Tip: To choose from a more limited set of display options for the thumbnails in the Filmstrip, right-click the Filmstrip and choose View Options from the menu.

The Lightroom Classic modules

Lightroom Classic has seven modules: Library, Develop, Map, Book, Slideshow, Print, and Web. Each module offers a set of tools for a different phase of your workflow: the Library for importing, organizing, and publishing your photos, the Develop module for correcting, adjusting, and enhancing images, and specialized modules for creating stylish presentations for screen, print, or web.

Use the Module Picker, or the commands and keyboard shortcuts listed in the Window menu, to move between each of these modules as you work.

The Lightroom Classic workflow

The Lightroom Classic interface makes it easy to manage every stage of your workflow, from image import to the final print:

- **Import** In the Library module, you can import images from your memory card, hard disk , or storage media, or directly into your Lightroom catalog through a tethering session.

- **Organize** You can attach keywords and other metadata to your photos during the import process, making this task much quicker. Once the photos have been added to your catalog, use the Library and Map modules to manage them—to tag, sort, and search your image library and create collections to group your photos. You can even share these collections online with others, providing feedback on your images.

- **Process** Crop, adjust, correct, retouch, and apply effects to your images one at a time or en masse in the Develop module.

- **Create** In the Book, Slideshow, Print, and Web modules, you can put together polished presentations and layouts to showcase your work.

- **Output** The Book, Slideshow, Print, and Web modules each have their own output options and export controls. The Library module hosts the Publish Services panel for sharing your images online. With each of these, you have the opportunity to export the right image, at the right resolution, for the right task.

In the exercises that follow, you'll go through a typical workflow as you familiarize yourself with the Lightroom Classic workspace.

▶ **Tip:** If you wish to process your images further in your favorite pixel-based editor as part of your workflow, you can launch an external application from inside the Library or the Develop module and Lightroom will keep track of the changes that you make.

Importing photos

You can import photos into your Lightroom Classic library from your hard disk, from your camera or memory card reader, or from external storage media. (We'll cover this in a lot more detail in Lesson 2.)

Before you start on the exercises, make sure you've set up the LRClassicCIB folder for your lesson files and created the LRClassicCIB Catalog file to manage them, as described in "Accessing the lesson files and Web Edition" and "Creating a catalog file for working with this book" in the "Getting Started" section at the beginning of this book.

If you haven't already, log in to your peachpit.com account to download the files for this lesson, or follow the instructions under "Accessing the lesson files and Web Edition" in the "Getting Started" section.

1 Start Lightroom Classic. In the Select Catalog dialog box, make sure that the file LRClassicCIB Catalog.lrcat is selected in the list of recently opened catalogs, and then click Open.

2 Lightroom Classic will open in the screen mode and workspace module that were active when you last quit. If necessary, switch to the Library module by clicking Library in the Module Picker at the top of the workspace.

3 Choose File > Import Photos And Video. If the Import dialog box appears in compact mode, as shown in the illustration below, click the Show More Options button at the lower left of the dialog box to access all of the options available in the expanded Import dialog box.

Tip: If you can't see the Module Picker, choose Window > Panels > Show Module Picker, or press the F5 key. Note that in macOS, the function keys are assigned to specific operating system functions by default and may not work as expected in Lightroom. If you find this to be the case, either press the fn key (not available on all keyboards) together with the F5 key, or change the keyboard behavior in the system preferences.

The layout of the header bar of the Import screen reflects the steps in the import process: working from left to right, first specify the source location of the files you wish to import; next, select the appropriate type of import; and then designate a destination (for Copy and Move imports) and set batch processing options.

4 In the Source panel at the left of the expanded Import dialog box, navigate to the Lessons folder inside the LRClassicCIB folder on your hard disk.

5 Select the lesson01 folder. Click the Check All button at the lower left of the preview grid to ensure that all of the images in the lesson01 folder are selected for import.

6 In the import options just above the thumbnail previews, click Add so that the imported photos will be added to your catalog without being moved or copied.

7 In the File Handling panel at the right of the expanded Import dialog box, choose Minimal from the Build Previews menu. Disable the Build Smart Previews option and ensure that Don't Import Suspected Duplicates is selected.

8 In the Apply During Import panel, choose None from both the Develop Settings menu and the Metadata menu, and then type **Lesson 01, Europe** (including the comma) in the Keywords text box. Make sure that your import is set up as shown in the illustration below, and then click Import.

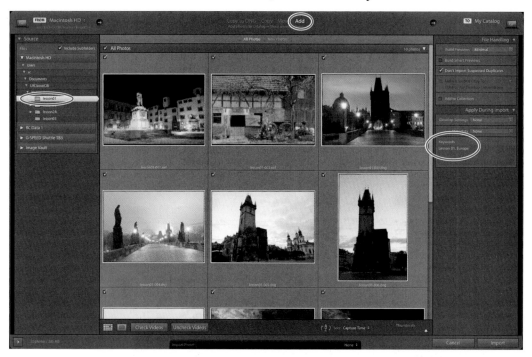

Thumbnails of the Lesson 1 images appear in the Grid view of the Library module and also in the Filmstrip at the bottom of the workspace. If you don't see the Filmstrip, press the F6 key or choose Window > Panels > Show Filmstrip.

Reviewing and organizing

When you're working with a library with many images, you'll need to be able to find exactly what you're looking for quickly. Lightroom provides multiple tools that make organizing and finding your files easy.

I make it a habit of going through my images immediately to sort them into groups and place them into collections. Investing a little time on the front end can help you later by making it easier to find what you need.

You've already taken the first step toward structuring your catalog by tagging the lesson images with the keyword *Europe* as they were imported.

Tagging photos with keywords is an intuitive and versatile way to organize your catalog, because it lets you sort and search your library based on whatever words you choose to associate with your images, making it easy to find the files you need, regardless of how they are named or where they are located.

About keywords

Keywords are labels (such as *desert* or *Dubai*) that you can attach to your images to make them easy to find and organize. Shared keywords create virtual groupings within your library, linking photos by association, although the image files may actually be stored in many separate locations.

Assign one or more keywords to your images and you can easily retrieve them by searching your library using the Metadata and Text filters located in the Filter bar across the top of the work area.

You can use keywords to sort your photos into photographic categories, organizing them according to content by tagging them with the names of people, places, activities, or events. The key here is to tag your images with general keywords to start, and then add more refined keywords later on in the organizational process.

Attach multiple keywords to your images to make retrieving the pictures you want even easier: you could quickly find all the photos that you've tagged with the keyword *Dubai*, and then narrow the search to only those that are also tagged *desert*. The more tags you attach to your photos, the more chances you have of finding exactly the right image when you need it.

For more on working with keywords, see Lesson 4, "Managing Your Photo Library."

Culling your images

Once your images are imported, it's a good idea to do a quick sort. The goal here is to flag images that you know were not successful as rejected, and flag images that you believe were successful as picked images. We'll talk about this method later on in more detail, but let's quickly go over it here.

● **Note:** Press Command+Return/ Ctrl+Enter to see your images large in a slide-show. The slideshow plays according to the settings current in the Slideshow module and will repeat until you press the Esc key to return to the Library.

1 Press the Spacebar or double-click an image to see it larger. Then, press Shift+Tab to hide all of the panels around the main work area. Once those panels are hidden, press the L key to dim everything on your screen except your image by 80%, known as Lights Out mode. Pressing the L key again will dim everything outside your images to 100% black.

Dimming the interface allows you to simply focus on the image that is in front of you. At this point you are trying to make only one choice: is this image successful or not?

2 Press the P key on your keyboard to flag the image currently displayed in your slideshow as a pick (⚐), press the X key to flag it as rejected (⚑), or press the U key to remove any flags. Press the right arrow key to move to the next image. Flag several of the Lesson 1 images as picks, and mark at least one as a reject.

The most important thing to remember is that if you have to think for a second about whether the image should be picked or rejected, skip it by pressing the right arrow key.

3 Press the Esc key to return to Grid view, then press L again to leave Lights Out mode.

In the Library module, you can use the Filter bar above the thumbnail grid to search your images by text or metadata, and then refine your search by filtering for one or more of the searchable attributes—flag status, edits, rating, label color, or file type—so that only those photos you want are displayed in the Grid view and the Filmstrip. For now we only want to show the images that are unflagged.

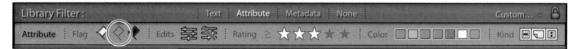

4 If the Filter bar is not already visible above the work area, open it by choosing View > Show Filter Bar. Click Attribute, and in the Attribute bar, select the center Unflagged option (the gray flag, circled above).

5 Repeat the process of hiding your panels and turning off your interface so you can focus on marking images as a pick or as rejected. You'll know when you are

finished with the culling process when you get to a completely dark screen. From here, press the L key to turn the lights back on, press Shift+Tab to bring back the interface, and deselect the Unflagged option in the Attribute bar. You can choose to display flags, along with other information, in the image cells in the Library views and in the Filmstrip. Images flagged as rejects appear grayed out, while those marked as picks are indicated by a white border.

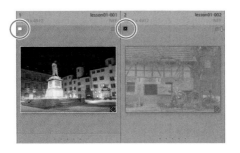

6 Stars can also help you rank your images in order of importance. To quickly assign a rating to the image that's currently displayed, press a number from 1 (for 1 star) to 5 (for 5 stars) on your keyboard. To remove the rating, press 0. You can attach only one rating to each photo; assigning a new rating will replace the old one. For the purposes of this exercise, mark three or four images with either 3, 4, or 5 stars.

▶ **Tip:** Whenever you use your keyboard to mark a photo in the impromptu slideshow, the rating, flag, or label you assign appears briefly in the lower-left corner of the screen to confirm your action.

Rating stars are displayed below the thumbnail images in all of the Library module views and in the Filmstrip, as shown in the illustration above.

Finally, color labels can be very useful to mark images for specific purposes or projects. You might use a red label for images you intend to crop, green for those that need correction, or blue to identify photos you wish to use in a particular presentation.

7 To assign a color label to the image currently displayed, use the number keys. Press 6 on your keyboard to assign a red color label, press 7 for yellow, 8 for green, or 9 for blue. There's no keyboard shortcut to assign a purple color label. To remove a color label simply press the same number again. Assign different color labels to several of the images, and then remove one.

In the Library module's Grid view, and in the Filmstrip, a photo with a color label will be framed in that color when it's selected, and surrounded by a tinted image cell background when it's not, as shown in the illustration at the right.

Remember, you can go back into the Library Filter and find specific images using all of these criteria. For example, can you find a picked image that is a 5-star image, and assigned a color label of Green?

Select all three of those markers and you will see an image that matches those criteria. If an image is not available, make sure to rank one with all three before you apply the filter.

Working with collections

Once you've marked specific images with flags, ratings, or color labels, you can group the resulting photos as a *collection*. A collection is an organization of images from anywhere in your Lightroom catalog. While we'll get into this in more detail in a later lesson, I think collections are a cornerstone of your organization, and merit getting under your belt as soon as possible. Here's a quick look at the different types of collections:

- The Quick Collection: a temporary holding collection in the Catalog panel, where you can assemble a selection of images on an ad-hoc basis.
- A "standard" collection: a more permanent grouping of images in the Collections panel.
- A smart collection: a selection of images automatically filtered from your library according to specific criteria.
- A collection set: a container that allows you to store multiple collections or other collection sets in it. It is largely used for organization.

For this exercise, you'll create a standard collection.

1 Ensure that Previous Import is selected in the Catalog panel. Choose View > Sort > File Name; the Grid view and the Filmstrip should display all images. If you cannot see all of your images, make sure that you deselect any attributes or click None in the Library Filter bar.

● **Note:** A selected image is highlighted in the Grid view and the Filmstrip by a narrow white border (or a colored border if the image has a color label) and a lighter cell background color. If more than one photo is selected, the active photo is shown with an even lighter background. Some commands will affect only the active photo, while others affect all selected photos.

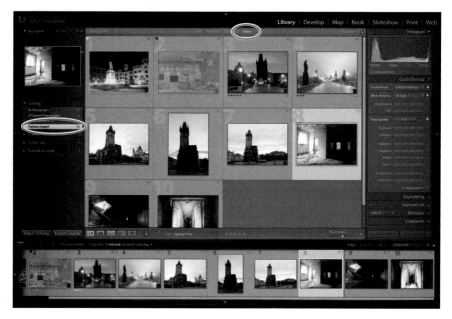

Once you import more images, the Previous Import folder will update and you'll no longer be able to isolate this particular group of images by selecting that entry in the Catalog panel. In this case, you could still retrieve this group by selecting its folder in the Folders panel or searching the Lesson 01 keyword, but it isn't as easy to retrieve a group of photos that don't share a keyword or that are spread across separate folders. Because of this, it's best to create a collection, a virtual grouping that is permanently listed in the Collections panel, allowing you to access that same set at any time with a single click.

▶ **Tip:** Collections can be nested using collection sets. For example, you could create a Portfolio collection set, and then create nested collections for Portraits, Scenic, Product Shots, Black & White, etc. Each time you import an outstanding new image, add it to one of these collections to slowly build up your portfolio.

2 Before we create this collection, press Command+A/Ctrl+A to select all of the images in the Grid view.

3 Click the plus sign (+) icon at the upper right of the Collections panel and choose Create Collection. In the Create Collection dialog box, type **Lesson 01 - Europe** as the collection name. Under Location, leave the Inside A Collection Set option disabled. Under Options, ensure that Include Selected Photos is selected and the other options are unselected, then click Create.

Your new collection is now listed in the Collections panel. The listing includes an image count showing that this collection contains 10 photos.

Rearranging and deleting images in a collection

One drawback to working with images in the Previous Import or All Photographs folder (listed in the Catalog panel) is that you don't have many options for reorganizing your images. The thumbnails are ordered either by capture time (the default) or by the other choices in the Sort menu in the Toolbar.

With a collection, however, you're free to rearrange the images in either the Grid view or the Filmstrip in any order, and even remove them from the working view without deleting them from the catalog.

1 If your new collection is not already selected in the Collections panel, click to select it now. Choose Edit > Select None or press Command+D/Ctrl+D.

2 In the Filmstrip, Command-click/Ctrl-click to select the fourth and sixth images and drag the selection over the dividing line between the first and second thumbnails in the Filmstrip. Release the mouse button when the black insertion line appears.

▶ **Tip:** Drag the thumbnail of one of your selected images, rather than the image cell frame, to move it.

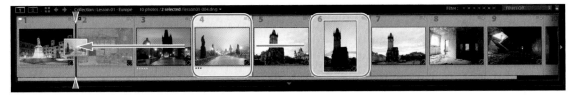

The selected photos snap to their new positions in the Grid view and the Filmstrip.

3 Deselect the photos by clicking an empty area in the main work area. Click to select the first thumbnail in the Grid view and drag it over the border between the fifth and sixth images. Release the mouse button when the black insertion line appears. In the Toolbar, the Sort criterion has changed to Custom Order.

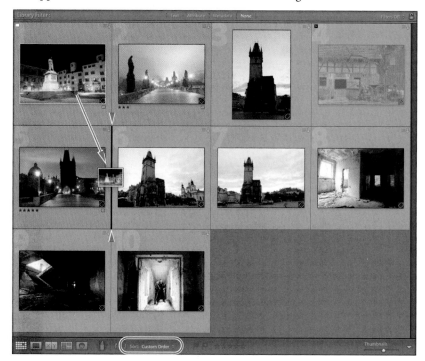

4 Choose Edit > Select None. Click the third image in the grid (lesson01-002), which is flat, to select it. Then, right-click the selected image and choose Remove From Collection from the menu.

In the Collections panel (and in the header bar of the Filmstrip) the image count shows that the new collection now contains only nine images.

Although you've removed a photo from the collection, it has not been deleted from your catalog. The Previous Import and All Photographs folders in the Catalog panel still contain all 10 images. A collection contains only links to the files in your catalog; deleting a link does not affect the file in the catalog.

There are two benefits to using images in collections. First, you can add an image to as many collections as you like since they are simply references to images in your Lightroom catalog, not copies. Second, if you make any change to one of the images in a collection, all of the other instances of that image in other collections will be changed as well. This allows for better picture housekeeping and gives you more opportunities to experiment with your work. We'll go into more examples of how to make collections really work for you in Lesson 4, "Managing Your Photo Library."

▶ **Tip:** Should you wish to edit the same image differently in two collections, you'll first need to make a virtual copy—an additional catalog entry for the image—for inclusion in the second collection. You'll learn about this in Lesson 6, "Advanced Editing."

Comparing photos side by side

Sometimes you'll need the ability to compare images to one another to find the best in a series. Lightroom's Compare mode will prove very useful here:

1 Select two images in the Filmstrip, and then click the Compare View icon in the Toolbar to switch to Compare view. Alternatively, choose View > Compare or press C on your keyboard.

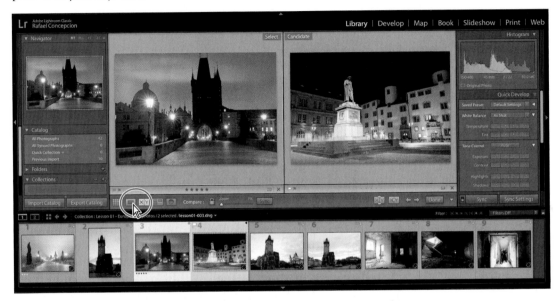

▶ Tip: If you have any images selected before you start, press Command+D/Ctrl+D to deselect all images.

2 The Select photo is active by default on the left. The right arrow key on your keyboard will let you move the next photo in the Filmstrip into the Candidate position. Keep pressing the right arrow to cycle through the other images.

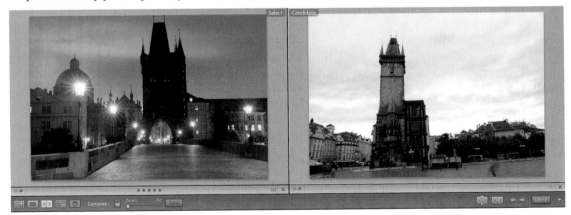

3 Press the Tab key on your keyboard, and then press F5 to hide the side and top panels so that your photos can be displayed at a larger size in the Compare view.

▶ Tip: If you're on a Mac without a full-size keyboard, press the Fn key and then the F5 key.

4 Once you find an image that should replace the selected image, click the Swap icon in the Toolbar below the Candidate image to swap the Candidate and Select images. Go back to using the arrows to compare the new Select photo with other candidates from the collection.

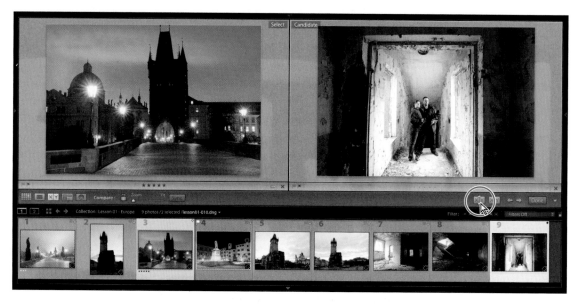

5 Once you have the image you want, click the Done button at the right end of the Toolbar. The Select image will appear in the single-image Loupe view.

Comparing several photos

▶ **Tip:** Having a group of images side by side can be helpful in selecting a 5-star image or an image that needs to be flagged for editing. You can continue to use flags, stars, and color labels to classify your images while in Survey view.

While Compare view lets you compare two images, Survey view is better when you are trying to pick the best image out of a series. In Survey view, you can compare several photos at once and narrow your selection until only the best one remains.

1 Choose Edit > Select None. In the Filmstrip, Command-click/Ctrl-click any five images and then click the Survey view icon in the Toolbar. Alternatively, choose View > Survey or press N on your keyboard.

Survey view displays all the selected images; the more images you select, the smaller the individual previews in Survey view. The active image has a thin white border; to activate a different photo, you can either click its thumbnail in the Filmstrip or click the image directly in the work area.

2 If you have two images you'd like to compare more directly, simply drag one next to the other. The rest of the images will shuffle automatically.

3 As you move the pointer over each image, a Deselect Photo icon (✖) appears in the

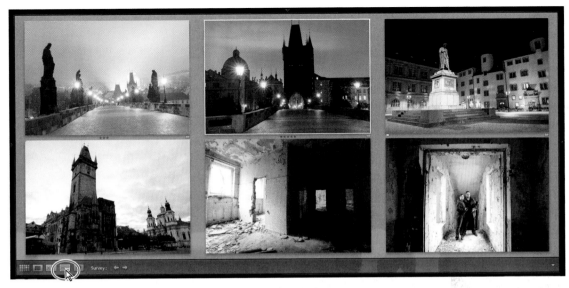

lower-right corner. Click this icon to remove a photo from the selection in Survey view.

As you eliminate candidates, the photos remaining in the work area are progressively resized and shuffled to fill the space available. When you eliminate a photo from Survey view, the image is simply dropped from the selection, not removed from the collection.

▶ **Tip:** If you eliminate a photo accidentally, choose Edit > Undo to return it to your Survey view, or Command-click/Ctrl-click the image in the Filmstrip. You can easily add a photo to the selection in the same way.

4 Eliminate another photo from Survey view so that your selection is narrowed down to a single image, and then press E on your keyboard to switch to the single-image Loupe view.

5 Press Shift+Tab (twice if necessary) to show all the workspace panels. Press G on your keyboard to return to the Grid view. Choose Edit > Select None.

Developing and editing

Once you have the images you want to edit selected, it's time to bring out the very best in them. While the Develop module is extremely powerful, you can start your edits right inside the Library module with Quick Develop.

The Quick Develop panel offers simple controls for basic color correction and tonal adjustment, and a choice of preset crop and develop settings. For a finer degree of control, the Develop module offers an extended suite of sophisticated image processing tools in a more comprehensive and convenient editing environment.

Using Quick Develop in the Library module

In this exercise you'll quickly improve the color and tonal balance of an image, and then tweak the results with the controls in the Quick Develop panel.

1 Select the Lesson 01 - Europe collection to see all nine of the lesson images.

2 In the Filmstrip or Grid view, hold the pointer over the second picture in the group (a building in Prague). You'll see basic image details displayed in a tool tip. Click the thumbnail to select it; the filename is also displayed in the status bar above the thumbnails in the Filmstrip.

3 Double-click the selected image in the Filmstrip to see it enlarged in Loupe view. Expand the Histogram and Quick Develop panels in the right panel group by clicking the arrows beside the panel names.

Tip: If the Filmstrip is not visible, choose Window > Panels > Show Filmstrip or press F6 on your keyboard.

Tip: If you can't see any images in your collection, check the Library Filter bar to make sure None is selected.

Tip: To make more space for the image in Loupe view, use the commands in the Window > Panels menu to hide the left panels, the Module Picker, and the Filmstrip. Commands for showing and hiding the Toolbar and Filter bar are listed in the View menu.

As you can see from both the image preview and the histogram, in this photo, everything but the sky is significantly underexposed and lacks midtone contrast, giving it a dull, flat look. Let's see how much better we can make it.

4 Click the Auto Tone Control button in the Quick Develop panel and watch the tone distribution curve shift in the Histogram panel.

Although the automatic adjustment isn't perfect, it could be an improvement. A lot of tone and color detail has been recovered from the darker shadows. These changes are reflected in the histogram, which has been pushed slightly over to the right. The tonal balance is better, but the image could still use a little help.

Tip: Click back and forth between the Reset All button at the bottom of the Quick Develop panel and the Auto Tone Control button to assess the results in the Loupe view.

5 Click the triangle to the right of the Auto button to expand the Tone Control area. Click the second button (the left-facing single arrow) once for the Exposure control and twice for Highlights. Click the right-most button once for Contrast, Whites, Blacks, Shadows, Vibrance, and Clarity.

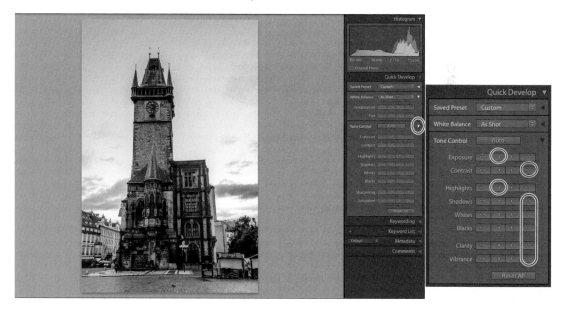

The adjusted image has more detail than the original in both the brightest and most shadowed areas, and the overall contrast and color is much better. If you press D to switch to the Develop module and press the backslash (\) key, you can see how

much we were able to get back from this raw file by seeing a before and after view of the picture.

Working in the Develop module

The controls in the Quick Develop panel let you change settings but don't show you absolute values for the adjustments you make to your images.

In our example, there is no way to tell which parameters were modified by the Auto tone adjustment or how much they were shifted. For finer control, and a more comprehensive editing environment, you need to move to the Develop module.

1. Keeping the image from the previous exercise selected, switch to the Develop module now by doing one of the following:

 • Click Develop in the Module Picker at the top of the workspace.

 • Choose Window > Develop.

 • Press Command+Option+2/Ctrl+Alt+2.

2. If necessary, expand the History panel in the left panel group and the Basic panel in the right panel group by clicking the triangle beside each panel's name. Collapse any other panels that are currently open, except the Navigator on the left and the Histogram at the right. Press F6 to hide the Filmstrip.

The History panel not only lists every modification you've made to a photo—even Quick Develop adjustments made in the Library module—but also enables you to return the image to any of its previous states.

The most recent Clarity adjustment you applied is at the top of the History list. The entry at the bottom of the list records the date and time of import. Clicking this entry will revert the photo to its original state. As you move the pointer over each entry, the Navigator displays a preview of the image at that stage of development.

The Basic panel displays numerical values for the adjustment settings that were unavailable in the Quick Develop panel. For our image in its most recent state, the Exposure is set to −0.15; Contrast is set to +26; Highlights, Shadows, Whites, Blacks, Clarity, Vibrance, and Saturation are set to −94, +100, +46, 0, +20, +35, and +2, respectively. Don't be concerned if your settings differ from these fractionally.

3 In the History panel, click the entry for the first modification you made to this photo—the Auto tone adjustment—and inspect the settings in the Basic panel.

For this image, clicking the Auto button modified all the settings in the Tone area and two under Presence, but applying Auto tone to another photo may affect fewer settings and produce very different adjustment values.

4 Click the top entry in the History list to return the photo to its most recent state.

5 In the Toolbar (View > Show Toolbar), click the small triangle to the right of the Before/After button and choose Before/After Left/Right from the menu.

▶ **Tip:** A new feature in Lightroom Classic allows you to clear the history of your file from the step you have selected. It's located directly below Copy History Step Settings To Before when you right-click a step.

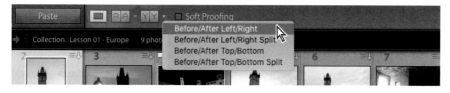

By comparing the Before and After images, you can see how much you've improved the photo with just a few clicks. Now let's look at how much difference your manual Quick Develop adjustments made after applying Auto tone.

6 Leaving the most recent Clarity adjustment activated in the History panel, right-click the entry for the Auto Settings adjustment, and choose Copy History Step Settings To Before from the menu.

▶ **Tip:** If you don't see the Before/After button in the Toolbar, click the triangle at the right of the Toolbar and choose View Modes in the Toolbar menu.

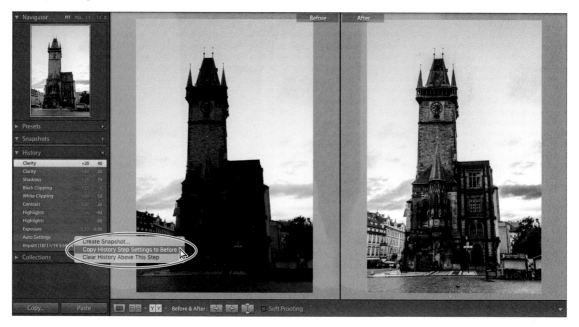

There's much more to learn about the correction and adjustment tools in the Develop module, but we'll leave that for later. For now, you'll straighten this slightly tilted photo and then crop it.

Straightening and cropping an image

1 Press D on your keyboard to switch to Loupe view in the Develop module.

2 Click the Crop Overlay tool (circled on top here), located just below the Histogram in the right panel group, or press the letter R. The Crop Overlay tool enables you to both crop and straighten an image.

3 A panel with tool-specific controls opens below the tool strip. Click the Straighten tool (circled here). The pointer changes to a cross-hairs cursor, and the level icon follows your movement across the image preview.

4 With the Straighten tool, drag a line that follows one of the horizontal lines of the sidewalk. Release the mouse button and the image is rotated so that your line becomes horizontal, and the Straighten tool returns to its place in the Crop Overlay tool options. If you are not satisfied with the result, undo the step (Command+Z/Ctrl+Z) and try again. You can also use the text box beside the Straighten tool slider to indicate a rotation. Let's use 0.54 degrees.

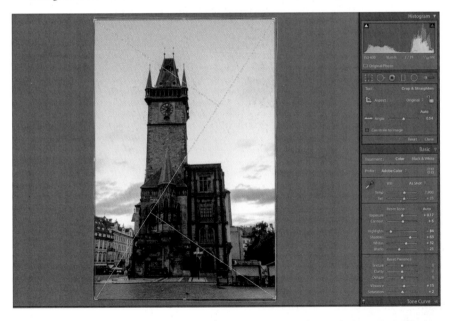

► **Tip:** To maintain the original aspect ratio of an image when you crop it manually, make sure that Original is selected from the cropping Aspect menu and that the aspect ratio is locked.

Lightroom has overlaid a cropping rectangle on the straightened photo, automatically positioned to achieve as large a crop as possible with the original aspect ratio while trimming away the angled edges.

If you wished to adjust the crop, you could drag any of the eight handles on the cropping rectangle. To assist with manual cropping, you can choose from a variety

of grid overlays in the Tools > Crop Guide Overlay menu, or hide the grid by choosing Tools > Tool Overlay > Never Show.

5 When you're done, apply the crop by clicking the Crop Overlay tool, the Close button at the lower right of the tool options, or the Done button in the Toolbar. You can reactivate and adjust the crop at any time by clicking the tool again.

Adjusting lighting and tonal balance

Previously, we used the Quick Develop tone controls to adjust a picture. Let's go into the Basic panel with another picture to see just how much tone we can pull out of an image.

1 While in the Develop module, press F6 and F7 (or use the Window > Panels menu) to show the Filmstrip and hide the left panels. In the Filmstrip, click to select lesson01_004.dng.

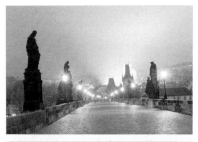

This image is very overexposed, it's crooked, and it lacks detail. There is some color in the sky, but details are missing in the statues. The image also has a ton of spots.

2 The histogram above the right panels gives you an idea of what you are work-ing with. It looks like a lot of the pixels sit to the right side of the exposure graph.

3 In the Basic panel, click the Auto adjustment button at the upper right of the Tone area, noting the effect on the histogram curve as well as the image in the work area.

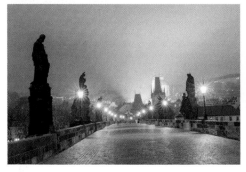
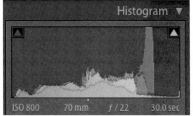

The image looks quite a bit better with one button push. From a histogram point of view, the range is pushed toward the middle, hence the darkening,

and it seems a little more spread out, giving us increased contrast. This is a good starting point, but I think we can make it even better.

4 In the Basic panel, the Auto tone adjustment affected all six of the settings in the Tone area, as well as the Vibrance and Saturation settings under Presence.

As the automatic adjustment moved this photo in the right direction, you can now use these settings as a starting point, and then make manual adjustments to tweak the tonal balance, as you did with the simplified Quick Develop controls in the previous exercise.

5 Watch the change in the histogram, as well as the photo, as you move the Highlights slider to the left, or type in the text box, to reduce the value to −**100**.

Reducing the highlights may seem counterintuitive, but it has effectively drawn image data inward from the ends of the histogram curve toward the center, reducing the tonal range most affected by the trough. We can then use Exposure, Shadows, and Contrast to push that trough out to an acceptable range, and finish with Whites, Temperature, and Tint.

6 Decrease the Exposure to −**1.60**. Increase the Shadows to +**87**, the Contrast to +**46**, and the Whites to +**31**. This will bring out a little more detail in the image.

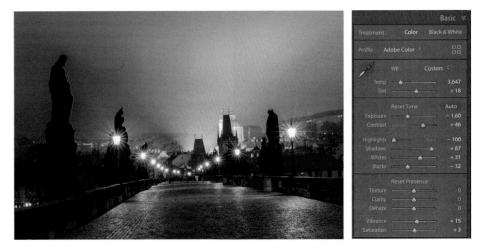

The problem with the image at this point is that the blue in it looks a bit too unnatural. Warming the image up a little can make the blues seem more realistic. I'll also share another trick here: increase your Tint setting ever so slightly to add an ethereal look to the sky.

7 Increase your Temp to **3647** and increase your Tint to a value of +**18**. This little tinge of magenta should do the trick to finalize the tonal changes to the image.

8 Press F7, or use the Window > Panels menu, to show the left panels. In the History panel, click back and forth between the current state at the top of the list, the Import state at the bottom, and the Auto Settings entry just above it, comparing the changes in the histogram as well as the results in the Loupe view. When you're done, leave the image open in Loupe view for the next exercise.

Original photo

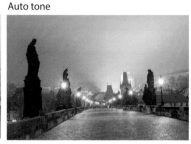

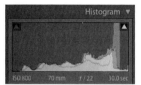

Auto tone

Auto tone with manual adjustments

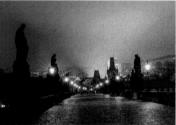

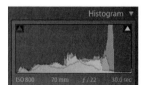

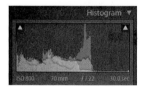

Creating effects with the Radial Filter tool

You can use the Radial Filter tool to create off-center custom vignettes by applying local adjustments to a selected area in an image through a feathered (soft-edged) elliptical mask.

Unlike the centered post-crop vignette in the Effects panel, you can place the center of your Radial Filter adjustment anywhere in the photo, focusing attention on whichever part of the image you choose.

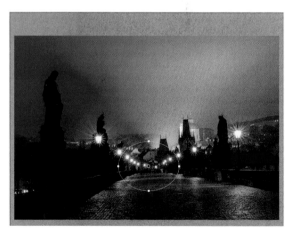

By default, your local adjustments are applied to the area outside the ellipse, leaving the inside unaffected, but the Radial Filter's Invert option enables you to reverse the focus of the filter.

By applying multiple Radial Filter adjustments, you can treat the inside and outside areas differently, highlight more than one area in the same image, or create an asymmetrical vignette, as shown here.

You can experiment with adding custom vignettes to your own photos later. In this exercise, you'll learn how to work with the Radial Filter tool as you set up a more complex effect that will add a little more color and atmosphere to our photo.

You'll start by setting up a combination of adjustments that will be applied to the photograph through your first Radial Filter.

1 Click to activate the Radial Filter tool—the fifth editing tool, located right below the Histogram in the right panel group.

Once it is activated, a panel of tool options appears below the tool strip. If necessary, double-click the Effect label in the upper left to reset the sliders to 0.

2 I want to bring the colors in the sky more into focus. Reduce the Exposure setting to **−0.16**, increase the Shadows to **21**, and decrease the Whites to **−6**. Set the Feather control near the bottom to **41** and make sure the Invert option is unselected.

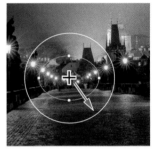

3 Drag in the Loupe view with the Radial Filter tool's crosshair cursor, starting from a point at the center of the bridge. When you've created an oval, and positioned and scaled it as shown in the illustration at the right, release the mouse button.

▶ **Tip:** Radial Filter adjustments scale from the center by default. Hold down Option/Alt to scale from one side.

▶ **Tip:** Make sure the color swatch at the bottom of the tool options shows a black X on a white background (no color selected). If this is not the case, click the swatch and reduce the Saturation setting to 0.

▶ **Tip:** If the colors you see on-screen differ significantly from those illustrated, consider calibrating your display. See macOS/Windows help for instructions. Slighter differences may be a result of conversion from RGB to CMYK color for printing.

Once created, the active Radial Filter adjustment is displayed with a circular *pin* at its center and four square control handles around its circumference. Whenever the tool is active, you can select an existing filter for editing by clicking its central pin, reposition it by dragging the pin, and resize the adjustment area or change its shape by dragging any of the square control handles.

By default, the Radial Filter adjustments are applied evenly across the unmasked parts of the image like an overlay, but you can set up the Range Mask control so the adjustments are applied only to a specific brightness (luminance) or a specific color in the image.

4 Near the bottom of the tool options, below the Feather control, choose Color from the Range Mask menu. Instead of attempting to manually enter a specific color, let's use the Color Range Selector to sample a specific area in the image.

5 Click the eyedropper icon (the Color Range Selector), then click an area of blue sky color in the image. (If necessary, uncheck Show Selected Mask Overlay in the toolbar below the preview.) You'll notice that the effect that we created with the radial gradient is now removed from the image and only applied to the areas that fall within the color that we have selected. The yellow lights that are on the bridge are not affected. With this effect selected, drop the Exposure a little further to **−0.30** and increase the Temperature to **10**. You'll notice that the sky now looks a little more realistic, yet we kept the feeling of the image.

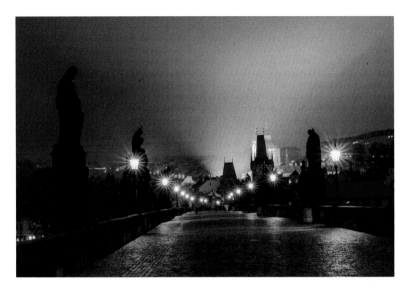

The image is almost complete, but the spots that appear across it take away from the overall feel. To get rid of them, we'll quickly tour the Spot Removal tool in Lightroom Classic.

Using the Spot Removal tool

Try as we may to prevent it, there will always be spots in our images that need to be removed. A spot can come from particles that have collected on your sensor after changing lenses several times (or in this case, after changing lenses on a bridge in Prague, never a good idea). Blemishes can also be things in a picture that you don't want to call attention to, like a hand that doesn't belong in the frame or a telephone pole that appears to be coming out of someone's head. Lightroom's Spot Removal tool helps you clone or heal these imperfections away and provides you with a tool that helps you see them better.

1 Activate the Spot Removal tool (the second tool from the left, directly under the Histogram) by clicking it or pressing the letter Q on your keyboard.

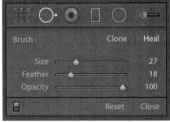

2 The Spot Removal tool has two options: Clone and Heal. The Clone option allows you to make a direct copy from one area to another. Heal attempts to blend the pixels to give you a more natural look. For this quick tour, we will leave the tool set to Heal. You can also control the size of the brush, the softness of the brush's edge (feather), and how opaque your result is (opacity).

▶ **Tip:** Press the bracket keys ([,]) to decrease or increase the brush size of the Spot Removal tool.

3 At the lower left of the preview there is a great feature in the Toolbar that you need to become familiar with: Visualize Spots. Select that option and the image

is inverted in black and white, making it easier to see any spots. You also have a slider that adjusts how much contrast appears in the image. Oftentimes, we are not aware that there are spots in a picture until after we have printed the picture, so to head this problem off early isn't just a good idea, it can save you quite a bit of money in printing costs.

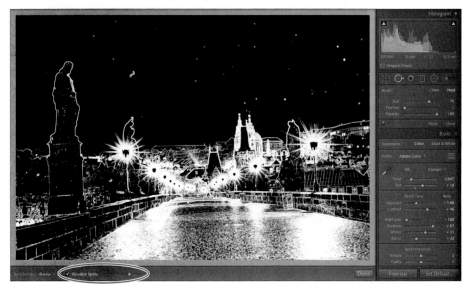

4 Adjust the brush to the size of the spot, click once right over the spot, and Lightroom attempts to find another area of the picture that matches it. When it does, a second circle appears with a line connecting it to the first one. If you're not happy with where the result landed, you can always click it and move it.

5 The great part about the Spot Removal tool is that it's not just limited to spots. You can drag in a larger area of a picture (like to the right of the nearest statue) and a highlighted stroke will appear. Release the mouse button and Lightroom will attempt to find an area to replace it with. As before, you can always move the result after the fact.

Let's take a look at where we started with spots, and just how far we've come.

Removing spots can be time-consuming, but it lends a finishing touch to your image by removing things that will divert the attention of the viewer. The number of spots that you have in your picture will vary (this was on the higher side, and I think half are stars), but it's much cleaner now. It's time to send this picture off.

Sharing your work by email

Now that you've edited and enhanced your photos, the final step in your workflow is to present them to your client, share them with friends and family, or publish them for the world to see on a photo-sharing website or in your own web gallery. In Lightroom Classic, it takes only minutes to create a sophisticated photo book or slideshow, customize a print layout, publish your photos online, or generate a stylish interactive gallery ready to be uploaded directly to your web server from within Lightroom.

Lesson 7, "Creating a Photo Book," Lesson 8, "Creating a Slideshow," Lesson 9, "Printing Images," and the online bonus lesson, "Publishing Your Photos," will provide much more detail on the many Lightroom Classic tools and features that make it simple to create professional-looking presentations, layouts, and galleries to showcase your photos. In this exercise, you'll learn how you can attach your finished images to an email without leaving Lightroom Classic.

1 Press G to return to Grid view, then press Command+D/Ctrl+D or choose Edit > Select None. In the Filmstrip, Command-click/Ctrl-click to select the two photos that you've edited in this lesson, lesson01_004.dng and lesson01_006.dng.

2 Choose File > Email Photos.

Note: For Windows users: if you have not specified a default email application in Windows, the sequence of dialog boxes you see may differ slightly from that described and illustrated here (from macOS). The process is basically the same, but you may need to refer to steps 8, 9, and 10 to set up an email account before returning to this step.

Lightroom automatically detects the default email application on your computer and opens a dialog box where you can set up the address, subject, and email account for your message, and specify the size and quality of the attached images.

3 Click the Address button to open your Lightroom address book. Click New Address, then enter a contact name and email address and click OK.

4 Click the Address button again, if necessary, to reopen the Lightroom Address Book dialog box. Here you can specify as many recipients for your message as you wish. For now, select your new contact, and then click OK.

5 Now type a subject line for your email.

6 Choose your image size and quality options from the Preset menu at the bottom.

7 If you intend to use your default email application, you're ready to click Send and add your message in the standard email window.

8 If you'd prefer to connect directly to a web-based mail service, you need to set up an account. In the From menu, choose Go To Email Account Manager.

9 In the Lightroom Email Account Manager dialog box, click the Add button at the lower left. In the New Account dialog box, enter your email account name and choose your service provider, then click OK.

10 Enter your email address and password under Credential Settings in the Lightroom Email Account Manager dialog box, and then click Validate.

Lightroom uses your credential settings to verify your account online. In the Lightroom Email Account Manager dialog box, a green light indicates that your web-based email account is now accessible by Lightroom.

11 Click Done to close the Lightroom Email Account Manager. Type a message in the text box above the thumbnails of your attached images, change the font, text size, and text color if you wish, and then click Send.

Review questions

1 What is non-destructive editing?

2 What are the seven Lightroom workspace modules and how do they relate to your workflow?

3 How can you increase the viewing area without resizing the application window?

4 What advantage is there to grouping images in a collection, rather than by keyword?

5 What is the difference between editing a photo using the Quick Develop panel in the Library module and editing it in the Develop module?

Review answers

1 Whatever modifications you make to an image in your library—cropping, rotation, corrections, retouching, or effects—Lightroom records the editing information only in the catalog file. The original image data remains unchanged.

2 The Lightroom workflow begins in the Library module: a hub where you'll import, organize, sort, and search your photos, manage your growing catalog, and keep track of the images you publish. You can leverage GPS metadata to organize your photos by location in the Map module. Move to the Develop module for a comprehensive editing environment with all the tools you need to correct, retouch, and enhance digital images and ready them for output. The Book, Slideshow, Print, and Web modules each provide a range of stylish preset templates together with a suite of powerful, intuitive controls to help you customize them so that you can quickly create sophisticated layouts and presentations to share and showcase your work in its best light.

3 You can hide any of the panels and panel groups surrounding the work area. The working view automatically expands into the space available. The work area is the only part of the Lightroom workspace that you cannot hide from view.

4 The difference between grouping images in a collection and applying shared keywords is that, in a collection, you can change the order of the photos displayed in the Grid view and the Filmstrip, and easily remove an image from the group.

5 The Quick Develop panel gives you simple controls for basic color correction and tonal adjustment, as well as a choice of preset crop and develop settings. The Develop module offers a finer degree of editing with sophisticated image processing tools in a more comprehensive and convenient editing environment.

PHOTOGRAPHY SHOWCASE
ZULFIKHAR AHMED

"I capture my human interactions, my experiences, my feelings of a space."

My passion for photography started as a child when my parents gifted me a film camera. Film and processing being an expensive affair, I was allowed only one roll (i.e., 36 frames) for the month. This experience taught me to be conservative in shooting and timing my shot to get the decisive moment. As technology progressed and photography equipment became more accessible to everyone, I pushed myself to discover the unexplored. I travelled to remote areas to find the undocumented, explore the unexplored, and share the unseen.

I capture my human interactions, my experiences, my feelings of a space. I push myself to capture that moment of magic, that glimpse of time that would normally be missed by a human eye. As a travel photographer, I have clients asking me for work shot over time and in multiple places. I use Lightroom extensively for cataloging my files and maintaining a library of images, which enables me to find and deliver work faster.

Zulfikhar Ahmed is an award-winning travel, cityscape, and lifestyle photographer based in Dubai. He shoots in a journalistic style, telling stories through his images.

www.zulfiphoto.com
instagram.com/zulfiphoto

2 BRINGING PHOTOS INTO LIGHTROOM CLASSIC

Lesson overview

Lightroom Classic allows a great deal of flexibility when importing photos: you can download them directly from a camera, import them from an external drive, or transfer them between catalogs on separate computers. During the import process, you can organize folders, add keywords and metadata to make your photos easier to find, make backup copies, and even apply editing presets. In this lesson, you'll learn how to:

- Import images from a camera or card reader.

- Import images from a hard disk or removable media.

- Evaluate images before importing.

- Organize, rename, and process images automatically.

- Implement a backup strategy.

- Set up automatic importing and create import presets.

- Acquire images from other catalogs and applications.

 This lesson will take about 1 to 2 hours to complete. To get the lesson files used in this chapter, download them from the web page for this book at www.adobepress.com/LRClassicCIB2020. For more information, see "Accessing the lesson files and Web Edition" in the Getting Started section at the beginning of this book.

Lightroom Classic helps you to begin organizing and managing your growing photo library from the moment you click the Import button; you can make backups, create and organize folders, inspect images at high magnification, and add keywords and other metadata that will save you hours sorting and searching your image library later—and all this before your photos even reach your catalog!

Getting started

Before you begin, make sure you've set up the LRClassicCIB folder for your lesson files and downloaded the lesson02 folder from your Account page at peachpit.com to the LRClassicCIB\Lessons folder, as described in "Accessing the lesson files and Web Edition" in the "Getting Started" section at the start of this book. Also, be sure you have created the LRClassicCIB Catalog file to manage the lesson files, as detailed in "Creating a catalog file for working with this book," also in the "Getting Started" section.

1 Start Lightroom Classic. In the Select Catalog dialog, make sure that LRClassicCIB Catalog.lrcat is selected, and then click Open.

▶ **Tip:** If you can't see the Module Picker, choose Window > Panels >Show Module Picker, or press the F5 key. If you're working on macOS, you may need to press the fn key together with the F5 key, or change the function key behavior in the system preferences.

2 Lightroom Classic will open in the screen mode and workspace module that were active when you last quit. If necessary, switch to the Library module by clicking Library in the Module Picker at the top of the workspace.

Lightroom is your digital notebook

Before we begin, I want to share with you an analogy that I think helps explain what Lightroom does in terms of organization. I'll come back to this analogy from time to time throughout the book.

Imagine you are sitting at home when someone knocks on the door and gives you a box of pictures. They ask you to store the pictures for safekeeping, so you take the box into your home and place it on top of your desk in the living room. In order to remember where you placed those pictures, you pull out a notebook and write down that they are in a box on the desk in the living room.

There's another knock at the door, and another box of pictures appears. You take these pictures and place them inside one of the drawers in your bedroom. You want to remember where they are, so you write it down in your notebook. More boxes of pictures appear, and you continue to place them in different areas of your house, writing down the location of each box of pictures in your notebook—there are a lot of pictures, and you don't want to forget!

That notebook becomes the central record of where the boxes of pictures are stored in your home.

Now, imagine that you're bored one day while at home, and you take the pictures that are in the box on top of the desk in the living room, and place them in a particular order. You want to make a note of this change, so you write down in your notebook that the pictures on top of the desk in the living room have been organized in a specific fashion.

The notebook you've been using serves as the master record of the location of each box of pictures inside your home, as well as a record of all the changes you've made to each picture.

That notebook is your Lightroom catalog—it's a digital notebook that keeps track of where your images are and what you have done to them.

Lightroom doesn't store your images; it stores information about your images in the catalog. This catalog includes a ton of information about each image (or video), including where the file lives on your drives; the camera settings at capture; any descriptions, keywords, ratings, and so on, that you apply in Lightroom's Library module; and a running list of every edit you make in Lightroom's Develop module.

When you think of your Lightroom catalog, just think of a digital notebook that's keeping track of where you put your pictures and what you are doing with them.

The import process

Lightroom Classic has a number of options for importing your images. You can import directly from a digital camera or card reader, your hard disk, or any external storage media, or you can transfer them from another Lightroom catalog or from other applications. You can import at the click of a button, use a menu command, or simply drag and drop. Lightroom can launch the import process as soon as you connect your camera, or import automatically whenever you move files into

a specified folder. Wherever you're acquiring photos from, it will be important to become familiar with the Import dialog box.

The top section of the Import dialog box presents the basic steps in the import process, arranged from left to right: choose an import source, specify how Lightroom is to handle the files you're importing, and then—if you choose to copy or move the source files—set up an import destination. If these are all of the details that you require for the importing of the images, you can leave the dialog box set to compact mode. For even more information, click the triangle at the lower left to expand the full panel.

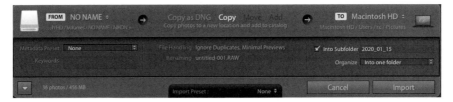

In expanded mode, the Import dialog box looks and works like the Lightroom Classic workspace modules. The Source panel at the left accesses your files on any available drive. The Preview area in the center displays images from the source as thumbnails in Grid view or enlarged in Loupe view. Depending on the type of import, the right panel group offers a Destination panel that mirrors the Source panel, and a set of controls for processing your images while they're being imported.

Importing photos from a digital camera

While this next section outlines the process of importing from a camera pretty clearly, I recommend that you try this with some sample images of your own. Take your camera and make 10–15 images of anything, really, just have something on the memory card that we can use for the import process.

The first step is to ensure the Lightroom preferences are set so that the import process is triggered automatically whenever you connect your camera or a memory card to your computer.

1 Choose Lightroom Classic> Preferences (macOS)/Edit > Preferences (Windows). In the Preferences dialog box, click the General tab. Under Import Options, select Show Import Dialog When A Memory Card Is Detected.

● **Note:** You'll find more options relating to the creation of DNG files during import on the File Handling preferences tab, but for the purposes of this exercise, you can ignore those settings. For more detailed information on DNG files, see the side-bar "About file formats," later in this lesson.

Some cameras generate folder names on the memory card. If you don't find these folder names helpful for organizing your images, select Ignore Camera-Generated Folder Names When Naming Folders. You'll learn more about folder naming options later in this lesson.

2 Click the Close button or OK to close the Preferences dialog box.

3 Connect your digital camera or card reader to your computer, following the manufacturer's instructions.

4 This step may vary depending on your operating system and the image management software on your computer:

- In Windows, if the AutoPlay dialog box or settings pane appears, select the option to open image files in Lightroom Classic. If you wish, you can set this option as the default.

- If you have more than one Adobe image management application—such as Adobe Bridge—installed on your computer and the Adobe Downloader dialog box appears, click Cancel.

- If the Import dialog box appears, continue to step 5.

- If the Import dialog box does not appear, choose File > Import Photos And Video, or click the Import button below the left panel group.

5 If the Import dialog box appears in compact mode, click the Show More Options button at the lower left of the dialog box to see all the options in the expanded Import dialog box.

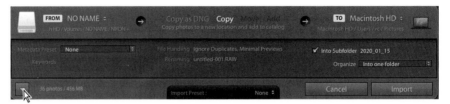

The top panel of the Import dialog box—visible in both the compact and expanded modes—presents three steps in the import process, arranged from left to right:

- Selecting the source location of the images you wish to add to your catalog.

- Specifying how you want Lightroom to handle the files you're importing.

- Setting the destination to which the image files will be copied and choosing any develop presets, keywords, or other metadata that you would like applied to your photos as they are added to your catalog.

Your camera or memory card is now shown as the import source in the FROM area at the left of the top panel and under Devices in the Source panel at the left of the Import dialog box.

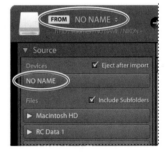

Depending on your computer setup, it's possible that your camera's memory card will be recognized as a removable storage disk. If this is the case, you may see some differences in the options available in the Import dialog box, but it shouldn't affect anything.

6 If your memory card is listed as a removable disk—rather than a device—in the Source panel, click to select it from the Files list and make sure that Include Subfolders is selected.

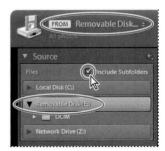

● **Note:** If your memory card is recognized as a removable disk, the Move and Add options may not be disabled as illustrated above and on the next page; these import options will be discussed later in this lesson.

7 From the import type options in the center of the top panel, choose Copy, so that the photos are copied from your camera to your hard disk and then added to your catalog, leaving the original files on your camera's memory card.

Lightroom displays a brief description of the action that will be taken for whichever option is currently selected.

8 Move your pointer over each of the options shown in the bar across the top of the Preview pane to see a tool tip describing the option. For this exercise, leave the default All Photos option selected and don't click the Import button yet.

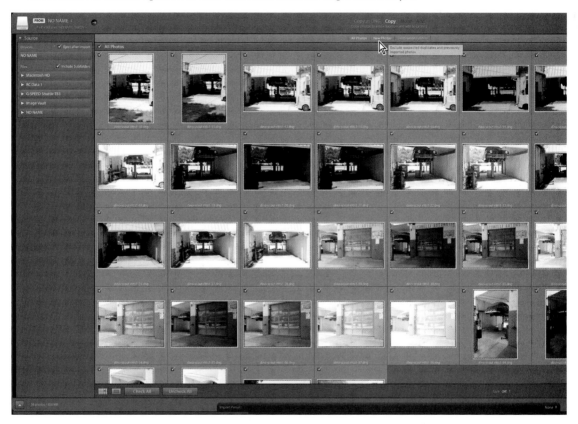

A check mark in the upper-left corner of an image cell indicates that the photo will be imported. By default, all the photos on your memory card will be selected for import. If you do not want to import an image, you can exclude it by clicking its checkbox to deselect it.

▶ **Tip:** Use the slider below the preview pane to change the size of the thumbnails.

You can select multiple images and then change all of their check marks simultaneously. To select a contiguous range of images, select the first image in the range by clicking the thumbnail or the surrounding image cell, then hold down the Shift key and select the last image in the series. To select individual additional images, Command-click/Ctrl-click their thumbnails. Click the check mark of any selected image to change the import status for the entire selection.

Notice that at the top of the import dialog, Copy is selected rather than Add. Keep in mind that, during the import process, Lightroom does not actually import the

image files themselves; it only adds entries to the Lightroom catalog to record their locations. Because you're copying the files, you'll need to specify a destination.

If you selected Add rather than Copy, you wouldn't have to specify a destination folder; the photos would stay where they are already stored. However, because memory cards are expected to be erased and reused, they should not be the permanent home for your pictures. Thus, you're not offered the Add or Move options when you import from a camera—Lightroom expects to copy your photos from your memory card to a more permanent location.

The next step, then, is to specify a destination folder to which your photos should be copied. This is the time to give some thought to how you intend to organize your photos on your hard drive. For now, leave the Import Photos dialog box open; you'll choose a destination folder and deal with the rest of the import options in the following exercises.

Organizing your copied photos in folders

By default, Lightroom tries to organize your images in the Pictures folder. You can choose any other location, but as a general rule, it is a good idea to keep all of your images organized into one location—no matter where that is. Nailing down that location (or workflow) early will help a ton in finding missing images (we'll talk about the workflow later in the book).

Before beginning the lessons in this book, you created a folder named LRClassicCIB inside your Users/*username*/Documents folder on your computer. This folder already contains subfolders for your LRClassicCIB Catalog file and for the image files used for the lessons in this book. For the purposes of this exercise, you'll create another subfolder inside the LRClassicCIB folder as the destination for the images that you import from your camera's memory card:

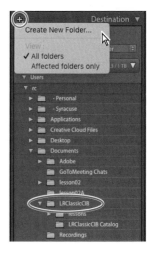

1 In the right panel group of the Import dialog box, collapse the File Handling, File Renaming, and Apply During Import panels; then, expand the Destination panel.

2 In the Destination panel, navigate to and select your LRClassicCIB folder; then, click the plus sign (+) button at the left of the Destination panel header and choose Create New Folder from the menu.

3 In the Browse For Folder/Create New Folder dialog box, navigate to and select your LRClassicCIB folder, if it's not already selected. Click the Make New Folder/New Folder button,

type **Imported From Camera** as the name for your new folder, and then click Create (macOS) or press Enter (Windows).

4 Make sure the new Imported From Camera folder is selected in the Browse For Folder/Create New Folder dialog box, and then click the Choose/Select Folder button to close the dialog box. Note that the new folder is now listed, and selected, in the Destination panel.

The name of the new destination folder also appears in the TO area at the right of the top panel of the Import dialog box.

The Organize menu, near the top of the Destination panel, offers various options to help you organize your photos into folders as you copy them onto your hard disk:

* **Into One Folder** With the current settings, the images would be copied into the new Imported From Camera folder. Instead, you could select Into Subfolder to create a new subfolder for each import from your camera.

* **By Date: [Date Format]** These options are all variations on organizing your photos by capture date. Your images would be copied into one or more subfolders, depending on your choice of date format. Choosing the format "2019/09/24," for example, would result in one folder per year, containing one folder per month, containing one folder per day for each capture date. Or, choosing 2019-09-24 simply creates one folder per date, as shown in the illustration at the right.

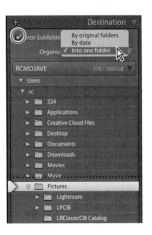

● **Note:** If your memory card has been recognized as a removable disk, you may also see the Organize option By Original Folders; this option will be discussed later in this lesson.

Think about which system of folder organization best suits your needs before you import photos from your camera, and then maintain that system for all your camera imports.

5 For the purposes of this exercise (and what I recommend to everyone as a default) choose Into One Folder from the Organize menu.

6 Select the Into Subfolder option at the top of the panel, and type **Lesson 2 Import** in the adjacent text box as the new subfolder's name. The subfolder should then appear inside the folder you choose in the bottom section of the Destination panel.

About file formats

Camera raw formats Camera raw file formats contain unprocessed data from a digital camera's sensor. Most camera manufacturers save image data in a proprietary camera format. Lightroom reads the data from most cameras and processes it into a full-color photo. You can use the controls in the Develop module to process and interpret the raw image data for your photo. For a list of supported cameras and camera raw formats, see https://helpx.adobe.com/photoshop/camera-raw.html.

Digital Negative format (DNG) The Digital Negative (DNG) file format is a publicly available archival format for raw files generated by digital cameras. DNG addresses the lack of an open standard for raw files created by individual camera models, ensuring that photographers will be able to access their files in the future. You can convert proprietary raw files to DNG in Lightroom. For more information about the Digital Negative (DNG) file format, visit https://helpx.adobe.com/photoshop/digital-negative.html.

TIFF format Tagged-Image File Format (TIFF, TIF) is used to exchange files between applications and computer platforms. TIFF is a flexible bitmap image format supported by virtually all paint, image-editing, and page-layout applications. Also, virtually all desktop scanners can produce TIFF images. Lightroom supports large documents saved in TIFF format (up to 65,000 pixels per side). However, most other applications, including older versions of Photoshop (pre-Photoshop CS), do not support documents with file sizes greater than 2 GB. The TIFF format provides greater compression and industry compatibility than Photoshop format (PSD), and is the recommended format for exchanging files between Lightroom and Photoshop. In Lightroom, you can export TIFF image files with a bit depth of 8 bits or 16 bits per channel.

JPEG format Joint Photographic Experts Group (JPEG) format is commonly used to display photographs and other continuous-tone images in web photo galleries, slideshows, presentations, and other online services. JPEG retains all color information in an RGB image but compresses file size by selectively discarding data. A JPEG image is automatically decompressed when opened. In most cases, the Best Quality setting produces a result indistinguishable from the original.

Photoshop format (PSD) Photoshop format (PSD) is the standard Photoshop file format. To import and work with a multi-layered PSD file in Lightroom, the file must be saved in Photoshop with the Maximize PSD and PSB File Compatibility option activated. You'll find this option in the Photoshop file handling preferences. Lightroom saves PSD files with a bit depth or 8 bits or 16 bits per channel.

PNG files Lightroom imports PNG files, but transparency is not supported; it will appear white.

CMYK files Lightroom imports CMYK files, but edits and output are performed in the RGB color space.

Video files Lightroom will import video files from most digital cameras. You can tag, rate, filter, and include video files in collections and slideshows. Video files can be trimmed, and also edited with most of the Quick Edit controls. Click the camera icon on the video file's thumbnail to launch an external viewer such as QuickTime or Windows Media Player.

File format exceptions Lightroom does not support the following types of files: Adobe Illustrator® files; Nikon scanner NEF files; files with dimensions greater than 65,000 pixels per side or larger than 512 megapixels.

Note: To import photos from a scanner, use your scanner's software to scan to TIFF or DNG format.

Creating import presets

When you import photos on a regular basis, you'll probably find that you're setting up the same configurations of options over and over. Lightroom Classic enables you to streamline your import workflow by saving your preferred settings as import presets. To create an import preset, set up your import in the expanded Import dialog box, and then choose Save Current Settings As New Preset from the Import Preset menu below the Preview pane.

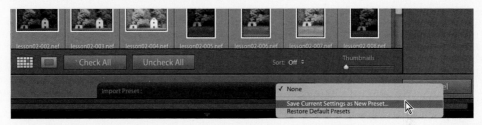

Type a descriptive name for your new preset, and then click Create.

Your new preset will include all of your current settings: the source, import type (Copy as DNG, Copy, Move, or Add), file handling and renaming options, develop and metadata presets, keywords, and destination. You might set up one preset to move photos from a memory card to your computer, and another preset to import from a memory card to a network-attached storage device. You could even create separate import presets tailored to the characteristics of different cameras, so you can quickly apply your favorite noise reduction, lens correction, and camera calibration settings during the import process, saving yourself time in the Develop module later.

Using the Import dialog box in compact mode

Once you've created the presets you need, you can speed up the process even more by using the Import dialog box in compact mode, where you can use your import preset as a starting point and then change the source, metadata, keywords, and destination settings, as required.

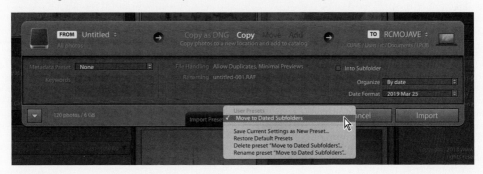

Backup strategies

Your next choice is whether or not to make backup copies of the images from your camera at the same time as Lightroom creates primary copies in the location you've just specified and adds them to the library catalog. For some, it's a good idea to create backup copies on a separate hard disk or on external storage media so you don't lose your images should your hard disk fail or in case you accidentally delete them.

1 In the right panel group of the Import dialog box, expand the File Handling panel and select the Make A Second Copy To option.

2 Click the small triangle to the right and select Choose Folder to specify a destination for your backup copies.

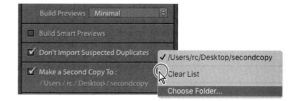

3 In the Browse For Folder/Choose Folder dialog box, navigate to the folder in which you wish to store the backup copies of your images, and then click OK/Select Folder.

Keep in mind that the purpose of this backup is mainly as a precaution against loss of data due to disk failure or human error during the import process; it's not meant to replace the standard backup procedure you have in place—or should have in place—for the files on your hard disk.

For the most part, I don't use this backup option, but rely instead on a combination of my computer's backup system (Time Machine) and the use of my network-attached storage device. This is part of my personal workflow strategy, which I'll share with you and explain later on in the book.

Renaming files as they are imported

▶ **Tip:** An option you should consider, if it's supported by your camera, is to set the camera to generate filenames with unique sequence numbers. When you clear your memory card, or change memory cards, your camera will continue to generate unique sequence numbers rather than starting the count from one again. This way, the images you import into your library will always have unique filenames.

The cryptic filenames created by digital cameras are not particularly helpful when it comes to sorting and searching your photo library. Lightroom can help by renaming your images for you as they are imported. You can choose from a list of predefined naming options, or create your own customized naming templates.

1 In the right panel group of the Import dialog box, expand the File Renaming panel and select Rename Files. Choose Custom Name - Sequence from the Template menu, type a descriptive name in the Custom Text box, and then press the Tab key on your keyboard. A sample name at the bottom of the File Renaming panel shows how your settings will be applied for the first image imported. You can enter

a number other than 1 in the Start Number text box; this is useful if you're importing more than one batch of images from the same shoot or series (often from multiple memory cards).

2 Click the small triangle to the right of the Custom Text box; your new text has been added to a list of recently entered names. You can choose from this list if you import another batch of files that belong in the same series. This not only saves time and effort, but helps you ensure that subsequent batches are named identically. Should you wish to clear the list, choose Clear List from the menu.

3 Choose Custom Name (x of y) from the Template menu. Note that the sample name at the bottom of the File Renaming panel is updated to reflect the change.

4 Choose Edit from the Template menu to open the Filename Template Editor.

In the Filename Template Editor dialog box, you can set up a filename template that makes use of metadata information stored in your image files—such as filenames, capture dates, or ISO settings—adding automatically generated sequence numbers and any custom text you specify. A filename template includes placeholders—or *tokens*—that will be replaced by actual values during the renaming process. A token is highlighted in blue on macOS and framed by curly brackets on Windows.

You could rename your photos automotive_garage-March 25, 2019-01, and so on, by setting up a filename template with a custom text token, a date token, and a two-digit sequence number token, separated by typed hyphens, as shown in the illustration at the right. After closing the Filename Template Editor you could type **slot_canyon** in the Custom Text box; the words "slot_canyon" would then replace the custom text token in the filename. The capture date from the images' metadata and the sequence number are added automatically.

Tip: For more information on using the Filename Template Editor, please refer to Lightroom Help.

5 Click Cancel to close the Filename Template Editor without making any changes.

Despite all of the options available for renaming your images during the import process, there's only so much information you can squeeze into a single filename. One of the immediate changes I make in the template is to change the sequence to a three-digit number and use simpler date and description information for the name of the files. It's better to take advantage of things like metadata, keywords, and collections for organizing and searching your image library. If you need to find images solely based on name, that must mean a lot went wrong in your computer.

Tips for naming your files and folders

We've talked about the importance of naming your folders to better organize your photos, and I gave you an example of how to name them. Here are some tips and suggestions for renaming your files:

- Name your files and folders similarly to make it easier to find the photos you want later.
- As with your folders, start the name of every file with the year, then add a month and day.
- Use lowercase when naming your files and folders.
- Add a descriptive word about the shoot after the date, and keep it as short as possible.
- If you need to add a space in your name, use an underscore (_) instead of a space.
- At the end of the filename, add C1, C2, C3, and so on, for card 1, card 2, card 3. This helps when you have a shoot that spans multiple memory cards.

For example, if I want to import images that I took at the state fair on October 26, 2019, my folder would be named *2019_oct_26_state_fair*. If I only shot one card during that shoot, the filename would be *2019_oct_26_state_fair_c1_ sequential file number*. Is the filename long? Yes. Does it give you all the information about the shoot? Absolutely.

Here's the practical reason for adding the C1 to your filenames: Every now and then, during a Lightroom import, you will run into a file that looks like the one here. While it may make for an interesting art project, it's actually something a lot more sinister. It is a corrupt picture, a quick sign that the card you used may not be as reliable as you thought. Memory cards, like everything else, can fail over time, and you cannot afford to lose an important shoot because of it. If you are importing from multiple cards, how do you tell which one is the bad one?

As soon as I purchase a memory card, I make it a point to label it using those C numbers. Then, I add that C number to the filename. The moment I see a potential problem with an image, I can look at the name and know exactly which card failed, so I can take that card out of rotation…and give it to a friend. Kidding! Simply labeling your memory cards and adding that C1 or C2 to your filenames can go a long way to helping you troubleshoot. Anal? Yes. Vital? Absolutely.

You'll learn about working with metadata, keywords, and collections in the following exercises and in Lesson 4, "Managing Your Photo Library."

6 For now, click Import if you wish to bring your photos into the LRClassicCIB catalog, or Cancel to close the Import dialog box without importing any images.

You have now completed this exercise on importing photos from a digital camera or a memory card. You'll learn about the other options that are available in the Import dialog box in the exercises to follow.

Importing images from a hard disk

When you import photos from your hard disk or from external drives, Lightroom Classic offers you more options for organizing your image files than are available when importing from a camera.

You can still choose to copy your images to a new location during the import process, as you did in the previous exercise, but you also have the option to add them to your catalog without moving them from their current location. You might choose to do this if the images you wish to import are already well organized in a folder structure on your drive.

For images that are already located on your hard disk, you have an extra option: to move them to a new location and remove them from their original location at the same time as they are added to your catalog. This option might appeal if the images on your hard disk are not already well organized.

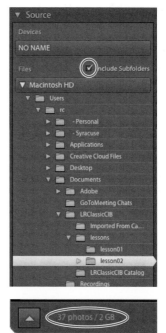

1 To import the images for this exercise from your computer hard disk, either choose File > Import Photos And Video, press Shift+Command+I/ Shift+Ctrl+I, click the Import button below the left panel group in the Library module, or drag the folder onto Lightroom's Library module.

Note: The same commands apply for importing images from a CD, DVD, or other external storage media.

2 In the Source panel at the left of the Import dialog box, navigate to the Lessons folder inside the LRClassicCIB folder on your hard disk. Click the lesson02 folder and select Include Subfolders at the upper right of the panel.

An image count in the lower-left corner of the Import dialog box shows that the lesson02 folder and its subfolder contain a total of 37 photos with a combined file size of 2 GB.

3 From the import type options in the center of the top panel, choose Add so that your photos will be added to your catalog without being moved—an option that is not available when importing images from a camera. Do not click Import yet!

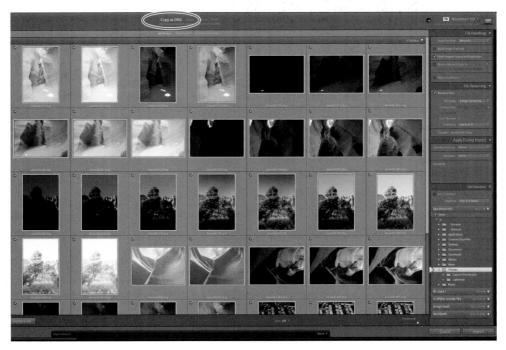

4 Use the scrollbar at the right of the Preview pane to view all of the images in the lesson02 folder and its subfolders. Drag the Thumbnail slider below the Preview pane to the left to reduce the size of the thumbnails so that you can see as many of the images as possible in the Preview area.

5 In the Source panel, deselect the Include Subfolders option. The Preview area now displays only 27 images in the lesson02 root folder and the image count in the lower-left corner of the Import dialog box reads: 27 photos/1 GB. Make sure to go back and select Include Subfolders again to get all of the images.

Before we go any further, let's review each of the import type options above the Preview area.

6 Click each of the import type options in turn, from left to right:

 • Copy As DNG will have Lightroom make copies of your images in DNG (digital negative) file format, which will be stored in a new location and then added to your catalog. You'll notice that for the Copy As DNG, Copy, and Move options, the right panel group offers the same suite of panels—File Handling, File Renaming, Apply During Import, and Destination.

- Click Copy to have Lightroom create copies of your images in a new location, and then add them to your catalog, leaving the originals in their current locations. You can set a destination for your copies in the Destination panel, as you did in the previous exercise. Expand the Destination panel and click the Organize menu. When you use either the Copy As DNG, Copy, or Move options to import images from your hard disk or from external storage media, the Organize menu offers you the option to copy your photos into a single folder, into subfolders based on the capture dates, or into a folder structure that replicates the original arrangement.

Note: Expand the File Handling and Apply During Import panels to see the options available.

- Click Move to have the images moved to a new location on your hard disk, arranged in whatever folder structure you choose from the Organize menu, and then deleted from their original locations.

- Click the Add option to have Lightroom add the images to your catalog without moving or copying them from their current locations, or altering the folder structure in which they are stored. For the Add option, the right panel group offers only the File Handling and Apply During Import panels; you cannot rename the original source images during import, and there's no need to specify a

destination because the files will remain where they are.

Applying metadata

Lightroom uses information attached to files to enable you to quickly find and organize your photos. This information is known as metadata. Some of this metadata is automatically added to the file at the point of creation (shutter speed, ISO, camera type, and so on), and some of it can be added after the fact (keywords, your name, and so on).

You can search your image library and filter the results by all of this metadata, as well as things like flag status, color label, shooting settings, or any combination of a wide range of other criteria.

You can also choose specific information about your images from this metadata and have Lightroom display it as a text overlay applied to each image in a slideshow, web gallery, or print layout.

Let's add some important information into our files quickly, and make sure we don't have to reinvent the wheel every time. For this, we'll use metadata presets.

1 In the Apply During Import panel, choose New from the Metadata menu.

2 Let's create a metadata preset that includes your copyright information in each file. In the New Metadata Preset dialog box, for Preset Name, type **2019 Copyright**. Then, enter your copyright information into the IPTC Copyright fields and contact information into the IPTC Creator fields. This should give anyone online enough information to get a hold of you should someone find your image interesting and want to use it. It does happen at times.

3 Click Done/Create to close the New Metadata Preset dialog box, and then confirm that your new metadata preset is selected in the Metadata menu.

4 Also in the Apply During Import panel, choose None from the Develop Settings menu and type **Lesson 02, Southwest** in the Keywords text box.

5 In the File Handling panel, choose Minimal from the Build Previews menu. Check that your settings are the same as those shown in the illustration below, and then click Import.

The images from the lesson02 folder are imported into your library catalog and thumbnails of the images appear in the Grid view and the Filmstrip in the Library module.

6 Right-click the lesson02-013 image in the Grid view and choose Go To Folder In Library from the menu.

In the Folders panel in the left panel group, the lesson02 folder is highlighted and the image count indicates that it contains 37 photos.

Right-clicking the folder at this point gives you options to update folder locations, or even find the folder of images inside of Finder (on macOS) or Explorer (on Windows). This comes in handy when you are missing folders, but we'll talk more about that later in the book. For now, choose Show In Finder/Show In Explorer to see the folder.

Importing via drag and drop

Perhaps the easiest way to add photos to your image library is to simply drag a selection of files—or even an entire folder—directly into Lightroom Classic.

1 The Finder/Explorer window, where you can see the lesson02A folder, should still be open from the previous exercise. Position the window so that you can see the Grid view in the Lightroom Classic workspace behind it.

2 Open the lesson02A folder, and then drag the folder from the Finder/Explorer window onto the Grid view.

In the Import dialog box, the lesson02A folder is now selected in the Source panel and the photos it contains are displayed in the Preview area.

3 In the Apply During Import panel, choose None from the Metadata menu and type **Lesson 02, Treeline** in the Keywords box. Don't click Import just yet.

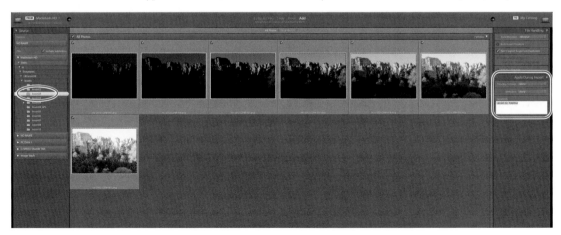

Evaluating photos before importing

Lightroom Classic makes it easy to decide which of your photos you wish to import by providing an enlarged Loupe view in the Import dialog box; you can examine each image in detail so that you can choose between similar images or exclude a photo that is out of focus.

1 Double-click any of the thumbnails to see the photo in Loupe view, or select the thumbnail and click the Loupe view button at the left of the Toolbar below the preview pane; the image is enlarged to fit the preview area and the pointer becomes a magnifying glass cursor. Depending on the size of your display and/or the application window, you may first see a Zoom Out cursor.

2 If necessary, click the image again to further magnify the image to a zoom ratio of 1:1. Use the Zoom slider below the preview pane to see even more detail. Drag the enlarged image in the preview pane to pan the view so that you can inspect portions of the photo that are not currently visible.

While you're examining the photo in Loupe view, you can select or deselect the Include In Import option in the Toolbar below the image preview.

3 Click the enlarged preview to return to the Fit view, where the entire image is visible. Double-click the image, or click either the Loupe view button or the Grid view button beside it, to return to the thumbnail display.

4 For the purposes of this exercise, deselect the Include In Import option for one of the images to exclude it, and then click Import.

Images that are already imported

Lightroom does a great job at trying to keep your collection organized and free from duplicates. During the import process, you'll notice that there is an option in the File Handling panel on the right side that prevents you from importing images that have already been added to your Lightroom catalog. When you are just starting out with Lightroom, it's a great idea to keep this selected.

When you try to import from a memory card that you have already imported from, any of the images that are duplicates (they are already in your Lightroom catalog) appear in gray and will not be selected for import. If the card has new images, those images will be visible and will already be selected, letting you specify where you would like them imported.

Note: While I suggest you stagger your shoots across multiple memory cards, I am not suggesting that you need to buy four memory cards. You can stagger shoots across as many cards as you own. Think of this as more of a workflow suggestion. That said, I can't emphasize enough how many times this has saved me from losing images.

As a general rule, I often advise photographers never to format their memory cards until after they have used up all the cards they own. For example, if I have four memory cards (A, B, C, and D) and I make images on card A, I will import that card into Lightroom but will not format it. At the next shoot, I use card B and repeat the process. The following shoot? Card C.

Should something go wrong on my computer, I have a much better chance of recovering the images from the memory cards if I stagger the formatting in this manner. Working this way, you may forget to format a card and shoot with one that you've already imported. Thankfully, Lightroom is there to catch these kinds of things.

Importing and viewing video

Lightroom Classic will import many common digital video files from digital still cameras, including AVI, MOV, MP4, AVCHD, and HEVC. Choose File > Import Photos And Video or click the Import button in the Library module, then set up your import in the Import dialog box, just as you would for photos.

In the Library module Grid view, you can scrub backward and forward in your video clips by simply moving the mouse over the thumbnails, making it easy to select the clip you want. Double-click a thumbnail to preview the video in Loupe view; drag the circular current time indicator in the playback control bar to scrub through the video manually.

Setting distinctive thumbnail images (poster frames) for your videos can make it easier to find the clip you want in the Grid view. Move the current time indicator to the frame you want; then, click the Frame button in the control bar and choose Set Poster Frame. Choose Capture Frame from the same menu to convert the current frame to a JPEG image that will be stacked with the clip. To shorten a video clip, click the Trim Video button. The playback control bar expands to display a timeline view of the clip where you can drag the start and end markers to trim the clip as desired.

Note: Beginning with Lightroom Classic 8.0 and Lightroom 2.0 (October 2018 releases), you can no longer import new AVI files on macOS. The existing AVI files in your catalog play as expected in Lightroom and in a separate window from the Library Loupe view in Lightroom Classic. On Windows, the support for AVI files is still available.

Note: HEVC video files are supported for import and playback on macOS High Sierra (10.13) only. On Windows and earlier macOS versions, the support for HEVC (MOV) files is not available.

Importing to a specific folder

From within the Library module, you can import photos directly to a folder in the Folders panel without needing to specify a destination in the Import dialog box.

1 In the Folders panel, right-click the lesson02A folder and choose Import To This Folder from the menu.

2 This will automatically bring up the Import dialog box. Notice that the Destination is already selected for you.

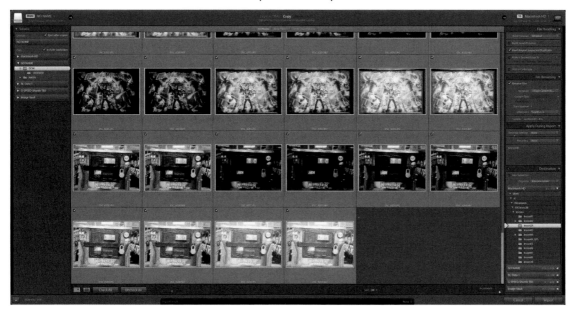

3 In the Source panel, you'll notice that you have your hard drive, any connected memory cards, and any network drives available to you for import.

4 All of the other panels are available for you to use. From here, you can still apply metadata templates, change the filename, add keywords, and so forth. Click Cancel when done.

This feature is useful when you are working with multiple memory cards and want to have all of them available to import to a shoot. That said, Lightroom does a great job of remembering the last location you saved to, so you may find that you rely on this a lot less than you'd think.

Importing from a watched folder

Designating a folder on your hard disk as a *watched folder* can be a very convenient way to automate the import process. Once you've designated a folder that is to be watched, Lightroom will detect any photos that are placed or saved into it, then automatically move them to a specified location and add them to the catalog. You can even have Lightroom rename the files and add metadata in the process.

1 Choose File > Auto Import > Auto Import Settings. In the Auto Import Settings dialog box, click the first Choose button to designate a watched folder. Navigate to your desktop and create a folder called **Watch This**, then click Choose/Select Folder.

Importing a Photoshop Elements catalog

Lightroom Classic makes it easy to import photographs and video from Photoshop Elements 6 and later on Windows, and from Photoshop Elements 9 and later on macOS.

The media files from your Photoshop Elements catalog are imported complete with keywords, ratings, and labels—even your stacks are preserved. Version sets from Photoshop Elements are converted to stacks in Lightroom Classic, and your albums become collections.

1 In the Lightroom Classic Library module, choose File > Import A Photoshop Elements Catalog.

Lightroom searches your computer for Photoshop Elements catalogs and displays the most recently opened catalog in the Import Photos From Photoshop Elements dialog box.

2 If you wish to import a Photoshop Elements catalog other than that selected by default, choose it from the pop-up menu.

3 Click Import to merge the photo library and all catalog information from your Photoshop Elements catalog to your Lightroom Classic catalog.

If you're migrating from Photoshop Elements to Lightroom Classic, or intend to use the two applications together, refer to the Adobe tutorial "Get started with Lightroom Classic and Photoshop for Photoshop Elements users" for useful tips and info: helpx.adobe.com/lightroom/how-to/photography-plan-photoshop-elements.html.

2 Now that you have designated a watched folder, you can click the checkbox at the top of the Auto Import Settings dialog box to Enable Auto Import.

3 Click the second Choose button, under Destination, to specify a folder to which Lightroom will move your photos when adding them to the library catalog. Navigate to and select the lesson02A folder, and then click Choose/Select Folder. Type **Auto Imported** in the Subfolder Name text box.

4 Under Information, select the metadata preset that we made in the previous lesson, choose None from the Develop Settings menu and Minimal from the Initial Previews menu. Click OK to close the Auto Import Settings dialog box.

5 Switch to Finder/ Windows Explorer and navigate to the Lesson02B folder. Open the Watch This folder and drag the image files inside this watched folder.

Tip: Once you've set a watched folder, you can activate or disable Auto Import at any time, without opening the Auto Import Settings dialog box, by choosing File > Auto Import > Enable Auto Import. A check mark beside this menu command indicates that the Auto Import feature is currently enabled.

When Lightroom has finished importing, you'll notice that the images are automatically placed into the Auto Imported folder we specified during the watched folder creation. Looking at the Watch This folder, you'll see that it is now empty.

If you nagivate to the lesson02A folder, you'll notice that there are several more pictures that have been added to that folder.

You'll find that this feature is very commonly used by photographers who are performing tethered shooting and have their computers using the manufacturer's software to control the camera. Dedicated to supporting photographers every step of the way, Lightroom also handles this type of shooting quite well. Want to learn more about tethered shooting? I'm glad you asked!

Specifying initial previews when importing

As photos are imported, Lightroom can immediately display a photo's embedded preview, or display higher-quality previews as the program renders them. You can choose the rendered size and quality for previews using the Standard Preview Size and Preview Quality menus on the File Handling tab of the Catalog Settings (choose Lightroom Classic > Catalog Settings/Edit > Catalog Settings). Please keep in mind that embedded previews are created on the fly by cameras and are not color managed, therefore they don't match the interpretation of the camera's raw files made by Lightroom. Previews rendered by Lightroom are color managed.

In the Import Photos dialog box, choose one of the four Build Previews options:

- **Minimal** displays images using the smallest previews embedded in the photos; Lightroom renders standard-size previews as and when needed.

- **Embedded & Sidecar** displays the largest possible preview available from the camera; slower than a Minimal preview but faster than a Standard preview.

- **Standard** displays previews as Lightroom renders them. Standard-size previews use the ProPhoto RGB color space.

- **1:1** displays a 1-to-1 view of the actual pixels.

You can also choose to build Smart Previews during the import process. Smart Previews are compressed, high-resolution previews that allow you to work on your photos, even when the originals are offline. They support editing at high magnification, though they are a fraction of the size of the source files. Generating Smart Previews for a large import takes time, but adds a lot of flexibility to your workflow.

Tethered shooting

Many modern digital cameras support tethered shooting, a process where you connect—or tether—your digital camera to your computer and save images to the computer's hard disk rather than to the camera's memory card. With tethered shooting, you can view a photo on your computer screen immediately after you shoot it—a vastly different experience from seeing it on your camera's LCD screen.

▶ **Tip:** Please refer to Lightroom Classic Help to see a list of cameras currently supported for integrated tethered shooting.

For a range of DSLR cameras, including many models from Canon and Nikon, you can capture photographs directly into Lightroom Classic without the need for any third-party software. If your camera allows tethered shooting but is not on the list of models supported by Lightroom Classic, you can still capture images into your Lightroom Classic library using either the image capture software associated with the camera or any of a number of third-party software solutions.

You can have Lightroom name the photos, add metadata, apply developing settings, and organize them in your library then and there. If necessary, you can adjust your

camera settings (white balance, exposure, focus, depth of field, and others), or even change cameras, before taking the next shot. The better the quality of the captured image, the less time you'll need to spend adjusting it later.

Tethered shooting with a supported camera

1 Connect your camera to the computer.

2 In the Library module, choose File > Tethered Capture > Start Tethered Capture.

3 In the Tethered Capture Settings dialog box, type a name for your shooting session. Lightroom will create a folder with this name inside the destination folder of your choice; this session folder will appear in the Folders panel.

● **Note:** Depending on your camera model and the operating system your computer uses, you may also need to install the necessary drivers for your camera.

4 Choose a naming scheme for your shots, select a destination folder, and specify any metadata or keywords that you want Lightroom to apply as the newly captured images are imported.

5 Click OK to close the Tethered Capture Settings dialog box. The tethered capture control bar appears.

The control bar displays the model name of the connected camera, the name you entered for the shooting session, and the current camera settings, all of which you can change. You can choose from a wide range of Develop presets in the Develop Settings menu at the right. You can trigger the shot with your camera's shutter button by clicking the large circular button at the right of the control bar or by pressing F12 on your keyboard.

▶ **Tip:** To collapse the control bar to just the shutter button, hold down the Option/Alt key and click the Close button at the upper right. Repeat to expand the control bar again.

As you shoot, the images captured will appear in both the Grid view and the Filmstrip. To see each captured photo as large as possible, switch to the Loupe view and hide unwanted panels or choose Window > Screen Mode > Full Screen And Hide Panels.

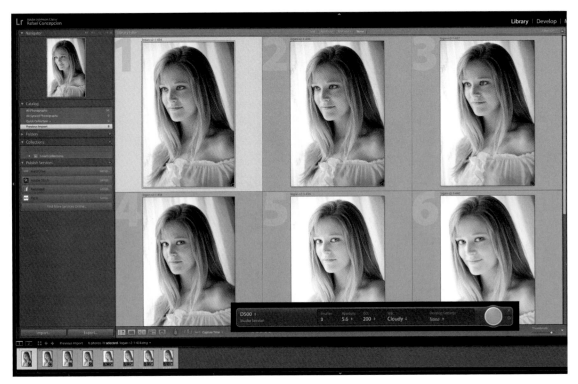

Viewing imported photos in the work area

In the Library module, the main display area—the work area—in the center of the application window is where you select, sort, search, review, and compare images. The Library module work area offers a choice of view modes to suit a range of tasks, from organizing your photos to choosing between similar shots.

1 If you're not already in the Library module, switch to it now.

● **Note:** You'll learn more about using the Filter bar controls in Lesson 4.

Depending on your workspace setup in the Library module, you may see the Filter bar across the top of the work area. You can use filters to limit the images that are displayed in the Grid view and the Filmstrip so that you'll see only those photos with a specified rating, or flag status, or containing particular metadata content.

The Toolbar, located at the bottom of the work area, is common to all the work-space modules, but contains different tools and controls for each.

2 If the Filter bar is not already visible at the top of the work area, show it by pressing the backslash key (\) on your keyboard or by choosing View > Show

Filter Bar. Press the backslash key again or choose View > Show Filter Bar again to hide it.

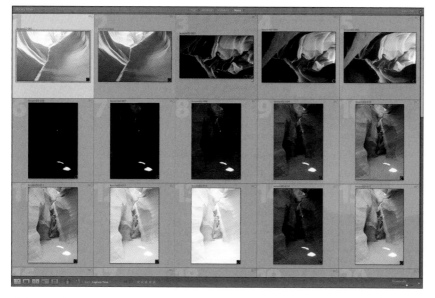

3 If the Toolbar is not already visible, press T to show it. Press T again to hide it. Switch to the Develop module. If the Toolbar is not already visible, press T to show it. Switch back to the Library module. In the Library module, the Toolbar is still hidden; Lightroom remembers your Toolbar setting for each module independently. Press T to show the Toolbar in the Library module.

4 Double-click an image in Grid view to switch to Loupe view. The Loupe view is available in both the Library and Develop modules, but the controls available in the Loupe view Toolbar differ for each of these modules.

5 To hide or show individual tools, click the white arrow at the right end of the Toolbar and choose their names from the pop-up menu. Tools that are currently visible in the Toolbar have a check mark in front of their names.

▶ **Tip:** If you activate more tools than can be displayed in the width of the Toolbar, you can increase the Toolbar's width by hiding the side panel groups, or disable tools that you don't need at the moment.

Setting Grid and Loupe view options

You can choose from many options in the Library View Options dialog box to customize the information Lightroom Classic displays for each image in the Grid and Loupe views. For the Loupe view overlay and thumbnail tool tips, you can activate two sets of options, then use a keyboard shortcut to switch between them.

1 Press G to switch to Grid view in the Library module.

2 Choose View > View Options. The Library View Options dialog box appears with the Grid View tab already selected. Position the Library View Options dialog box so you can see some of the images in the Grid view.

3 At the top of the Grid View tab, deselect Show Grid Extras. This disables most of the other options.

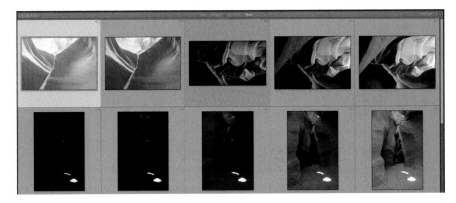

4 The only options still available are Tint Grid Cells With Label Colors and Show Image Info Tooltips. If they're not already activated, select both of these options. As this lesson's images have not yet been assigned color labels, activating the first option has no visible effect in the Grid view. Right-click any image—you can do this while the Library View Options dialog box is open—and choose a color from the Set Color Label menu.

In the Grid view and the Filmstrip, a color-labeled image that is currently selected will show a thin colored frame around the thumbnail; a color-labeled image that is not selected has a tinted cell background.

5 Position the pointer over a thumbnail in the Grid view or the Filmstrip; a tool tip appears. In macOS you'll need to click anywhere in the Lightroom Classic workspace window to bring it to the front before you can see the tool tips.

By default, the tool tip will display the filename, the capture date and time, and the cropped dimensions. You can specify the information to be displayed in the tool tip by choosing from the Loupe View options.

6 On macOS, if the Library View Options dialog box is now hidden behind the main application window, press Command+J to bring it back to the front.

7 On the Grid View tab, select the Show Grid Extras option and choose Compact Cells from the menu beside it. Experiment with each setting to see its effect in the Grid view display. Select and deselect the settings for Options, Cell Icons, and Compact Cell Extras. Position the pointer over the various icons in the image cells to see tool tips with additional information.

8 Under Compact Cell Extras, click the Top Label menu to see the long list of choices available. For some choices, such as Title or Caption, nothing will be displayed until you add the relevant information to the image's metadata.

9 Now choose Expanded Cells from the Show Grid Extras menu. Experiment with the Expanded Cell Extras options to see the effects in the Grid view. Click any of the Show Header With Labels menus to see the many choices available to customize the information that is displayed in the cell headers.

10 Click the Loupe View tab. The work area switches to Loupe view so you can preview the changes you'll make in the Library View Options dialog box.

● **Note:** When you choose an information item such as Capture Date And Time, those details are drawn from the image metadata. If the image's metadata does not contain the specified information, nothing will be displayed for that item. For both the Grid and Loupe view options you can choose the information item Common Attributes, which will display the flag status, star rating, and color label for each image.

For the Loupe view, you can select the Show Info Overlay option to display image information in the upper-left corner of the view. Choose items from the menus in Loupe Info 1 and Loupe Info 2 to create two different sets of information, and then choose either set from the Show Info Overlay menu.

You can reset either group to its default state by clicking its Use Defaults button. Select Show Briefly When Photo Changes to show the info overlay for only a few seconds when a new image is displayed in the Loupe view. Select the Show Message When Loading Or Rendering Photos option to display a notification in the lower part of the view while the image preview is updated.

11 Click the Close button to close the Library View Options dialog box.

12 You can choose which of the two information sets will be displayed by choosing an option from the View > Loupe Info menu, or by pressing the I key to cycle the info overlay through Loupe Info 1, Loupe Info 2, and its disabled state.

13 Switch to the Grid view. From the View > Grid View Style menu you can choose whether or not to display additional information, using either the Compact Cells layout or the Expanded Cells layout. Press the J key to cycle through the different cell layouts.

Review questions

1 When would you choose to copy imported images to a new location on your hard disk and when would you want to add them to your library catalog without moving them?

2 What is DNG?

3 When would you use the Import dialog box in compact mode?

4 Why would you use tethered shooting in Lightroom Classic?

5 How can you specify the information displayed for images in the Grid and Loupe views?

Review answers

1 When importing photos from a camera or memory card, the images need to be copied to a more permanent location, as memory cards are expected to be erased and reused. Copying or moving images might also be useful when you want Lightroom to organize the files into a more ordered folder hierarchy during the import process. Images that are already arranged in a useful way on the hard disk or removable media can be added to the library catalog in their current locations.

2 The Digital Negative (DNG) file format is a publicly available archival format intended to address the lack of an open standard for raw files generated by cameras. Converting raw files to DNG in Lightroom will help ensure that you'll be able to access your raw files in the future even if the original proprietary format is no longer supported.

3 Once you've created import presets to suit your workflow, you can speed up the import process by using the Import dialog box in compact mode. Use your import preset as a starting point, and then modify the settings as required.

4 When shooting tethered into Lightroom, you can see the images much larger on your computer screen than on the LCD on your camera, allowing you to adjust your camera settings as you shoot to reduce the amount of post-production work needed.

5 You can choose from the many options in the Library View Options dialog box (View > View Options) to customize the information Lightroom Classic displays for each image in the Grid and Loupe views. For the Loupe view and thumbnail tool tips, you can define two sets of options and then press the I key to switch between them. From the View > Grid View Style menu you can switch between Compact or Expanded Cells and activate or disable the display of information for either style.

PHOTOGRAPHY SHOWCASE
JOE CONZO

"Photography saved my life."

Photography. A word you didn't hear too much where I grew up. Growing up in the South Bronx, you had few choices: sports, gangs, or drugs. My mother raised five kids on her own and wasn't about to let us succumb to the latter, and sports really didn't come naturally for me. You see, I was that chubby kid with the huge Angela Davis afro, and having a camera set me apart from everyone in my neighborhood. My camera allowed me to document my surroundings and preserve a time that is long gone. Film was expensive for a kid like me, so each shot was planned or at least had some planning. Film allowed me to experiment with expressing my imagination. I tried to imitate Pablo Picasso and his light writing on film. Documenting the struggles of the South Bronx became important to me because of the role my family had as community activists. The kids I grew up with would end up creating a genre of music that has surpassed rock and roll, and I was there with my camera to document the birth of hip-hop.

Fast-forward 40+ years and photography has become my love and passion. It has brought me around the world documenting, exhibiting, and sharing. I tell some of the youth today that this kid from the South Bronx has been to Bulgaria—yep, Bulgaria! Never would I have imagined that my archives would be stored and displayed at Cornell University. I tell people that my images sit on the same shelf as the Gettysburg Address! How cool is that??!! I'm always pushing myself with the changing world of photography today. So much has changed, but I try to stay true to the way I started out: respect your subject, document your life, and have fun!

http://joeconzo.com
instagram.com/joeconzo

3 EXPLORING THE LIGHTROOM WORKSPACE

Lesson overview

Whether you prefer to use menu commands and keyboard shortcuts or buttons and sliders, whether you use one monitor or two, you can set up the Lightroom Classic workspace to suit the way *you* work. Customize each module to always have your favorite tools and controls at hand, arranged as you like them. In this lesson you'll explore the Library module and a variety of view modes, tools, and techniques for reviewing your images and navigating your catalog. In the process, you'll become familiar with the interface elements and skills that are common to all the workspace modules. You'll learn how to:

- Adjust the workspace layout, use the Navigator panel and the Filmstrip, and work with a second display.

- Work with the different image preview and screen modes.

- Use keyboard shortcuts.

- Compare, flag, and delete photos.

- Assemble groups of images using the Quick Collection.

 This lesson will take about 1 to 2 hours to complete. To get the lesson files used in this chapter, download them from the web page for this book at www.adobepress.com/LRClassicCIB2020. For more information, see "Accessing the lesson files and Web Edition" in the Getting Started section at the beginning of this book.

Make working with Lightroom Classic even more pleasurable, and ultimately more productive, by personalizing the workspace so that you always have your favorite tools and controls at hand. Here we are simulating how a picture will look in a sample magazine layout, which we cover in this chapter.

Getting started

● **Note:** This lesson assumes that you already have a basic working familiarity with the Lightroom Classic workspace. If you need more background information, refer to Lightroom Classic Help or review the previous lessons.

Before you begin, make sure you've set up the LRClassicCIB folder for your lesson files and created the LRClassicCIB Catalog file to manage them, as described in "Accessing the lesson files and Web Edition" and "Creating a catalog file for working with this book" in the "Getting Started" section at the beginning of this book.

If you haven't already done so, download the lesson03 folder from your Account page at www.peachpit.com to the LRClassicCIB\Lessons folder, as detailed in "Accessing the lesson files and Web Edition" in the "Getting Started" section.

1 Start Lightroom Classic.

2 In the Select Catalog dialog box, make sure the file LRClassicCIB Catalog.lrcat is selected under Select A Recent Catalog To Open, and then click Open.

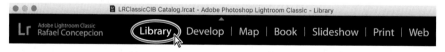

Adobe Photoshop Lightroom Classic - Select Catalog	
Select a recent catalog to open	
LRClassicCIB Catalog.lrcat	/Users/rc/Pictures/LRClassicCIB Catalog
LPCIB Catalog.lrcat	/Users/rc/Documents/LPCIB/LPCIB Catalog
RC Main Catalog-2.lrcat	/ - Personal/ - Lightroom Area
Lightwork Show LR Catalog.lrcat	/ - Syracuse/- Completed Projects/Lightwork Show LR Catalog
South Africa Print Show.lrcat	/ - Syracuse/ - Open Projects/South Africa Print Show
VIS Event Catalog.lrcat	/ - Syracuse/Resources/Vis Event/VIS Event Catalog
324.lrcat	/Users/rc/324

☐ Always load this catalog on startup ☐ Test integrity of this catalog

Note: Lightroom Catalogs cannot be on network volumes or in read-only folders.

Choose a Different Catalog... Create a New Catalog... Quit **Open**

▶ **Tip:** If you can't see the Module Picker, choose Window > Panels > Show Module Picker, or press the F5 key. If you're working on macOS, you may need to press the fn key together with the F5 key, or change the function key behavior in the system preferences.

3 Lightroom Classic will open in the screen mode and workspace module that were active when you last quit. If necessary, switch to the Library module by clicking Library in the Module Picker at the top of the workspace.

LRClassicCIB Catalog.lrcat - Adobe Photoshop Lightroom Classic - Library

Lr Adobe Lightroom Classic
Rafael Concepcion **Library** | Develop | Map | Book | Slideshow | Print | Web

Importing images into the library

The first step is to import the images for this lesson into the Lightroom library.

1 In the Library module, click the Import button below the left panel group.

2 If the Import dialog box appears in compact mode, click the Show More Options button at the lower left of the dialog box to see all the options in the expanded Import dialog box.

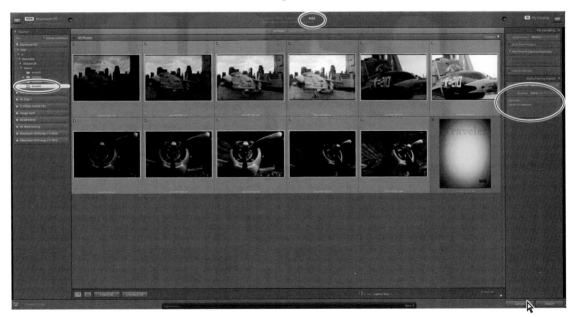

▶ **Tip:** The first time you enter any of the Lightroom Classic modules, you'll see tips that will help you get started by identifying the components of the workspace and stepping you through the workflow. Dismiss the tips by clicking the Close button. To reactivate the tips for any module, choose [*Module name*] Tips from the Help menu.

3 Under Source at the left of the expanded Import dialog box, locate and select your LRClassicCIB\Lessons\lesson03 folder. Ensure that all 11 photos in the lesson03 folder are selected for import (deselect the sample_cover.png file).

4 In the import options above the thumbnail previews, select Add so that the imported photos will be added to your catalog without being moved or copied. Under File Handling at the right of the expanded Import dialog box, choose Minimal from the Build Previews menu and leave the Don't Import Suspected Duplicates option unselected. Under Apply During Import, choose None from both the Develop Settings menu and the Metadata menu and type **Lesson 03, Airplanes** in the Keywords text box. Make sure that your import is set up as shown in the illustration below, and then click Import.

The 11 images are imported and now appear in both the Library module's Grid view and the Filmstrip across the bottom of the Lightroom Classic workspace.

Viewing and managing your images

The Library module is where every Lightroom Classic workflow begins, whether you're importing new images or finding a photo that's already in your catalog. The Library module offers a variety of viewing modes and an array of tools and controls to help you evaluate, sort, and group your photos. During import, you applied common keywords to the selection of images as a whole; now, even as you review your newly imported photos for the first time, you can begin to add more structure to your catalog, flagging picks and rejects and assigning ratings, tags, and labels.

Lightroom's search and filter features will enable you to leverage the metadata that you attach to your photos; you can search and sort the images in your library by any attribute or association, and then create collections to group them, making it easy to retrieve exactly the photos you want, no matter how big your catalog.

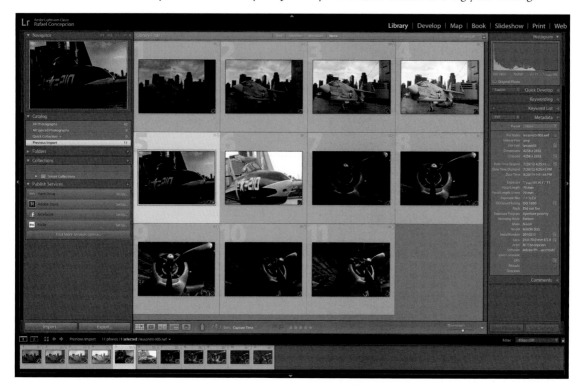

In the Library module's left panel group, you'll find panels where you can access and manage the folders and collections containing your photos. The right panel group presents controls for adjusting your images and working with keywords and metadata. Above the work area is the Filter bar, where you can set up a custom search. The Toolbar below the work area provides easy access to your choice of tools and controls, and the Filmstrip presents the images in the selected source folder or collection, no matter which view is active in the work area.

Adjusting the workspace layout

You can customize the layout of the flexible Lightroom Classic workspace to suit the way you prefer to work on any task in your workflow, freeing-up screen space as you need it and keeping your favorite controls at your fingertips. In the next five exercises, you'll learn how to modify the workspace on the fly and use the various screen display modes, skills that are applicable to any of the Lightroom modules.

Resizing panels

When you need more space to work, you can quickly change the width of the side panel groups and the height of the Filmstrip panel by simply dragging, or you can hide any of these elements.

1 Move the pointer over the right edge of the left panel group; the cursor changes to a horizontal double arrow. Drag to the right and release the mouse button when the panel group has reached its maximum width.

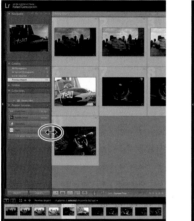

The central work area contracts to accommodate the expanded panel. This could be useful if you have a set of collections that has a long name and you want to see it.

2 Click Develop in the Module Picker to switch to the Develop module. You'll notice that the left panel group returns to the width it was when you last used the Develop module.

Lightroom Classic remembers your customized workspace layout for each module independently, so the workspace is automatically rearranged to suit the way you like to work for each stage of your workflow as you move between modules.

3 Press the G key to switch back to Grid view in the Library module.

4 In the Library module, drag the right edge of the left panel group to return the group to its minimum width.

5 Move the pointer over the top edge of the Filmstrip panel; the cursor changes to a double-arrow. Drag the top edge of the Filmstrip down as far as it will go.

The work area expands to fill the available space. This arrangement keeps the Filmstrip visible while increasing the space available for the Grid view when you're selecting photos, or for reviewing images in Loupe, Compare, and Survey views.

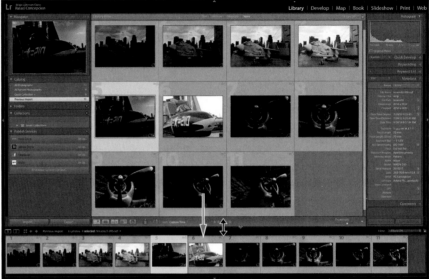

● **Note:** You can't change the size of the top panel, but you can hide or reveal it just like the side panel groups and the Filmstrip. You'll learn about showing and hiding panels in the next exercise.

6 Switch to the Develop module. The Filmstrip remains unchanged as you move between modules. Whichever module you switch to, the Filmstrip will remain at its current height until you resize it.

● **Note:** For the side panel groups, double-clicking the border will produce a different result. This is discussed in the next section, "Showing and hiding panels or panel groups."

7 Move the pointer over the top edge of the Filmstrip panel and it changes to a vertical double-arrow cursor. Double-click the top edge of the Filmstrip to reset the panel to its previous height, then switch back to the Library module.

8 Drag the top border of the Filmstrip to its maximum height. The thumbnails in the Filmstrip are enlarged and, if necessary, a scroll bar appears along the bottom of the Filmstrip. Scroll to view all the thumbnails, then double-click the top edge of the Filmstrip with the vertical double-arrow cursor to reset the panel to its previous height.

Showing and hiding panels or panel groups

By adjusting the size of the side panel groups and the Filmstrip, you can allocate more space for the controls you access most frequently and reduce the prominence of features you use less often. Once you've set up the workspace as you like it, you can maximize your working view as needed by temporarily hiding any, or all, of the surrounding panels.

1 To hide the left panel group, click the Show/Hide Panel Group arrow icon in the left margin of the window. The panel group disappears and the arrow icon is reversed to face right.

2 Click the reversed Show/Hide Panel Group arrow to reinstate the left panel group.

You can use the arrows in the top, right, and bottom margins of the workspace to show and hide the top panel, the right panel group, and the Filmstrip.

3 Deselect the menu option Window > Panels > Show Left Module Panels or press the F7 key to hide the left panel group. To show the group again, press F7 or choose Window > Panels > Show Left Module Panels. Deselect the menu option Window > Panels > Show Right Module Panels or press the F8 key to hide the right panel group. To show the group again, press F8 or choose Window > Panels > Show Right Module Panels.

4 Deselect the menu option Window > Panels > Show Module Picker or press the F5 key to hide the top panel. To show it again, press F5 or choose Window > Panels > Show Module Picker. To hide the Filmstrip, press the F6 key or deselect the menu option Window > Panels > Show Filmstrip. To show it again, press F6 or choose Window > Panels > Show Filmstrip.

5 To hide or show both side panel groups at once, press the Tab key or choose Window > Panels > Toggle Side Panels. To hide or show the top panel and the Filmstrip as well as the side panel groups, press Shift+Tab or choose Window > Panels > Toggle All Panels.

Lightroom Classic offers options that make the workspace even more flexible and convenient by showing and hiding panels or panel groups automatically in response to your movements with the pointer, so information, tools, and controls will appear only when you need them.

6 Right-click the Show/Hide Panel Group arrow in the left margin of the workspace. Choose Auto Hide & Show from the menu.

7 Hide the left panel group by clicking the Show/Hide Panel Group arrow, then move the pointer over the arrow in the left margin of the workspace. The left panels group automatically slides into view, partially covering the work area. You can click to select catalogs, folders, and collections; the left panel group will remain visible as long as the pointer remains over it. Move the pointer outside the left panel group and it will disappear again. To

> **Tip:** You don't need to be accurate clicking the Show/Hide Panel Group arrows. In fact, you can click anywhere in the outer margins of the workspace to hide and show panels.

> **Tip:** On macOS, some function keys are assigned to specific operating system functions by default. If pressing a function key in Lightroom Classic does not work as expected, either press the fn key (not available on all keyboard layouts) together with the respective function key or change the keyboard behavior in the system preferences.

show or hide the left panels independently of the current settings, press the F7 key.

8 Right-click the Show/Hide Panel Group arrow in the left margin of the workspace window and choose Auto Hide from the menu. Now the panel group disappears when you are done with it and does not reappear when you move the pointer into the workspace margin. To show the left panel group again, click in the workspace margin or press the F7 key.

9 To turn off automatic show and hide for this panel, right-click the Show/Hide Panel Group arrow in the left margin of the workspace and choose Manual from the menu.

10 To reset the left panel group to its default behavior, choose Auto Hide & Show in the menu. If either of the left or right panel groups is still hidden, press the F7 key or the F8 key, respectively, to show it again.

Lightroom remembers your panel layout for each module independently, including your choice of show and hide options. The options you choose for the Filmstrip and the top panel, however, remain unchanged as you move between modules.

Expanding and collapsing panels

Up to this point in our lesson, we've dealt with the left and right panels only as groups. Now you'll learn to work with the individual panels within the groups.

1 If you are not already in the Library module, switch to it now. Create more space to work with the side panel groups by hiding both the top panel and the Filmstrip. *(See step 4 in the previous exercise.)*

In the Library module, the left panel group contains the Navigator, Catalog, Folders, Collections, and Publish Services panels. Each panel within a group can be *expanded* to show its content or *collapsed* so that only the panel header is visible. A triangle next to the panel name indicates whether a panel is expanded or collapsed.

▶ **Tip:** You don't need to be accurate when you click the triangle. Clicking anywhere in the panel header will do, as long as you don't click any other control that might be located there, such as the plus sign (+) in the header of the Collections panel.

2 To expand a collapsed panel, click the triangle beside its name; the triangle turns downward and the panel expands to show its content. Click the triangle again to collapse the panel.

Folders within a panel—such as the Smart Collections folder in the Collections panel—can also be expanded and collapsed by clicking the triangle next to the folder name.

3 Open the Window > Panels menu; panels that are currently expanded and fully visible in the panel group show a check mark in front of their names. Choose any panel from that menu and toggle its display status.

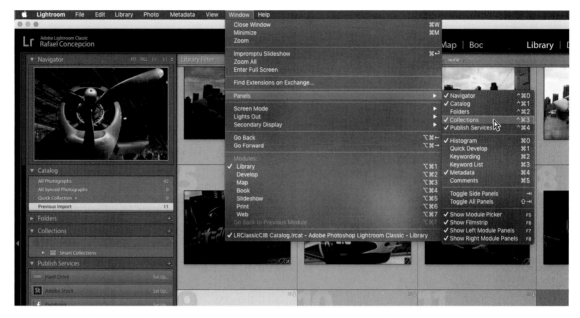

4 In the Window > Panels menu, look at the keyboard shortcuts for expanding and collapsing the individual panels.

For the panels in the left group, the keyboard shortcuts begin with Control+ Command/Shift+Ctrl followed by a number. The panels are numbered from the top down, so you press Control+Command+0/Shift+Ctrl+0 for the Navigator panel, Control+Command+1/Shift+Ctrl+1 for the Catalog panel, and so on.

For the panels in the right group, the keyboard shortcuts begin with Command/Ctrl followed by a number. Press Command+0/Ctrl+0 to collapse the Histogram panel. Press the same keyboard shortcut again to expand it. These keyboard shortcuts may be assigned to different panels in another module, but this shouldn't be too confusing if you remember that, whatever module you're in, the panels are always numbered from the top of the group, starting at 0.

Using keyboard shortcuts is a great way to streamline your workflow, so it's worth-while to note the shortcuts listed beside the menu commands you use.

5 Press Command+/ (macOS) or Ctrl+/ (Windows) to see a list of all the keyboard shortcuts for the currently active module. When you're done, click anywhere on the list to dismiss it.

With one click, you can expand or collapse all panels other than the topmost in each group, or have all the panels other than the top panel in the group and the

one you're working with close automatically. The top panel in each group has a special role and is not affected by these commands.

6 To collapse all panels in either of the side groups, right-click the header of any panel other than the top panel in the group and then choose Collapse All from the menu. If the top panel is already expanded, it will stay open.

7 To expand all the panels in either group, right-click the header of any panel—other than the top panel in each group— and choose Expand All from the menu. Once again, the top panel remains unaffected.

Tip: Option-click/Alt-click the header of any panel to quickly activate or disable the Solo mode.

8 To collapse all the panels in a group other than the one you're working with, right-click the header of any panel—other than the top panel in the group—and choose Solo mode from the menu. Only one panel will remain expanded. The triangles beside the panel names change from solid to dotted when Solo mode is activated. Click the header of a collapsed panel to expand it. The previously expanded panel collapses automatically.

Hiding and showing panels

If you use some panels in a group less often than others, you can hide them from view to create more space to expand the panels you use most frequently.

1 To show or hide an individual panel, choose it from the same menu. Panels that are currently visible have check marks in front of their names.

2 To show all of the panels that are currently hidden in either of the side panel groups, right-click the header of any panel other than the top panel in the group and choose Show All from the menu.

You can't access the panel group menu by right-clicking the header of the Navigator or Histogram panel; if you've hidden all of the panels other than the topmost in either side group, you can make the panel you want visible again by choosing its name from the Window > Panels submenu.

Toggling screen modes

Whichever of the Lightroom Classic modules you're working in, you can choose between several *screen modes* to suit the way you prefer to work. In the default mode, the workspace appears inside an application window that you can resize and position on your screen. If you prefer, you can expand the workspace to fill the screen, either with or without the menu bar, or switch to a full-screen preview to see the photo you're working on without any distracting workspace elements.

1 Choose Window > Screen Mode > Normal to ensure you're in the default mode.

In Normal screen mode, the Lightroom Classic workspace appears inside an application window. You can resize and reposition the application window just as you are used to doing with other applications.

2 Move the pointer over any edge or corner of the application window. When the pointer changes to a horizontal, vertical, or diagonal double-arrow, drag to reduce the size of the application window.

3 On macOS, click the green Zoom button at the left of the title bar; on Windows, click the Maximize button, located at the upper right of the window.

The application window expands to fill the entire screen, although the title bar remains visible. While the window is maximized, it's no longer possible to resize it as you did in step 2, or reposition it by dragging the title bar.

4 Click the Restore Down button/green Zoom button to restore the window to the size you established in step 2.

5 Choose Window > Screen Mode > Full Screen, and the workspace fills the entire screen. The menu bar is hidden, as is the Dock on macOS or the Task Bar on Windows. Move the pointer to the top edge of the screen to see the menu bar. Choose Window > Screen Mode > Full Screen And Hide Panels. Alternatively, use the keyboard shortcut Shift+Command+F/Shift+Ctrl+F.

The Full Screen And Hide Panels mode is a good choice to quickly maximize the space available for the main work area, whether you're working with the thumbnail grid or a single image in the Loupe view. You can still access any of the hidden panels when needed—using either keyboard shortcuts or your mouse, as we discussed earlier—without changing the view.

6 Press Shift+F repeatedly, or choose Window > Screen Mode > Next Screen Mode, to cycle through the working modes. As you switch between the screen modes, you'll notice that the panels around the work area remain hidden. To reveal all panels, press Shift+Tab. Press T to show or hide the Toolbar.

7 Press the F key to see a full-screen preview of the selected image at the highest magnification possible, without the distraction of workspace elements; then, press Option+Command+F/Alt+Ctrl+F to return to Normal screen mode.

Switching views

In each Lightroom Classic module, you have a different choice of working views to suit the various phases of your workflow. You can switch between viewing modes as you work by choosing from the View menu, using the keyboard shortcuts listed there, or clicking a view mode button at the left of the Toolbar below the work area.

In the Library, you can move between several viewing modes. Press the G key or click the Grid view button in the Toolbar to see thumbnails of your images while you search, apply flags, ratings, and labels, or create collections. Use the keyboard shortcut E or click the Loupe view button to inspect a single photo at a range of magnifications. Press C or click the Compare view button to see two images side by side. Click the Survey view button in the Toolbar or use the keyboard shortcut N to evaluate several images at once. The Toolbar displays a different set of controls for each view mode. For the purposes of this lesson, we'll ignore the fifth view button in the Toolbar, which is used in the process of tagging faces in your photos; you'll learn about using the People view in Lesson 4.

1 If you're not already in the Grid view, click the Grid view button. Adjust the size of the thumbnails to your liking by dragging the Thumbnails slider.

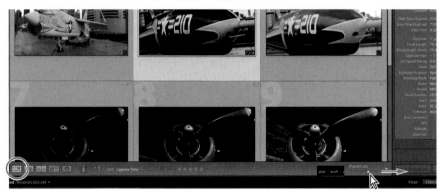

● **Note:** The order of the tools and controls from top to bottom in the menu corresponds to their order from left to right in the Toolbar.

2 Click the triangle at the right end of the Toolbar and ensure that View Modes is activated in the menu. If you're working on a small screen, you can disable any of the other options except Thumbnail Size for this lesson.

Tools and controls that are currently visible in the Toolbar have a check mark beside their names in the menu.

3 Review the section "Setting Grid and Loupe view options"—at the end of Lesson 2—and specify which items of information you would like to see displayed with each photo in the Grid view image cells.

Working in Loupe view

The Loupe view displays a single photo at a wide range of zoom levels. In the Develop module, where high magnification enables fine editing, the Loupe view is the default; in the Library module, you'll use it while evaluating and sorting your images. You can use the Navigator panel to set the level of magnification, and also to find your way around a zoomed image that's mostly out of frame. As with the Loupe view, you'll find the Navigator panel in both the Library and Develop modules.

1 In the Grid view or the Filmstrip, select a photo, and then click the Loupe view button in the Toolbar or press the E key. Alternatively, simply double-click the thumbnail in the Grid view or the Filmstrip.

Tip: In the Library View Options dialog box, activate Show Info Overlay if you wish to display text details overlaid on your image in the Loupe view. By default, the Loupe view info overlay is disabled.

2 If necessary, expand the Navigator panel at the top of the left panel group. The zoom controls in the upper-right corner of the Navigator panel enable you to switch quickly between preset magnification levels. You can choose from Fit, Fill, 1:1, or 2:1, or choose another option from a menu of 10 zoom ratios.

You can toggle between zoom levels by choosing View > Toggle Zoom View, by pressing Z on your keyboard, or simply by clicking the photo in the work area.

To better understand what happens when you use the Toggle Zoom View command (or click the enlarged image), you should be aware that the magnification controls are organized into two groups: Fit and Fill make up one group, while the numerical zoom ratio settings are in the other. The Toggle Zoom View command toggles the Loupe view between whichever magnification levels were last used in each group.

3 Click Fit in the zoom controls in the upper-right corner of the Navigator panel. Now click the 1:1 control. Choose View > Toggle Zoom View, or press Z. The zoom setting reverts to Fit. Press the Z key; the zoom setting reverts to 1:1.

4 Click Fill in the zoom controls, and then choose 2:1 from the menu at the far right of the Navigator panel header.

5 Click the image in the Loupe view. The zoom setting reverts to Fill. The difference between zooming this way and using the Toggle Zoom View command is that the zoomed view will now be centered on the area you clicked. Press Z to zoom to 2:1.

When you're working at such a high level of magnification, the Navigator helps you move around in the image quickly and easily.

6 Click anywhere in the Navigator preview and the zoomed view will be centered on that point. While the view is magnified, the white rectangle overlaid on the Navigator preview indicates the area currently displayed in the Loupe view. Drag the rectangle to pan the zoomed view, then watch the rectangle move as you drag the image in the Loupe view.

7 Using keystrokes to navigate an image can be helpful when inspecting the entire image in close detail. Press the Home key (fn+Left Arrow on a macOS laptop) to move the zoom rectangle to the upper left of the image, then press the Page Down key (fn+Down Arrow) to scroll through the magnified image one section at a time. When you reach the bottom of the photo, the zoom rectangle jumps to the top of the next column. To start in the lower-right corner of the image, press the End key (fn+Right Arrow), then use the Page Up key (fn+Up Arrow).

8 Show the Filmstrip, then select another photo with the same orientation and click in the Navigator preview to move the zoom rectangle to a different part of the image. Return to the previous image, and the zoom rectangle returns to its previous position for that photo. Choose View > Lock Zoom Position, and then repeat the first part of this step; the position of the zoom rectangle is now synchronized. This can be useful when comparing detail across similar photos.

9 Choose View > Lock Zoom Position again to disable it, and then click Fit in the header of the Navigator panel.

The zoom controls and the Navigator panel work the same way for the Loupe view in both the Library and Develop modules.

Using the Loupe view overlays

When you're working in Loupe view in the Library or Develop modules, or during a tethered capture session, you can choose to show configurable overlays that can be useful for setting up a layout, aligning elements, or making transformations.

1 Select any image in the Filmstrip. Choose View > Loupe Overlay > Grid and then choose View > Loupe Overlay > Guides. To hide both the grid and guides, choose Show in the same submenu; choose it again to show them.

The Layout Image option for the Loupe overlay can be useful when you're choosing a photo—or shooting one in tethered capture mode—that is intended for use in a printed layout, a web page design, or as a title screen for a slide show. You can create a layout sketch in PNG format, with a transparent background, and then choose the Layout Image option.

Let's say, for example, we want to review a series of images and simulate what they would look like on a magazine cover.

2 Choose View > Loupe Overlay > Choose Layout Image.

3 Navigate to the lesson03 folder and choose the sample_cover.png that I designed. This image is set as a transparent PNG file, so you should be able to see the layout as an overlay on the picture.

4 Hold down the Command/Ctrl key to bring up overlay controls, allowing you to reposition the layout image, change the opacity of the layout or matting (the area around the layout), and use a vertical and horizontal guide to align the text with the image. Choose View > Loupe Overlay > Show to hide it.

Comparing photos

As the name suggests, the Compare view is ideal for examining and evaluating images side by side.

1 In the Filmstrip, select any pair of similar photos; then, click the Compare View button in the Toolbar.

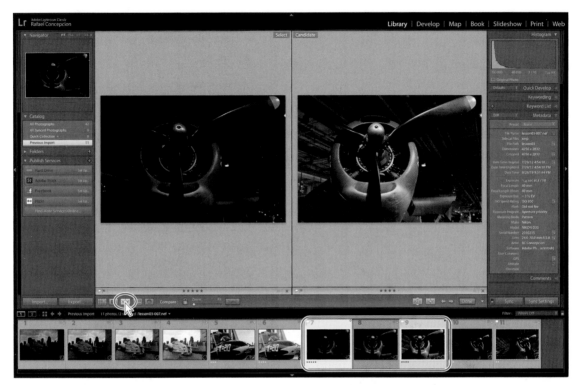

The first image that you selected becomes the *Select* image, which is displayed in the left pane of Compare view; the image displayed in the right pane is called the *Candidate*. In the Filmstrip, the Select image is marked with a white diamond icon in the upper-right corner of the image cell, whereas the Candidate image is indicated by a black diamond.

To use the Compare view to make a choice from a group of more than two photos, select your favored choice first to place it as the Select image, and then add other photos to the selection by Command-clicking/Ctrl-clicking them (for non-contiguous photos) or Shift-clicking the last one (for contiguous photos). Click the Select Previous Photo and Select Next Photo buttons (the left and right arrows) in the Toolbar or press the left and right arrow keys on your keyboard to move between the Select and Candidate photos. Should you decide that the current Candidate is better than the Select image, you can reverse their positions by clicking the Swap button in the Toolbar.

> **Tip:** To make the preview area (and thus your images) larger, press F5 and F7 or click the white arrows at the top and left edges of the workspace to hide the Module Picker and the left panels.

2 To compare fine detail in the images, zoom in by dragging the Zoom slider in the Toolbar. You'll notice that the images zoom together. Drag either of the images in the Compare view and they move in unison. The closed lock icon to the left of the Zoom slider indicates that the view focus of the two images is locked.

In some situations, this may prove to be inconvenient; for instance, with photos of the same subject shot at different zoom levels, or differently composed.

3 To pan the Select and Candidate images independently, click the Link Focus (lock) icon to unlink them, then drag either image to pan the view.

A thin white line surrounds whichever photo in the Compare view is currently the active image (the image that will be affected by the Zoom slider or the controls in the right panel group).

4 Click the photo on the right to make it active, and then alter the zoom ratio.

5 Press Shift+Tab twice to show all panels. Click the lock icon to relink the views, and then choose Fit from the zoom picker at the top of the Navigator.

6 Change the active image—the image to which your edits will be applied—by clicking the photo on the left, and then expand the Quick Develop panel. In the Tone Control section, experiment with the adjustment buttons to improve the image. Here we clicked the right double-arrow button for Exposure twice, then that for Shadows and Whites once, and the left double arrow for Highlights, to get to the result on the left, but see what you get by experimenting with it.

Using the controls in the Quick Develop panel while you're working in Compare view can help you choose between images. Applying a develop preset or making Quick Develop adjustments can help you assess how an image will look once it's edited and adjusted. You can then either undo your Quick Develop operations and move to the Develop module to edit the image with greater precision, or use the modifications you've already made as a starting point.

Using Survey view to narrow a selection

The last of the four viewing modes in the Library module, the Survey view lets you see multiple images together on one screen, and then refine your selection by dropping one photo after another from the view.

1 Make sure the Previous Import folder is selected as the image source in the Catalog panel. In the Filmstrip, select five of the airplane shots. Click the Survey view button (the fourth from the left) in the Toolbar, or press the N key. Press F7 or click the arrow at the left edge of the workspace, to hide the left panels.

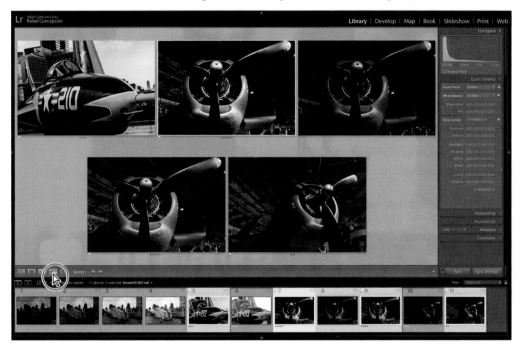

2 Navigate between the images by pressing the arrow keys on your keyboard or click the Select Previous Photo (left arrow) and Select Next Photo (right arrow) buttons in the Toolbar. The active image is surrounded by a thin white border.

3 Position the pointer over the image you like least; then, click the Deselect Photo (X) icon in the lower-right corner of the thumbnail to drop this photo from the Survey view selection.

As you eliminate candidates, the remaining photos are progressively resized and shuffled to fill the space available in the work area.

▶ **Tip:** If you have eliminated a photo accidentally, choose Edit > Undo Deselect Photo to return it to the selection, or simply Command-click/Ctrl-click its thumbnail in the Filmstrip. You can add a new photo to the selection in the Survey view in the same way.

Dropping a photo from the Survey view doesn't delete it from its folder or remove it from the catalog; the dropped image is still visible in the Filmstrip—it has simply been deselected. You can see that the images that are still displayed in the Survey view are also the only ones that remain selected in the Filmstrip.

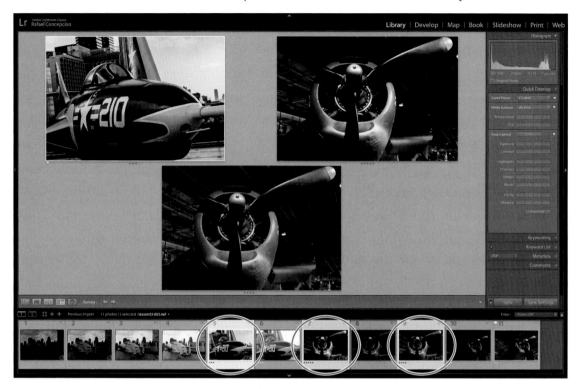

4 Continue to eliminate photos from the Survey view. For the purposes of this exercise, deselect all but one favorite. Keep the last image selected in the Survey view for the next exercise.

Flagging and deleting images

Now that you've narrowed down a selection of images to one favorite in the Survey view, you can mark your choice with a flag.

Flagging images as either picks or rejects as you review them is an effective way to quickly sort your work; flag status is one of the criteria by which you can filter your photo library. You can also quickly remove images flagged as rejects from your catalog using a menu command or keyboard shortcut.

A white flag denotes a pick, a black one with an x marks a reject, and a neutral gray flag indicates that an image has not been flagged.

1 Still in the Survey view, move the pointer over the remaining photo to see the flag icons just below the lower-left corner. The grayed icons indicate that the image is not yet flagged. Click the flag on the left. The flag turns white, which marks this image as a pick. In the Filmstrip, you can see that the thumbnail now displays a white flag in the upper-left corner of the image cell.

▶ **Tip:** Press the P key on your keyboard to flag a selected image as a pick, the X key to flag it as a reject, or the U key to remove any flags.

2 Select a different image in the Filmstrip, and then press the X key. The black reject flag icon appears at the lower-left corner of the image in the Survey view and at the upper left of the image cell in the Filmstrip. The thumbnail of the rejected image is dimmed in the Filmstrip.

3 Choose Photo > Delete Rejected Photos or press Command+Delete/Ctrl+Backspace. Then, click Remove to remove the rejected photo from your catalog without also deleting the master file from your hard disk.

> **Lr** Delete the rejected master photo from disk, or just remove it from Lightroom?
>
> Delete moves the file to Finder's Trash and removes it from Lightroom.
>
> Delete from Disk Cancel Remove

Having been removed from the Lightroom library catalog file, the rejected image is no longer visible in the Filmstrip. Press Command+Z/Ctrl+Z to restore the image.

4 Press the G key or click the Grid view icon in the Toolbar to see all the images as thumbnails in the Grid view. Press F7 to see the left panels again

Grouping images in the Quick Collection

A collection is a convenient way to keep a group of photos together in your catalog, even when the image files are actually located in different folders on your hard disk. You can create a new collection for a particular presentation or use collections to group your images by category or any other association. Your collections are always available from the Collections panel, where you can access them quickly.

The Quick Collection is a temporary holding collection: a convenient place to group images as you review and sort your new imports, or while you assemble a selection of photos drawn from different folders in your catalog.

In the Grid view or the Filmstrip, you can add images to the Quick Collection with a single click, and remove them just as easily. Your images will stay in the Quick Collection until you clear it or convert it to a more permanent collection listed in the Collections panel. You can access the Quick Collection from the Catalog panel so that you can return to work with the same selection of images at any time.

Moving images into or out of the Quick Collection

1 Expand the Catalog panel in the left panel group, if necessary, to see the listing for the Quick Collection.

2 In the Grid view or the Filmstrip, select the images lesson03_003, lesson03_005, lesson03_007, and lesson03_009.

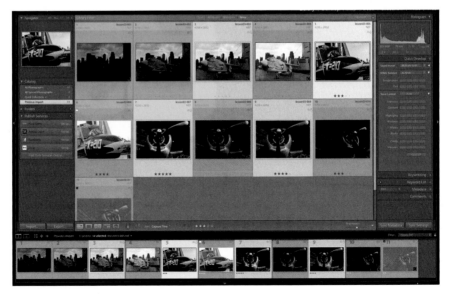

3 To add the selected photos to the Quick Collection, press the B key or choose Photo > Add To Quick Collection.

In the Catalog panel, the image count beside the Quick Collection indicates that it now contains four images. If you have activated the Show Quick Collection Markers option in the Library View Options dialog box, each of the four images is marked with a gray dot in the upper-right corner of its thumbnail in the Grid view. The same markers are also shown in the Filmstrip, unless the thumbnail size is too small.

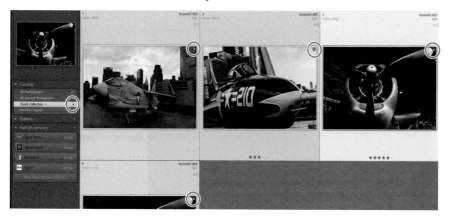

You can remove all of the selected photos from the Quick Collection by simply clicking the marker on one of the thumbnails or by pressing the B key.

4 For this exercise, you'll remove only the second image, lesson03-005, from the Quick Collection. First, deselect the other three images, then with only the lesson03-005 image selected, press the B key. The image count for your Quick Collection has been reduced to three.

▶ **Tip:** If you don't see the Quick Collection marker when you move your pointer over a thumbnail, make sure that Show Extras is activated in the View > Grid View Style menu. Choose View > View Options and activate Quick Collection Markers under Cell Icons in the Library View Options dialog box.

Converting and clearing the Quick Collection

1 Select the Quick Collection in the Catalog panel. The Grid view now displays only three images. Until you clear the Quick Collection, you can easily return to this group of images to review your selection.

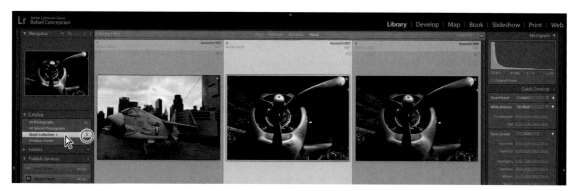

Now that you've refined your selection, you can move your grouped images to a more permanent collection.

2 Choose File > Save Quick Collection.

3 In the Save Quick Collection dialog box, type **Intrepid Collection** in the Collection Name box. Select the Clear Quick Collection After Saving option, and then click Save.

4 In the Catalog panel, you can see that the Quick Collection has been cleared; it now has an image count of 0. If necessary, expand the Collections panel so that you can see the listing for your new collection, which displays an image count of 3.

5 In the Folders panel, click the lesson03 folder. The grid view once more shows all the lesson images, including those in your new collection.

Designating a target collection

By default, the Quick Collection is designated as the *target collection*; this status is indicated by the plus sign (+) that follows the Quick Collection's name in the Catalog panel. The target collection is the collection to which a selected image is added when you press the B key or click the circular marker in the upper-right corner of the thumbnail, as you did in the previous exercise.

You can designate a collection of your own as the target collection so that you can use the same convenient techniques to add and remove photos quickly and easily.

1 Right-click the entry for your new Intrepid Collection in the Collections panel, and choose Set As Target Collection from the menu. The name of your collection is now followed by a plus sign (+).

2 Select the Previous Import folder in the Catalog panel, then Command-click/Ctrl-click to select lesson03-002 through lesson03-008 in the Grid view.

3 Make sure the Collections panel is open, and then watch as you press the B key on your keyboard; the image count for the Intrepid Collection increases as the selected images are added.

4 Press Command+Z/Ctrl+Z to undo the addition of those images. Right-click the Quick Collection in the Catalog panel and choose Set As Target Collection. The Quick Collection once again displays the plus sign (+).

Working with the Filmstrip

No matter which module or view you're working in, the Filmstrip across the bottom of the Lightroom Classic workspace provides constant access to the images in your selected folder or collection.

As with the Grid view, you can quickly navigate through the images in the Filmstrip using the arrow keys on your keyboard. If there are more images than will fit in the visible Filmstrip, you can either use the scroll bar below the thumbnails, drag the Filmstrip by the top edge of the thumbnail frame, click the arrows at either end of the Filmstrip, or click the shaded thumbnails at either end to access photos that are currently out of view.

Across the top of the Filmstrip, Lightroom Classic provides a convenient set of controls to help streamline your workflow.

At the far left, you'll find buttons for working with two displays, with pop-up menus that enable you to set the viewing mode for each display independently.

To the right of these buttons is the Grid view button, and arrow buttons for navigating between the different folders and collections you've recently been viewing.

Next is the Filmstrip Source Indicator, where you can see at a glance which folder or collection you're viewing, how many photos it contains, how many images are currently selected, and the name of the active image or the photo that is currently under your pointer in the Filmstrip. Click the Source Indicator to see a menu listing all the image sources that you've accessed recently.

Hiding the Filmstrip and adjusting its size

You can show and hide the Filmstrip and adjust its size, as you can with the side panel groups, to make more screen space available for the image you're working on.

1 Click the triangle in the lower border of the workspace window or press F6 to hide and show the Filmstrip. Right-click the triangle to set the automatic show and hide options.

2 Position the pointer over the top edge of the Filmstrip; the cursor becomes a double arrow. Drag the top edge of the Filmstrip up or down to enlarge or reduce the thumbnails. The narrower you make the Filmstrip, the more thumbnails it can display.

Using filters in the Filmstrip

As you'll see, when you only have a few photos in a folder, it's not difficult to see all the images at once in the Filmstrip. However, when you're working with a folder containing many images, it can be inconvenient to scroll the Filmstrip looking for the photos you want to work with.

You can use the Filmstrip filters to narrow down the images displayed in the Filmstrip to only those that share a specified flag status, rating, color label, or any combination of these attributes.

1 In the Filmstrip, you can see that one of the images in the lesson03 folder displays the white Pick flag that you assigned in a previous exercise. If you don't see the flag, right-click anywhere in the Filmstrip image cells and choose View Options > Show Ratings And Picks. Take a look at the other options available in the Filmstrip menu. Many of the commands apply to the image or images currently selected; others affect the Filmstrip itself.

2 From the Filter menu at the upper right of the Filmstrip, choose Flagged. Only the image with the white flag is displayed in the Filmstrip.

3 The white flag icon is now highlighted among the Filter controls in the top bar of the Filmstrip. Click the word Filter at the left of the flag icons to see the attribute filter options displayed as buttons in the Filmstrip header.

You can activate or disable any of the filters you saw in the Filter menu by clicking the respective Filter buttons. You can set up a combination of filters and save it as a custom preset by choosing Save Current Settings As New Preset from the menu.

4 Click the white flag button to deactivate the active filter or choose Filters Off from the menu to disable all filters. The Filmstrip once more displays all the images in the folder. Click the word Filter again to hide the filter buttons.

You'll learn more about using filters in Lesson 4, "Managing Your Photo Library."

Changing the sorting order of the thumbnails

Use the Sort Direction icon and the Sort menu in the Toolbar to change the display order of the thumbnail images in the Grid view and the Filmstrip.

1 If the sorting controls are not currently visible in the Toolbar, choose Sorting from the tools menu at the right of the Toolbar.

2 Choose Pick from the Sort menu.

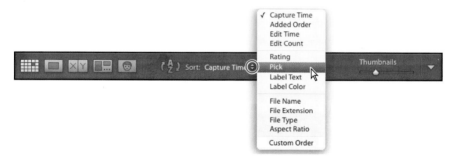

The thumbnails are rearranged in both the Grid view and the Filmstrip to display the unflagged images first, then the image with the white Pick flag, and then any rejected images.

3 Click the Sort Direction control to reverse the sorting direction of the thumbnails. The image with the white Pick flag now appears first in the order (if we had any rejected images, they would be first).

When you've grouped images in a collection, you can manually rearrange their order however you wish. This can be particularly useful when you're creating a presentation such as a slideshow or web gallery, or putting together a print layout, as the images will be placed in the template according to their sort order.

4 Expand the Collections panel and click the Intrepid Collection that you created earlier in this lesson. Choose File Name from the Sort Criteria menu.

5 In the Filmstrip, drag the first image to the right and release the mouse button when you see a black insertion bar appear after the second thumbnail.

▶ **Tip:** You can also change the order of the photos in a collection by dragging the thumbnail images in the Grid view.

The image snaps to its new location in both the Filmstrip and the Grid view. The new sorting order is also apparent in the Toolbar; your manual sorting order has been saved and is now listed as Custom Order in the Sort menu.

6 Choose File Name from the Sort menu, then return to your manual sorting by choosing Custom Order.

Using a secondary display

Click the lesson03 folder in the Folders panel so we have more images to work with. If you have a second monitor connected to your computer, you can use it to display an additional view that is independent of the module and view mode currently active on your main monitor. You can choose to have the secondary view displayed in its own window that can be resized and repositioned, or have it fill your second screen. Use the view picker at the top of the secondary display to switch between Grid, Loupe, Compare, Survey, and Slideshow views.

If you have only one monitor connected to your computer, you can open the additional display in a floating window that you can resize and reposition as you work.

Tip: You can use keyboard shortcuts to change the view in the secondary display—Shift+G for Grid, Shift+E for Loupe, Shift+C for Compare, and Shift+N for Survey. If the second window is not already open, you can use these keyboard shortcuts to quickly open it in the desired viewing mode.

1 To open a separate window—whether you're using one or two monitors—click the Second Window button (it looks like a monitor with a 2 in it), located at the upper left of the Filmstrip.

2 In the top panel of the secondary display, click Grid or press Shift+G.

3 Use the Thumbnails slider in the lower-right corner of the secondary display to change the size of the thumbnail images. Use the scroll bar on the right side, if necessary, to scroll to the end of the Grid view.

Although it's possible for the secondary display to show a different enlarged photo from the main window, the Grid view in the secondary display always shows the same images as the Grid view and the Filmstrip in the main window.

The Source Indicator and menu at the left of the secondary display's lower panel work the same way they do in the Filmstrip, and the top and bottom panels can be hidden and shown, just as they can in the main window.

4 Click to select any thumbnail in the secondary display's grid, and then click Loupe in the view picker at the left of the top panel. Check the picker at the right of the top panel to make sure that Normal mode is active.

When the secondary display is in Normal mode, the Loupe view displays the active image from the Grid view and the Filmstrip in the main display.

Note: If your secondary display is open in a window rather than on a second screen, you may need to change the focus for any keyboard input by clicking inside the main window or on its title bar.

5 Use the left and right arrow keys on your keyboard to select either the previous or next photo in the series. The new selection becomes the active image and the secondary display is updated accordingly.

6 Click Live in the mode picker at the right of the secondary display's top panel.

In Live mode, the secondary display shows the image that is currently under your pointer in the main window—whether that image is a thumbnail in the Filmstrip or the Grid view, or enlarged in the Loupe, Compare, or Survey view.

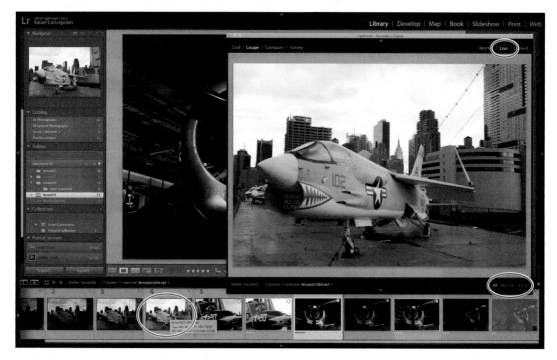

You can set a different zoom level for the secondary display by choosing from the picker at the lower right of the secondary window.

7 Select an image in the Filmstrip, then switch the secondary window to Locked mode by clicking Locked in the mode picker at the right of the top panel. The current image will now remain fixed in the secondary display until you return to Normal or Live mode—regardless of the image displayed in the main window.

8 Change the zoom level for the secondary display by choosing from the picker at the right of the lower panel: click Fit, Fill, or 1:1, or choose a zoom ratio from the menu at the far right.

9 Drag the zoomed image to reposition it in the secondary window, and then click the image to return to the previous zoom level.

10 (Optional) Right-click the image to choose a different background color or texture from the menu. These settings will apply to the secondary display independently of the options chosen for the main window.

11 Select Compare in the view picker at the left of the secondary window's top panel. In the main window, select two or more images in the Grid view or in the Filmstrip.

12 As in the main window, the image on the left of Compare view is the Select image; the image on the right is the Candidate. To change the Candidate photo, make sure the Candidate pane is active, and then click the Select Previous Photo or the Select Next Photo button. If you have more than two images selected, only images from the selection are considered as candidates. To replace the Select image with the current Candidate, click the Make Select button.

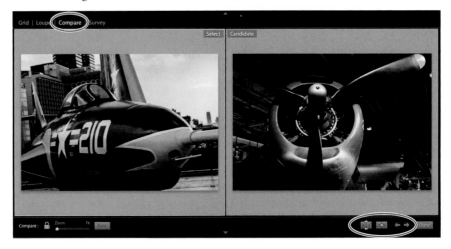

13 In the main window, select three or more images, and then click Survey in the top panel of the second window. Use the Survey view to compare more than two images at once. To remove an image from the Survey view, move the pointer over the unwanted image and click the Deselect Photo button that appears in the lower-right corner of the image.

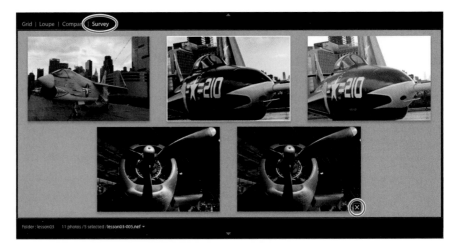

14 Choose Show in the Window > Secondary Display menu to deselect it, or click the Close button to close the secondary display.

Review questions

1 Name the four working views in the Library module, and explain how they're used.

2 What is the Navigator?

3 How do you use the Quick Collection?

4 What is the target collection?

Review answers

1 Press the G key or click the Grid view button in the Toolbar to see thumbnails of your images while you search, apply flags, ratings, and labels, or create collections. Use the keyboard shortcut E or click the Loupe view button to inspect a single photo at a range of magnifications. Press C or click the Compare view button to see two images side by side. Click the Survey view button in the Toolbar or use the keyboard shortcut N to evaluate several images at once or refine a selection.

2 The Navigator is an interactive full-image preview that helps you move around easily within a zoomed image in Loupe view. Click or drag in the Navigator preview to reposition the view while a white rectangle indicates the portion of the magnified image that is currently visible in the workspace. The Navigator panel also contains controls for setting the zoom levels for the Loupe view. Click the image in Loupe view to switch between the last two zoom levels set in the Navigator panel.

3 To create a Quick Collection, select one or more images and then press the B key or choose Photo > Add To Quick Collection. The Quick Collection is a temporary holding area; you can continue to add—or remove—images until you are ready to save the grouping as a more permanent collection. You'll find the Quick Collection listed in the Catalog panel.

4 The target collection is the collection to which a selected image will be added when you press the B key or click the circular marker in the upper-right corner of the thumbnail. By default, the Quick Collection is designated as the target collection; this status is indicated by the plus sign (+) that follows the Quick Collection's name in the Catalog panel. You can designate a collection of your own as the target collection so that you can use the same convenient techniques to add and remove photos quickly.

PHOTOGRAPHY SHOWCASE
JOE MCNALLY

"When it works, it's magic."

The work you see here is all over the lot. It reflects the path of a general assignment photographer. I've never had the luxury, or the desire, to call myself any one thing in photography, like a portrait photographer or a sports shooter. I've pretty much done it all, mostly because I enjoy it all, and to a degree, I didn't have much of a choice in the matter. When you have an irritable wire service editor on deadline in NYC screaming at you to go shoot this damn job and get it back to the office on deadline so they can get your miserable images on the wire and beat the other competitive publications to the punch, well, that's not the time to talk to them about what you'd really like to do as a personal project so you can express yourself.

I'm being mildly facetious here. I've never needed cajoling to get behind the camera. I'm as in love with the sound of the shutter now, forty years downstream, as I was when I was an excited, mistake-prone pup in my first years in New York. The field has changed and the clients have changed, but the basic mission has never changed: be a good storyteller. It sounds deceptively simple, doesn't it? Tell stories, shoot pictures! "Wow, I've got a smartphone! I can surely do that!"

And of course, anyone can. Nowadays, making a reasonable picture, a correctly exposed picture, a shot that is sharp, publishable, printable, Instagram-worthy, even, is absurdly simple. But a correctly exposed picture is not necessarily a good picture.

The alchemy that only occasionally occurs at the lens is something we all seek. It's when our head, heart, sympathies, timing, and intuition somehow line up with the gesture we are observing, and the click of the camera freezes that gesture for all time. It's maddeningly difficult. So much can go wrong. It only goes sublimely right a very small percentage of the time. It's a delicate, infinitely fragile process, but when it connects, the results are quite durable, and become part of our memories.

When it works, it's magic. I'm still behind the camera. I still seek the magic.

http://joemcnally.com

instagram.com/joemcnallyphoto

IRONMAN, UNDERWATER

USAIN BOLT

PEGASUS

4 MANAGING YOUR PHOTO LIBRARY

Lesson overview

As your photo library grows, it is increasingly important to organize your files so that they can be found easily. Lightroom Classic offers options for organizing your images before you even click the Import button, and even more once they're in your catalog. You will manage folders and files without leaving the Library module, apply keywords, flags, ratings, and labels, and then group photos in convenient collections, regardless of where they're stored. In this lesson, you'll learn how to:

- Work with a folder structure and understand and use collections.

- Work with keywords, flags, ratings, and labels.

- Tag faces in the People view and organize images by location in the Map module.

- Edit metadata and use the Painter tool to speed up your workflow.

- Find and filter files.

This lesson will take about 1 to 2 hours to complete. To get the lesson files used in this chapter, download them from the web page for this book at www.adobepress.com/LRClassicCIB2020. For more information, see "Accessing the lesson files and Web Edition" in the Getting Started section at the beginning of this book.

Lightroom Classic delivers powerful, versatile tools to help you organize your image library. Use people tags, keywords, flags, labels, ratings, and even GPS location data to sort your images, and group them into virtual collections by any association you choose. Make fast, sophisticated searches, based on practically limitless combinations of criteria, that will put the photos you want at your fingertips.

Getting started

● **Note:** This lesson assumes that you already have a basic working familiarity with the Lightroom Classic workspace. If you need more background information, refer to Lightroom Classic Help, or review the previous lessons.

Before you begin, make sure you've set up the LRClassicCIB folder for your lesson files and created the LRClassicCIB Catalog file to manage them, as described in "Accessing the lesson files and Web Edition" and "Creating a catalog file for working with this book" in the "Getting Started" section at the start of this book.

If you haven't already done so, download the lesson04 and lesson04_GPS folders from your Account page at www.peachpit.com to the LRClassicCIB\Lessons folder (*see "Accessing the lesson files and Web Edition" in the "Getting Started" section*).

1 Start Lightroom Classic.

2 In the Adobe Photoshop Lightroom Classic - Select Catalog dialog box, make sure the file LRClassicCIB Catalog.lrcat is selected under Select A Recent Catalog To Open, and then click Open.

▶ **Tip:** The first time you enter any of the Lightroom Classic modules, you'll see module tips that will help you get started by identifying the components of the workspace and stepping you through the workflow. Dismiss the tips by clicking the Close button. To reactivate the tips for any module, choose [*Module name*] Tips from the Help menu.

3 Lightroom Classic will open in the screen mode and workspace module that were active when you last quit. If necessary, switch to the Library module by clicking Library in the Module Picker at the top of the workspace.

Importing images into the library

The first step is to import the images for this lesson into the Lightroom library.

1 In the Library module, click the Import button below the left panel group.

2 If the Import dialog box appears in compact mode, click the Show More
 Options button at the lower left of the dialog box to see all the options in the
 expanded Import dialog box.

3 Under Source at the left of the expanded Import dialog box, locate and select
 your LRClassicCIB\Lessons\lesson04 folder. Ensure that Include Subfolders is
 checked and all 30 images from the lesson04 folder are selected for import.

4 In the import options above the thumbnail previews, select Add so that the
 imported photos will be added to your catalog without being moved or copied.
 In the File Handling panel at the right, choose Minimal from the Build Previews
 menu and ensure that the Don't Import Suspected Duplicates option is selected.
 In the Apply During Import panel, choose None from both the Develop
 Settings menu and the Metadata menu, and type **Lesson 04, Collections** in
 the Keywords text box. Make sure that your import is set up as shown in the
 illustration below, and then click Import.

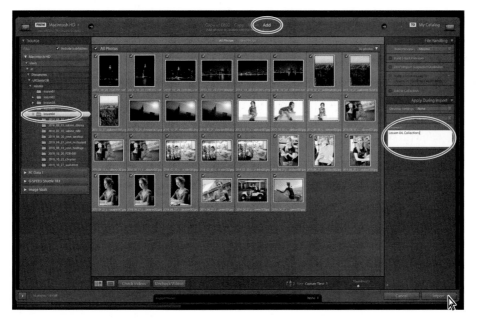

The 30 images are imported from the lesson04 folder and now appear in both the
Grid view of the Library module and in the Filmstrip across the bottom of the
Lightroom Classic workspace.

Folders vs. collections

▶ **Tip:** The Import New Photos option in the Synchronize Folders dialog box automatically imports any files that have been added to a folder without yet having been added to your image library. Optionally, activate Show Import Dialog Before Importing to choose which of those files you wish to import. Activate the Scan For Metadata Updates option to check for files with metadata modified in another application.

Each time you import an image, Lightroom creates a new catalog entry to record the file's address on your drive—the folder in which it is stored and the volume that contains that folder—in the Folders panel in the left panel group.

To keep a handle on your growing library, you need to store your pictures in folders, and you need those folders to keep some sort of structure. However, folders are an inefficient way of organizing your information, especially when it comes to photography, where you may want access to individual images in a whole bunch of places. To do that, you need collections.

Folders store; they do not organize

Let me give you a quick example. Let's imagine that this is a picture I think is so amazing, I want to use it for a variety of things. I think this image is a good example of my child photography, that it captured one of the best moments in our family life, that it is a great picture of my daughter, Sabine. I may want to show it to different people at different times and in different circumstances. My solution? I create an album for each of these moments, and place the picture of Sabine in each of the folders.

While that might seem like a good solution, we now have one file living in five different places. If this picture is 10 MB in size, I would be taking up 50 MB of storage—five times the amount I need—simply to have it easily accessible in every possible photo group I might need it in. From a disk usage standpoint, that's inefficient.

Then what happens if I need to make a change to the file? I would have to remember all of the locations where that file lives, and make sure that every change I make is added to the image in each location. That's even more inefficient. Thankfully, Lightroom solves a lot of this with collections.

Using collections to organize images

A collection is a virtual folder that allows you to organize your pictures from any number of separate physical folders, whether on your hard disk, removable drive, or network-attached storage device. A single master image can be included in any number of collections without adding space, and gives you the flexibility to create organization from all of your images. If we followed the previous example, I can have five different collections in Lightroom—one for each situation—and each collection can have the image inside of it, but all of those "images" are simply references in the catalog to the same physical file.

This concept is the literal cornerstone of everything you do in Lightroom, and your ability to master this method of organization makes using it so much easier.

There are several types of collections in Lightroom: the Quick Collection, collections, collection sets, and smart collections, listed in the order I feel they are important to your workflow.

Any collection can also be part of an output collection—a collection that is created automatically when you save a print layout or a creative project such as a photo book or web gallery, linking a set of images to a particular project template, together with all of your customized settings.

Any collection can also become a publish collection, which automatically keeps track of images that you've shared via an online service, or that is synced to Lightroom on your mobile device via Adobe Creative Cloud.

Let's walk through the first four, step by step, as it is vital that you get these under your belt.

The Quick Collection

The Quick Collection is a temporary holding collection, a convenient place to assemble a group of images from different folders. You can access the Quick Collection from the Catalog panel so that you can easily return to work with the same selection of images at any time. Your images will stay in the Quick Collection until you are ready to convert your selection to a permanent collection that will then be listed in the Collections panel.

You can create as many collections and smart collections as you wish, but there is only one Quick Collection; if there is already a selection of images in the Quick Collection, you'll need to clear the Quick Collection or convert it to a standard collection and then clear it before you can use it to assemble a new grouping.

We already created a Quick Collection in Lesson 3, so let's move on to the two that you will use the most in Lightroom: the collection and the collection set.

▶ **Tip:** If you are a user of the Apple service iTunes, think of collections as playlists for your pictures. You have one picture, but it can go to multiple playlists.

● **Note:** You can learn more about publish collections in the bonus lesson in the download files. For how to access those files, see the "Getting Started" section at the beginning of the book.

▶ **Tip:** If the Thumbnail Badges option is selected in the Library View Options, a photo that is included in a collection of any kind displays the collection badge in the lower right of its thumbnail.

Click the badge to see a menu listing the collections in which the image is included. Select a collection from the list to switch to that collection.

Creating collections

In the lesson04 folder, there are a series of images that are placed inside of subfolders. The idea here was that this would simulate how you would normally import your images. We're going to start there and give these pictures some order.

1 Navigate to the 2019_04_20_jenn_tacobus folder in lesson04. Once the images appear in the Grid view, select all of them by pressing Command+A/Ctrl+A.

2 Click the plus sign (+) button at the upper right of the Collections panel, and choose Create Collection. In the Create Collection dialog, type **Jenn at Taco Bus** and in the Options area, make sure Include Selected Photos is selected, and then click Create.

● **Note:** Once you've grouped a selection of photos as a collection you can rearrange them in the Grid view or the Filmstrip, changing the order in which they will appear in a presentation or a print layout. Your customized sorting order is saved with the collection.

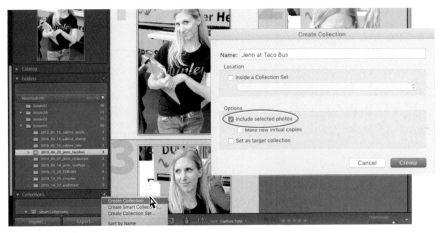

A new collection has been made in the Collections panel with three images in it. The pictures in this collection are digital references to the physical copies on your hard drive.

Let's experiment with the power of collections even further.

3 Create two additional Collections called *Summer Portfolio* and *Happy Jenn*. Make sure that you place the first file of the previously selected ones— 2019_04_27_jenn_tacobus-001—in both of the collections you just created.

As a result, we now have three different collections: Summer Portfolio, Happy Jenn, and Jenn at Taco Bus. Each collection has the same file of my wife, Jenn, but they still only reference one physical file. But wait, it gets better.

4 Select the Happy Jenn collection, and be sure the above picture is selected.

5 In the Quick Develop panel, click the Exposure single-arrow on the left two times to make this image properly exposed.

Click each of the collections in the Collections panel, and you'll see that this photo is automatically updated in all three collections the moment you make a change in one of the collections, since they all reference that same, single physical image file.

Smarter file management, smaller file sizes, immediate version control—this is why collections are so important.

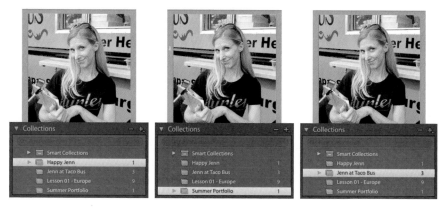

Pro tip: Automatic collections from folders

While I hope that this has inspired you to make collections out of everything you import, it can be a little daunting to make collections when you have been using folders for some time. So since you'll need them for the next exercise, I'll share a pro tip with you.

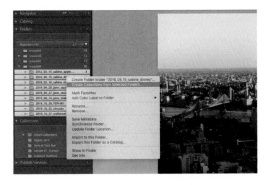

You can make collections from the remaining folders for this lesson by clicking the first one and Shift-clicking the last one in the series. Once they are selected, right-click and select Create Collections From Selected Folders.

In the Collections panel, you'll see that there is now a series of collections, one for each of the folders that you imported from the lesson04 folder.

Your turn: Make a new collection

Let's make another new collection, this time one that includes images from multiple folders.

1 Click the Collections panel's plus sign (+) button again, and create a new collection called Lightroom Book Highlights. Make sure Include Selected Photos is unselected. Click Create.

2 Click All Photographs in the Catalog panel to see all of the images you've imported. If necessary, make the thumbnails smaller so you can see all of them at the same time.

3 Command-click (Ctrl-click) seven of the images (choose your favorites) and drag them into the new collection. The goal here is to make sure that you are selecting images from each of the lesson folders you have imported so far, from Lessons 1 to 4.

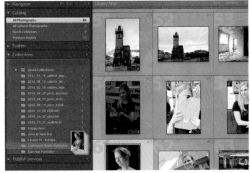

Your new collection now houses images from different folders, yet each one still only reflects a single physical copy on your computer. As your photographic needs grow, you'll find that you need to organize collections like digital albums, to share the best of a series of images in short order.

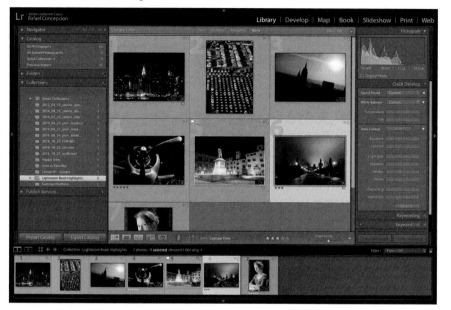

Working with collection sets

It's easy to see that, as you add more collections, your list in the Collections panel could get a little unwieldy. If you use Lightroom for professional and personal work and have a lot of different collections for each, it will be hard to scroll through them all and and see where your work images are versus your family images.

We need to better group and organize our collections. This is where collection sets come in. Collection sets are virtual folders that can hold both collections and other collection sets.

Let's go through some examples with the collections that we have so far. Take a look at the collections we've made so far; we can find some elements that each of them share.

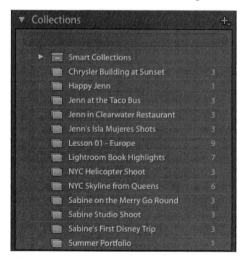

● **Note:** While it's incredibly useful to have collections created from existing folders, I'm not a fan of having them named exactly the same as my folder names. When I make collections, the names are more descriptive and less technical. So I renamed the collections to something that makes more sense to me. To make it easier to follow along, you may want to rename the collections using the illustration to the left as a guide.

There is a series of collections with images of my wife, Jenn. There also is a series of collections with images of my daughter, Sabine. Let's start with Jenn.

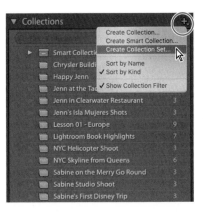

1 Click the plus sign (+) button at the upper right of the Collections panel and choose Create Collection Set.

2 In the Create Collection Set dialog box, for Name, type **Jenn Vacation Images**, and make sure Inside A Collection Set is unselected.

3 Click Create, and then drag the three Jenn collections into the Jenn Vacation Images collection set.

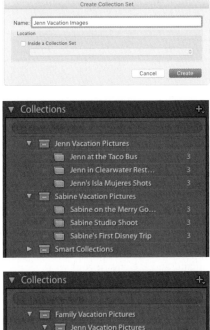

You now have all three collections organized in one spot.

4 Create another collection set, and this time, for Name, type **Sabine Vacation Pictures**. Place all of the Sabine collections inside of it. When done, your collections should look like the illustration to the right.

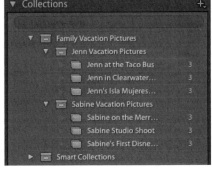

5 Looking at the Jenn and Sabine collection sets, what do these two sets have in common? They are family vacation pictures! Let's create one more collection set. In the Create Collection Set dialog box, for Name, type **Family Vacation Pictures**. Instead of placing collections in it, drag the two collection sets—Jenn Vacation Images and Sabine Vacation Pictures—inside of it.

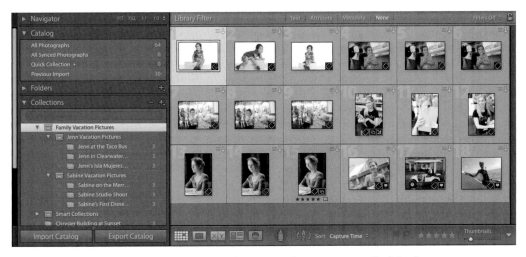

This is the start of Lightroom organizational nirvana. If I want to see all of the family vacation pictures, I can click the Family Vacation Pictures collection set and see all of them. If I want to see just the Jenn Vacation Images collection set, I can click it and see only images of my wife. If I want to see images of my daughter at Disney, I can click that individual collection and see only those photos.

In the illustration below, I created a collection set called New York City and placed the remaining collections we made from the lesson04 folder images into it. Then, I made one final collection set called Work Images, and placed the New York City collection set in it. Try this on your own and see how well you do!

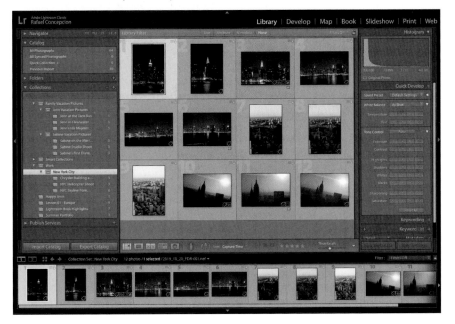

Smart collections

A smart collection searches the metadata attached to your photos and gathers together all those images in your library that meet a specified set of criteria. Any newly imported photo that matches the criteria you've set up for a smart collection will be added to that collection automatically.

You can create a smart collection by choosing Library > New Smart Collection and choosing a descriptive name based on the criteria you add. Then specify the search criteria for your smart collection by choosing options from the menus in the Create Smart Collection dialog box.

You can add more search criteria by clicking the plus sign (+) button to the right of any of the rules. Hold down the Option/Alt key and click the plus sign (+) button to refine a rule. In the illustration below, a second rule has been added to search for images containing the words *New York* in any searchable text, and then a third and a fourth rule have been added to search for images that are flagged and were edited this year. I also changed the name of the smart collection to reflect the new criteria.

Taking your collections on the road

Lightroom Classic enables you to sync photo collections between your desktop computer and your mobile devices so that you can access, organize, edit, and share your photos anywhere, anytime. Whether you're working in Lightroom on your desktop or on your iPad, iPhone, or Android device, any changes you make to photos in a synced collection will be updated automatically on the other device.

Syncing photos from Lightroom Classic

Lightroom lets you sync from only one catalog. Since we are working on a sample catalog, I won't recommend that you switch to your personal catalog and sync images now. Instead, I'll switch to my personal catalog and demonstrate the process of syncing—it's easy enough to do—so you'll be prepared to share and sync online when you are finished with the book and have switched back to your own catalog.

● **Note:** This exercise assumes that you have already signed in to Lightroom Classic with your Adobe ID. If you have not yet signed in, you'll need to do so before you begin; choose Help > Sign In.

1 Move the pointer over your name in the identity plate at the upper left of the workspace. Click the small white triangle to open the activity center, and then choose Sync With Lightroom.

2 In the Collections panel, click the empty checkbox at the left of the name of one of your collections to sync it to Lightroom. If the Share Your Synced Collections tip appears, dismiss it for now.

You'll know that your collection is online when you see a Make Public button at the top right of the work area.

By default, when you share it online, your collection is private. If you click the Make Public button, it switches to Make Private and a URL is generated that you can copy to give to others or click to go to the collection online.

The link that you get from Lightroom Classic is designed to allow recipients to view, like, and comment on your collection. Lightroom also gives you a few options for managing your online collections, both in the mobile app and in a browser.

Viewing synced photos on your mobile device

1 On your mobile device, tap the Lightroom app icon, then sign in to Lightroom for mobile with your Adobe ID, Facebook, or Google.

The first screen you'll see is the Albums view, which lists the collections you've synced from your desktop, as well as any you create in Lightroom mobile, and also offers some built-in views. First is the All Photos view, where you can browse all your synced images and all photos taken by your device camera and imported into Lightroom. There is a view that shows you only the images taken in Lightroom, one that shows you the most recently added images, and one that shows only photos with faces.

Scroll down to find the album that has been synced online and tap it to see it.

2 One of my favorite features about the mobile apps is that you can perform edits on images in collections that you have synced online. Tap an image in the synced collection to see the editing tools in groups along the bottom (with the device vertical) or right side (with the device horizontal) of the screen.

All of the editing tools that you will learn how to use in the Develop module, in the next lesson, are available to you on a mobile device. You can import, sync, and then work on the go in a matter of seconds. Tap a tool group to open it.

Any changes that you make online will automatically sync (if you have an internet connection) with Lightroom Classic. This makes for a powerful editing combination.

Editing on the Lightroom.adobe.com site

If you don't have access to the mobile app but do have access to a browser, simply go to lightroom.adobe.com and sign in. On this site, you'll have access to all of the collections that you shared online, and you can do more than just view the images.

As with the mobile app, the website offers you a suite of controls, similar to what you would use in Lightroom Classic. With all of this flexibility, you are never too far from an edit or a share.

As soon as you complete this book, I encourage you to sign in to the Lightroom website (lightroom.adobe.com) and share a couple of your own collections. You'll be surprised at how much you can do.

New in Lightroom Classic: Colors for collections

Previous versions of Lightroom allowed you to select colors for images that could be seen in the Library module's Grid view, but the feature has been added to collections and collection sets with the August 2019 release of Lightroom. This should be another great visual aid to find what you need that much faster.

To assign a color to a collection, right-click the image and select Add Color Label to Collection from the menu. You will have the option of selecting Red, Yellow, Green, Blue, or Purple. Once you select a color, it will appear at the far right of the collection's name in the Collections panel.

If you have color labeled collections nested in a hierarchy of collection sets, you also have an option to filter your collections by a specific color. Click the magnifying glass in the search field at the top of the Collections panel and you will see an option to filter the collections in your list by color labels.

To remove a color from a collection, right-click the collection, select Add Color Label to Collection, and select None from the menu. To create your own label names (like changing Red to In Progress and Blue to Final Images), go to Metadata > Color Label Set > Edit. In the Edit Color Label Set dialog box, click the Collections tab, then change any label names you want.

Using keyword tags

Perhaps the most direct way to mark your photos so that they're easier to find later is by tagging them with keywords—text metadata attached to the image files to categorize them by subject or association.

For example, the image in the illustration at the right could be tagged with the keywords Empire State Building, New York City, and Manhattan, and could therefore be located by searching for any one or a combination of those tags. If the Thumbnail Badges option is selected in the Library View Options dialog box, photos with keyword tags are identified by a keywords badge at the lower right of the thumbnail.

You can apply keywords to your photos individually or tag an entire series of images with shared metadata in one operation, thereby linking them by association and making them easier to access among all the photos that make up your library. Keywords added to images in Lightroom can be read by Adobe applications such as Bridge, Photoshop, and Photoshop Elements, and by other applications that support XMP metadata.

Viewing keyword tags

Because you applied keyword tags to the images for this lesson during the import process, the thumbnails in the Grid view and the Filmstrip are all marked with the keywords badge. Let's review the keywords you already attached to these photos.

1 Make sure that you are still in the Grid view, and then select the lesson04 folder in the Folders panel.

Tip: Clicking the keyword badge of an image in Grid view will automatically expand the Keywording panel.

2 Show the right panel group, if necessary, and then expand the Keywording panel. Expand the Keyword Tags text box at the top of the panel. By selecting each thumbnail in the Grid view in turn, you can confirm that all of the images in the lesson04 folder share the keywords "Collections" and "Lesson 04."

3 Select any one of the photos in the lesson04 folder. In the Keyword Tags text box at the top of the Keywording panel, select the text "Lesson 04" and press the Delete/Backspace key on your keyboard to delete it.

4 Click anywhere in the Grid view, and then choose Edit > Select All or press Command+A/Ctrl+A to select all the photos in the lesson04 folder. In the Keyword Tags text box, the keyword "Lesson 04" is now marked with an asterisk to indicate that this tag is not shared by every image in the selection.

5 Expand the Keyword List panel.

In the Keyword List, a check mark to the left of the keyword "Collections" indicates that this tag is shared by every image in the selection, while the tag "Lesson 04" is marked with a dash, indicating that it is attached to some, but not all, of the selected images. The image count to the right of the Collections tag shows that it is shared by all 30 of the images for this lesson, while the Lesson 04 tag shows that it is shared by only 29 of the 30 images.

6 With all 30 images still selected, click the dash mark in front of the Lesson 04 tag to reinstate the deleted tag; a check mark replaces the dash and the image count for the Lesson 04 keyword increases to 30.

> **Tip:** You can apply an existing keyword tag to selected images by clicking the tag in the Keyword Suggestions area in the Keywording panel. To remove a tag from a selected photo or photos, either delete the word from the Keyword Tags text box in the Keywording panel, or click the checkbox to disable that keyword in the Keyword List panel.

Adding keyword tags

You already added keywords to your images during the process of importing them into your Lightroom library. Once the images have been added to your Lightroom library, you can add more keywords by using the Keywording panel.

1 In the Collections panel, click the Jenn's Isla Mujeres Shots collection, and then choose Edit > Select All or press Command+A/Ctrl+A.

2 In the Keywording panel, at the bottom of the Keyword Tags area, click where it says "Click Here To Add Keywords," and type **Isla Mujeres, Mexico**. Make sure to separate the new keywords with a comma.

● **Note:** Always use a comma to separate keywords; words separated by a space (Copenhagen Denmark) or by a period (Copenhagen.Denmark) will be treated as a single keyword.

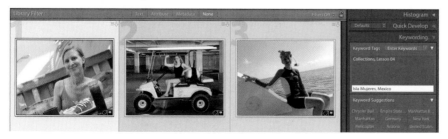

3 Press Return/Enter when done. The new keywords are listed in alphabetical order in the Keywording panel and in the Keyword List panel.

4 In the Folders panel, select the lesson04 folder, and then choose Edit > Invert Selection to select all the images other than the three previously keyworded.

5 In the Keywording panel, click in the text box at the bottom of the Keyword Tags area and type **Holiday**. Press Return/Enter.

6 Choose Edit > Select None or press Command+D/Ctrl+D on your keyboard.

Working with keyword sets and nesting keywords

▶ **Tip:** Keyword sets are a convenient way to have the keywords you need at hand as you work on different collections in your library. A single keyword tag may be included in any number of keyword sets. If you don't see the Lightroom presets in the Keyword Set menu, open the Lightroom Preferences and click the Presets tab. In the Lightroom Defaults options, click Restore Keyword Set Presets.

You can use the Keyword Set area in the Keywording panel to work with *keyword sets*—groups of keywords compiled for a particular purpose. You could create a set of keywords for a specific project, another set for a special occasion, and one for your friends and family. Lightroom Classic provides three basic keyword set presets. You can use these sets as they are or as starting points for creating sets of your own.

1 Expand the Keyword Set area in the Keywording panel, if necessary, and then choose Wedding Photography from the Keyword Set menu. You can see that the keywords in the set would indeed be helpful in organizing the shots from a big event. Look at the categories covered by the other Lightroom keyword sets. You can use these as templates for your own keyword sets by editing them to suit your needs and saving your changes as a new preset.

Grouping your keywords in keyword sets is one way to keep your keywords organized. Another handy technique is to nest related tags in a keywords hierarchy.

2 Click the Germany keyword in the Keyword List panel, then drag it onto the Europe keyword. The Europe keyword (the "parent" keyword) expands automatically to show the Germany tag (the "child" keyword tag) nested inside. Do the same with the Prague keyword.

3 In the keyword list, click the Manhattan keyword and drag it onto the NYC keyword. The NYC tag expands to show the nested Manhattan tag.

4 I want to create a Czechia keyword inside of the Europe keyword. Click the Europe keyword, then click the plus sign (+) button at the upper left of the Keyword List panel to create a new keyword tag.

5 In the Keyword Name text box in the Create Keyword Tag dialog box, type **Czechia**. Make sure the first three options under Keyword Tag Options are selected as shown in the illustration at right, and then click Create.

Include On Export Includes the keyword tag when your photos are exported.

Export Containing Keywords Includes the parent tag when your photos are exported.

Export Synonyms Includes any synonyms associated with the keyword tag when your photos are exported.

6 In the Folders panel, select the lesson01 folder, and then choose Edit > Select All or press Command+A/Ctrl+A to select all of the images in the folder. Drag the Czechia keyword tag from the Keyword List onto any of the selected images in the Grid view.

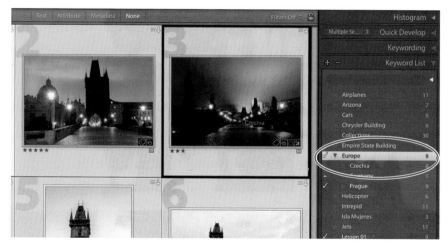

In the Keyword List, check marks in front of the new Czchecia and Europe keyword tags, and the image count to the right of each entry, indicate that both keyword tags have been applied to all selected photos.

Searching by keyword

Once you've taken the time to organize your images by adding keywords and other metadata, such as ratings, flags, and labels, it is easy to set up sophisticated and detailed filters to find exactly the photo you're looking for.

For now, we'll look at some techniques for finding the photos in your library by searching (or filtering) for keywords alone.

Tip: If you find that you cannot have two panels open at the same time in either of the side panel groups, right-click the header of any panel in the group and disable Solo mode in the menu.

1 Choose Library > Show Photos In Subfolders, if it's not aleady selected. In the left panel group, collapse other panels, if necessary, so that you can clearly see the contents of the Catalog and Folders panels. In the Folders panel, click the lesson04 folder, and then choose Edit > Select None or press Command+D/Ctrl+D.

2 Use the Thumbnails slider in the Toolbar to reduce the size of the thumbnails to the minimum, so that you'll be able to see as many images as possible in the Grid view. If the Filter bar is not already visible above the Grid view, choose View > Show Filter Bar or press the Backslash key (\).

3 In the right panel group, collapse other panels, if necessary, so that you can see the contents of the expanded Keyword List panel.

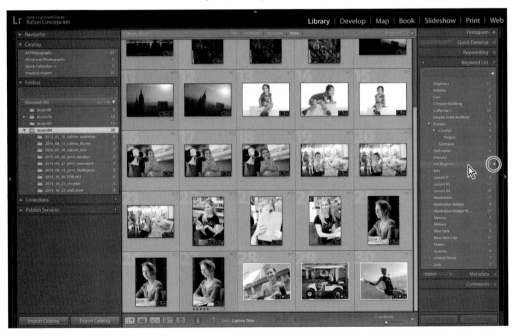

4 In the Keyword List panel, move your pointer over the entry for the keyword Isla Mujeres, and then click the white arrow that appears to the right of the image count.

Tip: To transfer lists of keywords between computers or share them with colleagues who are also working in Lightroom, use the Export Keywords and Import Keywords commands, which you'll find in the Metadata menu.

In the left panel group, All Photographs is now selected in the Catalog panel, indicating that your entire catalog was searched for photos with the Isla Mujeres tag.

The Metadata filter was activated in the Filter bar at the top of the work area, and the Grid view now displays only those images in your library that are tagged with the Isla Mujeres keyword tag.

The images in the Grid view are filtered so that only the three photos with the tag are still visible. Now you'll use a different technique to search.

5　Click All at the top of the Keyword column, then click Text at the top of the Filter bar. In the Text filter options, choose Any Searchable Field from the first menu and Contains from the second menu, noting the options available in each menu. Then type **Intrepid** in the text box at the right and press Return/Enter.

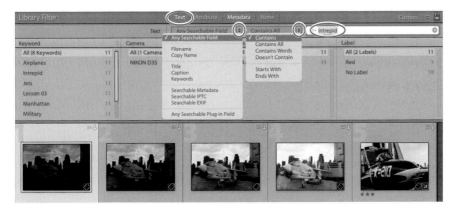

Tip: You can use the lock button at the right end of the Filter bar to keep your current filter settings active when you choose a different image source from the Catalog, Folders, or Collections panels.

Only 11 photos are still visible in the Grid view—the ones you added in Lesson 3. Of course, the true power of the Library filters only comes into play when you set up more complex filters based on a combination of criteria, but this exercise should have given you at least a glimpse of the possibilities.

6 At the top of the Filter bar, click None to deactivate the filters. In the Folders panel, select the lesson04 folder, and then choose Edit > Select None or press Command+D/Ctrl+D.

Using flags and ratings

The Attribute filters in the Filter bar allow you to search and sort your images according to attributes such as flags and ratings. When you click Attribute in the Library Filter bar, the Filter bar expands to display controls for sorting your images by flag status, edit status, star rating, color label, copy status, or any combination of these attributes.

Flagging images

Assigning flags to sort the good images from the rejects (and from the unflagged so-so images) can be a good way to begin organizing a group of photos. You can flag an image as a pick or a reject, or you can leave it unflagged.

1 Select Attribute at the top of the Filter bar. The Filter bar expands to show the Attribute filter controls.

2 If the Toolbar is not already visible below the Grid view, press the T key. Click the triangle at the right side of the Toolbar and choose Flagging from the menu to show the Flag As Pick and Set As Rejected buttons in the Toolbar.

> **Tip:** In the Grid and Loupe views, you'll find tools for adding ratings, flags, and color labels in the Toolbar. In the Compare and Survey views, you can change any of these attributes using the controls beneath the images. You can also flag, rate, or color label a selected image by using the Set Flag, Set Rating, or Set Color Label commands in the Photo menu.

3 In the Folders panel, select the 2019_10_20_FDR-001 subfolder inside the lesson04 folder.

4 In the Grid view, click your favorite from this group of photos captured in New York City. If the Flags option is selected under Cell Icons in the Library View

Options dialog box, you'll see a gray (unfilled) flag icon in the upper-left corner of the image cell, indicating that this photo is not flagged. If necessary, hold the pointer over the image cell to see the flag, or disable the Show Clickable Items On Mouse Over Only option in the Library View Options dialog box.

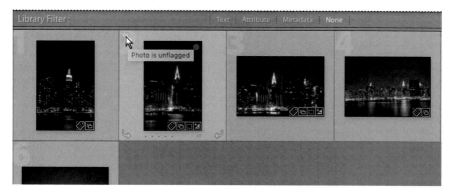

5 To change the flag status to Flagged, you can click either the flag badge in the image cell or the Flag As Pick button in the Toolbar. Note that the photo is now marked with a white flag icon in the upper-left corner of the image cell.

6 Click the white flag button in the Attribute Filter bar. The Grid view displays only the image that you just flagged. The view is now filtered to display only flagged images from the 2019_10_20_FDR-001 folder.

Lightroom Classic offers a variety of ways to flag a photo. To flag a photo as a pick, choose Photo > Set Flag > Flagged or press the P key on your keyboard. Click the flag icon at the upper-left corner of the image cell to toggle between Unflagged and Pick status. To flag an image as a reject, choose Photo > Set Flag > Rejected, press the X key, or Option-click/Alt-click the flag icon in the upper-left corner of the image cell. To remove a flag from an image, choose Photo > Set Flag > Unflagged or press the U key. To set any flag status for an image, right-click the flag icon in the upper-left corner of the image cell and choose Flagged, Unflagged, or Rejected from the menu.

► **Tip:** You can use the Library > Refine Photos command to sort your photos quickly on the basis of their flagging status. Choose Library > Refine Photos, and then click Refine in the Refine Photos dialog box; any unflagged photos are flagged as rejects and the picks are reset to unflagged status.

7 With the white flag still selected in the Attribute Filter bar, click the gray flag button (the flag in the center). The Grid view now displays any photos flagged as picks and all unflagged photos, so once again we see all of the images in the 2019_10_20_FDR-001 folder.

8 In the Filter bar, click None to disable the Attribute filters.

Assigning ratings

A quick and easy way to sort your images as you review and evaluate them is to assign each photo a rating on a scale from one to five stars.

1 In the Collections panel, click the Jenn at the Taco Bus collection, and in the Grid view, click the third photo to select it.

2 Press the 3 key on your keyboard and the words "Set Rating To 3" will appear onscreen briefly. The photo is now marked with three stars at the lower left of its image cell.

▶ **Tip:** If you don't see the star rating in the image cell, choose View > View Options and make sure Rating And Label is activated in the Compact Cell Extras display options.

3 Click the triangle at the right of the Toolbar and choose Rating in the menu, if necessary. The stars in the Toolbar reflect the rating you just applied to the selected image. If you have multiple images selected with different ratings, the Toolbar will reflect the rating of the first image selected.

▶ **Tip:** You can also assign ratings in the Metadata panel, by choosing a rating from the Photo > Set Rating menu, or by choosing a rating from the Set Rating submenu when you right-click a photo's thumbnail.

It's easy to change the rating for a selected image: simply press another key between 1 and 5 to apply a new rating or press the 0 key to remove the rating altogether.

Working with color labels

Color labeling can be a very versatile tool for organizing your workflow. Unlike flags and ratings, color labels have no predefined meanings; you can attach your own meaning to each color and customize separate label sets for specific tasks.

While setting up a print job, you might assign the red label to images you wish to proof, the blue label to those that need retouching, and the green label to mark images as approved. For another project, you might use the different colors to indicate levels of urgency.

Applying color labels

You can use the colored buttons in the Toolbar to assign color labels to your images. If you don't see the color label buttons, click the triangle at the right of the Toolbar and choose Color Label from the menu. You can also click the color label icon displayed in a photo's image cell (a small gray rectangle, for an unlabeled image) and choose from the menu. Alternatively, choose Photo > Set Color Label and choose from the menu; you'll notice that four of the five color labels have keyboard shortcuts.

To see—and set—color labels in the Grid view image cells, choose View > View Options or right-click any of the thumbnails and choose View Options from the menu to open the Library View Options dialog box. On the Grid View tab, select Show Grid Extras. In the Compact Cell Extras options, you can choose Label or Rating And Label from either the Bottom Label or Top Label menus. In the Expanded Cell Extras options, select the Include Color Label option.

Editing color labels and using color label sets

You can rename the color labels to suit your own purposes and create separate label sets tailored to different parts of your workflow. The Lightroom default options in the Photo > Set Color Label menu are Red, Yellow, Green, Blue, Purple, and None. You can change the color label set by choosing Metadata > Color Label Set, and then choosing either the Bridge or Lightroom default sets or the Review Status set.

The Review Status label set gives you an idea of how you might assign your own label names to help you keep organized. The options in the Review Status set are To Delete, Color Correction Needed, Good To Use, Retouching Needed, To Print, and None. You can use this label set as it is or as a starting point for creating your own sets. To open the Edit Color Label Set dialog box, choose Metadata > Color Label Set > Edit. Choose a preset to start from, make sure you're on the Images tab, enter your own name for each color, and then choose Save Current Settings As New Preset from the Presets menu.

Searching by color label

In the Filter bar, click Attribute to see the Attribute filter controls. You can limit your search to a single color label by clicking just one button, or select more than one button. To deselect a color label button, simply click it again. You can use the color label search buttons together with other Attribute filters, or to refine a Text or Metadata search. The Attribute filters, including the color label filters, are also available in the bar above the thumbnails in the Filmstrip (if you don't see them, click Filter to the left of the menu).

Adding metadata

You can leverage the metadata information attached to the image files to help you organize and manage your photo library. Much of the metadata, such as capture date, exposure time, focal length, and other camera settings, is generated by your camera, but you can also add your own metadata to make it easier to search and sort your catalog. In fact, you did just that when you applied keywords, ratings, and color labels to your images. In addition, Lightroom supports the information standards evolved by the International Press Telecommunications Council (IPTC), which includes entries for descriptions, keywords, categories, credits, and origins.

You can use the Metadata panel in the right panel group to inspect or edit the metadata attached to a selected image.

1 In the Collections panel, click the NYC Helicopter Shoot collection. In the Grid view, select the first image.

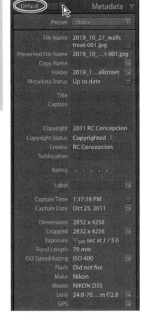

2 Expand the Metadata panel. If necessary, collapse the other panels in the right panel group or hide the Filmstrip so that you can see as much of the Metadata panel as possible. Choose Default from the Metadata Set menu in the header of the Metadata panel.

Even the default metadata set exposes a great deal of information about the image. Although most of this metadata was generated by the camera, some of it can be very useful in sorting your photos—you could filter images by capture date, search for shots taken with a particular lens, or easily separate photos taken on different cameras. However, the default set displays only a subset of an image's metadata.

3 Choose EXIF And IPTC from the Metadata Set menu. Scroll down in the Metadata panel to get an idea of the kinds of information that can be applied to an image.

4 For the purposes of this exercise, choose Quick Describe from the Metadata Set menu.

In the Quick Describe metadata set, the Metadata panel shows the filename, copy name (for a virtual copy), folder, rating, and some EXIF and IPTC metadata. You can use the panel to add a title and caption to a photo, attach a copyright notice, provide details about the photographer and the location where the photo was shot, and change the star rating.

5 In the Metadata panel, click the third dot to the right of Rating to assign the image a rating of three stars, and then type **NYC Flyover** in the Title text box and press Return/ Enter.

6 Command-click/Ctrl-click either of the other two photos to add it to the selection. In the Metadata panel you can see that the folder name, dimensions, and camera model are shared by both files, but items not shared by both images now show the entry <mixed>. Changes made to any of the items in the Metadata panel, even those with mixed values, will affect both of the selected images. This is a convenient way to edit items such as copyright details for a whole batch of selected images at the same time.

Storage of metadata

File information is stored using the Extensible Metadata Platform (XMP) standard. XMP is built on XML. In the case of camera raw files that have a proprietary file format, XMP isn't written into the original files. To avoid file corruption, XMP metadata is stored in a separate file called a sidecar file. For all other file formats supported by Lightroom (JPEG, TIFF, PSD, and DNG), XMP metadata is written into the files in the location specified for that data.

XMP facilitates the exchange of metadata between Adobe applications and across publishing workflows. For example, you can save metadata from one file as a template, and then import the metadata into other files. Metadata that is stored in other formats, such as EXIF, IPTC (IIM), and TIFF, is synchronized and described with XMP so that it can be more easily viewed and managed. To find out more about metadata, please refer to Lightroom Classic Help.

—From Lightroom Classic Help

Tagging faces in the People view

Undoubtedly, your growing photo library will include many photos of your family, friends, and colleagues. Lightroom Classic makes it quick and easy to tag the people that mean the most to you, taking much of the work out of sorting and organizing what probably amounts to a large portion of your catalog, and making it even easier to retrieve exactly the photos you're looking for.

Face recognition automatically finds the people in your photos and makes it simple for you to tag them. And the more faces you tag, the more Lightroom Classic learns to recognize the people you've named, automatically tagging their faces whenever they appear in new photos.

There are no lesson images provided for this exercise, so the first thing you need to do is import some of your own photos.

▶ **Tip:** If any of the photos you import have embedded GPS information, the Enable Address Lookup dialog will open. Click Enable.

1 Use either the Import button or the drag-and-drop method you learned in Lesson 2 to import a selection of photos featuring the faces of people you know. Make sure you have a mix of single-person images and groups of various sizes, with plenty of overlap—and at least a few strangers' faces.

By default, face recognition is disabled, so we need to have Lightroom analyze our photos and build an index of those images that include faces.

2 In the Catalog panel, change the image source from Previous Import to All Photographs, so that Lightroom Classic will index the entire catalog. Press Command+D/Ctrl+D or choose Edit > Select None.

3 Press T to show the toolbar, if necessary, and click the People button.

4 Lightroom displays a message screen welcoming you to the People view. Click Start Finding Faces In Entire Catalog. A progress bar appears at the upper left of the workspace and the Activity Center menu opens with a tip showing you where you can turn face recognition off and on. Wait for the indexing process to complete before moving on.

The work area is now in People view mode. Lightroom Classic stacks similar faces for tagging, with an image count for each stack. The default sorting order is alphabetical, but as none of the faces are yet tagged, they are arranged by stack size. At this point, all the faces are listed in the Unnamed People category.

5 Click the stack badge on a people stack to expand it. Command-click/Ctrl-click all of the photos in the stack that belong together, then click the question mark below a selected thumbnail, type the person's name, and press Return/Enter.

Lightroom moves the selected photos into the Named People category, and the image counts in both category headers are updated.

6 Repeat the process for two or more unnamed stacks. Already, Lightroom is learning, suggesting more photos that may belong with those you've named. Move the pointer over a suggested name to confirm or dismiss the suggestion.

▶ **Tip:** You can also add photos to the Named People groups by simply dragging them directly from the Unnamed People area.

7 Continue until you've named at least five or six people and tagged several photos for each, then double-click one of the faces in the Named People stack to enter the Single Person view, where the upper division is now labeled as the Confirmed category, showing all the photos tagged with the selected name. Below, the Similar category displays only the suggested matches for this face.

8 Add as many photos as you can to the group in the Single Person view, then when you're done, click "< People" at the left of the Confirmed header to return to the People view.

Tip: You can quickly isolate your People tags in the Keyword List panel by expanding the filter options at the top of the list of keywords and clicking People.

9 Repeat the process for all named people, alternating between the People and Single Person views, until the only untagged photos are people you don't know or image fragments incorrectly identified as faces. Dismiss any incorrect suggestions on the leftover photos, then remove them from the Unnamed People list by clicking the X icon that appears with the question mark in the label.

10 Click the Grid view button in the toolbar, then double-click a photo with multiple people to see it enlarged in the Loupe view. Click the Draw Face Region button in the toolbar to see the People tags attached to the image. When you find a face that has not been identified by face recognition, you can use the Draw Face Region tool to drag a box around it, and then enter a name.

11 Inspect the Keyword List panel to see your new People tags listed with your other keywords. You can use the Keyword List panel or the Text and Metadata filters to search for People tags, just as you would for any other keyword.

Organizing photos by location

In the Map module, Lightroom Classic enables you to leverage geotagging technology so that you can see exactly where your photos were captured on a Google map, and search and filter the images in your library by location.

● **Note:** You need to be online to make use of the Map module.

Photos that were captured with a camera or phone that records GPS coordinates will appear on the map automatically. You can easily add location metadata to images captured without GPS information by dragging them directly onto the map from the Filmstrip, or by having Lightroom match their capture times to a tracklog exported from a mobile device.

1 In the Library module, click the Import button below the left panel group.

2 Under Source at the left of the Import dialog box, navigate to the folder LRClassicCIB\Lessons\lesson04_GPS. Make sure that all of the images in the folder are selededed for import. Set the import options above the thumbnails to Add, type **Lesson 04, GPS** in the Keywords text box, and then click Import.

▶ **Tip:** If GPS address lookup has not yet been enabled for your catalog, you may see a dialog box asking you to authorize Lightroom Classic to exchange GPS location information with Google Maps. Click Enable, then click away from the pop-up notification to dismiss it.

3 In the Grid view, set the Sort menu to File Name, then select the first image, seen in the illustration to the right. The first is of Prague's astronomical clock.

4 Click Map in the module picker.

Working in the Map module

Lightroom has automatically plotted the selected photo's location by reading the GPS metadata embedded in the image file; the location is marked by a yellow pin. Depending on your zoom depth, you may see the number of images at that location on the pin. Click the pin to see thumbnails of the images taken at that location.

▶ **Tip:** If you don't see the Map Info overlay at the upper right, and the Map Key explaining the color-coding of location pins, choose Show Map Info and Show Map Key from the View Menu.

● **Note:** What you see onscreen may differ from this illustration, depending on the map style and zoom depth set when you last used the Map module.

1　Dismiss the Map Key by clicking the Close button (x) at the upper right or by deselecting Show Map Key in the View menu. Double-click the map next to the pin to zoom in on that location.

The Navigator panel at the left shows an overview map, with a white rectangle indicating the area visible in the main map view. The Toolbar below the map view offers a Map Style menu, a Zoom slider, and buttons for locking pins and loading GPS tracklogs. The Metadata panel at the right displays embedded location information.

2　Click repeatedly on the Zoom In (+) button at the right of the slider in the Toolbar. In the Map Style menu, select each of the six styles in turn. In the other styles, you'll see place names, like the Hard Rock Cafe to the left of the first pin.

You can drag the map in the main view to reposition it, or move the map's focus by dragging the white-bordered box in the Navigator. Hold down the Option/Alt key and drag a rectangle in the main map view to zoom in to that area.

The Location Filter bar above the map lets you highlight just those photos captured at locations currently visible on the map or filter for tagged or untagged shots.

▶ **Tip:** Click the location marker badge on a thumbnail in the Library module's Grid view or the Filmstrip to be taken to the image's location in Map view.

3　Click each of the four filters in the Location Filter bar in turn, noting the effect on which images are displayed in the Filmstrip.

In the Filmstrip and the Library module's Grid view, images that are tagged with a GPS location are marked with a location marker badge.

Geotagging images captured without GPS data

▶ **Tip:** To check if a photo selected in the Library has GPS metadata, choose the Location metadata set in the Metadata panel, then look for coordinates in the GPS field.

Even if your camera does not record GPS data, the Map module makes it easy to tag your photos with map locations.

1　In the header of the Filmstrip, click the white arrow to the right of the name of the currently selected image and choose Folder: lesson01 from the Recent Sources list in the menu. Command-click/Ctrl-click to select the first two images of the Charles Bridge in Prague.

2 In the search box in the Location Filter bar, type **Charles Bridge**, then press Return/Enter.

The map is redrawn and the new location is marked with a Search Result marker.

3 Clear the Search Result marker by clicking the X button at the right of the text search box in the Location Filter bar.

4 Right-click the found location on the map and choose Add GPS Coordinates To Selected Photos.

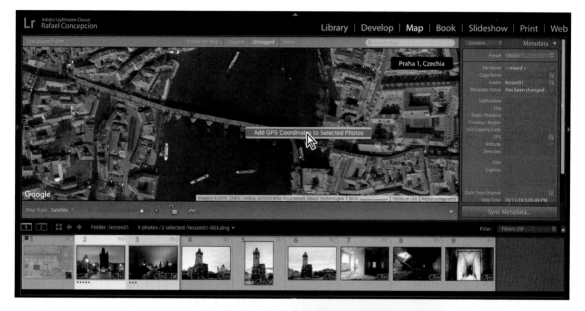

5 Choose Edit > Select None. Move the pointer over the marker pin on the map to see a preview of the photos captured at that location. Click the marker pin to select the photos attached to that location. Click the white arrows at the sides of the preview thumbnail to cycle through the other images mapped to this location, and then click away from the preview to close it.

6 Right-click the map pin and choose Create Collection. Type **Landmarks** as the name for the new collection, then deselect all options and click Create.

The new collection appears in the Collections panel, and you can drag the images into it.

Saving map locations

In the Saved Locations panel, you can save a list of your favorite places, making it easy to locate and organize related images. You could create a saved map location to encompass a cluster of places that you visited, or to mark a single location that you used for a photo shoot for a client.

1 Click the Recent Sources menu in the Filmstrip header again, and choose All Photographs. Zoom out in the map view until it's similar to the image below.

2 Expand the Saved Locations panel on the left, if necessary, and then click the Create New Preset button at the right of the header.

3 In the New Location dialog box, type **Old Town** as the location name. Under Options, set the Radius value to **0.4** Miles, then click Create.

Your new listing appears in the Saved Locations panel; the image count will show that there are two tagged images that fall within the specified radius. On the map, the saved location has a gray center pin that can be repositioned (as shown below), and a second pin on the border for changing its radius.

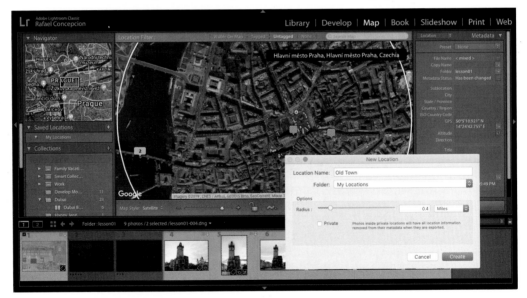

Selecting or deselecting a location in the Saved Locations panel shows and hides the circular location overlay, and makes the location active for editing. To add photos to a saved location, you can either drag them directly from the Filmstrip onto the location's entry in the Saved Locations panel or select the images in the Filmstrip and click the checkbox to the left of the location name in the panel.

Click the white arrow that appears to the right of the location name when you move your pointer over the location in the Saved Locations panel to move to that saved location on the map. To edit a location, right-click its entry in the Saved Locations panel and choose Location Options.

Once your photos are tagged with locations, you can search your library using the filter picker and search box in the Location Filter bar above the map, the Saved Locations panel, and the Library Metadata filters set to GPS Data or Map Location.

4 Click Library in the module picker to return to the Library module.

Using the Painter tool

Of all the tools Lightroom Classic provides to help you organize your growing image library, the Painter tool is the most flexible. By simply dragging across your images in the Grid view with the Painter tool you can "spray on" keywords, metadata, labels, ratings, and flags—and even apply developing settings, rotate your photos, or add them to a Target Collection.

When you pick up the Painter tool from its well in the Toolbar, the Paint menu appears beside the empty tool well. From the Paint menu, you can choose which settings or attributes you wish to apply to your images. Once you've made your choice, the appropriate controls appear to the right of the Paint menu.

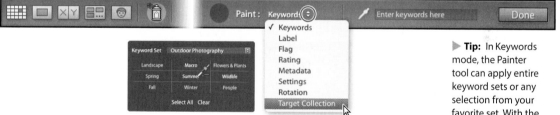

▶ **Tip:** In Keywords mode, the Painter tool can apply entire keyword sets or any selection from your favorite set. With the Painter tool in Keywords mode, press the Shift key to activate the eyedropper and access the Keyword Set picker.

In this exercise, you'll use the Painter tool to mark images with a color label.

1 Click the lesson04 folder in the Folders panel. If necessary, press G to switch to the Grid view, and then make sure that none of the images are currently selected. If you don't see the Painter tool in the Toolbar, click the triangle at the right side of the Toolbar and choose Painter from the tools menu.

2 Click the Painter tool to pick it up from its well in the Toolbar, choose Label from the Paint menu beside it, and click the red color label button.

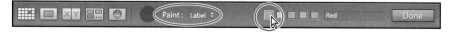

3 The Painter tool is now "loaded." Move the pointer over any of the thumbnails in the Grid view and a red spray can icon appears.

4 Click the thumbnail in the Grid view and the Painter tool applies the red label. Whether you see the color as a tint in the image cell depends on your Library View Options settings and on whether the image is currently selected (our example is not). If you don't see the red color label marker (circled in the illustration at the right), choose View > Grid View Style > Show Extras.

5 Move the pointer back over the same thumbnail, then hold down the Option/Alt key and the cursor changes from the Painter tool spray can to an eraser. Click the thumbnail with the eraser cursor and the red color label is removed.

6 Release the Option/Alt key and click the image once more, but this time drag the spray can across several photos to apply the red color tag to multiple images with one stroke. Hold down the Option/Alt key again, and remove the label from all but one of the photos.

7 Click Done at the right side of the Toolbar, or click the Painter tool's empty well, to drop the Painter tool and return the Toolbar to its normal state.

Finding and filtering files

Now that you're familiar with the different techniques for categorizing and marking your photos, it's time to see some results. Next you'll look at how easy it is to search and sort your images once they've been prepared in this way. You can now filter your images by rating or label, or search for specific keywords, GPS locations, and other metadata. There are numerous ways to find the images you need, but one of the most convenient is to use the Filter bar across the top of the Grid view.

Using the Filter bar to find photos

1 If you don't see the Filter bar above the Grid view, press the backslash key (\) or choose View > Show Filter Bar. In the Folders panel, select the lesson04 folder. If you don't see all 30 photos, choose Library > Show Photos In Subfolders.

The Filter bar picker contains three filter types: Text, Attribute, and Metadata; choose any of these and the Filter bar will expand to display the settings and controls you'll use to set up a filtered search. You can either use the different filters separately or combine them for a more sophisticated search.

Use the Text filter to search any text attached to your images, including filenames, keywords, captions, and the EXIF and IPTC metadata. The Attribute filter searches your photos by flag status, star rating, color label, or copy status. The Metadata filter enables you to set up to eight columns of criteria to refine your search; choose to add or remove a column from the menu at the right end of the column headers.

2 If the Text or Metadata filters are active, click None to disable them. Click Attribute to activate the Attribute filters. If any of the flag filters is still active from the previous exercise, click the highlighted flag in the Filter bar to disable it, or choose Library > Filter By Flag > Reset This Filter.

3 In the Rating controls, click the third star to search for any image with a rating of three stars or higher.

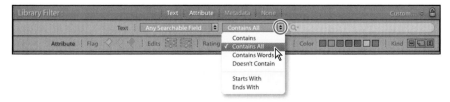

The grid view displays only the images that have a three-, four-, or five-star rating.

4 There are many options for refining your search. Click Text in the header of the Filter bar to add an additional filter. In the Text filter bar, open the first menu to see the search target options. You can narrow the search to Filename, Copy Name, Title, Caption, Keywords, or searchable IPTC and EXIF metadata, but for this exercise you can choose Any Searchable Field as the search target. Click the second menu and choose Contains All.

5 In the search text box, type **holiday**. Your narrowed search returns only one image in the Grid view.

6 In the Rating controls, click the third star to disable the current Rating filter or choose Library > Filter By Rating > Reset This Filter. Click Attribute in the header of the Filter bar to close the Attribute filter controls.

7 In the Text filter bar, clear the previous search by clicking the X icon at the right of the text box, and then type **NYC**.

The Grid view now displays 11 images in the lesson04 folder.

Using the filters in the Filmstrip

The Attribute filter controls are also available in the header of the Filmstrip. As in the Filter bar, the Filter menu lists the different attributes you can filter by and offers the option to save your filter settings as a custom preset, which is then added to the menu.

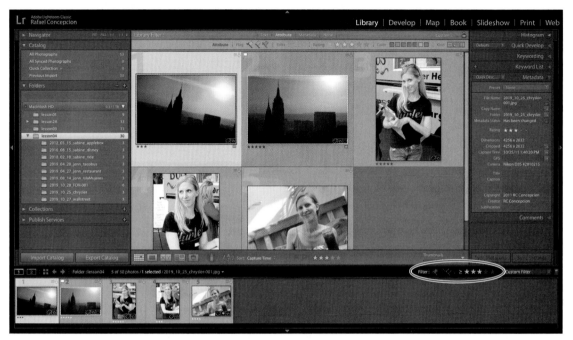

The Default Columns preset opens the four default columns of the Metadata search options—Date, Camera, Lens, and Label—in the Filter bar.

Choose Filters Off to turn off all filters and collapse the Filter bar. Choose Flagged to display only photos with a Pick flag.

Choosing Rated displays any photos that match the current star rating criteria. Click a different star to change the star rating and the symbol before the stars to choose whether to see photos with three stars or more, three stars or less, or exactly three stars. Choose Unrated to see all the photos without a star rating.

For the illustration above, I filtered to images that have a rating of three stars or higher. This returned a result of five images.

To disable all filters and display all the images in the lesson04 folder, choose Filters Off from the Filter menu or click the switch at the far right of the Filmstrip's header.

▶ **Tip:** If you don't see any filter presets in the Filter menu, open Lightroom Preferences and click Restore Library Filter Presets under Lightroom Defaults on the Presets tab.

Hardware suggestion: Monogram Creative Console

When trying to work on the iterative culling process, I find that I am the most successful when I make sure that I do not touch anything on the computer other than the buttons I need for Pick, Reject, Previous, and Next.

Many photographers bemoan the process and the time it takes them to "edit" a shoot, but it's not really the editing of the shoot, but the amount of time wasted in culling that is causing the problem.

I found this company called Monogram (the company was redesigned; it was previously called Palette Gear) that produces a series of analog controls that you can plug into your computer and assign commands to from a variety of applications. While there are a ton of different applications that it can be used with (I'm using them in InDesign to write this book!), I think the strongest case can be made for their simplest kit: two buttons and one dial, and that's it.

Assign one of the buttons to Pick and the second to Reject, and the dial moves you between the pictures.

This is not something that is required for this process, but I found it enough of a help to make a video about it for others who want to learn how to incorporate it into their workflow. You can find it at https://rcweb.co/paletteRC.

Review questions

1 When do you use a collection and when do you use a collection set?

2 What is a smart collection?

3 What are keyword tags?

4 What are the three modes in the Filter bar?

5 How can you search for images by location?

Review answers

1 Use a collection when you want to group a number of images that reside in different folders, when you want to put the same image in more than one group, or when you want to arrange your photos in a custom order. Use a collection set to further organize your images by putting multiple collections or collection sets in the same group.

2 A smart collection can be configured to search the library for images that meet specified criteria. Smart collections stay up to date by automatically adding any newly imported photos that meet the criteria you've specified.

3 Keyword tags are text added to the metadata of an image to describe its content or classify it in one way or another. Shared keywords link images by subject, date, or some other association. Keywords help to locate, identify, and sort photos in the catalog. Like other metadata, keyword tags are stored either in the photo file or (in the case of proprietary camera raw files) in XMP sidecar files. Keywords applied in Lightroom Classic can be read by Adobe applications such as Bridge, Photoshop, or Photoshop Elements, and by other applications that support XMP metadata.

4 The Filter bar offers three filter groups: Text, Attribute, and Metadata filters. Using combinations of these filters, you can search the image library for metadata or text, filter searches by flag, copy status, rating, or label, and specify a broad range of customizable metadata search criteria.

5 Once your photos are tagged with locations, you can search your library from the Map module by using the Location Filter bar above the map and the Saved Locations panel. In the Library, you can use the metadata filters, set to GPS Data or GPS Location.

PHOTOGRAPHY SHOWCASE
TITO HERRERA

"Make the ordinary extraordinary."

I fell in love with photography by looking at magazines like *National Geographic*, *Time*, and *Life*, and finding the beauty in the everyday moments and in telling the stories of "ordinary" people. That beauty has guided my photographic journey from the beginning, as I clearly knew what kind of photos I wanted to take. I still try to guide my work by this simple, self-imposed rule: Make the ordinary extraordinary.

To me, the good photos are not so much about finding fascinating subjects. The truth is that whatever is amazing to someone in one part of the world is completely normal and ordinary to someone in another part, and what makes a subject amazing is not so much the subject itself, but rather the way it's presented by the photographer. A beautiful person or an amazing location can look really bad if not photographed properly, while some of the most mundane things can catch your eyes for hours if photographed from the right angle and with the right light.

The trick is to keep an open mind, continue to be amazed by the world, be inquisitive and creative, and push yourself to see differently. Start by finding the beauty, good light, and interesting subjects in your own backyard. Until you learn to do this, I guarantee you that you won't find them halfway around the world.

It's not about finding amazing subjects; it's about making every subject look amazing.

www.titoherrera.com
instagram.com/titoherrera

LA 18

173

LA 18

BEAR GRYLLS

CASCO VIEJO, PANAMA

LA 18

BANGKOK, THAILAND

5 DEVELOPING BASICS

Lesson overview

Lightroom delivers an extensive suite of powerful, yet easy-to-use, developing tools to help you make the most of your photos with a minimum of effort, whether they're incorrectly exposed, shot at an angle, poorly composed, or even spoiled by extraneous objects.

This lesson introduces you to a range of basic editing options in the Develop module, from automatic adjustments and develop presets to cropping, straightening, and finishing tools. Along the way, you'll pick up a little background knowledge in digital imaging as you become familiar with some basic techniques. You'll learn how to:

- Crop your images for the best effect.

- Use the histogram and properly set your white balance.

- Perform basic edits in the Develop module.

- Apply artistic color profiles to your images.

- Effectively use sharpening and noise reduction.

- Create versions of images using virtual copies and snapshots.

- Create compelling black-and-white images.

 This lesson will take about 2 to 2-1/2 hours to complete. To get the lesson files used in this chapter, download them from the web page for this book at www.adobepress.com/LRClassicCIB2020. For more information, see "Accessing the lesson files and Web Edition" in the Getting Started section at the beginning of this book.

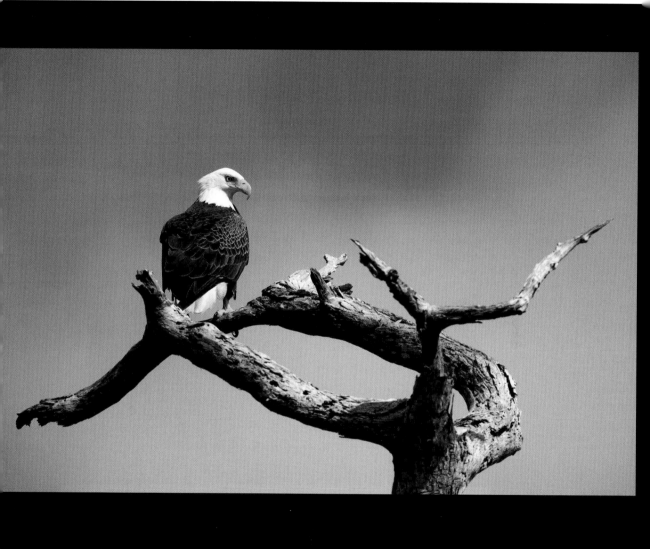

Now that you've imported your photos and organized your catalog, you can jump right in and begin editing them with a range of options from one-click automatic adjustments to specialized retouching tools. You can experiment with any of these, secure in the knowledge that, thanks to Lightroom's non-destructive editing, the modifications you make while you're learning won't alter your master files.

Getting started

● **Note:** This lesson assumes that you already have a basic working familiarity with the Lightroom Classic workspace. If you need more background information, refer to Lightroom Classic Help, or review the previous lessons.

Before you begin, make sure you've set up the LRClassicCIB folder for your lesson files and created the LRClassicCIB Catalog file to manage them, as described in "Accessing the lesson files and Web Edition" and "Creating a catalog file for working with this book" in the "Getting Started" section at the start of this book.

If you haven't already done so, download the lesson05 folder from your Account page at www.peachpit.com to the LRClassicCIB\Lessons folder, as detailed in "Accessing the lesson files and Web Edition" in the "Getting Started" section.

1 Start Lightroom Classic.

2 In the Select Catalog dialog box, make sure the file LRClassicCIB Catalog.lrcat is selected under Select A Recent Catalog To Open, and then click Open.

▶ **Tip:** If you can't see the Module Picker, choose Window > Panels > Show Module Picker, or press the F5 key. If you're working on macOS, you may need to press the fn key together with the F5 key, or change the function key behavior in the system preferences.

3 Lightroom Classic will open in the screen mode and workspace module that were active when you last quit. If necessary, switch to the Library module by clicking Library in the Module Picker at the top of the workspace.

Importing images into the library

The first step is to import the images for this lesson into the Lightroom library.

1 In the Library module, click the Import button below the left panel group.

2 If the Import dialog box appears in compact mode, click the Show More Options button at the lower left of the dialog box to see all the options in the expanded Import dialog box.

3 Under Source at the left of the expanded Import dialog box, locate and select your LRClassicCIB\Lessons\lesson05 folder. Ensure that all nine images in the lesson05 folder are selected (checked) for import.

4 In the import options above the thumbnail previews, select Add so that the imported photos will be added to your catalog without being moved or copied. Under File Handling at the right of the expanded Import dialog box, choose Minimal from the Build Previews menu and leave the Don't Import Suspected Duplicates option unselected. Under Apply During Import, choose None from both the Develop Settings menu and the Metadata menu and type **Lesson 05, Develop** in the Keywords text box. Make sure that your import is set up as shown in the illustration below, and then click Import.

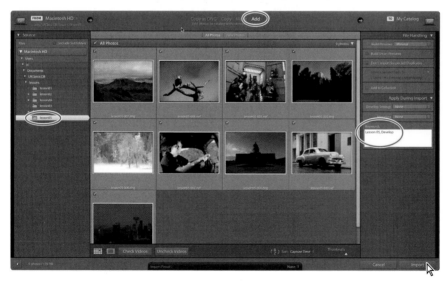

▶ **Tip:** The first time you enter any of the Lightroom Classic modules, you'll see tips that will help you get started by identifying the components of the workspace and stepping you through the workflow. Dismiss the tips by clicking the Close button. To reactivate the tips for any module, choose [*Module name*] Tips from the Help menu.

The nine images are imported and now appear in both the Library module's Grid view and the Filmstrip across the bottom of the Lightroom workspace.

The Develop module

Although the Library module's Quick Develop panel offers access to many basic image editing options, you'll work in the Develop module to make more detailed adjustments and modifications to your photos. The Develop module is a comprehensive editing environment, presenting all the tools you'll need to correct and enhance your images in a single workspace. The controls are simple enough for a beginner to use, and yet have the depth and power required by the advanced user.

The Develop module offers three viewing modes: the Loupe view, where you can focus on a single image; the Reference view, where you can compare your image to a reference image; and the Before/After view, which has several layout options that make it easy to compare the original and edited versions of a photo. The Toolbar across the bottom of the work area presents buttons for switching between the views and a slightly different suite of controls for each viewing mode.

The tools and controls in the Develop module's right panel group are arranged from top to bottom in the order in which they would ordinarily be used, a layout that guides you intuitively through the editing workflow.

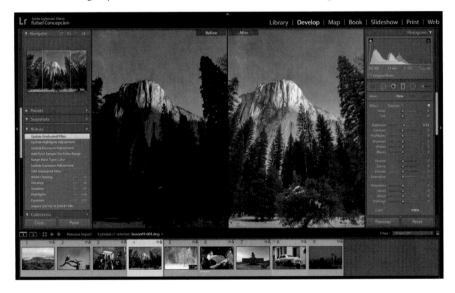

The left panel group contains the Navigator panel, which can be collapsed but not hidden, and any combination of the Presets, Snapshots, History, and Collections panels, which can be shown or hidden to suit the way you prefer to work.

At the top of the left panel group, the Navigator panel helps you find your way around a zoomed image, lets you preview the effects of developing presets before you apply them, and lets you review past stages in an image's developing history. At the right of the Navigator's header is a zoom picker for setting the magnification level in the working views.

At the top of the right panel group is the Histogram panel. Immediately below the histogram is an array of tools for cropping, removing image flaws, applying local adjustments through graduated or radial masks, and painting develop settings directly onto an image selectively. Clicking any of these tools expands a tool options panel with controls and settings for that tool.

Below these editing tools is the Basic panel, your starting point for color correction and tonal adjustments. In many cases, this may be the only panel you need to achieve the result you want. The remaining panels offer specialized tools for various image enhancement tasks.

For example, you can use the Tone Curve panel to fine-tune the distribution of the tonal range and increase midtone contrast. Use the controls in the Detail panel to sharpen an image and reduce noise.

It's not intended that you use every tool on every photo. In many circumstances, you may make only a few slight adjustments to an image; however, when you wish to polish a special photo—or if you need to work with shots captured at less than ideal camera settings—the Develop module gives you all the control you need.

Reorganize the Develop module

The December 2018 release of Lightroom Classic added a new feature in the Develop module. Right-click any panel's header in the right panel group, and choose Customize Develop Panel. You'll be presented with a dialog box with the names of all the panels in the group. Drag the panel names to rearrange the order of the panels. The checkboxes toggle each panel's visibility. Clicking the Save button will prompt you to restart Lightroom. After the restart, your panels will be organized as you set them, showing only the ones you need in the order you prefer.

To get back to the original arrangement, go back into the Customize Develop Panel dialog box, click Default Order at the bottom right, then click Save and restart Lightroom to see the change.

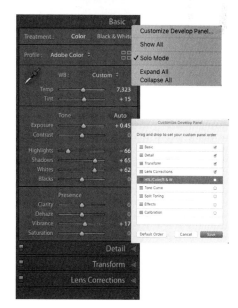

Creating a collection from a previous import

Now that we are familiar with how to create collections inside of Lightroom, it's a good idea to get into a workflow habit of making collections for images that we will be working on in Lightroom.

1 After importing images into the Library, all of the images reside in the Previous Import group in the Catalog panel. Press Command+A/Ctrl+A to select all of the images in the group.

2 Click the plus sign (+) button at the upper right of the Collections panel and make a collection called Develop Module Practice, making sure the Include Selected Photos option is selected.

Note: If you do not see the Toolbar at the bottom of the panel, press the letter T to show it.

3 The images are automatically added to the Develop Module Practice collection. From here, you can drag to reorganize them to your liking, or choose File Name from the Sort menu in the Toolbar at the bottom of the work area to see them in order by filename.

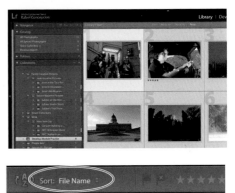

Now that we have ourselves organized, let's start tackling the Develop module by working on some of the most popular tools from the top down.

Cropping and rotating images

The Crop Overlay tool makes it simple to improve your composition, crop away unwanted edge detail, and even straighten your image.

1 Select the raw image of the Star Wars cosplayers (lesson05-001) in the Grid view or Filmstrip and press the D key to switch to the Develop module.

2 Hide the left panel group to enlarge the work area; you'll find keyboard shortcuts for showing and hiding any or all of the panels listed beside the commands in the Window > Panels menu. If you're not already in the Loupe view, press the D key or click the Loupe view button in the Toolbar. If you don't see the Toolbar, press the T key.

3 Click the Crop Overlay tool button just below the Histogram panel, or press the R key. A crop overlay rectangle appears on the image in the Loupe view and an options panel for the Crop Overlay tool opens above the Basic panel.

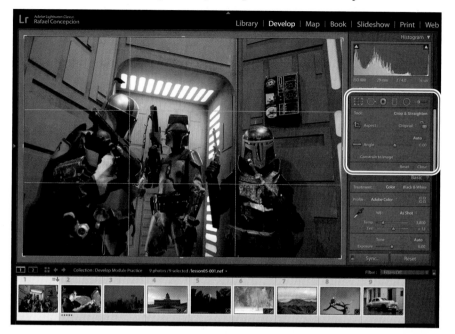

4 Drag the top corners inward and the area outside of the crop overlay will darken, giving you a better idea what the crop will look like. Drag the image to reposition the crop. Move your pointer outside the corners of the overlay, and it turns into a curved double-headed arrow, allowing you to drag clockwise or counterclockwise to rotate the image.

5 The crop overlay includes a set of compositional aids you can use to make better crop adjustments to your images. The default overlay is the Rule Of Thirds, shown above. Press the O key to cycle between the overlays. The Golden Spiral overlay is shown in the illustration at the right.

● **Note:** If you press Shift+O, you can change the orientation of the overlays.

Changing crop overlays

●**Note:** The following crop overlays are available in Lightroom Classic: Grid, Rule Of Thirds, Diagonal, Triangle, Golden Ratio, Golden Spiral, and Aspect Ratios.

These crop overlays are meant to be guidelines or suggestions for aligning and cropping your image. In the example to the right, I am using the Rule Of Thirds overlay. This is one of the most common photographic principles: any image that puts the subject at one of the intersecting points on a Rule Of Thirds grid is more compositionally interesting. By using the Rule

Of Thirds grid, I can crop to ensure a subject's helmet is at that top left intersecting point, making the picture more interesting.

You may not need all of the guides that are available, however. Here's how you can limit the amount you see.

Choose Tools > Crop Guide Overlay > Choose Overlays To Cycle. In the resulting dialog box, you can deselect any of the guides that you do not find necessary. Click OK, and the next time you use the Crop Guide Overlays menu, you will only see the ones that you have selected.

Using the Straighten tool

●**Note:** Whether you use the Straighten tool or rotate the photo manually, Lightroom will automatically trim the angled edges of the rotated photo when you commit the crop by clicking the Crop Overlay tool or double-clicking the image in the Loupe view. Lightroom will find the largest crop possible with the specified aspect ratio. Changing or unlocking the aspect ratio can minimize the amount of the photo that will be trimmed away.

In the Crop Overlay tool's options panel is the Straighten tool. Its icon looks like a level, and you use it to adjust your images if they are askew.

1 Click the tool in the panel and your pointer turns into a crosshair and a level.

2 Move over the picture and drag along something that should be horizontally level or Shift-drag along something that should be vertically straight. In this case, I am using the elevator door. Drag a line that runs along your straight edge, and the picture will level itself along that guide.

Cropping to specific dimensions

Photographers often want to lock their picture's crop to the specific ratio it was shot at (in this example, the aspect ratio of a DSLR sensor, 3:2). There are times,

however, when you may want to change your cropping ratio, perhaps creating a square crop for Instagram, a wider Facebook cover post, or a 16:9 wide shot.

With the Crop Overlay tool active, click to the right of Aspect, and you'll see a menu of commonly used photo sizes, such as 1x1 (square crop), 4x5 (great for making 8x10 images), and 16x9. For this example, choose the 16x9 crop to give the image a little more of a cinematic feel. The crop overlay automatically resizes, and now is constrained by the 16x9 crop.

Seeing your crop better

One last piece of advice: when you are making a crop, make sure that you get rid of the Lightroom interface while you are making judgements on the crop. The best way to do this is to press Shift-Tab on the keyboard. This will hide the panels, Module Picker, and Filmstrip, giving you the most real estate for the picture.

Once the panels are hidden, press the letter L twice. The first press of the L key will switch Lightroom to Lights Dim mode, dimming the interface by 80%. The second time you press the L key turns the lights off entirely (Lights Out mode). This gets rid of all of the distractions around the edges, and lets you focus on only the elements you want in the picture as you move the crop around.

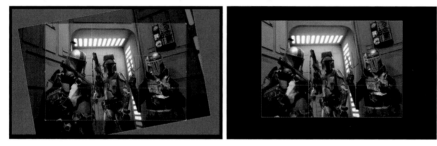

Press Return/Enter to complete your crop, then press the letter L to turn the lights back on, and press Shift-Tab to bring back the panels.

▶ **Tip:** Thanks to non-destructive editing, you can return at any time and adjust your crop—or the angle of the photo—by simply reactivating the Crop Overlay tool. The crop becomes "live"—the trimmed portions of the image become visible once more and you can rotate the photo or resize and reposition the cropping rectangle as you wish.

What are camera profiles?

When shooting in JPEG mode, the camera applies color, contrast, and sharpening to your image files. Switching to shooting in raw, your camera captures all of the raw data at the point of capture, but builds a small JPEG preview as well. This JPEG preview—with all of the color, contrast, and sharpening—is what you see in the LCD on the back of the camera.

When you import this image into Lightroom, Lightroom initially shows you that JPEG preview as a thumbnail. Behind the scenes, it starts to render the raw data

into pixels you can view and work with onscreen (a process known as demosaicing). To do this, Lightroom looks at the image's metadata—white balance and everything buried in your camera's color menu—and interprets it as best it can.

Because Lightroom can't interpret some proprietary camera settings, the preview almost never looks like the JPEG that you saw on the back of your camera. This is why your thumbnails shift in color shortly after (or during) the import process.

This shift frustrated many photographers before Lightroom's developers added camera profiles (presets that attempt to mimic the settings included in a camera's JPEGs). While not 100 percent accurate, they let you get closer to what you saw on the back of your camera. They used to be located in the Camera Calibration panel.

As more photographers started using them, some created profiles for artistic effects. Adobe realized that users wanted to add profiles first—for both color fidelity and artistic expression—and moved them to the top of the Basic panel.

The new profiles in Lightroom

● **Note:** Color lookup tables (LUTs) are tables that remap or transform color in an image. Originally used in the video space to attempt to make footage from different video sources look similar, LUTs gained popularity as Photoshop users began using them to colorize their images as an effect. These effects sometimes are known as cinematic color grading.

The April 2018 release of Lightroom Classic greatly expanded how photographers use camera profiles in their workflow by creating three categories to explore:

- Adobe Raw profiles: These profiles are not camera-dependent and aim to give users of any camera a more unified look and feel for their images.

- Camera Matching profiles: These profiles mimic the profiles built in to your camera, and vary by camera manufacturer.

- Creative profiles: These profiles are built for artistic expression and leverage Lightroom's ability to include 3D LUTs for even more coloring effects.

Now that we know what these tools can do, let's spend some time exploring how to use them to make our work really stand out: Select the first image in the Develop Module Practice collection (when sorted by File Name in the Grid view's Sort menu), and press the D key to make sure you are in the Develop module. To make it easier for you to see the changes we are making, close the left-side panels and the Filmstrip by clicking the gray triangles in the middle of each side.

At the top of the Basic panel (directly below Treatment) is the Profile area. On the left is the Profile pop-up menu, a quick way to access some of the Adobe Raw profiles that mimic your camera settings (these appear only when working on a raw file). You also can add your favorite profiles from the Profile Browser to this menu for easier access.

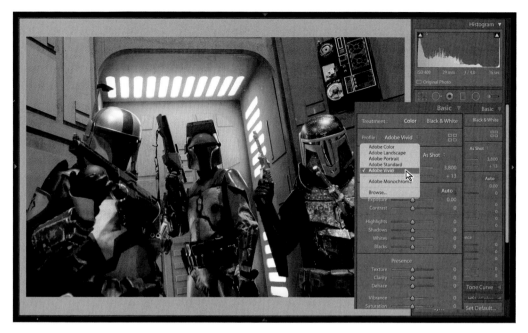

On the right is the Profile Browser icon (it looks like four squares), where you can access a variety of profiles, including the Adobe Raw Profiles. Josh Haftel, principal product manager for Adobe, wrote a blog post explaining the new color profiles:

> "*Adobe Monochrome* has been carefully tuned to be a great starting point for any black and white photograph, resulting in better tonal separation and contrast than photos that started off in Adobe Standard and were converted into black and white.
>
> *Adobe Portrait* is optimized for all skin tones, providing more control and better reproduction of skin tones. With less contrast and saturation applied to skin tones throughout the photo, you get more control and precision for critical portraiture.
>
> *Adobe Landscape*, as the name implies, was designed for landscape photos, with more vibrant skies and foliage tones.
>
> *Adobe Neutral* provides a starting point with a very low amount of contrast, useful for photos where you want the most control or that have very difficult tonal ranges.
>
> *Adobe Vivid* provides a punchy, saturated starting point."

While I believe that Adobe has done a great job with the Adobe Raw profiles, many photographers will want to go directly to the Camera Matching profiles, the profiles that are specific to your camera make and are based on the ones you can choose on your camera. To do this, click the Profile Browser icon.

Using the Profile Browser

The new Profile Browser gives you access to all the profiles Adobe created. We already discussed the Adobe Raw profiles at the top of the Profile Browser. The Camera Matching profiles include any profiles that are specific to your camera make, so the number of profiles available will vary by camera type.

At the bottom of the Profile Browser are the creative profiles, separated by category: Artistic, B&W, Modern, and Vintage. If you expand any of them, you'll see a series of thumbnails showing what each profile will look like on your photo.

I encourage you to experiment with all of the profiles. While the Camera Matching profiles might offer you a one-click solution to get closer to what you saw on the back of your camera, the creative profiles might spark a new interpretation of your image. My other favorite part? The creative profiles have an Amount slider, allowing you to dial in the effect to your liking. Once you choose a profile and an Amount setting, click the Close button at the upper right of the browser to return to the Basic panel.

The profiles that have been created also include black-and-white presets that can really enhance and serve as a great starting point for creating compelling black-and-white images. We'll talk about how to create your own black-and-white images later on in the lesson.

For the purposes of this image, select the Vintage06 preset and click the Close button.

The end result is a grungier look with more compressed midtones.

Setting your picture's white balance

White balance refers to the color of light in a photo. Different kinds of light—fluorescent or tungsten bulbs, overcast skies, and so on—create different color casts in your photo. White balance adjustment is done by adjusting the temperature and tint to bring the color back to what you intended. Click the lesson05_003 file, then click As Shot next to WB near the top of the Basic panel and experiment with the different white balance menu choices.

● **Note:** On raw images, you can use the WB menu to access white balance presets, although it's usually quicker to set it manually using the White Balance Selector. Your camera's white balance is baked into JPEGs, so this menu has far fewer options for them.

If you shoot in a raw format, you have more choices in the menu—the ones you typically find in your camera (they're not available with a JPEG). Choose the one that most closely matches the lighting you shot in. You can also make your own adjustments with the Temp and Tint sliders.

If you don't like the results, in the Basic panel, click the White Balance Selector (it looks like an eyedropper) or press W on your keyboard. Move your cursor over your image, and click an area that *should* be neutral in color, such as a light or medium gray (you can use the Loupe that appears to help you find a neutral color).

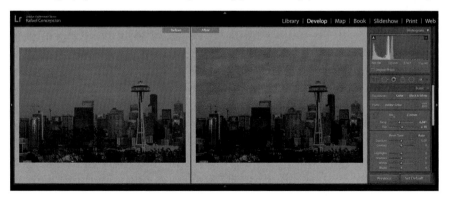

In this example of a picture that I took of the Space Needle in Seattle, I want to get rid of the blue tone that the original picture had. Once I get the white balance closer to what I want, I can go in and adjust the temperature of the picture to get it where I really want it. The White Balance Selector tool doesn't have to be a one-step solution, but it can certainly shave some time off the process.

About white balance

In order to correctly display the full range of color information recorded in an image file, it's critical to balance the distribution of color in the photo—that is, to correct the photo's *white balance*.

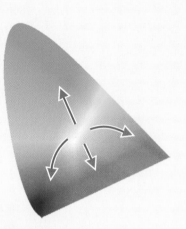

This is achieved by shifting the image's *white point*, the neutral point around which the colors in the image are distributed on the two axes of temperature (blue to red, visualized in the illustration at the right as a curved axis) and tint (green to magenta).

An image's white point reflects the lighting conditions in which the photo was captured. Different types of artificial lighting have different white points; they produce light that is dominated by one color or deficient in another. Weather conditions also have an effect on the white balance.

The higher the red component in the lighting, the warmer the colors in the photo will appear; the higher the blue component, the cooler the image, so movement along this axis defines the photo's color *temperature*, while the term *tint* refers to shifts in the direction of green or magenta.

The sensors in a digital camera record the amount of red, green, and blue light that is reflected from an object. Under pure white lighting, an object that is a color-neutral gray, black, or white reflects all color components of the light source equally.

If the light source is not pure white but has a predominant green component, for example (typical of fluorescent lighting), a higher amount of green will be reflected. Unless the composition of the light source is known—and the *white balance* or *white point* is corrected accordingly—even objects that should appear color-neutral will have a green color cast.

When shooting in auto white balance mode, your camera attempts to estimate the composition of the light source from the color information measured by the sensors. Although modern cameras are doing better at automatically analyzing lighting and setting the white balance to meet conditions, the technology is not infallible; it's preferable—if your camera supports it—to use your camera to measure the white point of the light source before shooting. This is usually done by photographing a white or neutral, light gray object in the same lighting conditions as the intended subject.

Together with the color information collected by the camera sensors, raw images also contain "As Shot" white balance information, a record of the white point determined automatically by the camera at the moment of capture. Lightroom can use this information to correctly interpret the recorded color data for a given light source. The recorded white point information is used as a calibration point in reference to which the colors in the image will be shifted to correct the white balance.

You can use the White Balance Selector tool, located in the upper-left corner of the Basic panel, to correct the white balance in your photo. Click to sample an area in your photo that you know should appear onscreen as a light neutral gray; Lightroom will use the sampled information to determine the point around which the image can be calibrated and set the image's white balance accordingly.

As you move the White Balance Selector tool across the image, you will see a magnified view of the pixels under the eyedropper cursor and RGB values for the central target pixel. To avoid too radical a color shift, try to click a pixel where the red, green, and blue values are as close as possible. Do not use white or a very light color (such as a spectral highlight) as the neutral target; in a very bright pixel, one or more of the color components might already have been clipped.

Color temperature is defined with reference to a concept known as *blackbody radiation* theory. When heated, a blackbody will first start glowing red, then orange, yellow, white, and finally blue-white. A color's temperature is the temperature—in kelvin (K)—to which a blackbody must be heated to emit that particular color. Zero K corresponds to −273.15°C or −459.67°F and an increment of one unit kelvin is equivalent to an increment of one degree Celsius.

What we generally refer to as a warm color (with a higher red component) actually has a lower color temperature (in kelvin) than what we would call a cool color (with a higher blue component). The color temperature of a visually warm scene lit by candlelight is about 1500 K. In bright daylight you would measure around 5500 K and light from an overcast sky results in a color temperature in the photo of about 6000 to 7000 K.

The Temperature slider adjusts the color temperature (in kelvin) of the designated white point, from low at the left side of the range to high on the right side. Moving the Temp slider to the left reduces the color temperature of the white point. In consequence, the colors in the image are interpreted as having a higher color temperature relative to the adjusted white point and are shifted toward blue. The colors displayed in the track of the Temp slider control indicate the effect a change in that direction will have on the image. Moving the slider to the left will increase the blue in the image, moving the slider to the right will make the image look more yellow and red.

The Tint slider works in the same way. For example, to remove a green cast in an image, you would move the Tint slider to the right, away from the green displayed inside the slider control. This increases the green component in the white point so the colors in the image are interpreted as less green relative to the adjusted white point.

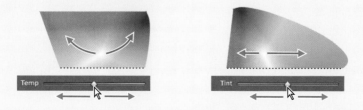

Adjusting the Temp and Tint sliders corresponds to shifting the white point within the color gamut.

Setting exposure and contrast

Exposure is determined by how much light your camera's sensor captures and is measured in f-stops (indicating how much light your camera's lens lets in). In fact, the slider simulates stops on a camera: a setting of +1.00 is like exposing one stop over the metered exposure in-camera. In Lightroom, the Exposure slider affects midtone brightness (in portraits, that's skin tones). Drag to the right to increase brightness, or drag to the left to decrease brightness (you can see this in the slider itself—white is to the right and black is to the left).

1 Keep the lesson05_003 image open, and move the Exposure slider to the right to +1.0. Immediately, the image gets brighter.

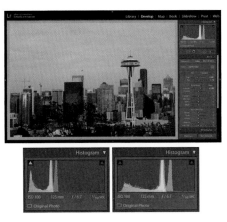

2 If you move your pointer over the middle of the histogram at the top of the right-side panels, the area affected by the Exposure slider is highlighted in light gray and the word *Exposure* appears below the lower-left corner of the histogram.

Before the change, the range of information lived on the left side of the histogram (shown above left). With the exposure adjustment, all of that has moved toward the right (shown above right).

▶ **Tip:** To have Lightroom perform an auto adjustment for a single slider, no matter where it appears in the adjustment panels, Shift-double-click it. This is especially helpful in setting contrast—if, say, you opt to set exposure and contrast manually rather than using the Auto button—because contrast can be tough to get right (you can easily mess up your highlights and shadows).

Contrast adjusts the difference in brightness between the darkest and lightest tones in your picture. When you drag this slider to the right (increasing contrast), you "stretch out" the histogram's data, creating darker blacks and brighter whites. It's like parting (or joining) the middle of the histogram.

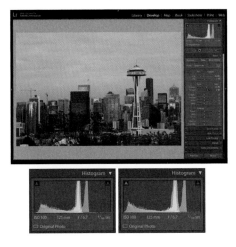

If you drag this slider to the left (decreasing contrast), you scrunch the histogram's data inward, shortening the distance between the darkest (pure black) and lightest (pure white) endpoints, making the photo's tones look flat or muddy.

3 Experiment with adjusting the contrast of the image and see the results. In this image, I moved the Exposure to +1.75 and the Contrast slider to +50, which makes the picture stand out a bit more.

4 Press the Y key for a side-by-side comparison between the before and after of the image. This will give you a great idea of just how far you have taken the file. This is one of the greatest benefits of making images in a raw format.

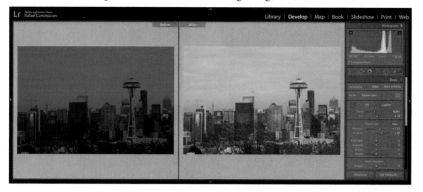

Adjusting shadows and highlights

The Highlights and Shadows sliders let you recover details in areas that may be clipped. Clipping occurs when areas in the picture are too dark or too light. If an area is too dark (sometimes referred to as *blocked*), there is not enough data in the shadows to show detail—it's too black, too muddy, and no good. If there is an area that is clipped in the highlights (sometimes referred to as *blown out*), it is so bright that there is no detail in it. Printing this part of a picture would show areas where no ink would hit the page!

▶ **Tip:** You can turn clipping warnings on and off by pressing J on your keyboard.

As a general rule, you want both your shadows and highlights to have as much detail as possible without affecting the rest of the image. I made this picture in Yosemite National Park by underexposing it to keep from blowing out the highlights, but I still lost some detail in the bottom of the picture. Let's see if Shadows can help us here.

1 Open lesson05_005 in the Develop module and move your pointer over the shadows clipping warning at the upper left of the histogram, which turns the clipped shadows in your image blue. Let's start by adding +1.00 of Exposure (shown in the next step).

2 Drag the Shadows slider to the right to see how much information you get back in the sides of the image—those areas were extremely dark. The shadows (or highlights, in the next step) are no longer clipping when you see the blue (for shadows) or red (for highlights) disappear or the clipping warnings in the histogram turn gray again.

3 In lesson05-006 you'll notice that the snow at the bottom of the picture is so overexposed that all the detail is lost. Drag the slider to −100, and you can see how much information is recovered in the area. Unfortunately, it looks like we hit a limit at −100. If you want to try to bring back more of those highlights, you'd have to consider underexposing the image a little further.

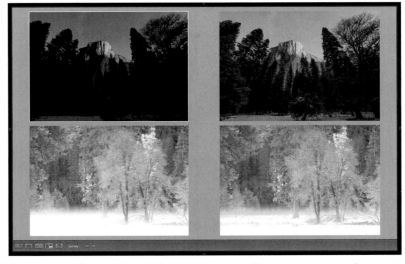

While there are plenty of times when Lightroom will require you to make some elaborate modifications to your images, I cannot stress how many times I've relied on these four sliders to do a lot of my heavy lifting. Most of the time, it's all I need.

You will run into people who believe that the best way to develop pictures is to start with the Whites and Blacks sliders. Let's open up lesson05_08 (a picture I took in Portland, Maine) and go through how to develop your images this way.

Adjusting whites and blacks

If we understand that a histogram is a representation of pixel data across a range of tones in a picture, then it's a good idea for us to establish what those limits are within that range.

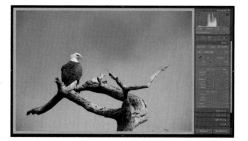

The whites and blacks are the brightest and the darkest parts of the picture. Setting their values sets the "limits" of your tonal range. In many (but not all) pictures, making sure that all of your pixel information is within those white and black limits can yield great photos.

I look at it this way: Imagine seeing a bunch of kids playing in only half of a yard. The key to happiness is to spread the kids all around the yard. The problem with blacks and whites in images is that it can be difficult to see exactly where they are.

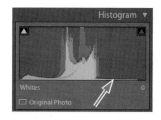

1 Hold down the Option/Alt key and click the Whites slider, and the image turns completely black. As you drag the Whites slider to the right, you'll see some color changes. What you're looking for is the first area that turns white. White tells you that portion of the picture is clipping, so that is the brightest you can make the whites without losing information. If other colors appear before you see white, Lightroom is letting you know that they are predominantly bright in the image.

Looking at the original image, it feels like it has a small amount of yellow in it. This is known as a *color cast*. The yellows that appear when we do this clipping trick suggest there is a bit of bright yellow in the picture, but I am okay with that. You may see other colors as you drag, but what you're looking for is white.

What is a histogram?

When you start looking at your images in Lightroom, you may get into (occasionally heated) discussions about the histograms of your photos. In photography, you may hear that you need to keep the histogram "as a curve" or, worse, hear about the "perfect" histogram (supposedly the one illustrated at the right). It's essential for you to understand what it is that you are looking at when you look at a histogram, but it's even more important for you to understand that this tool is intended to be just that—a tool, not a goal.

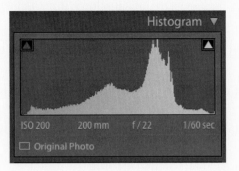

This is extremely oversimplified, but think of a histogram as kind of a chart. On the left side of the histogram are pixels of 0% luminance. On the right are pixels of 100% luminance. The white area is showing you color values from 0 to 255, each of them from darkest to lightest.

Imagine if you only had three luminance values in your picture. Your histogram would (kind of) look like the top chart here (and would probably not be from the camera you want to buy in 2019).

Now, imagine if your histogram only had 12 tones. A sample readout of these 12 luminance values might look like the bottom chart here. It's starting to get a little crowded in that bar chart.

The histogram is just a whole mess of bars in a bar chart. There are so many of those bars that they are literally butting up to one another. But the concept is still the same. Going from left to right are the luminance values (the X axis), and from top to bottom is how bright each luminance value is (the Y axis), from 0 to 255.

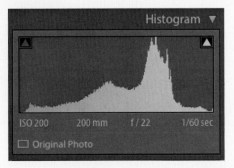

When you see color in a histogram, think of the same bar chart, but with a new bar chart for each color behind that original chart. Each color chart (say, for blue) measures the amount of that color's (blue's) pixels, from super-dark (blue) on the left to super-bright (blue) on the right.

It's the same for yellow, and the same for red. All they are is bar charts, informing you how much data you have in the picture. The more important question is: what were you aiming to get?

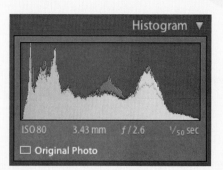

The Histogram Hall of Fame

I used to believe that we were all in search of the perfect bell curve in a histogram until a conversation that I had with famed portrait photographer Gregory Heisler at Syracuse University. Professor Heisler explained that intention would prove to be infinitely more important than what the readout of the histogram said.

In our conversation, he offered a series of pictures that he often uses as a foundation for the "Histogram Hall of Fame." These histograms would often be rejected as problematic, until you realize that the photographer intended them to be this way. They were made like this for a reason.

Because of copyright law, I can't show you what the original images look like, but I'll leave you with a test. Here, we have the histograms of five pictures. Take a look at those pictures online, and compare them with the histograms below (the URLs should take you right to them).

What you should watch out for when using the histogram is whether you are clipping a portion of tone, and how best to remedy that. You'll learn how to do that in this lesson.

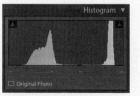

Portrait of Igor Stravinsky, by Arnold Newman
rcweb.co/histogram1

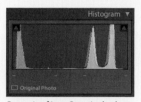

Moonrise, Hernandez, New Mexico, by Ansel Adams
rcweb.co/histogram2

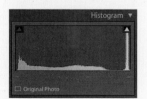

Seascapes, by Hiroshi Sugimoto
rcweb.co/histogram3

American West Portraits, by Richard Avedon
rcweb.co/histogram4

The Tetons and the Snake River, Grand Tetons, by Ansel Adams
rcweb.co/histogram5

▶ Tip: Hold down the Shift key and double-click the Whites or Blacks slider, and Lightroom makes the change automatically.

2 Once you're done with the whites, Option-click/Alt-click the Blacks slider and drag it to the left. This time, the image turns white, and what you're looking for is the first spot of black. This tells you how far you can drag the Blacks slider. If you see other colors, they are predominantly dark.

3 Notice the change in the histogram compared to the original. Once we have the whites and blacks set, we'll apply an Exposure setting of **−0.85**, a Contrast setting of **−8**, and a Shadows setting of **+30**. Then we'll drag the Whites to **+65** and the Blacks to **−31**. These settings add a great amount of brightness to the final image yet retain its detail.

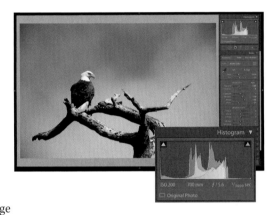

This leads us to a question: does this mean that the "Whites and Blacks first" method is preferable to working with Exposure and Contrast? Not necessarily. You could have achieved a similar result by starting with Exposure and Contrast, and adjusting Shadows and Highlights to your liking. In learning how to develop pictures, it's important that you understand how the technology works, but that you allow yourself the opportunity to find your own way of getting to the solution you find the best.

Clarity, vibrance, and saturation

Once you've dialed in your picture's tonality, you can move on to making some of the final Basic panel adjustments to the shot. Clarity, vibrance, and saturation round out the basic editing of a picture. To do this, let's work on a picture I made in the city of Guanajuato, Mexico.

1 To start, open the lesson05_009 image and make some basic adjustments to it. On this image, set the Contrast to **+17**, the Highlights to **−100**, the Whites to **+41**, and the Blacks to **−9**.

Setting the picture's contrast affects the shadows and highlights, and the whites and blacks. The one part that doesn't get a lot of attention is the midtones, and sometimes, adding a little punch in the midtones is very helpful.

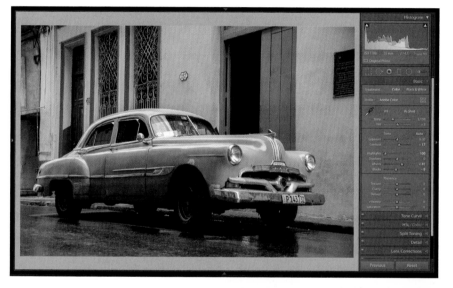

2 Set the Clarity slider to **+41**.

The Clarity slider controls midtone contrast. It's great for adding a bit of a gritty element to your pictures—things like metals, textures, brick walls, and hair all can do with a little bit of a clarity boost.

Keep in mind, though, when you're using the Clarity slider, that out-of-focus areas in a picture generally don't look good with clarity applied to them. It also doesn't do well with softer elements in a picture, so use it sparingly, or use the effect attached to an adjustment brush. We'll cover that in the next lesson.

New in Lightroom Classic: The Texture slider

In May 2019, the Lightroom team released a new feature that I find myself using more and more: the Texture slider.

Originally developed as a function to help portrait retouching for skin smoothing, the Texture slider can be considered a subtler way to add details—or frequency—to an image in a specific area.

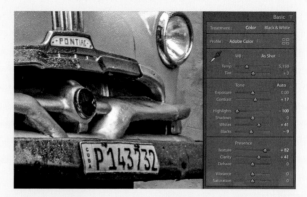

Think of it this way: Images are composed of high, medium, and low frequencies. When you add adjustments like sharpening to a picture, you are invariably affecting the edges of things in that picture. These are the high frequency areas of a picture. Adjust it too much, and you'll see those enhancements creep into midtone and shadow areas of an image.

The Texture slider allows you to add this detail into the medium frequencies of the picture, but does not affect the lower frequencies.

While clarity does a good job of enhancing the midtone contrast, it tends to affect more regions of the picture. Texture looks a little like clarity when added to an image, but you'll notice that you get all of the beneift of the details, but none of the negative effects of excessive clarity.

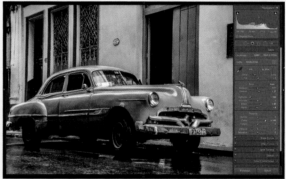

The image to the right has had clarity applied to the extreme. Notice the change in the wall behind the car and the dark halo along the top of the car.

The picture at the bottom has texture applied to the extreme. The wall does not seem to be affected as much, but a lot more detail has been added to the picture.

In the end, I find myself using more a combination of both Clarity and Texture to get the amount of detail I want in my images, and I would encourage you to experiment with it to see how much detail you can get into your pictures.

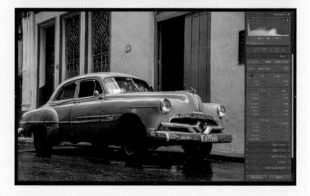

While adding detail in the frequencies is something that you may find yourself doing, you'll also find that many use these techniques to separate the frequencies and smooth out the higher frequencies. In Photoshop retouching, it's a technique called *frequency separation*.

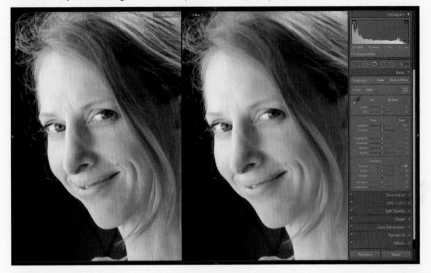

In frequency separation, you separate the high (detail) frequencies from low (color and tone) frequencies so that you can soften up some of the blemish details and still keep some skin texture. Previously, this was something that required you to create separate layers in Photoshop for manipulation. Now, you can get the same effect in Lightroom Classic with one slider.

The picture above is of my wife, Jenn. Now, I have to say she is beautiful and does not need to have this effect applied to her, as I believe she is perfect, but she gamely allowed me to use this photo to educate. On the left, you have the original image; on the right, you have a negative Texture setting applied. Notice that her skin seems softer, but still has a good amount of color and texture. You can take this effect even further by applying it locally with the Adjustment Brush tool. We'll cover the use of the Adjustment Brush in the next lesson.

The Texture slider is the brainchild of Max Wendt lead engineer of the Texture project at Adobe, and he has a wonderful blog post on the Adobe Blog site that goes into even more detail on how you can really unlock its potential. Be sure to check out his blog post at https://rcweb.co/lrtexture.

The Saturation and Vibrance sliders both deal with the application of color to a picture, but they work a little differently.

3 Experiment by dragging the Saturation slider far to the right. This intensifies all of the colors in your image evenly, as shown in the illustration to the right.

Saturation doesn't take into account whether a color is overrepresented already. It's an easy way to make a picture look too colorful and unrealistic in Lightroom.

Vibrance should really be called "smart Saturation." Drag the Vibrance slider to the right, and any underrepresented colors are intensified more. Any colors that are overrepresented are not adjusted as much. If there are any skin tones in the picture, Vibrance tries not to affect them at all.

4 Let's darken the image a little: set the Exposure to **−0.35**, the Shadows to **+52**, and the Whites to **+45**, and leave the Contrast at +17, the Highlights at −100, and the Blacks at −9. Then set the Texture to **+40** and the Clarity to **+27**, bring the Saturation back down to **0**, and drag the Vibrance slider to **+31**.

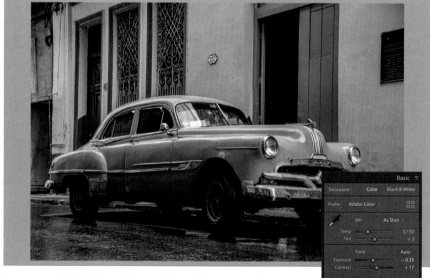

As a general rule, I usually start by making any color adjustments I need as Vibrance adjustments, and then move on to Saturation only if necessary.

Now that we have color and tone taken care of, we need to finish the picture by adding a little detail to it.

Adding detail to your images

When you shoot in JPEG mode, the camera adds color, contrast, and sharpening to the final image. Photographers are quick to make the tonal adjustments we just discussed, but many skip sharpening their images. By default, Lightroom adds a small amount of detail to raw files, but it is never really enough for input sharpening.

In the Detail panel, there is a Sharpening area with four sliders: Amount, Radius, Detail, and Masking. Above those sliders is a 100% preview of the picture (click the little triangle at the upper right of the panel to show/hide it). This preview doesn't give you a good idea how much sharpening is being applied.

1 Click the larger image in the center preview area once to zoom in to 100%. Drag around the picture to find an area where you can better see the sharpening you're applying, so you can make better sharpening decisions.

2 The Amount slider is pretty straightforward: it dictates how much sharpening you want to apply to the picture. Let's drag it to 102. Hold down the Option/Alt key as you drag to see a black-and-white preview, which may help you see the sharpening better.

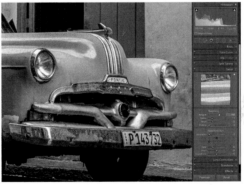

The Radius slider lets you change how far from the center of the pixel you want to apply that sharpening. It's hard to see this by just dragging the Radius slider, so here's a trick.

3 Hold down the Option/Alt key as you drag the slider. Drag it to the left, and your image turns gray; drag it to the right, and you start seeing more edge information. The visible edge information is the area that is sharpened. Anything that's gray won't be sharpened. Let's drag it to 2.6 here.

Once you have the Radius set, move on to the Detail slider. The Detail slider brings out more texture or detail in a picture as you drag it to the right. However, if you move it too far, or all the way to the right, it will start introducing a little bit of noise. You'll want to watch out for that.

4 Drag the detail slider to +13.

If you want to limit how that sharpening is applied, use the Masking slider. It creates a black-and-white mask, where the black areas won't be sharpened and the white areas will be sharpened, confining your sharpening to only the edges.

5 Hold down the Option/Alt key and drag the Masking slider to the right to determine where you want that sharpening to occur. As soon as you release the Option/Alt key, you'll see a much sharper picture without the noise you might get from sharpening everything evenly. Let's move the masking to +50, as shown in the illustration at right.

To see a before/after of your sharpening, click the power switch at the far left of the Detail panel's header to turn the sharpening off. Click it again to turn the sharpening back on, and now you can see whether you've added enough.

Once you're done with sharpening, go ahead and tackle noise. Noise in a picture appears for one of two reasons: you used a camera with a really high ISO setting (you shot in low light) or you added a lot of sharpening to your photo. In this example, we're using a picture taken at 1,100 ISO, so it's a little high.

The Noise Reduction area has two different types of noise you can affect. The first of these is luminance noise, which is that grainy look. Drag the Luminance slider to the right, and the noise starts disappearing. You'll use this slider for 90% of the noise you want to remove.

If you feel you have lost too much detail after dragging the Luminance slider, grab the Detail slider below it and drag it to the right. If you want to add contrast back after these adjustments, drag that slider to the right a bit. Increasing the Detail and the Contrast reduces some of the effect of the luminance noise reduction because they tend to counterbalance each other, so be careful.

6 Set the Luminance Noise Reduction slider to **15**, the Detail slider to **50**, and the Contrast slider to **0**. Click the Detail panel's power switch to turn your adjustments off and back on to see your results.

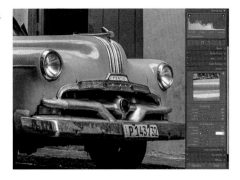

Color, Detail, and Smoothness are used when you see noise that comes in different colors: red, green, or blue dots (this problem is prevalent with some cameras and tends to appear in shadows). To get rid of that kind of noise, drag the Color slider to the right until those dots are desaturated, then add a bit of detail back in and balance it with a little smoothness.

Noise reduction brings back some smoothness to a file with a high ISO, but it's also something you have to do if you excessively sharpen a picture. The more you sharpen a picture, the more noise gets introduced, especially if you use the Detail slider. So every time you go into the Detail panel's sharpening section and create a lot of sharpening, add a little bit of noise reduction to counterbalance the effect.

Lens corrections and transformations

All lenses exhibit some trademark problem: distortion, dark edges (vignetting), or the appearance of chromatic abberations (colored pixels that appear along the edges of objects). To correct these problems, we have the Lens Corrections and Transform panels. Select lesson05-004 and apply the following corrections in the Basic panel: set the Temperature to **6203**, the Exposure to **+1.60**, the Contrast to **+42**, the Highlights to **−51**, the Shadows to **+93**, and the Vibrance to **+26**.

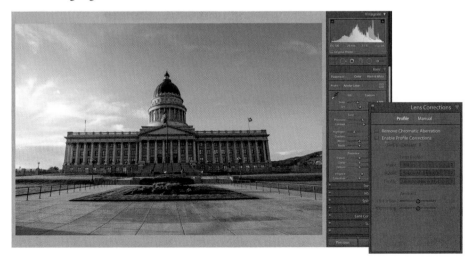

1 Expand the Lens Corrections panel. In the panel's Profile tab, select Enable Profile Corrections and Lightroom reads the image's embedded EXIF data to determine what make and model of lens you used. It then chooses a built-in profile and automatically adjusts the picture, often yielding a better-looking file. If it can't find your lens, choose the closest one from the Make and Model menus.

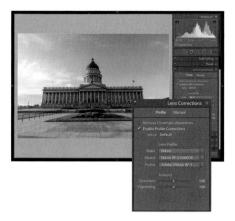

There are times, however, when the problem with your image has little to do with your lens and more to do with your position when you made the picture. In this photo, the building is tall enough that I have a low perspective, so the building looks like it is leaning back. This is where the Transform panel can help. The building is also a little crooked, as you can see from the grid that appears when you move your pointer over the Transform sliders in the Transform panel.

The buttons in the Upright area of the Transform panel tilt and skew your image in an attempt to fix it. You have the following four options to choose from.

- Auto: Balances level, vertical, and horizontal perspective corrections, and keeps the aspect ratio as much as possible.

- Level: Perspective corrections are weighted toward horizontal details.

- Vertical: Perspective corrections are weighted toward vertical details and level corrections.

- Full: Combination of full Level, Vertical, and Auto perspective corrections.

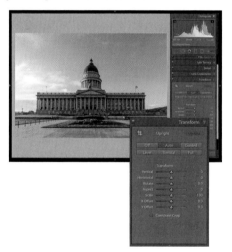

2 Click each of the transformation options to see if any of the results help what you are trying to do.

If none of the options fully solves your problem, try the Guided option to really move things along. Guided transformation allows you to draw up to four lines on the picture, tracing the edges of areas that should be straight. As you draw the lines, the image adjusts itself to what it believes is a straight picture.

Input, creative, and output sharpening

When you import a raw photo, Lightroom automatically applies a little sharpening to your photo so you can see the details it contains. This sharpening is attempting to mimic the sharpening that your camera would normally apply to an image if it were shot as a JPEG, and is commonly referred to as *input sharpening*. In my opinion, this level of sharpening is never enough as input sharpening, which means that you have to take it into your own hands at the start of the import process. What we cover in this book would be considered input sharpening, and is only a start.

As you work on your image, you may decide that you want to sharpen more in some areas and not as much in others. In the picture above, I would probably want to apply a little more sharpening on the car in the foreground of this picture to add emphasis. I would not apply as much sharpening to the buildings and street. I'd probably want to apply some noise reduction to the doorways and street, though.

This additional sharpening is commonly known as *creative sharpening*—sharpening you perform to highlight a specific thing in a picture.

When you're completely finished adjusting the photo, you can add more sharpening according to how you'll output it, which is cleverly referred to as *output sharpening*. For example, a photo that's destined to become a canvas gallery wrap needs more sharpening than one you'll print on glossy or metallic stock, or one that you will use online only.

How much to sharpen these images, when to sharpen them, and what process to use in doing so in Photoshop could be the subject of an entirely new book. I believe Jeff Schewe is one of the masters in this space, and his *The Digital Print* (from Peachpit Press) is a book that will take you through this entire process, from start to finish.

3 Click the Guided Upright tool and draw one horizontal line along the base of the building and two vertical lines along the columns on either side of the building, following the edges outlined by the arrows on the illustration at right.

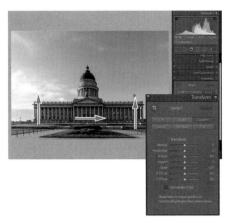

Once the transformation is complete, use the Transform sliders to make any final tweaks. If the image ends up with a lot of white background in the bottom corners that need to be cropped, you can use the Crop Overlay tool (R). You can also select the Constrain Crop option to have Lightroom automatically remove the white areas. Click the Done button. The final image is smaller than the original one, but it certainly is straighter.

4 Add some finishing adjustments using the Basic panel as you like, and the transformation is quite noticeable.

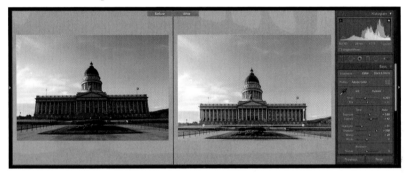

Using virtual copies for variations

Lightroom does a great job of keeping your library organized by keeping the number of duplicate images down to zero. One image can be referenced in multiple collections, and making a change in the file in one collection automatically cascades that change to the file in all other collections.

What if you want a copy of the file to try out a different look without changing the original? This is where another powerful feature comes in handy: the virtual copy.

1 Press the letter G to go to the Grid view, and select the lesson05_009 image again.

2 Click the plus sign (+) button at the right of the Collections panel's header and make a new collection called **Virtual Copies**. Make sure you include the selected photo.

3 Right-click the image and select Create Virtual Copy from the menu.

4 Make an additional virtual copy so you have a total of three files in your collection.

● **Note:** You can create virtual copies by pressing Command + ' (apostrophe)/Ctrl+' on the keyboard.

These new files are virtual copies of the original image. You can make changes to each of the copies in the Develop module and they will be treated as separate images with separate changes.

While they look like separate images—full copies not tied to the original image—they actually refer to the same physical copy of the image. That's the virtual part.

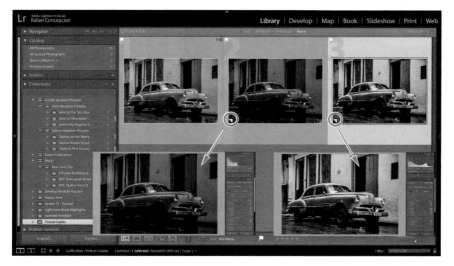

You can create multiple virtual copies of a photo to try out different edits without taking up much additional space on your hard drive. You can make better judgements about which edits you prefer by having these virtual copies side by side.

5 Highlight all three images and press the letter N on your keyboard to enter Survey mode to compare your changes. When finished, press the G key to get back to Grid view.

Using snapshots for variations

To save different edits to a photo without making separate copies of the image for comparison, snapshots are a great option.

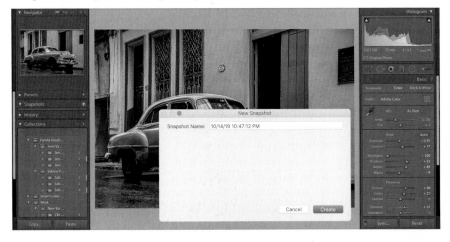

Edit the image to a point you want to save, and then click the plus sign (+) button at the right of the Snapshots panel's header. A dialog box will appear with the date and time that you are creating the snapshot in the Snapshot Name text box. You can either keep that date and time or rename the snapshot (maybe to a brief description of the photo at that stage) and click Create.

Continue editing your picture and when you are ready to save another change, click the plus sign (+) button again to save a new snapshot. This is a great way to save variations and keep tabs on your progress, although I prefer the side-by-side nature of working with virtual copies.

Review questions

1 What does the Navigator panel do?

2 What is the meaning of the term *white balance*?

3 How can you straighten a crooked photo?

4 How do you get Lightroom to perform an automatic adjustment for a setting in the Basic panel?

5 How do you get Lightroom to perform an automatic lens correction?

Review answers

1 The Navigator panel helps you find your way around a zoomed image, lets you preview Develop module presets before applying them, and lets you view past stages in an image's developing history.

2 An image's white balance reflects the light source when the picture was taken. Different types of artificial lighting and weather conditions can produce light that is dominated by one color or deficient in another, resulting in images with a color cast.

3 You can straighten a tilted image by dragging to rotate the cropping rectangle or using the Straighten tool, which lets you mark a horizontal or vertical element in a tilted photo as a reference around which Lightroom then straightens the image.

4 Shift-double-clicking any slider in the Basic panel will cause Lightroom to automatically adjust that setting.

5 In the Profile tab of the Lens Corrections panel, select the Enable Profile Corrections option. If Lightroom cannot locate your lens make and model, select the closest match using the Lens Profile menus.

PHOTOGRAPHY SHOWCASE
SARA LANDO

My personal work explores identity, the boundaries between what is real and what is imagined, and the way memory deteriorates and is reshaped over time. I am interested in the moments when the traditional relationship between us and the world around us is unraveled and replaced by a new definition of what we are or what we could be.

I work using photography, illustration, collage, and digital manipulation. The techniques I use derive from a playful curiosity and direct interaction with the object. I am fascinated by the fragmentation and degradation of the image, and the concept of creation as a consequence of the physical and digital destruction of a photograph.

To me, photography is a medium, not dissimilar from writing, that allows me to be honest without needing to be univocal. Photography is a language. To most of us, it's a foreign language we are learning how to speak, but even if you are fluent in shutter speed and aperture, even if you know everything about bouncing flash and own the best camera on the market, the thing is if you don't have something to say, then you're pretty screwed.

I have been taking pictures for the last 20 years and I think the single most important advice I could give is that, at some point, you'll have to invest some time in finding your voice, in making sure you're not actually wasting time narrating someone else's story.

I've been using Photoshop since you could only go back a few steps in the history. At first it was a crutch to help me fix my mistakes, but over the years it became a tool that helped me to add subtlety.

www.saralando.com
instagram.com/holeinthefabric

6 ADVANCED EDITING

Lesson overview

The Develop module offers a series of sliders that can quicky change your images, bringing out their best. But not all problems can be solved with global sliders. Some images have localized problems that need correcting. Often, the difference between a good print and a great print lies in you paying attention to those little details. This lesson builds upon what you've learned in the Develop module and pushes your toolbox even further. In this lesson, you'll learn how to:

- Use Graduated and Radial Filters to adjust specific image areas.
- Use Spot Retouching tools to fix sensor spots and problem areas.
- Use the HSL and Tone Curve panels with precision.
- Create compelling black-and-white images.
- Experiment with Range Mask tools for adjusting light and color.
- Develop panoramic and HDR images with ease.
- Synchronize your changes to multiple images using presets.

 This lesson will take about 2 to 2-1/2 hours to complete. To get the lesson files used in this chapter, download them from the web page for this book at www.adobepress.com/LRClassicCIB2020. For more information, see "Accessing the lesson files and Web Edition" in the Getting Started section at the beginning of this book.

Fine-tune and polish your photographs with precise, easy-to-use tools, and then take your developing a step beyond just correcting your images; use the Develop module tools and controls creatively to customize your own special effects, and then save them as custom develop presets.

Getting started

Note: This lesson assumes that you already have a basic working familiarity with the Lightroom Classic workspace. If you need more background information, refer to Lightroom Classic Help, or review the previous lessons.

Before you begin, make sure you've set up the LRClassicCIB folder for your lesson files and downloaded the lesson06 folder from your Account page at peachpit.com to the LRClassicCIB\Lessons folder, as described in "Accessing the lesson files and Web Edition" in the "Getting Started" section at the start of this book. Also, be sure you have created the LRClassicCIB Catalog file to manage the lesson files, as detailed in "Creating a catalog file for working with this book," also in the "Getting Started" section.

1 Start Lightroom Classic.

2 In the Select Catalog dialog, make sure that LRClassicCIB Catalog.lrcat is selected, and then click Open.

Tip: If you can't see the Module Picker, choose Window > Panels > Show Module Picker, or press the F5 key. If you're working on macOS, you may need to press the fn key together with the F5 key, or change the function key behavior in the system preferences.

3 Lightroom Classic will open in the screen mode and workspace module that were active when you last quit. If necessary, switch to the Library module by clicking Library in the Module Picker at the top of the workspace.

Importing images into the library

The first step is to import the images for this lesson into the Lightroom library.

1 In the Library module, click the Import button below the left panel group.

2 If the Import dialog box appears in compact mode, click the Show More Options button at the lower left of the dialog box to see all the options in the expanded Import dialog box.

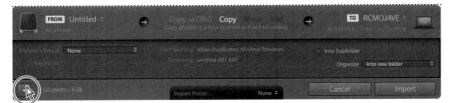

3 Under Source at the left of the expanded Import dialog box, locate and select your LRClassicCIB\Lessons\lesson06 folder. Ensure that all 31 photos in the lesson06 folder are selected for import.

4 In the import options above the thumbnail previews, select Add so that the imported photos will be added to your catalog without being moved or copied. Under File Handling at the right of the expanded Import dialog box, choose Minimal from the Build Previews menu and leave the Don't Import Suspected Duplicates option unselected. Under Apply During Import, choose None from both the Develop Settings menu and the Metadata menu and type **Lesson 06** in the Keywords text box. Make sure that your import is set up as shown in the illustration below, and then click Import.

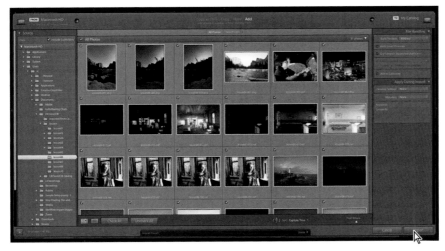

> **Tip:** The first time you enter any of the Lightroom Classic modules, you'll see tips that will help you get started by identifying the components of the workspace and stepping you through the workflow. Dismiss the tips by clicking the Close button. To reactivate the tips for any module, choose [*Module name*] Tips from the Help menu.

The 31 photos are imported from the lesson06 folder and now appear in both the Grid view of the Library module and in the Filmstrip across the bottom of the Lightroom workspace.

Creating a collection for your images

While we're in the Library module, let's create two collections for this lesson.

1 Make sure Previous Import is selected in the Catalog panel, then press Command+A/Ctrl+A to select all of the images. Click the plus sign (+) button at the upper right of the Collections panel and make a collection called Selective Edits, making sure the Include Selected Photos option is selected.

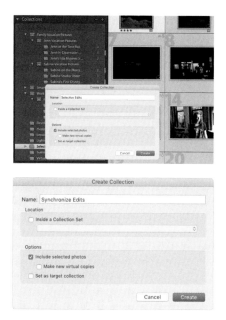

2 Press Command+D/Ctrl+D to deselect all the images. Command-click/Ctrl-click lesson06-028 through lesson06-031, and create a new collection called Synchronize Edits, again making sure Include Selected Photos is selected.

Using the Graduated Filter tool

The Graduated Filter tool lets you apply adjustments to part of a picture in a linear direction. The effect uses sliders that are similar to the ones in the Basic panel, but that let you fade out the effect in the direction you drag. In this exercise, you'll apply two Graduated Filter tool adjustments to a single photo.

1 Click the Selective Edits collection in the Collections panel and select the lesson06-001 picture, an image from Yosemite National Park, then press the D key to switch to the Develop module. The sky is really bright in this image. We want to darken that sky a bit, slowly fading the darkening as it reaches the horizon. This will draw the viewer's attention toward the horizon. At the same time, the bottom part of the picture seems a little too dark. Ideally, I'd want to lighten the foreground a little in the bottom of the picture, without lightening the top part of the picture.

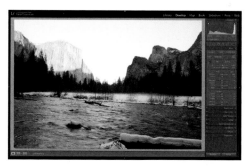

We're going to add two different gradients to the picture—one to darken and one to lighten and remove the color cast from the shadows—then remove some of the spillover in the effect by erasing the gradient with a brush, a newer feature offered in Lightroom Classic.

2 Select the Graduated Filter tool in the tool strip above the Basic panel (it's the fourth tool from the left), or press M on your keyboard. The Graduated Filter options panel appears below the tool strip.

The sliders for all the local adjustment tools are sticky, so it's important to remember to reset them. To reset an individual slider to its default value, double-click the slider label or the slider itself. To reset all the sliders to 0, double-click the Effect label at the upper left of the panel or hold down the Option/Alt key, and when the Effect label changes to Reset, click it.

3 Reset all the sliders in the Graduated Filter options panel, then drag the Exposure slider to the left to about –1.63 and the Whites slider to the right to 19. Setting one or more sliders before you use the tool loads it with those settings so they're applied as soon as you drag on the photo.

4 To apply the filter, Shift-drag from the middle of the photo down to slightly past the edge of the water, so the adjustment covers the sky, mountains, and trees (holding down the Shift key keeps the filter straight).

Lightroom adds a mask in a linear gradient over the area where you dragged. This gradient mask controls where the adjustment is visible. Drag the pin in the middle of the gradient to reposition the filter. When the pin is selected, it's black and you can

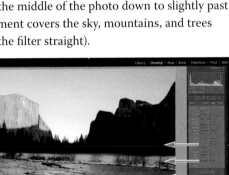

adjust the filter's sliders; when it's unselected, it's light gray and adjusting the sliders no longer affects that filter. To delete a filter, click its pin and press the Delete/Backspace key.

The filter's three white lines represent the strength of the adjustment from the direction you dragged: 100%, fading to 50%, and then down to 0%. You can contract or expand the filter's gradient by dragging the top or bottom lines toward or away from the center line. To rotate the filter, move your cursor near the center line, and when it turns into a curved arrow, drag it clockwise or counterclockwise.

In this instance, we were able to add a little darkening to the sky, but it looks like we also darkened the mountains on the right and the trees. We will deal with those a little later.

▶ **Tip:** Press O on your keyboard to turn on the gradient mask overlay in light red. Press the same key to turn it back off (alternatively, select Show Selected Mask Overlay at the left side of the toolbar, below the photo). To change the mask color, press Shift+O on your keyboard (this is helpful when the mask color also appears in your photo).

▶ **Tip:** Lightroom automatically hides the pins when you move your mouse away from the preview area. To change this, use the Show Edit Pins menu in the toolbar below the photo. (If you don't see the toolbar below your photo, press T on your keyboard.)

▶ **Tip:** You can create overlapping graduated filters too!

5 To add another graduated filter, click New at the upper right of the panel, and then drag another filter from just above the bottom of the trees up to the top of the shortest trees. This deselects the first pin, which changes to light gray.

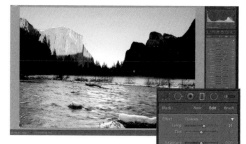

6 Double-click Effect to reset all the sliders, and then drag the Temp slider to the right, to about 21, to remove the blue color cast from the shadows. Then, drag the Contrast to 52, the Shadows to 59, and the Whites to 33 to lighten the foreground a little.

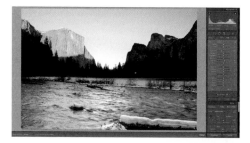

7 Click the panel switch at the bottom left of the Graduated Filter panel to turn both filters off, and then click it again to turn both filters back on to see the change so far.

8 We want to make sure that the darkening of the sky goes to the bottom of the tree line, so let's click the first pin and readjust that gradient so the top line sits at the base of the trees in the picture. This ensures that all of the sky is darkened.

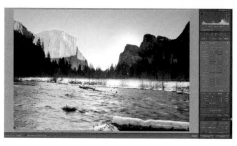

9 To remove the darkening from the trees and the mountains in shadow, we'll erase part of the gradient mask. Click Brush at the upper right of the panel, and at the top of the Brush options that appear at the bottom of the panel, click Erase. Use the Right Bracket key to make your brush larger (]) or the Left Bracket key to make it smaller ([). Paint over the trees and dark mountains.

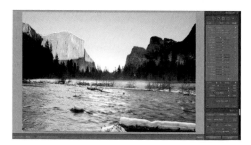

10 Don't worry if you brush too much, as in the previous step. Click A (to the left of Erase) to switch to your A brush. Make the brush smaller, be sure

Feather, Density, and Flow are all set to 100, and select Auto Mask below the brush sliders to have Lightroom determine where the edges of the trees are. Paint over the areas you didn't mean to erase, keeping the crosshair (in the center of the brush) off the trees and shadowed mountain areas.

The Graduated Filter tool can help accentuate portions of your picture and make them stand out. Here are a few more things that are helpful to know about using this tool (these tips work with the Radial Filter and Adjustment Brush too):

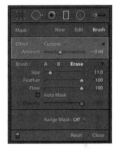

- You can use a brush to erase portions of a filter. If the filter bleeds onto an area where you don't want it, click the filter's pin to select it. Click Brush at the upper right of the filter's panel. Click Erase in the Brush section at the bottom of the panel to switch to Erase mode. Paint over any areas where you want to remove the filter (notice the minus sign [–] inside your brush cursor).

- You can lower the strength of all the settings of a single filter at once by selecting its pin and clicking the black triangle at the upper right of the tool panel (just above the sliders and to the right of the Effect label) to collapse the panel and reveal an Amount slider. Drag it to the left to reduce the opacity of *all* the settings you applied with that filter.

- You can save tool settings as a preset. To do that, click the Effect menu near the top of the tool's panel (shown at right) and choose Save Current Settings as New Preset. In the resulting dialog box, enter a meaningful name and click Create. From this point on, your preset will be available in the Effect menu. This is useful if you're making several adjustments with a single filter.

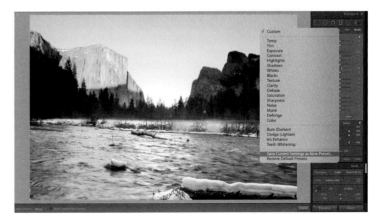

There are plenty of other problems with this picture, but we'll cover them a little later. Instead, let's talk about how to use the Radial Filter tool, which can be found next to the Graduated Filter tool in the tool strip and works in a similar manner.

Using the Radial Filter tool

You can use the Radial Filter tool to apply the same adjustments as the Graduated Filter tool, but in a circular pattern instead of a linear gradient. The Radial Filter tool is handy for spotlighting a specific area of your photo by brightening, darkening, blurring, or shifting the color of a background, or for creating an edge vignette that you can move around (say, to draw attention to a subject that is off-center).

In this exercise, you'll learn how to add a radial filter that draws your attention to a non-circular area. This area will be off-center (common in photography).

▶ **Tip:** To get the Las Vegas strip picture to look a little better, change the Temperature of the picture to 3250 and the Tint to 22.

1 In your Selective Edits collection, click the lesson06-002 image in the Filmstrip, a photo of the Las Vegas skyline. A post-crop vignette may seem needed here, darkening the edges of the image. If we want the center of the attention to be the strip, however, the darkening needs to happen off-center, only on the road.

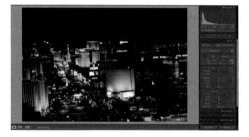

2 Click the Radial Filter tool in the tool strip above the Basic panel (it's the fifth tool from the left) or press Shift+M on your keyboard.
The Radial Filter options panel appears beneath the tool strip.

▶ **Tip:** Using the Tab key will let you move down the specific fields in the options panel and manually enter a number. If you'd like to move up in those fields, press Shift+Tab.

3 Double-click the Effect label at the upper left of the panel to reset all sliders to 0.

4 Near the bottom of the tool options, set the Feather to around 41. This ensures a gradual, soft transition at the outside edge of your radial filter.

5 Click the field to the right of the Exposure slider to highlight it, and enter **−0.91**.

6 Position your cursor near the left end of the strip and then drag diagonally downward and to the right (the filter is created from the center out).

The adjustments you made immediately darken the area around the oval. While this is a good start, we want to angle this oval to better redirect the light.

7 Reposition and resize the filter to your liking using the following techniques:

- Reposition the filter by dragging its pin to a different area.

- Resize the filter by moving your cursor over one of the square anchor points on the filter's outline. When your cursor changes to a double-headed arrow, drag toward or away from the center of the filter to resize it. Do this to adjacent anchor points to reshape it.

- Rotate the filter by moving your cursor outside the filter's outline. When your cursor changes to a curved arrow, drag to rotate the filter.

8 Click the panel switch at the lower left of the Radial Filter panel to turn it off; click the switch again to turn it back on.

It's important to note that you can add multiple Radial Filter adjustments to one photo. To do that, after you finish adjusting your first radial filter, click New at the upper right of the filter's panel, and then double-click the Effect label to reset all the sliders to 0. Adjust the sliders for the next filter (you can tweak them later), and then drag over your photo to apply it.

I want to add a little more attention to the MGM Grand hotel on the right side of the picture.

1 Click the New button at the upper right of the Radial Filter tool's options panel, and drag a new radial filter over the MGM Grand on the right side of the picture. The effect immediately darkens the previous radial effect you made because these filters are cumulative—they don't pay attention to your previous filters and skip them.

2 Set the Exposure to 1.22 and your Contrast to 51, then select Invert near the bottom of the

tool panel. This reverses the effect, highlighting the hotel area. Click Done to get back to the Basic panel.

3 Looking at the picture as a whole, I want to make some additional changes in the Basic panel. You can adjust the picture as you wish, but here are the settings that I used:

- Exposure: +0.25

- Highlights: −19

- Whites: +28

- Crop Rotation: 2.06 for a 16x9 Crop

While the Gradient and Radial Filters offer detailed control, the Adjustment Brush gives you the most control. Let's explore that now.

Using the Adjustment Brush tool

While the Graduated Filter and Radial Filter allow you to make specific adjustments to an image, they do not have the fine control that is sometimes needed. Ideally, you would pinpoint every adjustment in the Basic and Detail panels to the specific areas that need them. This is where the Adjustment Brush comes in.

The Adjustment Brush is perfect for making precise changes to specific areas, such as lightening and darkening (dodging and burning), blurring, sharpening, reducing noise, boosting color, and so on. In this section, you'll learn how to use it to do some photo finishing.

1 Select the lesson06_003 image, a picture of my good friend Daniel doing his best *Breaking Bad* impression for me out in Las Vegas. The two flashes on the right and left of the picture make it a little too bright. I want to control more of that light spill in very specific areas.

2 Select the Adjustment Brush tool (K), and double-click the Effect label to reset all of the sliders. Type in **−0.95** for Exposure and **−100** for Highlights. Using a brush size of 16, with Feather and Flow set to 100, paint along the top left portion of the picture.

A pin is dropped on the picture, letting you know that an adjustment has been painted. If you move your pointer over the pin, an overlay appears, showing you where you applied the effect. Press Shift+O while your pointer is over the pin to cycle through the overlay colors.

● **Note:** You can change the size of the Brush by using the [and] keys on your keyboard.

3 Continue to use the brush along the top and right side of the picture. We started using the brush to darken, but it provides an added benefit by increasing texture on the interior metal. Paint into the hands a little bit (circled in the illustration at right). Your settings for the brush will affect how much it paints onto his hands.

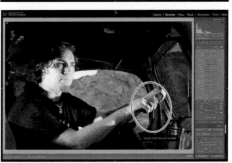

- The Size of the brush is indicated by the smaller solid circle in the center.

- The Feather of the brush creates a soft-edged transition between the area you're working on and the surrounding pixels. The distance between the inner and outer circle represents the feather amount.

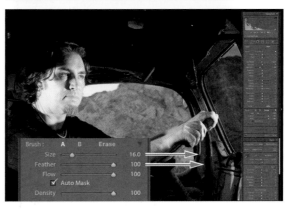

- Flow controls the rate at which the effect is painted.

- Density controls the transparency of the effect.

- Auto Mask confines the brush stroke you made to areas of similar color.

Holding down the Option/Alt key allows you to temporarily access the Erase tool. With it selected (keep holding down the Option/Alt key), make the brush smaller, and erase the effect from his hands.

4 Click New at the upper right of the options panel to add another adjustment, this one for the side of his face and hands (shown in the overlay here). Set the Exposure to −0.24 and Highlights to −36 to bring back some detail in the neck area and hands.

We'll add a couple more finishing touches to this image later. Before we do, we need to learn another key finishing move: the Spot Removal tool.

Hardware suggestion: Digital tablets

I've always found that using brush-based tools with a mouse makes it a little harder than it needs to be. To that end, I've always invested in a digital tablet.

Having a surface and a tool that let you mimic the actions of a pen or pencil on paper is more efficient when doing detail work, like painting your adjustments.

The Wacom tablet on my desk has been with me for years— inside my bookbag, and thrown almost everywhere—and it's still ticking. They make a great product.

There are two versions of the Intuos, and three sizes. For my students, I recommend the smallest size to make it easier when traveling. The Pro versus regular question is largely based on your own needs. All of the specifics that you need, from a brush-based tool perspective, are included in the regular tablet, saving you hundreds. I've opted for the Pro tablets in the past for the extra sensitivity.

Whichever you choose, it will last, and make your job so much faster.

wacom
Intuos

With a light, super-accurate pen and free downloadable software to suit your style, Wacom Intuos is built to bring your wildest ideas to life.

Live. Dare. Create.

Learn more ⓘ

Meet the Wacom family of Intuos pen tablets

Wacom's line of creative pen tablets include a range of choices for your creative interests. The Intuos line up is a great place to start, especially for drawing, sketching and photo activities. The choices in Intuos Pro deliver the pressure-sensitivity, pen performance and productivity features most sought out by serious creatives.

Wacom Intuos Pro
A professional pen tablet with multi-touch capabilities available in medium and large sizes

Wacom Intuos
A pen tablet with a simply great pen experience. It couldn't be easier.

Removing distractions with the Spot Removal tool

Lightroom's Spot Removal tool does a nice job of removing smaller distractions such as sensor dust spots, objects with lots of open space around them (say, power lines), blemishes, and so on. It also can be used to perform some quick photo retouching of subjects.

The Spot Removal tool works in both Heal and Clone modes, which lets you determine whether you want an automatic blending of surrounding pixels or a straight copy and paste, respectively.

Removing sensor spots and syncing changes

In this exercise, you'll use the Spot Removal tool to get rid of sensor spots from this picture in Monument Valley.

1 In the Develop module's Collections panel, click the Selective Edits collection and select lesson06-004 from the Filmstrip.

2 Before we make any changes to the spots, in the Basic panel, let's set the Temperature to 7000 and the Highlights to −50. We will also add a little definition to the image by setting the Texture to +20.

The Spot Removal tool is above the Basic panel (it's the second tool from the left) or press Q on your keyboard. The Spot Removal options panel appears beneath the tool strip.

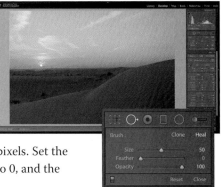

3 In the Spot Removal options panel, click Heal so Lightroom blends the change with surrounding pixels. Set the Size slider to around 50, the Feather to 0, and the Opacity to 100.

▶ **Tip:** If you don't see a toolbar beneath your image in the preview area, press T on your keyboard to summon it.

4 In the toolbar beneath the image preview, select Visualize Spots. Lightroom inverts the image in black and white, making it like a negative so the outlines of its content are visible. Any sensor spots in the photo appear as white circles or grayish dots. Drag the Visualize Spots slider to the right to increase sensitivity and see more spots; drag to the left if you see too many spots.

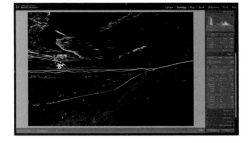

The Visualize Spots feature is critical for revealing spots caused by dust on your lens, sensor, or scanner. Although these tiny imperfections may not be noticeable onscreen, they often show up when you print the photo. You can see a number of them easily on the right side of this photo.

5 Zoom in to the photo by clicking 1:1 in the Navigator panel at the upper left. Hold down the Spacebar on your keyboard, and drag to reposition the photo so you can see one of the spots.

▶ **Tip:** When a local adjustment tool is active, you can also zoom in by pressing the Spacebar on your keyboard as you click the photo, and then continue to hold it down to move around. When a local adjustment tool isn't active, simply clicking the photo zooms in and out.

● **Note:** Because the Tool Overlay menu in the toolbar beneath the photo is set to Auto here, the circles disappear when you mouse away from the preview area, just like the pins of the Graduated Filter, Radial Filter, and Adjustment Brush tools. To change this behavior, click the Tool Overlay menu and choose Always, Never, or Selected (to see only the selected fix).

6 Move your cursor over one of the spots, resize it so it's slightly bigger than the spot itself, and then click the spot to remove it.

Lightroom copies content from a nearby area in the photo and uses it to remove the spot. You see two circles: One marks the area you clicked (the destination), and

another marks the area Lightroom used to remove the spot (the source), with an arrow that points to where the spot used to be.

7 If you don't like the results, try changing the area Lightroom used for the fix, or try changing the tool size. To do that, click the destination circle to select the spot and then:

- Press the Forward Slash (/) key on your keyboard to have Lightroom pick a different source area. Keep tapping the key until the removal looks good.

- Manually change the source area by moving your cursor over the source circle and, when your cursor turns into a tiny hand, dragging the circle to another location in the photo.

- To resize the destination or the source, move your cursor over either circle, and when your cursor changes to a double-sided arrow, drag outward to increase or inward to decrease the size of the circles. Alternatively, you can drag the Size slider in the Spot Removal panel.

▶ **Tip:** To thoroughly inspect a photo for spots (if, say, you'll print it or submit it to a stock photography service), press the Home key on your keyboard to start at the upper-left corner of the photo. Press the Page Down key on the keyboard to page through the photo from top to bottom in a column-like pattern.

Of course, you can always start over by removing the fix. To do that, select the destination circle and then press the Delete/Backspace key on your keyboard.

8 Spacebar-drag to reposition the photo, and repeat these instructions to remove all the spots.

9 Turn off Visualize Spots in the toolbar to return to regular view, and see if all the spots are gone.

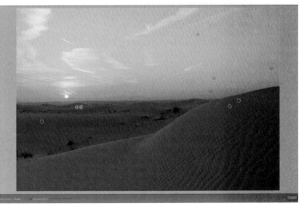

You can remove spots in either view, or you can switch back and forth between views as you work by turning Visualize Spots on and off.

You can select multiple photos taken at the same time and location before removing spots, but be sure to inspect the other photos to be certain the spots were successfully removed. If the spots weren't in exactly the same place in the other photos, reposition the removals by dragging the destination circles.

Don't put away the Spot Removal tool yet, because you'll use it in the next exercise.

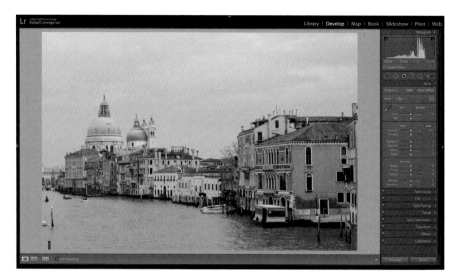

Removing objects from photos

Now let's take a look at how you can use the Spot Removal tool to remove slightly larger objects by dragging.

1 Select the lesson06-005 photo in the Filmstrip. We're going to work on removing the boats and markers in the canal along the left side of the photo. Zoom in to a 1:1 view to see them better.

Tip: You can adjust the Feather slider after you drag to remove an object, which is helpful to add more or less smoothing in the transition area.

Tip: Remember that you can also press the Forward Slash (/) key on your keyboard to have Lightroom pick a different source area if you don't like the initial results.

2 In the Spot Removal panel, set the tool to Clone at the top of the options, then adjust the Size to 28 and the Feather to 9 and drag a wide brush stroke around the first boat. Lightroom will attempt to find another area to sample from and remove the boat. If you don't like the result, you can drag it to a better spot.

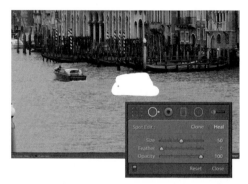

3 Press the Spacebar, drag to the left, and remove those boats. In the lower left, drag a brush stroke over the channel marker and boat together to remove them. Make sure that you resize the brush to be slightly larger than the marker.

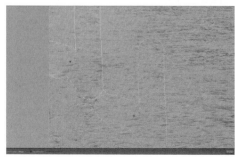

4 Let's go back to the big brush stroke we did to remove the channel marker and boat. Notice that the sample that we have there does not look blended into the picture. This is because the tool was set to Clone. Click this pin to select it and switch the blending mode to Heal, and the texture will blend better with the surrounding environment, leading to a better picture.

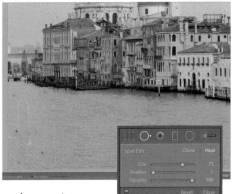

Let's apply the same spot removal techniques to the portrait of Daniel that we worked on previously. Navigate back to the image, and with the Spot Removal tool still active, we're going to use a combination of clicking and dragging to remove some of the spots on his shirt and distractions inside the car, leaving the picture with a cleaner look.

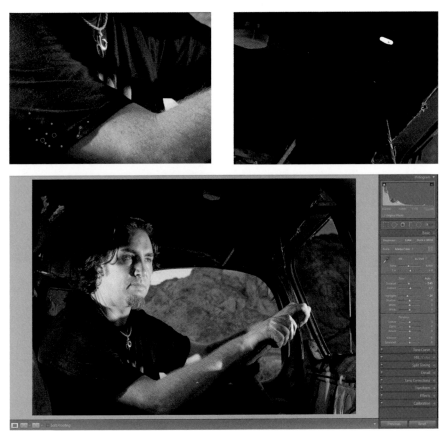

Range selection for specific control

Although Lightroom has the ability to adjust localized color with brushes and gradients, neither it nor Photoshop has had a quick way to localize adjustments based on color and luminosity. Since late 2017, though, users have had the ability to use color and luminosity controls in all of Lightroom Classic's local adjustment tools, taking your editing that much further.

1 Select the lesson06-006 image and use the Linear Gradient tool to make a gradient over the sky similar to what you see here. Set the Exposure to something really dark, like −2.50.

Notice that all of the elements in the picture above the top part of the line are dark. The lighthouse, clouds, and sky have all been made darker because of this effect.

Range Selection allows us to limit the effect in a given area to a specific color or a specific luminance in the picture. Let's try to limit this darkening effect to the blue part of the sky.

2 At the bottom of the Gradient Filter options is the Range Mask menu. Choose Color from that menu.

3 Select the eyedropper tool in the upper left of the Range Mask area and move it over to a blue portion of the picture. Click any of the blue area indicated in this region.

4 All of the darkening that we had in the image has now been limited to the color that we sampled with the eyedropper (you'll see an eyedropper icon in the spot you clicked). This gives us a lot of control over the sky. We can darken it and be confident that the clouds will not be affected. It's a little too dark, so go to the gradient's Exposure setting and change it to −1.78.

With the Color Range Selector active and that color selected, you can add additional samples of color by holding down the Shift key as you click. In the example above, I added a color sample on the left side. I wasn't happy with the results, so dragged the Exposure to −0.79, set the Contrast to 52, set the Saturation to 35, and reset the Sharpness to 0.

The Range masks in Lightroom allow you to do the following:

- Luminance (another word for brightness) allows you to select specific areas based on the luminance range you select.

- Color allows you to create a selection mask based on the colors that you sample within the mask area.

- The Depth Range option was released in October 2018. It allows you to select an area based on depth map information (for photos that include it).

▶ **Tip:** If you want to delete a color sample (eyedropper), holding down the Option/Alt key will turn the eyedropper cursor into scissors, allowing you to click the sample point to cut it from the list.

5 Now that we have the sky darker and bluer, let's see about getting the clouds to pop a little more. Select the Adjustment Brush tool. Double-click the Effect label to reset the sliders to 0, and make sure Auto Mask is still selected.

6 Paint over the sky in the image using a large brush starting on the blue part of the sky and continuing over the clouds. Because Auto Mask is on, it will do a good job of staying away from the lighthouse.

7 Switching the Range Mask menu to Luminance gives you another eyedropper. This time, click some of the wispy clouds in the image. Enter **0.82** for Exposure, **35** for Contrast, **−16** for Highlights, and **77** for Shadows.

While I think the numbers are helpful here, they're only helpful to this exercise. It's important to talk about *what* we actually did. We selected a specific brightness in an image—the clouds—and attempted to bring back some of their fine detail (contrast and highlight adjustments), while trying to make them a bit brighter (whites). Making the sky darker makes that color recede into the picture. Making the wisps brighter brings them forward. The play between the three colors almost gives the image a 3D look.

8 Click New at the upper right of the Adjustment Brush options, then reset the sliders. Paint across the bottom portion of the picture using a large brush.

9 Set the Range Mask menu to Color and sample some of the color in the brighter plants near the bottom. Darken the area using an Exposure of −0.87 and a Saturation of 100.

10 Finally, use one last Adjustment Brush to lighten some of the color in the sky at the lower left, with Luminance chosen in the Range Mask menu, the Exposure set to 0.73 and the Shadows set to 100.

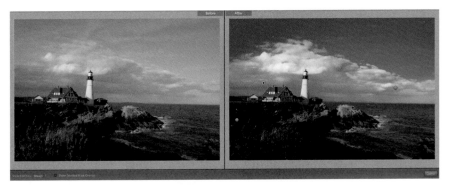

It will take a couple of tries with range masking to get the hang of how to work with luminance and color, and when to use each, but I guarantee you it is an incredibly powerful tool that gets the very best out of specific areas in an image.

HSL and Tone Curve adjustments

The HSL/Color, Tone Curve, and B&W panels all operate with a similar set of tools, making it easier for us to learn how to use all three panels by learning one of them. Let's start by exploring how to manipulate the HSL/Color panel.

Working with the HSL/Color panel

Inside the HSL/Color panel, there are a series of sliders that allow you to change colors by dragging them to the left or right. While the sliders can offer you a very detailed way to adjust color, I believe that the Targeted Adjustment tool can give you even more control.

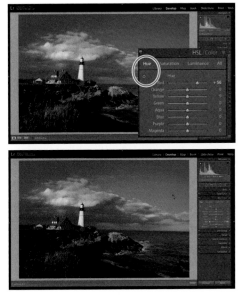

1 Click the Targeted Adjustment tool in the upper left of the HSL/Color panel (it looks like a small bullseye), and make sure Hue is selected above it.

2 Click the sky and drag up or down, and Lightroom will determine which colors are under the tool and adjust the sliders of only those colors, adjusting their hue. As you drag, the sliders in the Hue panel automatically change to adjust the color.

3 Click Saturation at the top of the panel and use the Targeted Adustment tool to drag up and down on any colors in a specific area and desaturate them (drag down) or oversaturate them (drag up). Note that the changes are not confined to the area you drag, but to the colors where you drag. If those colors appear elsewhere in the photo, they will be affected there too.

4 Click the Luminance tab and use the Targeted Adustment tool to drag up and down on the colors in a specific area to make them brighter (drag up) or darker (drag down).

Working with the Tone Curve panel

If you want to add a little more contrast outside of what you have added in the Basic panel, you can use the Tone Curve panel. Expand the Tone Curve panel to see the tone curve and the sliders that let you adjust the curve (if you don't see the sliders, click the curve icon to the right of Point Curve at the bottom of the panel).

This curve represents changes made to the tonal scale of your picture. The horizontal axis shows the original tonal (input) values, with black on the left and moving progressively brighter to the right.

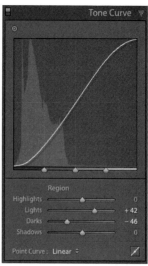

The vertical axis represents the changed tonal (output) values, with black on the bottom and progressing to white at the top.

If a point on the curve moves up, it becomes a lighter tone; if it moves down, it becomes darker. A straight, 45°-angle line indicates no change to the tonal scale.

While this gives you an understanding of how to adjust tonal regions in your picture, I find it much more intuitive to use the same Targeted Adjustment tool we used in the HSL panel to make adjustments to the picture.

1 Click the Targeted Adjustment tool in the Tone Curve panel and hover over the picture. Notice that as you hover over an area of the picture, the corresponding area in the tone curve is highlighted.

2 Drag downward to make that area of the picture darker; drag upward to make that tonal region brighter. Keep an eye on how dragging up or down affects your tone curve.

You can do a lot of creative experimentation with the Tone Curve panel, but your ability to add contrast and detail to an image using the Targeted Adjustment tool cannot be overstated.

Creative color and black & white effects

According to famed environmental portrait photographer Gregory Heisler, black-and-white imagery "allows you to see the structure of the image in a way that color cannot." While we often see photographs in black and white as nostalgic, the lack of color in the image allows the viewer to focus on stronger components of the picture—composition, structure, gesture, and so on.

Your camera may have settings that allow you to make black-and-white pictures. These settings, however, are only for images shot in JPEG format. Allowing your digital camera to produce black-and-white images robs you of the ability to target specific colors in a picture and decide how you want them to appear.

Taking this technique further, Lightroom lets you add individual colors to an image, creating a hand-tinted photograph that can expand your exploration. These coloring techniques can start with a single color, and move on to several colors to produce retro effects in a snap.

When I made this picture in Portland, Maine, I was trying to make a series of images that had an Ansel Adams feel to them—very contrasty black-and-whites with an ethereal feel. We've been working on setting up a lot of contrast on this lighthouse. It's time to take it to black and white.

Converting a color photo to black and white

Note: Often, I'll oversaturate the image to better see the color representation of the photo. I also adjust Highlights, Shadows, Blacks, Whites, and Dehaze to make sure every bit of detail in the image is available. All of the color will disappear shortly, but it's good to see this beforehand.

Note: In previous versions of Lightroom, creating a black-and-white image required you to go to the HSL panel to start. With the 2019 release, this option is now located in the Basic panel. Clicking Black & White at the upper right of the panel will change the HSL/Color panel into the B&W panel for you to adjust the black-and-white mix.

1 By now, your image should have quite a bit of contrast. In the Basic panel, I dragged the Exposure slider to +0.85 and the Contrast to 45.

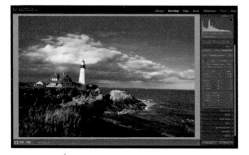

2 Click Black & White in the upper right of the Basic panel. The image undergoes a basic black-and-white conversion and the HSL/Color panel changes to the B&W panel.

3 Expand the B&W panel, and there are a series of sliders representing different colors in your image. Dragging any of the sliders to the right will make any color in that range more white; dragging to the left will make that range of colors more black.

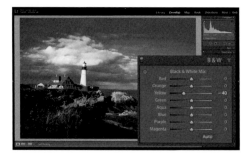

4 The biggest problem that we run into here is that we are attempting to adjust color sliders in an image that is now black and white. This is where the Targeted Adjustment tool comes in handy. Click the tool, then move to a part of your photo you'd like to adjust, and drag upward to brighten the colors underneath the tool, or drag downward to darken them.

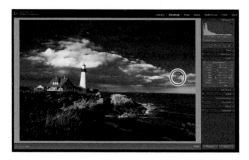

Applying split-toning and retro effects

Lightroom's Split Toning panel lets you add a color tint to the high-lights and another one to the shad-ows in your photo. The best results often come from using colors that

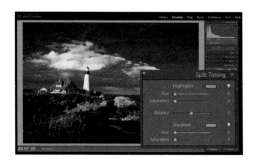

are opposite each other on a color wheel, such as orange and blue, yellow and purple, green and red, and so on.

1 Expand the Split Toning panel. There are Hue sliders for both the highlights and shadows, as well Saturation sliders for both. Drag the Highlights Saturation slider to 58, so we'll see something when we move the Hue slider.

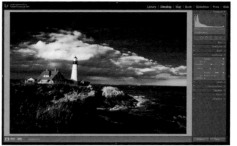

2 Drag the Highlights Hue slider to the right to experiment with the different colors you can apply to the highlights of the image. Then adjust the Saturation slider to your liking. I ultimately settled on 37 for Hue and 40 for Saturation.

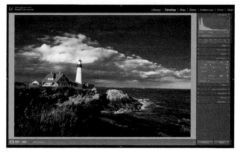

3 Set the Shadows Saturation slider to 80 and play with the colors in the Hue slider. I ultimately decided to reset the Saturation slider to 0, as I liked the overall effect of the hue tint only in the highlights.

4 Adjust the blending between the highlights and shadows tints with the Balance slider for different effects.

The Effects panel

The Effects panel in Lightroom allows you to add grain and post-crop vignetting to your images. Post-crop vignetting is a great feature when you want to add a specific focus to the center of the picture, but it requires a lot of care or you risk your image looking kitschy.

We're going to keep using the same photo, so set the Highlights Saturation slider back to 0, and then expand the Effects panel. We'll start with the Post-Crop Vignetting sliders at the top of the panel.

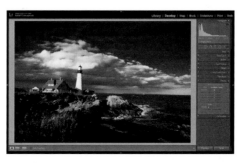

Post-crop vignetting is an effect that evolved from the undesirable darkening in the corners of images

taken using specific lenses. People started to like this effect of "burning the edges in," as it drew attention to the center of the picture.

Lightroom introduced a Vignetting slider in the original release of the program that was supposed to be used to correct the effect, not add it. Photographers, however, began using it to apply a vignetting effect, but when they cropped their pictures, the vignette effect disappeared.

Lightroom has since moved the Vignetting sliders (to remove vignetting) into the Lens Corrections panel and added Post-Crop Vignetting (which retains the size and centeredness of the vignetting even if you crop the image) in the Effects panel.

There are three Style menu choices available under Post-Crop Vignetting:

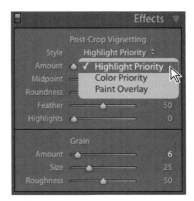

- Highlight Priority can bring back some blown-out highlights, but can lead to color shifts in darkened areas of a photo. It's good for images with bright areas, such as clipped specular highlights.

- Color Priority minimizes color shifts in darkened areas of a photo, but cannot perform highlight recovery.

- Paint Overlay mixes the cropped image values with black or white pixels and can result in a flat appearance.

There are five sliders available to you under Post-Crop Vignetting:

- Amount darkens the edges of the picture as you drag to the left, and lightens as you drag to the right.

- Midpoint adjusts how tight to the corners the effect is created. A low number moves it away from the corners, toward the center; a higher number moves it closer to the corners.

- Roundness adjusts whether the effect looks like an oval or a circle. Drag to the left and it becomes more of an oval; drag to the right and you get a circle.

- Feather adjusts how soft the effect's transition appears. Drag to the right and the effect appears softer; drag to the left for a hard transition.

- Highlights is available only when Highlight Priority or Color Priority is chosen in the menu. This slider controls the degree of highlight contrast that is preserved.

Grain is a little more straightforward. You can control the amount of grain added to your image, how big the individual grains are, and how jagged they are. The grain looks pretty realistic and can add an extra punch to images, especially if you're working in black and white.

I am not a fan of post-crop vignetting, as I would rather have the greater control of the Adjustment Brush tool and Radial Filter. Let's reset all of the post-crop vignetting by double-clicking the sliders for each of the values. I did, however, add a little grain to finish off the image and dropped the Highlights to −78 in the Basic panel.

Making panoramas

Panoramic images can give people a feeling of complete immersion in a picture. But taking panoramic pictures used to require specialized lenses that were wide enough to fit the scene you wanted to capture. Lightroom has made such incredible strides in making panoramic images out of regular-sized images that it borders on magic. Simply take a series of pictures, and let Lightroom take care of the rest.

There are a couple of key things that Lightroom does when making panoramic images that really make it stand out.

First, Lightroom includes a Boundary Warp slider that all but negates the need to crop the resulting panorama due to the spherical distortion necessary to align so many images. Previously, you had to rely on Photoshop to use Content-Aware Fill to avoid cropping, but now more of that can be done in Lightroom.

Second, the resulting file in Lightroom is also a raw file (specifically, a DNG), allowing you to work in the Develop module with a much greater range than you were able to previously. Third, the panorama merge now supports a headless mode.

The October 2018 release of Lightroom added another tool to its panorama arsenal: you can now make HDR panoramas, making the task of creating individual HDR files and then merging them into a panorama a thing of the past.

Finally, Lightroom Classic now allows you to fill the edges of a picture, offering you a complete look without warping the image.

Merging to a panorama in Lightroom

▶ **Tip:** When capturing images for a panorama, try to overlap each shot with the preceding one by about 30 percent. Set your camera to manual focus and manual exposure so that those parameters don't change automatically as the camera moves from shot to shot. If possible, use a tripod.

In this exercise, you'll stitch three photos together. Happily, it doesn't matter what order the photos are in because Lightroom intelligently analyzes the photos to see how they logically fit together. You can wait to adjust tone and color until after you've merged the images.

1 Select lesson06-007 through lesson06-009 in the Library module by clicking the first image in the series and Shift-clicking the last image.

2 Right-click one of the thumbnails and choose Photo Merge > Panorama or press Control+M/Ctrl+M.

One of the first things that is apparent is the speed at which the panorama is built. In recent versions of Lightroom, it uses the embedded JPEG images to create your preview. There's nothing more frustrating than waiting a while to see if the panorama is good, only to find out it's a bust.

3 The options in the Panorama Merge Preview dialog box control the layout method Lightroom uses to align the individual images. It's worth taking each method for a spin, although if your pano is really wide, Adobe suggests using Cylindrical. If it's a 360-degree or multi-row pano (you took two rows of photos), try Spherical. If it has a lot of lines in it (say, an architectural shot), try Perspective.

In this case, Spherical works well; however, there are white areas all around the image that need to be cropped out or filled in.

4 Drag the Boundary Warp slider to the right until the white areas disappear to see how it looks. This slider corrects the distortion so well that you may never need to crop or fill in the edges of your panorama again. Reset it to 0 for now. If you decide that you want to crop out the edges, select the Auto Crop option.

5 Click the Fill Edges button and all of the edges are filled, giving you an even more natural look. Once, complete, Click Merge to close the dialog box. Lightroom merges all four images, and the result is a seamlessly blended panorama. If you left the Auto Settings option selected in the Panorama Merge Preview dialog box, Lightroom will try to develop your image. Select the panorama in the Filmstrip (it has the word *pano* in its name) to see how it did.

◆ **Warning:** If the panorama doesn't immediately appear in the Library module's Grid view or the Filmstrip, give it a few seconds. The same goes for merging to HDR.

6 Use the panels in the Develop module as well as the color range techniques we've discussed in this lesson to tweak the tone and color. The merged file is a DNG, so you have all of the tonal benefits of a raw file.

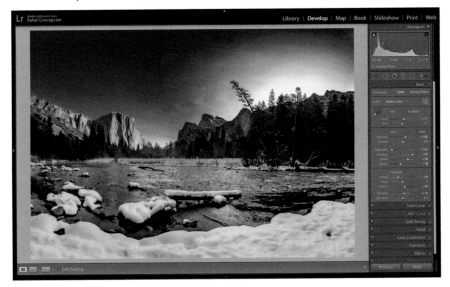

Headless mode for panoramas

Since panoramas can take some time to perform their final merge, I tend to use headless mode to speed things up a bit. Hold down the Shift key as you select Photo Merge > Panorama, and the file will skip the Panorama Merge Preview dialog box and render the file in the background.

Making HDR images

Very few images exploit the full range of possible brightness tones, from the lightest lights to the darkest darks. Often, you'll have more info on one end of the histogram than the other, meaning that either the highlights *or* the shadows are well exposed and full of detail, but not both. That's because digital cameras have a limited dynamic range; they can collect only so much data in a single shot. If you have a scene with both light and dark areas, you have to choose which area to expose correctly. In other words, you can't expose for both areas in the same photo.

To create photos that take advantage of the full range of tones from light to dark, you need to do one of the following:

● **Note:** Even if you're shooting in raw, it's worth knowing how to quickly turn on your camera's bracketing feature. For example, you may want to capture multiple exposures of a poorly lit scene in case you can't achieve the results you want by tone mapping only one exposure. If the single exposure gets you where you want to go, then you can always delete the other exposures from your Lightroom catalog or hard drive.

- Shoot in raw format and tone map the photo in Lightroom. As long as you capture good detail in the highlights—check the histogram on the back of your camera to make sure you do—you may be able to pull out an incredible amount of detail using the sliders in the Basic panel.

- Shoot multiple versions of the same shot at different exposure values (EVs), and then merge them into a high dynamic range (HDR) image. You can do this manually by taking three to four photos with, say, a single f-stop difference between them, or you can have your camera do it automatically by turning on its *bracketing* feature.

 Bracketing lets you tell the camera how many shots to take (use a minimum of three, though more is better) and how much of an exposure difference you want between each one (pick one or two EV stops if you have the choice). For example, for three shots, you'd have one at normal exposure, one that's one or two stops lighter than normal, and another that's one or two stops darker than normal.

● **Note:** The term *tone mapping* means to take the existing tones in your image and alter them so they reflect a broader dynamic range.

In the last couple of releases, Lightroom has taken great leaps forward in the ease of creating HDR images. While both Lightroom and Photoshop can merge to HDR, it's easier to do it in Lightroom because you can quickly switch to the Basic panel to tone map the merged result.

Let's cover how to create an HDR image in Lightroom and how to speed up the process when we need to work with more than one set of images. You will be shocked to see how simple it actually is.

Merging to HDR in Lightroom

In this exercise, you'll use Lightroom to merge three exposures of a room in a bar in Bodie, California, into a single image that you'll then tone map.

1 Select lesson06-010 through lesson06-012 in the Library module by clicking the first image in the series and Shift-clicking the last image in the series.

2 Right-click one of the thumbnails and choose Photo Merge > HDR or press Control+H/Ctrl+H.

As with the panorama, the overall speed with which Lightroom creates an HDR preview of your images is fast. I've merged really large image files to HDR and been amazed at how fast the preview renders.

3 The HDR Merge Preview dialog box gives you a quick series of options to help you along with the process:

- Auto Align automatically corrects any movement in between the capture of the images—perhaps you moved the tripod slightly as you made the images.

- Auto Settings applies Develop module settings you normally see in the Basic panel, so you get a good result out of the gate. It's okay to leave it on since you can always change any settings when the merge is complete.

- Deghosting compensates for anything inside the frame that moved. Imagine there was a strong wind and the trees moved when you made the picture, or people walked through the frame. Deghosting gives you a choice of intensities to remove the movement. Select this setting on a case-by-case basis.

- If you have selected a Deghost Amount, you can select the Show Deghost Overlay option to see where changes will be made.

- Finally, you have the option to create a stack of all the component images and the resulting HDR. Stacks are outside the realm of this book, so let's leave this unselected.

Once you click Merge, the HDR processing happens in the background—another benefit of doing this in Lightroom. In older versions, merging HDR images in Lightroom meant that you were locked out of doing any work until the HDR image was complete. Now, you can go back into Lightroom and continue to work until the HDR is finished.

One of the other powerful features of HDR in Lightroom is that the resulting HDR file that is created is still a raw file (a DNG, specifically). This means that you can change temperature and tint, and perform Develop adjustments, with much greater range than if the image were turned into pixel data. Dragging the Exposure slider from one side to the other in the two images on the next page shows just how much tone you have available to you in the resulting image.

Note: An HDR image can be tone mapped to look realistic or surrealistic. The realistic approach brings out detail but leaves the image looking natural. The surrealistic look emphasizes local contrast and detail, and is either very saturated or undersaturated (for a grungy style). There's no right or wrong here; it's purely subjective.

Tip: If you are interested in exploring how to make realistic and surrealistic HDR images, your author wrote a book on the subject. Go check out *The HDR Book*, second edition.

When Lightroom finishes merging your HDR, it will appear next to the images you merged. Click it in the Filmstrip (it has *HDR* in its name), and press D to go to the Develop module if necessary. Expand the Basic panel so you can see, and make changes to, the settings Lightroom applied.

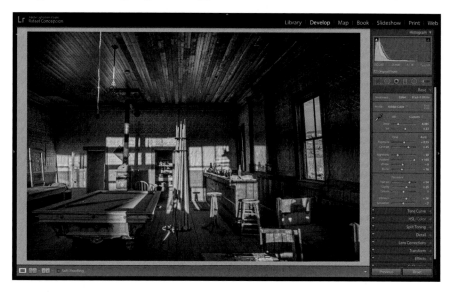

Headless mode for HDR

Another great feature that has been added to HDR in Lightroom is headless mode. There are plenty of times when you do not need to see the HDR Merge Preview dialog box to make any decisions—you just want Lightroom to get to work. Hold down the Shift key when you choose Photo Merge > HDR, and Lightroom bypasses the preview dialog box and starts making your HDR file immediately.

Creating HDR panoramas

Since the October 2018 release of Lightroom, you can create panoramas with a series of HDR images all at once. Previously, you had to merge each bracketed series of exposures into an individual HDR file, and then merge those files into

a panorama. Lightroom has automated the entire process and still kept the resulting file as a DNG, letting you tone it with great detail.

Some time ago, I took a series of bracketed exposures (four exposures for each photo, ranging from –3½ EV to 2½ EV) of that same lighthouse in Maine we saw earlier, while learning about range masking. I wanted to make sure that I captured all of the tonality of the moment, while making an image large enough to feel like you can get lost in it. Let's see how Lightroom handles the process.

1 Select lesson06-016 through lesson06-027 in the Library module by clicking the first image in the series and Shift-clicking the last image.

2 Right-click one of the thumbnails and choose Photo Merge > HDR Panorama. With 12 images being merged to HDR and then merged as a panorama, you might expect it to take quite a while, but it's actually faster than you'd think.

3 The result of the HDR pano looks like what you'd expect to see from the merged files, with white areas in the corners. Try the different projections. The Spherical projection looked like the best of the three here.

4 Selecting the Auto Crop option eliminates too much of the foreground. While I appreciate the efficiency of it, I think Boundary Warp or Fill Edges will work much better for this image.

5 Deselect the Auto Crop option and select the Fill Edges option instead. This corrects the perspective while bringing the edges back.

Click Merge and Lightroom will start merging your HDR pano.

6 The final result is an extremely compelling HDR panorama, and it was all done automatically. Go to the Develop module to further tone and pull details from it.

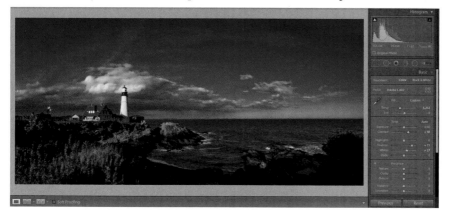

Saving time in Lightroom

One of the things that I really like about Lightroom is how easy working with images is for the most part. The goal for all of this technology is to make it easier for you to realize your vision, and to get back to making more images. All of the skills you've learned help in the process of realizing your vision, but how do we make it go faster? Synchronizing your changes across images is a great first start.

Applying previous corrections

I'd like to correct the white balance and exposure for a series of images in this collection a little more intelligently. I'd like to select one of the images, and make sure those changes are applied to the other two images.

1 Click lesson06-028 and press the letter D to enter the Develop module. Near the top of the Basic panel, get the White Balance Selector tool, and click the back wall in the picture to automatically correct the white balance (you can see a before and after on the next page).

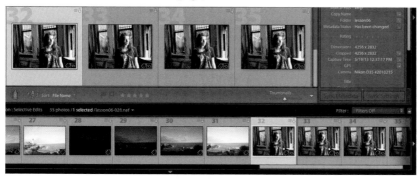

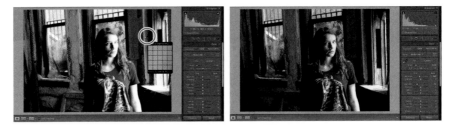

2 Once you've set your white balance, enter **−0.80** for Exposure and **−54** for Highlights.

3 Press the right arrow key to move to the next picture. You'll notice the same white balance and exposure problem as before. This time, click the Previous button below the right-side panels. Lightroom will copy all of the settings that you added on the other image and apply them to the new picture.

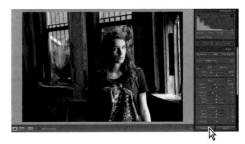

Synchronizing corrections

Clicking the Previous button to apply corrections to another picture is a great way to make it easier if you have one or two pictures, but what if you have 50 of them? For that, you'll want to use the Synchronize command.

1 Press Command+Z/Ctrl+Z to undo the correction we just made to the second image.

2 Click the first image in the filmstrip, then Shift-click the last image in the series. The first image that was selected will be the source image from which your corrections will synchronize.

3 Click the Sync button below the right-side panels.

4 In the Synchronize Settings dialog box, click the Check None button in the lower left, and then select the settings that we changed in this image. I selected Process Version, White Balance, and the Basic Tone information. Once you've selected all of the options to synchronize, click the Synchronize button.

You'll notice that all of the settings were synchronized between all three images, but there is a new problem with two of the images. It appears that the second and fourth images were overexposed a little. The initial changes we made to the first image were okay, but the settings seem to overexpose the second and third images. Here's another secret setting in Lightroom I like to use in situations like this.

5 With the four images still selected, choose Settings > Match Total Exposures. This will take the first image and match the other images to that exposure. You now have three images that are similar in exposure, in no time at all.

The significance of process version

Process version (PV) refers to Lightroom's underlying image processing technology. The instructions in this book, particularly those that concern the Basic panel, are for the current Lightroom process version, Process Version 5, which was introduced in 2018. You can find the process version of the image by going to the Camera Calibration panel in the Develop module.

If you used Lightroom to adjust photos prior to 2018, a different process version was used. In fact, if you used a version of Lightroom from 2012 and looked at its Develop module, some of the Basic panel sliders would look and behave differently than in Lightroom. Some sliders have different names, their starting points are different, and the Clarity slider, in particular, uses a completely different algorithm in earlier process versions.

If you like the way a photo looks with its older processing, you can leave it alone. If you want to take advantage of the improvements in Process Version 5, you can change the photo's process version, although doing so may significantly change the way it looks.

Creating a Develop preset

Another great way to develop images quickly is through the use of a preset. Go to the Develop Module Practice collection and select the first picture there. As with the Synchronize process, clicking the plus sign (+) button at the right of the Preset panel's header and choosing Create Preset will bring up a dialog box that allows you to save specific settings for the toning of your images. Type **Mandalorian** as your preset name, click Check All, and click Create, as seen below.

Once the preset is saved, you can access it under User Presets in the Presets panel. Navigate to any other image in the Filmstrip in the Develop module (I went back to our Selective Edits collection, to the photo of the Las Vegas strip) and click the preset in the panel on the left to apply it.

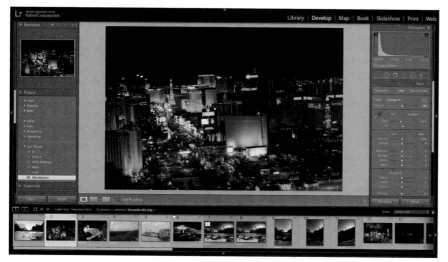

Press G to return to the Library module's Grid view. You can even select a series of images in the Grid (by clicking the first one and Shift-clicking the last one), and apply the same preset using the Saved Preset menu at the top of the Quick Develop panel. Now that's a timesaver.

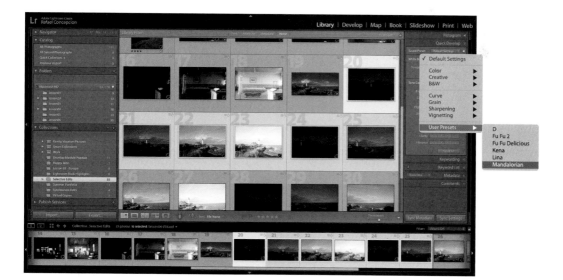

Review questions

1 How do you reset all the sliders in the local adjustment tools' options panels?

2 How do you remove part of a Graduated Filter's or Radial Filter's effect?

3 How do you create a vignette for an off-center subject?

4 What is the difference between the Spot Removal tool's Heal and Clone modes?

5 What are the three Range Mask choices and what does each one do?

6 How do you synchronize changes to one photo with multiple similar photos?

Review answers

1 When using a local adjustment tool (the Graduated Filter, the Radial Filter, or the Adjustment Brush tool), you can reset all the sliders in the options panel by double-clicking the Effect label.

2 Once you have created a Graduated Filter or Radial Filter, if you need to remove a portion of the effect, click Brush in the upper right of the options panel, then click Erase in the Brush settings at the bottom of the options. Adjust your brush settings, as needed, and paint over the area you want to remove from that adjustment.

3 If your subject is off-center in the photo, you can create a Radial Filter around your subject and use it to darken the area outside of your subject.

4 When using the Spot Removal tool, Heal gives you an automatic blending of surrounding pixels, while Clone gives you a straight copy and paste.

5 The three Range Mask choices are Luminance, Color, and Depth Range, and they allow you to select the specific areas of your image that will be affected by that local adjustment. Luminance allows you to select what is affected based on a luminance (brightness) range you choose. Color allows you to select an area based on the colors you sample in the image. Depth Range lets you choose the area affected based on depth map information.

6 If you have multiple photos taken in the same lighting, you can make your tonal adjustments to one photo, select all the photos, and then click the Sync button at the bottom of the right panel group. In the Synchronize Settings dialog box, select all the settings you changed in the first image, and click Synchronize.

PHOTOGRAPHY SHOWCASE
MARANIE STAAB

"Photography is a means to an end; the camera, a tool to be used wisely."

In a world that seems to be increasingly focused on division, building walls, and what makes us different from one another, images have the capacity to transcend these lines and help us see a bit of ourselves in the "other."

Driven by curiosity and a desire to learn, I'm armed with a combination of compassion and moderated outrage at all that is wrong in the world. Much of my work focuses on human rights and social justice issues, displacement, and the impact of conflict on individuals and society. I like to get close to people and their experiences and am forever grateful to those who have allowed me into their lives.

To make photographs is to be in love with and eternally curious about the world. It's a constant state of discovery, an unparalleled way to connect with people, and an excuse to be somewhere I wouldn't otherwise belong.

My belief in the power of images and storytelling is my constant motivation. We sometimes hear that photography can change the world. I believe that, but it's not the images alone; it is what we do with them. It is how we choose to engage, and how we allow ourselves to be informed and changed. Many times, this change has shown its face in the acceptance of another way of life and the willingness to identify with others. My hope is that the work might help move us, as a collective society, one step closer to embracing our shared, flawed humanity.

www.maranierae.com

instagram.com/maranierae

7

CREATING A PHOTO BOOK

Lesson overview

Whether it's produced for a client or as a professional portfolio, designed as a gift or as a way to preserve precious memories, a photo book makes a stylish way to share and showcase your images. The Book module makes it easy to design beautiful, sophisticated book layouts, and then publish them without leaving Lightroom. This lesson will give you the skills to create your own professional-looking photo book. You'll learn how to:

- Work with text and photo cells to modify page layout templates.

- Set a page background.

- Place and arrange images in a layout.

- Add text to a book design.

- Use the Text Adjustment tool.

- Save your photo book, and custom page and book layouts.

- Export your creation.

 This lesson will take about 1 to 2 hours to complete. To get the lesson files used in this chapter, download them from the web page for this book at www.adobepress.com/LRClassicCIB2020. For more information, see "Accessing the lesson files and Web Edition" in the Getting Started section at the beginning of this book.

The Book module delivers everything you need to create polished book designs that can be uploaded directly from Lightroom Classic for printing through the on-demand book vendor Blurb, or exported to PDF and output on your own printer. Template-based page layout, an intuitive editing environment, and state-of-the-art text tools make it easy to present your photographs in their best light.

263

Getting started

● **Note:** This lesson assumes that you already have a basic working familiarity with the Lightroom Classic workspace. If you need more background information, refer to Lightroom Classic Help, or review the previous lessons.

Before you begin, make sure you've set up the LRClassicCIB folder for your lesson files and created the LRClassicCIB Catalog file to manage them, as described in "Accessing the lesson files and Web Edition" and "Creating a catalog file for working with this book" in the "Getting Started" section at the start of this book.

If you haven't already done so, download the lesson07 folder from your Account page at www.peachpit.com to the LRClassicCIB\Lessons folder, as detailed in "Accessing the lesson files and Web Edition" in the "Getting Started" section.

1 Start Lightroom Classic.

2 In the Select Catalog dialog box, make sure the file LRClassicCIB Catalog.lrcat is selected under Select A Recent Catalog To Open, and then click Open.

▶ **Tip:** If you can't see the Module Picker, choose Window > Panels > Show Module Picker, or press the F5 key. If you're working on macOS, you may need to press the fn key together with the F5 key, or change the function key behavior in the system preferences.

3 Lightroom Classic will open in the screen mode and workspace module that were active when you last quit. If necessary, switch to the Library module by clicking Library in the Module Picker at the top of the workspace.

Importing images into the library

The first step is to import the images for this lesson into the Lightroom library.

1 In the Library module, click the Import button below the left panel group.

2 If the Import dialog box appears in compact mode, click the Show More
 Options button at the lower left of the dialog box to see all the options in the
 expanded Import dialog box.

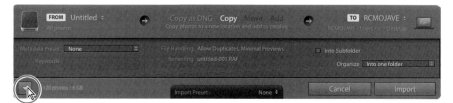

3 Under Source at the left of the expanded Import dialog box, locate and select
 your LRClassicCIB\Lessons\lesson07 folder. Ensure that all 23 images in the
 lesson07 folder are selected (checked) for import.

4 In the import options above the thumbnail previews, select Add so that the
 imported photos will be added to your catalog without being moved or copied.
 Under File Handling at the right of the expanded Import dialog box, choose
 Minimal from the Build Previews menu and leave the Don't Import Suspected
 Duplicates option unselected. Under Apply During Import, choose None from
 both the Develop Settings menu and the Metadata menu and type **Lesson 07,
 Dubai** in the Keywords text box. Make sure that your import is set up as shown
 in the illustration below, and then click Import.

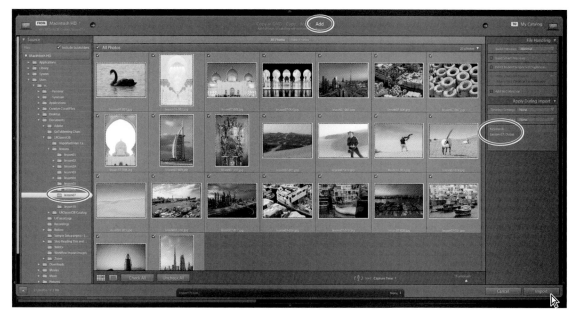

The 23 images are imported and now appear in both the Library module's Grid
view and the Filmstrip across the bottom of the Lightroom workspace.

Assembling photos for a book

▶ **Tip:** The first time you enter any of the Lightroom Classic modules, you'll see tips that will help you get started by identifying the components of the workspace and stepping you through the workflow. Dismiss the tips by clicking the Close button. To reactivate the tips for any module, choose [*Module name*] Tips from the Help menu.

The first step in creating a book is to gather the photos you wish to include. Since we just imported them, the images for this lesson are already isolated from the rest of your catalog in the Previous Import folder, which is selected as the image source.

The Previous Import folder is merely a temporary grouping and you can't rearrange the images inside it, or exclude a photo from your project without removing it from the catalog entirely. Instead, use either a collection or a single folder without subfolders as the source for the images in your book; both will let you reorder photos in the Grid view or the Filmstrip. For this exercise, you'll create a collection—you can exclude an image from a collection without deleting it from your catalog.

1 Make sure that either the Previous Import folder in the Catalog panel or the lesson07 folder in the Folders panel is selected as the image source, then press Command+A/Ctrl+A or choose Edit > Select All.

2 Click the plus sign (+) button in the Collections panel's header and choose Create Collection. In the Create Collection dialog box, type **Dubai** as the name for the collection. Make sure that the Include Selected Photos option is selected and all the other options are disabled, and then click Create. Your new collection appears in the Collections panel, where it is automatically selected.

3 Choose Edit > Select None. In the Toolbar, set the Sort order to File Name, then click Book in the Module Picker at the top of the workspace.

Working in the Book module

Whether you want to commemorate a family moment, organize your memories from a special trip, or create a vehicle to show your work, a photo book is an attractive and sophisticated way to showcase your photography. The Book module delivers everything you need to create stylish books that can be uploaded directly from Lightroom for printing through the on-demand book vendor Blurb, or exported to PDF and printed on your own printer.

Setting up a photo book

In the work area, you may or may not see photos already placed in page layouts, depending on whether you've already experimented with the Book module's tools and controls. You can start this project by clearing the layout and setting up the workspace so that we're all on the same page.

1 Click the Clear Book button in the header bar across the top of the work area. If you don't see the header bar, choose View > Show Header Bar.

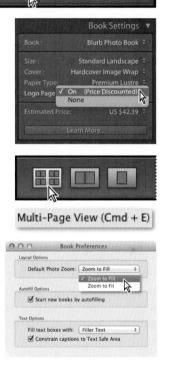

2 In the Book Settings panel at the top of the right panel group, select Blurb Photo Book from the Book menu and make sure that the Size, Cover, Paper Type, and Logo Page are set to Standard Landscape, Hardcover Image Wrap, Premium Lustre, and On, respectively. The estimated price of printing the book at the current settings is displayed at the bottom of the panel.

3 If it's not already selected, click the Multi-Page View button at the far left of the Toolbar at the bottom of the work area. In the View menu, disable Show Info Overlay.

4 Choose Book > Book Preferences and examine the options. You can choose whether photos are zoomed to fit their image cells or cropped to fill them, toggle the Autofill feature for new books, and set your preferences for text behaviors. Leave the settings at the defaults and close the Book Preferences dialog box.

The Autofill feature is activated by default; if you just entered the Book module for the first time, you would have seen the images from the Dubai collection already placed in the default book layout. An automatically generated layout can be a great starting point for a new book design, especially if you're beginning without a clear idea of exactly what you want.

> **Note:** If you're publishing to Blurb.com, auto-layout is limited to books of 240 pages. There is no auto-layout page limit for books published to PDF.

5 Expand the Auto Layout panel, if necessary. From the Auto Layout Preset menu, choose the Left Blank, Right One Photo, With Photo Text layout, then click the Auto Layout button. Scroll in the work area to see all the page thumbnails. Click the Clear Layout button and repeat the procedure for the One Photo Per Page auto-layout preset.

6 Take a look at the book results in the work area; scroll, if necessary, to see all the page thumbnails arranged as two-page spreads in the Multi-Page view. To get more space, hide the Module Picker and the left panel group by pressing F5 and F7, or by clicking the triangles at the top and left edges of the workspace. Drag the Thumbnails slider in the Toolbar to reduce or enlarge the thumbnails.

Note: Blurb offers a discounted price for photo books that incorporate the Blurb logo on the last page.

Lightroom generates a book with a cover, separate pages for each of the images in the collection—placed in the order in which they appear in the Filmstrip—and a twentieth page reserved for the Blurb logo. You can't place a photo on the Blurb logo page, but you can disable it in the Book Settings panel, if you prefer.

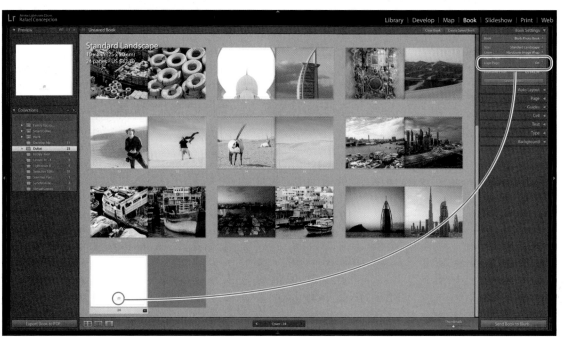

▶ **Tip:** If you want to rearrange the order of images in the Filmstrip before you click Auto Layout, you'll first need to save your book.

The first image in the Filmstrip is placed on the front cover; the last photo in the series becomes the back cover image. The number above each photo in the Filmstrip indicates how many times it has been used in the book; the first and last images have each been used twice—on the cover and also on pages 1 and 23.

Changing page layouts

Using an auto-layout preset can help you get started on your book. Then you can focus on individual spreads and pages to introduce subtlety and variety to the design. For this project, however, you'll build your book layout from scratch.

1 In the Auto Layout panel, click the Clear Layout button.

2 Right-click the Page panel header and choose Solo Mode from the menu.

3 In the Multi-Page view, double-click the front cover (the right side of the spread).

The cover layout fills the work area in the Single Page view, with the front cover's photo cell selected, as indicated by the yellow border. The Page panel shows a diagrammatic preview of the default cover template: two image cells (identifiable by central cross-hairs) and a narrow text cell positioned along the book's spine.

4 Click the Change Page Layout button (it's black with a gray triangle) to the right of the layout preview thumbnail in the Page panel, or in the lower-right corner of the cover spread displayed in the work area.

5 Scroll down in the page template picker to see all of the available cover layout templates. Gray areas with central cross-hairs indicate image cells; rectangles filled with horizontal lines represent text cells. Click to select the third template in the menu. The single cross-hairs at the center of the spread shows that this template has a single image cell that extends across both covers, and three text cells: one on the back cover, one on the spine, and one on the front cover.

6 Expand the Guides panel. Make sure that the Show Guides option is selected, then watch the layout in the work area as you toggle each of the guides in turn. Move the pointer over the layout to see the borders of the text cells.

The Page Bleed guide's wide gray border shows the area to be cut off after printing. A thin gray line borders the Text Safe Area, where your text will be well clear of accidental trimming. The Filler Text guide shows filler text (here, the word *Title*) to mark the position of text cells. Filler text disappears when you click a text cell.

7 Disable Photo Cells, leaving the three options mentioned above selected, then click the Multi-Page View button in the Toolbar.

The first page in a photo book is always on the right side of the first spread; the grayed-out left side represents the inside of the front cover, which is not printed. Likewise, the last page in a photo book to be published to Blurb must always occupy the left side of the final spread. At this stage, your book consists of a cover and a single double-sided page, the back of which is the Blurb logo page.

8 Right-click page 1 and choose Add Page from the menu. A second spread appears in the Multi-Page view. Right-click page 2 and choose Add Page to copy the same page layout to page 3.

9 Click to select page 2, and then click the Change Page Layout button below the lower-right corner of the page.

For inside pages, unlike the cover, the page template picker groups layout templates in categories according to style, project type, or the number of photos per page.

▶ **Tip:** To add a page layout to the Favorites category in the template picker, click the circle that appears in the upper-right corner of the template's thumbnail when you move the pointer over it.

10 Click 2 Photos to see all the templates with two image cells. Select the fourth template: a layout without text cells that fills the page with two portrait-format images, side by side. In the Guides panel, turn Photo Cells on briefly so that you can see the changed page layout.

Adding page numbers to a photo book

● **Note:** The context menu of a page number cell also lists commands that enable you to hide the page number on a selected page, or set the page numbering to start from a page other than page 1.

1 Double-click page 1 to shift to Single Page view, then select Page Numbers at the top of the Page panel. From the Location menu, choose Bottom Corner, and choose Left and Right from the Display menu. Right-click page 1 and make sure that the Apply Page Number Style Globally option is activated in the menu.

2 Click the new page number cell in the page preview, then expand the Type panel and inspect the default font, style, size, and opacity settings. With Apply Page Number Style Globally activated, any change to these type style settings is made throughout the book; for now, leave them unchanged.

Placing photos in a book layout

You can add photos to a page layout in any of the three views.

1 Click the Multi-Page view button at the left of the Toolbar, then drag the thirteenth thumbnail in the Filmstrip, lesson07_013.jpg, up to the cover spread. Drop it in the middle of the spread and it will zoom to fill the covers.

2 Drag the lesson07_011 image from the Filmstrip to page 1 in the Multi-Page view. Place the lesson07_002 and lesson07_009 photos in the left and right image cells on page 2, respectively, and the lesson07_004 image on page 3.

Note: An exclamation mark badge in the upper-right corner of an image cell indicates that the image may not be of a high enough resolution to print well at the current size. You can either reduce the size of the image in your layout, or ignore the alert if you are prepared to accept a lower print resolution.

Changing the images in a photo book

You can remove a photo from a page layout by right-clicking the image in the layout and choosing Remove Photo from the menu. If you simply want to replace a photo, you don't need to remove it first.

1 Drag the lesson07_018 photo onto page 1, which replaces lesson07_011. But I want to keep that one near the front, so drag lesson07_011 onto page 3.

2 In the Multi-Page view, drag the image on page 1—lesson07_018—onto the photo on page 3—lesson07_011. The photos on pages 1 and 3 swap places.

Tip: You should see the image thumbnail move as you drag, not the page itself. If you move the page instead, drag it back into place and try again, making sure to drag from well inside the photo cell.

Tip: You can easily rearrange the order of the pages in your photo book—or even shuffle entire spreads—in the same way; simply drag them to new positions in the Multi-Page view.

Working with photo cells

The photo cells in a page layout template are fixed in place; you can't delete them, resize them, or move them on the page. Instead, you can use the *cell padding*—the adjustable space around a photo within its cell—to position the images in your page layout exactly as you want them.

1 Double-click page 3. The Book Editor switches from Multi-Page view to Single Page view.

2 Click the photo to select it, and then experiment with the Zoom slider. When you enlarge the image too much (for this photo, above 18%), an exclamation-point badge appears in the upper-right corner to alert you that the photo may not print well. Right-click the photo and choose Zoom Photo To Fill Cell; the image is scaled so that its shortest edge fills the cell (at a zoom value of 11%, for this photo). Drag the photo to position it horizontally within the cell. Drag the slider all the way to the left; the minimum setting reduces the image so that its longest edge fits within the image cell. Click well within the borders of the photo and drag it to the top of the cell.

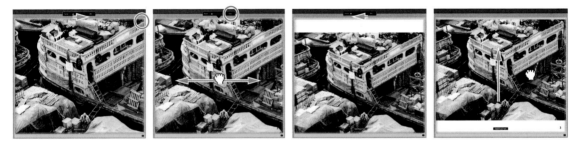

▶ **Tip:** If you don't see the Amount slider, click the triangle above the padding values.

3 Leave the photo at the 0% zoom setting. Expand the Cell panel and increase the padding by dragging the Padding Amount slider or typing a new value of **75** pt.

4 Click the black triangle above the Padding value to expand the padding controls. By default, the four controls are linked so the adjustment you made in the previous step changed all four values. Disable the Link All option (the checkbox darkens), then set the Top padding to **95** pt and the Bottom value to **162** pt.

By starting with the right template and then setting the photo cell padding, you can position an image anywhere on the page, cropped however you wish.

5 In the Cell panel, select Link All, and then drag any of the sliders to set all of the padding settings to zero. Right-click the photo in the Single Image view and choose Zoom Photo To Fill Cell. Drag the image horizontally inside its cell to find a pleasing crop.

6 Click the Spread View button in the Toolbar to see pages 2 and 3 as a spread.

7 Select the image on the left of page 2. Set the linked padding controls to **50** pt, then unlink them and reduce the Right padding to **15** pt. Repeat the process for the photo on the right of page 2, but this time, reduce the Left padding to **15** pt.

8 Double-click the yellow frame below page 2 to see it enlarged in the Single Image view. In the illustration at the right, the photo on the left is zoomed to about 4%, and the photo on the right is zoomed to about 10%. Drag the images inside their cell padding to position them as shown. For a clearer view, click the gray space outside the page to deselect it.

9 In the Toolbar below the Single Image view, click the left navigation arrow to jump to page 1. Along the horizon, I would like to see the mountains on the left instead of the flat horizon on the right side of the image. Drag the image to the right so that the mountains are showing.

10 Click away from the page to deselect it, and then click the Multi-Page View button in the Toolbar for an overview of the changes you've made.

Setting a page background

By default, all the pages in a new book share a plain white background. You can change the background color, set up a partially transparent backdrop image, or choose from a library of graphics, applying this design to the entire book or just one of the pages.

You can start by adding two more spreads to your book layout.

1 Right-click page 4 and choose Add Page from the menu. To apply the default layout to page 5, right-click page 5 and choose Add Page. Right-click page 6 and choose Add Blank Page.

2 Click to select page 6 in the Multi-Page view, and then click the Spread View button in the Toolbar.

3 Expand the Background panel. Deselect the Apply Background Globally option, then drag lesson07_022.jpg to the preview pane in the Background panel. Drag the slider to set the opacity of the image to 50%.

4 Select the Background Color option, and then click the adjacent color swatch to open the color picker. Drag the saturation slider at the right of the color picker about two thirds of the way up its range, and then drag the eyedropper cursor in the picker to find a muted tone; I chose a color with R, G, and B values of 94, 95, and 75, respectively. Press Return/Enter to close the picker.

5 In the Background panel, activate the Apply Background Globally option, and then click the Multi-Page View button in the Toolbar.

Your background is applied to every page (except the Blurb logo page, where only the color is applied); it can be seen on pages 4, 5, 6, and 7 and behind the images on page 2. On other pages, the background design is hidden behind photo cells.

6 Deselect the Background Color option, then right-click the image in the background preview pane and choose Remove Photo. Deselect Apply Background Globally.

7 Select page 2 in the Multi-Page view, and then reactivate the Background Color option. Click the color swatch to open the color picker, and then click the black swatch at the top of the picker. Press Return/Enter to close the color picker.

Adding text to a photo book

There are several ways to add text to your pages in the Book module, each useful in different situations:

- Text cells that are built into page layout templates are fixed in position; they can't be deleted, moved, or resized, but you can use the adjustable cell padding to position text anywhere on a page.

- A photo caption is a text cell that is linked to a single image in the layout. It can be positioned above or below an image, or overlaid on the photo, and can be moved vertically on the page.

- A page caption is a text cell that is linked to the page as a whole, rather than any particular image. Page captions span the full width of the page; you can move them vertically, and then adjust the cell padding to position text horizontally, enabling you to place custom text anywhere in your layout.

On a single page, you can add a page caption, and a separate photo caption for each image—even if the page is based on a layout template that has no fixed text cells. Fixed text cells and photo captions can be configured for custom text or set to display captions or titles extracted automatically from your photos' metadata.

The Book module incorporates state-of-the-art text tools that give you total control over every aspect of the text styling. Type attributes can be adjusted using sliders or numerical input, or tweaked visually with the Text Adjustment tool.

Working with text cells

As mentioned above, text cells incorporated in a page layout template are fixed in place. Instead, you can use the adjustable cell padding—the space surrounding the text within its cell—to position text in your page layout exactly as you want it.

1 Click the Multi-Page View button to see your entire book layout, then double-click just below the cover spread to zoom in on the layout. Click in the center of the front cover to select the fixed text cell.

2 Expand the Type panel. Make sure that the Text Style Preset is set to Custom to accommodate manually entered text, rather than metadata from the image.

3 Choose a font and type style from the menus below the preset setting. I chose American Typewriter, Regular. Click the Character color swatch to open the color picker, click the white swatch at the top of the picker, and then press Return/Enter to close the picker.

> **Tip:** To select a page or a spread, rather than the text and image cells in the layout, click near the edge of the thumbnail or just below it.

Set the type size to 43 pt, and leave the opacity set to 100%. Click the Align Center button at the lower left of the Type panel.

4 Type the word **Welcome**, then, press Return/Enter and type **Dubai**. Double-click the word *Dubai* to select it, and then type **120** pt in the Size text box to increase the size of the selected text.

5 Keeping the text selected, click the black triangle at the right of the Character color swatch to see the type attribute controls. Reduce the Leading—the spacing between the selected text and the line above it—to 72 pt. To keep the text off the image's subject (me), select both lines of text and click the Align Right button at the bottom of the panel.

▶ **Tip:** Once you've changed the Leading value, the Auto Leading button becomes available below the text adjustment controls, making it easy for you to quickly reinstate the default setting. The Auto Kerning button works the same way.

6 Click inside the text cell, but away from the text, to keep the cell selected while deselecting the text, then expand the Cell panel. Deselect the Link All option, and then increase the Top padding to **120** pt.

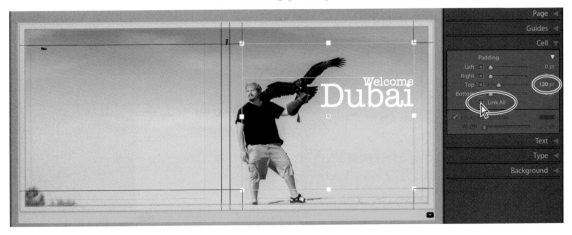

Fine-tuning type

In the Type panel, Lightroom incorporates a suite of sophisticated, yet easy-to-use, type tools that allow you detailed control over the text styling. You can use the adjustment sliders and numerical input to set type attributes in the Type panel, or tweak your text visually in any view using the intuitive Text Adjustment tool.

1 Expand the Type panel and examine the four controls below the Size and Opacity sliders. Be sure to undo any changes you make at this stage.

- **Tracking** adjusts the letter spacing throughout a text selection. You can use tracking to change the overall appearance and readability of your text, making it look either more open or more dense.

- **Baseline** adjusts the vertical position of selected text relative to the baseline—the imaginary line on which the text sits.

- **Leading** adjusts the space between selected text and the line above it.

- **Kerning** adjusts the letter spacing between specific pairs of letters. Some pairings produce optical effects that cause letter spacing to appear uneven; place the text insertion cursor between two letters to adjust the kerning.

2 Select all of the text in the front cover text cell, and then click to activate the Text Adjustment tool, to the left of the Character color setting in the Type panel.

3 Drag horizontally across the selection to adjust the text size. The adjustment is applied relatively; the different sizes of text are changed by relative amounts. Choose Edit > Undo or press Command+Z/Ctrl+Z to undo the change.

4 Drag vertically over the selection to adjust the leading, then choose Edit > Undo or press Command+Z/Ctrl+Z to undo.

5 Hold down the Option/Alt key—to temporarily disable the Text Adjustment tool—and drag up from the letter D in Dubai to select the word **Welcome**, leaving the word **Dubai** unselected. Release the Option/Alt key and the mouse button, and hold Command/Ctrl as you drag horizontally over the selected text to decrease the tracking slightly. Watch the Tracking control in the Type panel as you drag to set a value of −4 em.

6 Release the mouse button. Hold down the Command/Ctrl key and drag vertically over the selected text to shift it in relation to its baseline. Drag it to 13 pt and click away from the text to deselect it.

7 If necessary, press F7, or choose Window > Panels > Hide Left Module Panels to see your front cover text larger. Make sure that the Text Adjustment tool is still

active, then use your left arrow to move your cursor between the W and E in Welcome. Drag to the left over the insertion point. Watch the Type panel as you drag to set a Kerning value of –140 em.

8 Reset your leading for the type by selecting the text and dragging the leading slider until it looks good. Click the Text Adjustment tool in the Type panel to disable it, and then click the Multi-Page View button in the Toolbar to see your entire book layout. Double-click page 1 to zoom to the Single Page view.

Working with captions

Unlike the fixed text cells built into layout templates, page and photo caption cells can be moved vertically; horizontal placement of captions is achieved by adjusting padding. Each page can include one page caption text cell and one photo caption cell for each photo on the page, even if the page template has no built-in text cells.

1 Right-click the header of the Type panel and disable Solo Mode; then, leaving the Type panel open, expand the Text panel.

▶ **Tip:** If you prefer, you can add a photo or page text caption by selecting the respective option in the Text panel, rather than using the floating buttons.

2 Move the pointer over page 1. The template for this page has no fixed text cell; hence, nothing is highlighted. Click the photo, then click the Add Photo Text button. In the Text panel, the Photo Text controls become active. Press Command+Z/Ctrl+Z to undo the photo caption. Now click the yellow footer below the photo to switch the Add Photo Text button to the Add Page Text button. Click the Add Page Text button, and the Page Text controls are activated in the Text panel.

● **Note:** Unlike fixed template text cells and photo captions, page captions can't be set to display information drawn from a photo's metadata; they can only be used for custom text.

3 To anchor the page caption to the top of the page, click the Top button in the Page Text controls, then drag the Offset slider to 9 pt.

4 With the page caption active, set up the Type panel as you did for steps 2 and 3 of the "Working with text cells" exercise earlier in this lesson, but set the Size to 60 pt, set the Tracking to 3 em, and click the Auto Leading button. Then type

whatever you like in the page caption, using the Return/Enter key to break the lines so that the text is shaped to fit the image, as in the illustration below.

5 Click the Multi-Page View button in the Toolbar.

Creating a custom text preset

You can save your text settings as a custom text preset, so you can apply the same style elsewhere in your book or reuse it in a different project, by choosing Save Current Settings As New Preset from the Text Style Preset menu in the Type panel.

Saving and reusing custom book page layouts

Once you've used cell padding and caption text to modify a page layout, you can save your design as a custom template that will be listed in the Page Layout menus.

1 Expand the Page panel, then watch the layout thumbnail as you right-click the page 1 preview and choose Save As Custom Page.

The original single-photo layout now is overlaid by a text cell with the proportions and position of the page caption we just created.

2 Click the Change Page Layout button below the lower-right corner of the page preview, or to the right of the Page panel's layout thumbnail. The saved layout is listed in the Custom Pages category.

Another way to reuse the work you've put into a layout is to copy and paste it directly onto another page in your book, where you can use it as is or make further modifications to the design. You'll find the Copy Layout and Paste Layout commands in the same menu you used in step 1 when you right-clicked the page.

Creating a saved book

Since you entered the Book module, you've been working with an unsaved book, as is indicated in the bar across the top of the work area.

Until you save your book layout, the Book module works like a scratch pad. You can move to another module, or even close Lightroom, and find your settings unchanged when you return, but if you need to clear the layout to begin another project, all your work will be lost.

Converting your project to a saved book not only preserves your work, but also links your book layout to the particular set of images for which it was designed.

Your photo book is saved as a special kind of collection—an output collection—with its own listing in the Collections panel. Clicking this listing will instantly retrieve the images you were working with and reinstate all of your settings, no matter how many times the book layout scratch pad has been cleared.

1 Click the Create Saved Book button in the bar at the top of the work area, or click the New Collection button in the header of the Collections panel and choose Create Book.

2 In the Create Book dialog box, type **Dubai Book** as the name for your saved layout. Make sure that, in the Location options, the Inside option is selected with the Dubai collection chosen from the menu, then click Create.

Your saved book appears in the Collections panel, marked with a Saved Book icon and nested inside the source collection. The image count shows that the output collection includes only six of the photos in the source collection. The bar above the work area shows the name of the book.

> **Tip:** Adding more images to your saved photo book is easy: simply drag photos to the book's collection in the Collections panel. To jump directly from the Library to your layout in the Book module, move the pointer over your saved book in the Collections panel and click the white arrow that appears to the right of the image count.

Depending on the way you like to work, you can save your book layout at any point in the process—you could create a saved book as soon as you enter the Book module with a selection of images, or wait until your design is finalized.

Once you've saved your book project, any further changes you make to the design are auto-saved as you work.

Copying a saved book

Your saved photo book design represents a lot of effort. If you want to try something different without losing what you already have, or add pages and photos without a clear idea of what you'd like to achieve, you can duplicate your saved book and make changes to it without the risk of losing your work thus far.

1 Right-click your saved book in the Collections panel and choose Duplicate Book from the menu.

If you're happy with your extended design, you can delete the original saved book, and then rename the duplicate.

2 Right-click the original saved book in the Collections panel and choose Delete, then confirm the deletion.

3 Right-click the duplicated book in the Collections panel and choose Rename. In the Rename Book dialog box, delete the word *Copy* from the end of the book's name, and then click Rename.

Exporting a photo book

You can upload your book to Blurb.com, or export it to a PDF and print it at home.

1 To publish your photo book to Blurb.com, click the Send Book To Blurb button below the right panel group.

2 In the Purchase Book dialog box, either sign in to Blurb.com with your email address and password, or click "Not A Member?" in the lower-left corner and register to get started.

3 Enter a book title, subtitle, and author name. You'll see an alert at this stage warning that your book must contain at least 20 pages; the Upload button is disabled. Click Cancel, or sign out of Blurb.com first and then cancel.

Books published to Blurb must have between 20 and 240 pages, not including the front and back covers. Blurb.com prints at 300 dpi; if a photo's resolution is less than 300 dpi, an exclamation point badge (!) appears in the upper-right corner of the image cell in the work area. Click the exclamation point to find out what print resolution can be achieved for that photo. Blurb.com recommends a minimum of 200 dpi for optimum quality.

For help with printing, pricing, ordering, and other Blurb.com issues, visit the Blurb.com Customer Support page.

4 To export your photo book as a PDF file, first choose PDF from the Book menu at the top of the Book Settings panel. Examine the controls that appear in the lower half of the Book Settings panel. You can leave the JPEG Quality, Color Profile, File Resolution, Sharpening, and Media Type settings at their defaults for now (these will change based on the printer and paper you're using). Click the Export Book To PDF button below the right panel group.

5 In the Save dialog box, type **Dubai** as the name for the exported book. Navigate to your LRClassicCIB\Lessons\lesson07 folder, and then click Save.

6 To export your Blurb photo book as a PDF file for proofing purposes, leave the Book selection set to one of the Blurb choices, and click the Export Book To PDF button below the left panel group.

Well done! You've successfully completed another Lightroom Classic lesson. In this lesson, you learned how to put together an attractive photo book to showcase your images.

In the process, you've explored the Book module and used the control panels to customize page templates, refine the layout, set a backdrop, and add text.

In the next lesson, you'll find out how to present your work in a dynamic slideshow, but before you move on, take a few moments to reinforce what you've learned by reading through the review questions and answers on the next page.

Review questions

1 How do you modify a photo book page layout?

2 What options are available for page numbering?

3 What is cell padding and how is it used?

4 What text attributes are affected by the Tracking, Baseline, Leading, and Kerning controls in the Type panel?

5 How can you use the Text Adjustment tool to fine-tune text?

Review answers

1 Click the Change Page Layout button to the right of the layout preview thumbnail in the Page panel, or in the lower-right corner of a selected page or spread displayed in the work area. Choose a layout category, and then click a layout thumbnail to apply that template. Use cell padding to tweak the layout.

2 Page numbering can be found in the Page panel, where you can also set the global position for the numbers, and whether you want them on both right and left pages. Use the Type panel to set text style attributes. Right-click a page number to apply the style globally, hide the number on a given page, or have the page numbering start on a page other than page 1.

3 Cell padding is the adjustable space around an image or text within its cell. It can be used to position text or a photo anywhere on the page. In combination with the Zoom slider, it also can be used to crop an image any way you wish.

4 Tracking adjusts the letter spacing throughout a text selection, making it look either more open or more dense. The Baseline setting shifts selected text vertically in relation to the baseline. Leading affects the space between selected text and the line above it. Kerning adjusts the letter spacing between specific pairs of letters.

5 Drag horizontally across selected text to adjust the text size. Drag vertically over the selection to increase or decrease the leading (line spacing). Hold down the Command/Ctrl key as you drag horizontally over selected text to adjust the tracking. Hold down the Command/Ctrl key and drag vertically over a text selection to shift it in relation to its baseline. Hold down the Option/Alt key to temporarily disable the Text Adjustment tool when you wish to change the text selection. Click between a pair of letters to place the text insertion cursor, and then drag horizontally across the text insertion point to adjust kerning.

I'm eternally grateful that I have eyeballs. Wired to my brain. Ducted through my heart.

I'm endlessly fascinated by how light follows this path and produces an emotional tug on how people and things look. It's never neutral. Capturing light as it exists, reproducing it from memory, or creating it from scratch is the challenge I relish in eliciting an immediate response from the viewer. It is how I approach making an image. It's my way in; once I envision the light, the rest falls into place. I know how the picture will look.

Light is all the camera sees, but it never sees it the way I do in my mind. So I need to be the interpreter, translating the language of the light into the more limited language the camera can understand; otherwise, there's a heartbreaking disparity between what I can see and imagine, and what I actually get.

Traditionally, camera settings were the primary tool for interpreting light. Conventional darkroom techniques allowed a further measure of control. Then the addition of flash or continuous illumination offered the opportunity to completely reinterpret, reshape, or re-create the light. Now, Lightroom and Photoshop have presented us with incredibly sophisticated tools to work with the light after the image has been captured.

This can be used to create fantastical effects and fiction, or to faithfully restore the image as seen or experienced, which is essentially a documentary pursuit. This is why I believe it is essential to understand and master these applications. It is critical for the photographer to make these post-production decisions. They are not purely aesthetic. They affect the narrative in an immediate and powerful way. Only the photographer knows what was originally seen, felt, and experienced. Only the photographer knows the intention driving the image.

Only the photographer can be its true author, and light is the key.

www.gregoryheisler.com
instagram.com/eyeballcalisthenics

MUHAMMAD ALI

ROBERT BALLARD

DENZEL WASHINGTON

HARRY BELAFONTE

KUSHOK BAKULA

8 CREATING A SLIDESHOW

Lesson overview

Once you've spent time bringing out the best in your images, showing them off in a slideshow is one of the easiest and most effective ways to share your photos with friends and family or to present them to a client. Choose a template as a starting point, then customize the layout, color scheme, and timing. Add backdrops, borders, text overlays—even music and video—to create a dynamic presentation that will complement your work and captivate your audience. In this lesson, you'll learn how to:

- Group the images for your slideshow as a collection.

- Choose a slideshow template, adjust the layout, set a backdrop image, and add a text overlay, sound, and motion.

- Save your slideshow and your customized template.

- Export your presentation.

- View an impromptu slideshow.

 This lesson will take about 1 to 2 hours to complete. To get the lesson files used in this chapter, download them from the web page for this book at www.adobepress.com/LRClassicCIB2020. For more information, see "Accessing the lesson files and Web Edition" in the Getting Started section at the beginning of this book.

In the Slideshow module you can quickly put together an impressive onscreen presentation complete with stylish graphic effects, transitions, text, music, and even video. Lightroom Classic makes it easier than ever to share your images with family and friends, clients, or the world at large by giving you the option of exporting your slideshow to PDF or video.

Getting started

● **Note:** This lesson assumes that you already have a basic working familiarity with the Lightroom Classic workspace. If you need more background information, refer to Lightroom Classic Help, or review the previous lessons.

Before you begin, make sure you've set up the LRClassicCIB folder for your lesson files and created the LRClassicCIB Catalog file to manage them, as described in "Accessing the lesson files and Web Edition" and "Creating a catalog file for working with this book" in the "Getting Started" section at the start of this book.

If you haven't already done so, download the lesson08 folder from your Account page at www.peachpit.com to the LRClassicCIB\Lessons folder, as detailed in "Accessing the lesson files and Web Edition" in the "Getting Started" section.

1 Start Lightroom Classic.

2 In the Select Catalog dialog box, make sure the file LRClassicCIB Catalog.lrcat is selected under Select A Recent Catalog To Open, and then click Open.

Adobe Photoshop Lightroom Classic - Select Catalog

Select a recent catalog to open

Lr	LRClassicCIB Catalog.lrcat	/Users/rc/Pictures/LRClassicCIB Catalog
Lr	LPCIB Catalog.lrcat	/Users/rc/Documents/LPCIB/LPCIB Catalog
Lr	RC Main Catalog-2.lrcat	/ - Personal/ - Lightroom Area
Lr	Lightwork Show LR Catalog.lrcat	/ - Syracuse/- Completed Projects/Lightwork Show LR Catalog
Lr	South Africa Print Show.lrcat	/ - Syracuse/ - Open Projects/South Africa Print Show
Lr	VIS Event Catalog.lrcat	/ - Syracuse/Resources/Vis Event/VIS Event Catalog
Lr	324.lrcat	/Users/rc/324

☐ Always load this catalog on startup ☐ Test integrity of this catalog

Note: Lightroom Catalogs cannot be on network volumes or in read-only folders.

[Choose a Different Catalog...] [Create a New Catalog...] [Quit] [**Open**]

▶ **Tip:** If you can't see the Module Picker, choose Window > Panels > Show Module Picker, or press the F5 key. If you're working on macOS, you may need to press the fn key together with the F5 key, or change the function key behavior in the system preferences.

3 Lightroom Classic will open in the screen mode and workspace module that were active when you last quit. If necessary, switch to the Library module by clicking Library in the Module Picker at the top of the workspace.

Lr LRClassicCIB Catalog.lrcat - Adobe Photoshop Lightroom Classic - Library

Lr Adobe Lightroom Classic
Rafael Concepcion (Library) Develop | Map | Book | Slideshow | Print | Web

Importing images into the library

The first step is to import the images for this lesson into the Lightroom library.

1 In the Library module, click the Import button below the left panel group.

▶ Collections +
▶ Publish Services +
[Import...] [Export]

2 If the Import dialog box appears in compact mode, click the Show More
 Options button at the lower left of the dialog box to see all the options in the
 expanded Import dialog box.

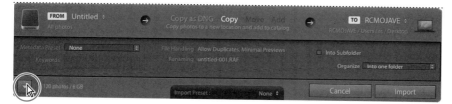

3 Under Source at the left of the expanded Import dialog box, locate and select
 your LRClassicCIB\Lessons\lesson08 folder. Ensure that all 24 images in the
 lesson08 folder are selected (checked) for import.

4 In the import options above the thumbnail previews, select Add so that the
 imported photos will be added to your catalog without being moved or copied.
 Under File Handling at the right of the expanded Import dialog box, choose
 Minimal from the Build Previews menu and leave the Don't Import Suspected
 Duplicates option unselected. Under Apply During Import, choose None from
 both the Develop Settings menu and the Metadata menu and type **Lesson
 08, Mexico** in the Keywords text box. Make sure that your import is set up as
 shown in the illustration below, and then click Import.

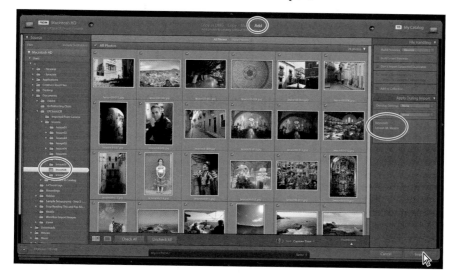

The 24 images are imported and now appear in both the Library module's Grid
view and the Filmstrip across the bottom of the Lightroom workspace.

Assembling photos for a slideshow

▶ **Tip:** Your slideshow can include video as well as still images.

The first step in creating a slideshow is to gather the photos you wish to include. Since we just imported them, the images for this lesson are already isolated from the rest of your catalog in the Previous Import folder, which is selected.

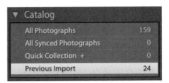

Although you could move to the Slideshow module now, this isn't a good solution. The Previous Import folder is a temporary grouping. The next time you import images into Lightroom, the Previous Import will contain another set of images. Also, the images there cannot be reorganized.

1 With the Previous Import folder selected, in the Grid view, drag the second picture down after the fourth picture. You'll see a warning dialog letting you know that this picture cannot be reorganized into a custom order.

There will be many times that you'll want to organize a set of images for a slide-show that come from a variety of folders in your catalog. If you want to make a slideshow of the best pictures you took all year, you'll need them all in one place, but they'll come from different folders.

What do you do? Create a collection to group the photos for your project, where you can rearrange the image order and add to it from different sources. A collection has a permanent home in the Collections panel, which is accessible in every module, making it easy to retrieve the set of images at any time.

▶ **Tip:** You can reorder photos in a collection by simply dragging the thumbnails in the Grid view or the Filmstrip. Your custom display order will be saved with the collection.

2 With the Previous Import folder still selected, press Command+A/Ctrl+A or choose Edit > Select All. Click the plus sign (+) button in the Collections panel's header and choose Create Collection from the menu. In the Create Collection dialog box, type **Mexico** as the name for

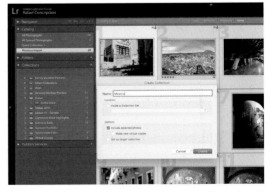

the new collection. Make sure the Include Selected Photos option is selected and the rest of the options are unselected, then click Create.

Your new collection appears in the Collections panel, where it's automatically selected. The image count at the right indicates that the Mexico collection contains 24 photos.

This is also a good time to point out that as your list of collections increases, it may become harder to find a collection. Directly under the Collections panel's header, there is a search box. Type in any collection name, and it searches all the collections in the panel for a match.

3 With the Mexico collection selected, in the Toolbar below the Grid view, change the Sort menu to File Name (you can reorganize them later, while setting up your slideshow).

4 Press Option+Command+5/Alt+Ctrl+5, or click Slideshow in the Module Picker to switch to the Slideshow module.

Tip: The first time you enter any of the Lightroom modules, you'll see tips that help you identify the components of the workspace and understand the workflow order. You can dismiss the tips by clicking the Close button. To reactivate the tips for any module, choose [*Module name*] Tips from the Help menu.

Working in the Slideshow module

The Slide Editor view is the main area where you'll work on your slide layouts and preview your slideshow in operation.

In the left panel group, the Preview panel displays a thumbnail preview of whichever layout template is currently selected (or under the pointer) in the Template Browser panel, while the Collections panel provides easy access to your photos.

Note: Your preview may look slightly different from the illustration, depending on the size and proportions of your computer display.

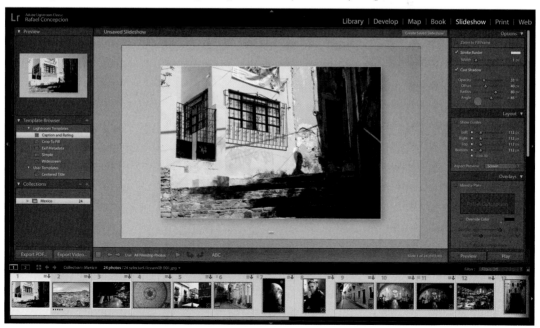

The Toolbar below the Slide Editor view offers controls for navigating through the images in your collection, previewing the slideshow, and adding text to your slides.

Choosing a slideshow template

Each of the preset Lightroom slideshow templates incorporates a different combination of layout settings—such as image size, borders, backgrounds, shadows, and text overlays—that can be customized to create your own slide designs.

▶ **Tip:** The default template will be used when you launch the impromptu slideshow from another module. To designate a different template for this purpose, right-click its name in the Template Browser and choose Use For Impromptu Slideshow. A plus sign (+) appears after the name of the new default template.

1 In the Template Browser panel, expand the Lightroom Templates folder, if necessary, then move the pointer slowly up and down the list of Lightroom templates. The Preview panel shows you how the selected image looks in each template layout as you move over it. Select a different image in the Filmstrip, and then preview the templates again.

2 When you're done previewing the options in the Template Browser, click to select the Widescreen template.

3 In the Toolbar below the slide preview, choose All Filmstrip Photos from the Use menu. In the Filmstrip, select the first image, lesson08-001.

4 Click the Preview button at the bottom of the right panel group to preview your presentation in the Slide Editor view. When you're done, press the Esc key on your keyboard, or click in the Slide Editor view to stop the preview.

Template options for slideshows

As a convenient starting point for creating your own slide layouts, you can choose from these customizable Lightroom templates:

Caption And Rating This template centers the images on a gray background and displays the photo's star rating and caption metadata on each slide.

Crop To Fill Your photos fill the screen and may be cropped to fit the screen's aspect ratio, so this is probably not a good option for images in portrait format.

EXIF Metadata The slides are centered on a black background and include star ratings, EXIF (Exchangeable Image Format) information, and your identity plate.

Simple This template centers your photographs on a black background and incorporates your custom identity plate.

Widescreen Your images are centered and sized to fit the screen without being cropped; any empty space outside the image is filled with black.

Customizing your slideshow template

For the purposes of this lesson, you won't be adding an identity plate or metadata information to your slides, so the Widescreen template will serve as a good basis for setting up a customized layout.

Adjusting the slide layout

Once you've chosen a slide template, you can use the controls in the right panel group to customize it. For this project, you'll start by modifying the layout, and then change the background to set up the overall look of the design before you make decisions about the style and color of borders and overlaid text. The Layout panel enables you to change the size and position of the photo in the slide layout by setting the margins that define the image cell.

1 If the Layout panel in the right panel group is currently collapsed, expand it by clicking the triangle beside its name. Make sure that the Show Guides and Link All options are selected. If your screen has an aspect ratio other than 16:9, choose 16:9 from the Aspect Preview.

▶ **Tip:** Video clips in a slideshow are placed in your slide layout in the same way as still images, complete with borders and shadows.

2 Move the pointer over the lower edge of the image in the Slide Editor view. When the pointer changes to a double-arrow cursor, drag the edge of the image upward. As you drag, gray layout guide lines appear against the black background around the scaled-down image. All four guides move at the same time because the Link All option is selected in the Layout panel. As you drag upward, watch the linked sliders and numerical values change in the Layout panel and release the mouse button when the values reach 55 px.

▶ **Tip:** You could also drag the sliders in the Layout panel, or click the pixel values and type new numbers, to adjust the size of the image in the slide layout. With the settings linked, you only need to drag one slider or enter one value. Remember that the proportions of your slides may differ from what you see in the illustrations in this lesson, depending on the aspect ratio of your computer display.

Now you can increase the width of the slide's top margin to create a space where you can add text later in the lesson.

3 In the Layout panel, deselect the Link All option, and then either drag the Top slider to the right, type over the adjacent pixel value, or drag the top guide in the Slide Editor to set a value of 135 px. Deselect the Show Guides option, and then collapse the Layout panel.

Setting up the slide background

In the Backdrop panel, you can set a flat background color for your slides, apply a graduated color wash, or place a background image—you can even mix all three elements to create an atmospheric frame for your photos.

1 In the Filmstrip, select any image other than the fourth photo in the series.

2 If necessary, expand the Backdrop panel in the right panel group. Select the Background Image option, and then drag the fourth image, lesson08-004, from the Filmstrip into the Background Image well. Drag the Opacity slider to the left to reduce the value to around 50%, or click the Opacity value and type **50**.

With the Background Color option disabled, the default black background shows through the partially transparent image, effectively darkening it. However, the background is still competing too much with the featured photos. You can use the Color Wash feature to darken the backdrop a little more. Color Wash applies a graduated wash that fades from whatever color is set in the Color Wash swatch to the background image (or color).

3 Select the Color Wash option. Click the Color Wash swatch, and then click the black swatch at the top of the Color Picker.

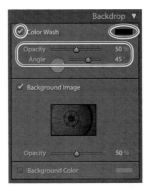

4 Click the Close button at the upper left of the Color Picker, and then use the Opacity slider to set the color wash opacity to 50%. Set the Angle of the wash to 45. When you're done, collapse the Backdrop panel.

With the background photo set to partial transparency, your backdrop design is now a composite of all three optional elements: a graduated color wash, an image, and the default background color.

Adjusting stroke borders and shadows

Now that you've established the overall layout and feel for your slides, you can "lift" the images to make them stand out more against the background by adding a thin stroke border and a drop shadow. We'll choose a border color that will provide a contrast to the predominantly gold backdrop.

1 In the right panel group, expand the Options panel. Select the Stroke Border option, and then click the color swatch beside it to open the Color Picker.

2 To set a pale blue color for the stroke border, click to select the R, G, and B percentages at the lower right of the Color Picker in turn and type values of **70**, **85**, and **90**, respectively. Click outside the Color Picker to close it.

3 Use the Width slider to set a width of 1 px or type **1** in the text box.

4 Select the Cast Shadow option in the Options panel and experiment with the controls. You can adjust the opacity of the shadow, the distance the shadow is offset from the image, the angle at which it is cast, and the Radius setting, which affects the softness of the shadow's edge. When you're done, set the controls as in the illustration at the right, and then collapse the Options panel.

Adding a text overlay

● **Note:** For this exercise, you won't incorporate an identity plate or watermark in your slideshow. For more information on identity plates, refer to the online bonus chapter "Publishing Your Photos" or the Lightroom Classic Help topic "Add your identity plate to a slideshow."

In the Overlays panel, you can add text, an identity plate, or a watermark to your slides and have Lightroom display the rating stars you've assigned to your images or the captions that you've added to their metadata. In this exercise, you'll add a simple headline that will be overlaid on the background for every slide.

1 Expand the Overlays panel and select the Text Overlays option. If the Toolbar is not visible just below the Slide Editor view, press the T key. In the Toolbar, click the Add Text To Slide button (ABC).

| | | Use: All Filmstrip Photos ⇕ | ▶ | ↳ ↵ | **ABC** | Slide 12 of 12 (0:01:22) |

Add text to slide

2 Type **GUANAJUATO MEXICO** in the Custom Text box, and press Return/Enter. The text appears in the lower-left corner of the slide, surrounded by a bounding box.

| | ← → | Use: All Filmstrip Photos ⇕ | ▶ | ↳ ↵ | ABC | Custom Text ⇕ | **GUANAJUATO MEXICO** |

3 The settings in the Text Overlays area of the Overlays panel update to show the default font details. Click the double triangle beside the font name and choose a different font, then choose the face. Here, I chose Helvetica Neue Condensed Bold. Leave the text color set to the default white (the swatch at the right of Text Overlays). If it's too bright, decrease the Opacity to 80% to soften the effect.

4 Drag the text upward, and allow it to attach itself to the anchor at the center of the slide's upper edge. Drag the handle at the bottom of the text bounding box upward to scale the text, making it a little smaller, then use the up and down arrow keys to position the title as shown in the illustration below.

As you drag text on a slide layout, Lightroom tethers the bounding box either to the nearest of various reference points around the edge of the slide or to a point on the border of the image itself.

5 To see this in operation, drag the text around the slide, both inside and outside of the image, and watch the white tether-line jump from point to point. When you're done, return the text to its original position.

Throughout a slideshow, the tethered text will maintain the same position either relative to the slide as a whole, or to the border of each image, whatever its shape.

You can use this feature to ensure that photo-specific caption text, for instance, will always appear just below the left corner of each image no matter what its size or orientation, while a title that applies to the presentation as a whole—as does the text in our example—will remain in a constant position on the screen. In the latter case, the text is tethered to one of the anchors around the edge of the slide; in the former, the text would be tethered to an anchor on the border of the feature image.

The color and opacity controls in the Text Overlays area operate just as they do in the Color Wash and Stroke Border areas. On macOS, you can also set up a drop shadow for your text.

6 Collapse the Overlays panel and deselect the text box in the Slideshow Editor.

7 Select the first slide in the Filmstrip and click the Preview button at the bottom of the right panel group to preview your slideshow in the Slideshow Editor view. When you're done, press Esc to stop playback.

Using the Text Template Editor

In the Slideshow module, you can use the Text Template Editor to access and edit the metadata that is stored in your photos and set up text overlays to be displayed on each slide, drawn from that information. You can add custom text and choose from titles, captions, image size, camera info, and a wide range of other options, then save your choices as a text template preset that will help you streamline and automate your workflow for similar projects in the future.

To call up the Text Template Editor, first click the Add Text To Slide button (ABC) in the Toolbar, then click the double triangle beside the Custom Text box in the Toolbar and choose Edit from the menu.

In the Text Template Editor, you can set up a string of one or more text tokens, placeholders that represent the information items to be drawn from each photo's metadata for display in your slideshow.

In the Preset menu at the top of the editor, you can apply, save, and manage text overlay presets, saved sets of info tokens that are customized for different purposes.

Use the Image Name menu to set up a text string with the current or original filename, copy name, or folder name.

Use the Numbering menu to number the images in your slideshow and display image capture dates in a variety of formats.

Choose from EXIF metadata including image dimensions, exposure, flash settings, and many other attributes.

IPTC metadata includes copyright, creator details, and numerous other options.

Creating a saved slideshow

Since you entered the Slideshow module, you've been working with an unsaved slideshow, as is indicated in the bar across the top of the Slideshow Editor view.

> **Unsaved Slideshow** Create Saved Slideshow

Until you save your slideshow, the Slideshow module works like a scratch pad. You can move to another module, or even close Lightroom Classic, and find your settings unchanged when you return, but if you click a new slideshow template—or even the one you started with—in the Template Browser, the "scratch pad" will be cleared and all your work will be lost.

Converting your project to a saved slideshow not only preserves your layout and playback settings, but also links your design to the particular set of images for which it was designed. Your slideshow is saved as a special kind of collection—an output collection—with its own listing in the Collections panel. Clicking this listing will instantly retrieve the images you were working with, and reinstate all of your settings, no matter how many times the slideshow scratch pad has been cleared.

1 Click the Create Saved Slideshow button in the bar at the top of the Slideshow Editor view, or click the plus sign (+) button in the header of the Collections panel and choose Create Slideshow.

2 In the Create Slideshow dialog box, type **Guanajuato Slideshow** as the name for your saved presentation. In the Location options, select Inside and choose the Mexico collection from the menu, then click Create.

> **Tip:** The Make New Virtual Copies option is useful if you wish to apply a particular treatment, such as a developing preset, to all the pictures in your slideshow, without affecting the photos in the source collection.

The title bar above the Slide Editor now displays the name of your saved slideshow, and no longer presents the Create Saved Slideshow button.

Your saved slideshow appears in the Collections panel, marked with a Saved Slideshow icon and nested inside the original source collection, Mexico. The image count shows that the new output collection, like the source, contains 24 photos.

You can save your slideshow at any point in the process—you could create a saved slideshow as soon as you enter the Slideshow module with a selection of images or wait until your presentation is polished. Once you've saved your slideshow, any changes you make to the layout or playback settings are auto-saved as you work.

For the purposes of this lesson, saving the project at this stage enables you to delete and rearrange slides to refine your presentation, without affecting the source collection. Any image you exclude from the slideshow now will be removed from the NYC Slideshow output collection but will remain a part of your NYC collection.

This could be useful if you also plan to use the photos in the NYC collection to produce a print layout and a web gallery, for instance. Your original collection remains intact, while the output collection for each project may contain a different subset of images, arranged in a different order.

Refining the content of a slideshow

▶ **Tip:** Adding more photos to your saved slideshow is easy: simply drag images to the slideshow's listing in the Collections panel. Click the white arrow that appears to the right of the image count when you move the pointer over your saved slideshow in the Collections panel to jump from the Library to your presentation in the Slideshow module.

It's a good idea to finalize the photo set for your slideshow at this point, before you go on to specify playback settings. If you remove an image later, you might need to readjust the time allocated for each slide and transition, especially if your slideshow is timed to match the duration of a sound file.

1 In the Filmstrip, right-click the lesson08-004 image—the photo you used as a background image—and choose Remove From Collection.

Note that, although the photo disappears from the Filmstrip and will not feature on any slide in the presentation, it is not removed from the slide background in the Slide Editor view. The background image has become part of the slide layout, rather than merely one of the selected photos to be displayed.

Even if you fill your slideshow with a different set of photos entirely, the background image will remain in place. Your saved slideshow includes a link to the photo that is independent of the output collection or its parent collection.

In the Collections panel, the nested Guanajuato Slideshow output collection now shows an image count of 23 photos, while its parent collection still contains the original count of 24.

2 In the Filmstrip, drag the photo lesson08-007 to a new position between the lesson08-005 and lesson08-006 images, releasing the mouse button when the black insertion bar appears.

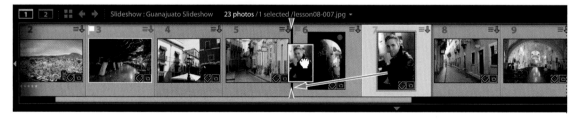

Adding sound and motion to your slideshow

One way to make your presentation more dynamic is to add video clips, which are placed on their own slides according to your layout, just like your photos—complete with stroke borders, shadows, and overlays.

Even for a slideshow composed entirely of still images, you can easily create atmosphere and generate emotional impact by adding music, and bring your photos to life with filmic pan and zoom effects.

You'll find a sound file named guanajuato-rc.mp3 in your lesson08 folder. This piece of music will underline the bright, vibrant theme of the slideshow; however, feel free to choose any other file from your music library that you'd like. With only 23 images in the slideshow, a fairly short piece will probably work best.

1 Expand the Music and Playback panels in the right panel group. Click the switch at the left of the Music panel's header to enable the soundtrack for your slideshow. Click the Add Music button, then navigate to your LRClassicCIB\Lessons\lesson08 folder, select the guanajuato-rc.mp3 file, and click Open/ Choose.

The name of the sound file and its duration are displayed in the Music panel.

2 Expand the Titles panel and select both the Intro Screen and Ending Screen options. Deselect the Add Identity Plate option for both screens.

The next step is to fine-tune the timing of the slideshow by setting the duration of the slides and the transitions between them to match the length of the music file.

3 In the Playback panel, watch the Slide Length and Crossfades values change as you click the Fit To Music button below the sliders.

The timing is adjusted to fit the 23 images and two title screens to the duration of the music file.

4 Drag the Crossfades slider to the right to increase the duration of the fade transitions to 4 seconds, and then click the Fit To Music button once more, keeping an eye on the Slide Length value as you do so. Lightroom recalculates the slide duration so that the slideshow fits the music file despite the lengthened fades.

5 Deselect the Repeat Slideshow and Random Order options, farther down in the Playback panel. In the Filmstrip, select the first image, then click the Preview button at the bottom of the right panel group to preview the slideshow in the Slideshow Editor view. When you're done, press Esc to stop playback.

Adding music has created a sense of narrative for the presentation; now it's time to add some movement that will help to make it not just a story, but a journey.

6 Select the Pan And Zoom option in the Playback panel. Drag the slider to set the level for the effect about one-third of the way between Low and High.

The higher you set the Pan And Zoom slider, the faster and broader the movement; a low setting creates a slow drift that never moves too far from a full-frame view.

7 Make sure the first photo is selected in the Filmstrip, and then click the Play button at the bottom of the right panel group to see the slideshow in full-screen mode. If you wish, you can press the spacebar to pause and resume playback. When you're done, press the Esc key to end the slideshow.

Tip: You can add up to 10 music files to your slideshow soundtrack; to change the order in which they'll play, drag files to new positions in the Music panel list.

For a slideshow that contains more images than our lesson project, use the Add Music button to attach more sound files. If your slideshow includes multiple sound files, clicking the Fit To Music button will fit your slides and transitions to the combined duration of the music tracks.

The Sync Slides To Music option disables the Slide Length and Crossfades controls and the Fit To Music button. Lightroom analyzes the sound file and sets the timing of the slideshow not only to match the tempo, but also to respond to prominent sounds in the music.

The Playback panel also incorporates an Audio Balance slider that enables you to mix your soundtrack music with the audio from video clips in your slideshow.

If you have a second display attached to your computer, you'll see the Playback Screen area at the bottom of the Playback panel, where you can choose which screen will be used when you play your slideshow at full screen, and whether the other screen will be blanked during playback.

Saving a customized slideshow template

Having spent so much time customizing your slideshow template, you should now save it so that it becomes available as a new choice in the Template Browser panel. This is not the same as saving your slideshow, as you did earlier. As mentioned earlier, a saved slideshow is actually an output collection, an arranged grouping of

Modifying and organizing user templates

The Template Browser offers numerous options for organizing your templates and template folders:

Renaming a template or template folder

You cannot rename the Lightroom Templates folder, any of the Lightroom templates, or the default User Templates folder. To rename any of the templates or template folders that you have created, right-click the template or folder in the Template Browser and choose Rename from the menu.

Moving a template

If you wish to move a template into another folder in the Template Browser, simply drag the template to that folder. If you wish to move a template into a new folder, right-click the template and choose New Folder from the menu. The selected template will be moved into the new folder as it is created. If you try to move one of the Lightroom templates, the template will be copied to the new folder but will still remain in the Lightroom Templates folder.

Updating a custom template's settings

If you wish to modify one of your own custom templates, select it in the Template Browser and make your changes using any of the controls in the right panel group. To save your changes, right-click the template in the Template Browser and choose Update With Current Settings.

Creating a copy of a template

You may wish to create a copy of a template so that you can safely make modifications without affecting the original. If you wish to create a copy of the currently selected template in an existing template folder, click the Create New Preset button (+) in the Template Browser panel header. In the New Template dialog box, type a name for the copy, choose the destination folder from the Folder menu, and click Create. If you wish to create a copy of the currently selected template in a new folder, click the Create New Preset button (+) in the Template Browser panel header, and in the New Template dialog box, type a name for the copy and choose New Folder from the Folder menu. Then, in the New Folder dialog box, give your new folder a name and click Create. The new folder appears in the Template Browser. Click Create in the New Template dialog box to dismiss it. The copied template will be created in the new folder.

Exporting a custom template

To export your custom slideshow template so that you can use it in Lightroom on another computer, right-click the template name in the Template Browser menu and choose Export from the menu.

Importing a custom template

To import a custom template that has been created in Lightroom on another computer, right-click the User Templates header or any of the templates in the User Templates menu and choose Import from the menu. In the Import Template dialog box, locate the template file and click Import.

(continues on next page)

Modifying and organizing
user templates (continued)

Deleting a template

To delete a custom template, right-click the template name in the Template Browser and choose Delete from the menu. You can also select the template and click the Delete Selected Preset button in the header of the Template Browser. You cannot delete the templates in the Lightroom Templates folder.

Creating a new templates folder

To create a new empty folder in the Template Browser, right-click the header of any other folder and choose New Folder from the menu. You can drag templates into the new folder.

Deleting a templates folder

To delete a templates folder, you'll first need to delete all the templates within that folder—or drag them to another folder. Right-click the empty folder, and choose Delete Folder from the menu.

Saving your customized slideshow template will save you a lot of time later should you wish to put together a related presentation, or simply use the template as a starting point for creating a new design.

By default, your customized template will be listed with the User Templates in the Template Browser panel.

1 With your slideshow still open, click the Create New Preset button in the header of the Template Browser panel, or choose Slideshow > New Template.

▶ **Tip:** When saving a customized template, it's a good idea to give it a descriptive name. This will make it easier to find as you add more new templates to the Template Browser.

2 In the New Template dialog box, type **Centered Title** as the new template name. Leaving the default User Templates folder selected as the destination folder in the Folder menu, click Create.

Your new customized template is now listed under User Templates in the Template Browser panel.

Exporting a slideshow

To send your slideshow to a friend or client, play it on another computer, or share it on the web, you can export it as a PDF file or as a high-quality video file.

1 In the Slideshow module, click the Export PDF button at the bottom of the left panel group.

2 Review the options available in the Export Slideshow To PDF dialog box, noting the settings for size and quality, and then click Cancel.

● **Note:** PDF slide-show transitions work when viewed using the free Adobe Reader® or Adobe Acrobat®. However, slideshows exported to PDF will not include music, random-ized playback order, or your customized slide duration settings.

3 Repeat the process for the Export Video button. Review the Export Slideshow To Video dialog box, noting the range of options available in the Video Preset menu. Select each export option in turn to see a brief description below the Video Preset menu.

Lightroom Classic exports slideshows in the MP4 movie format so that you can share your slideshow movies on video sharing sites or optimize them for playback on mobile devices. Preset size and quality settings range from 480 x 270, optimized for personal media players and email, to 1080p, optimized for high-quality HD video.

4 In the Export Slideshow To Video dialog box, type a name for your exported video and specify a destination folder. Choose an option from the Video Preset menu, and then click Export.

A progress bar in the upper-left corner of the workspace shows the status of the export process.

Playing an impromptu slideshow

Even outside the Slideshow module you can play an impromptu slideshow. In the Library module, for instance, this makes a convenient way to see a full-screen preview of the photos you've just imported.

▶ **Tip:** To change the slideshow template used for the impromptu slideshow, right-click a template in the Slideshow module Template Browser and choose Use For Impromptu Slideshow.

The impromptu slideshow can be launched from any of the Lightroom Classic modules. The slide layout, timing, and transitions for the impromptu slideshow will depend on the template currently set in the Slideshow module for use with the impromptu slideshow. If you haven't set one, it will use the current settings in the Slideshow module.

1 Switch to the Library module. In the Catalog panel, select Previous Import. Use the Sort menu in the Grid view Toolbar to set the sorting order to either Capture Time or File Name. Choose View > Sort > Ascending, or click the Sort Direction button beside the Sort menu, if necessary, to set an ascending sort direction (the Sort Direction button should show an "A" above a "Z").

2 Select the first photo in the Grid view, then press Command+A/Ctrl+A or choose Edit > Select All to select all of the images from the previous import.

▶ **Tip:** In the Library and Develop modules, you can also use the Impromptu Slideshow button in the Toolbar. If you don't see the Impromptu Slideshow button in the Toolbar, choose Slideshow from the content menu at the right end of the Toolbar.

3 Choose Window > Impromptu Slideshow or press Command+Return/Ctrl+Enter to start the impromptu slideshow.

4 Use the spacebar to pause and resume playback. The slideshow will repeat, cycling through the selected images until you either press the Esc key on your keyboard or click the screen to stop playback.

Well done! You have successfully completed another Lightroom Classic lesson. In this lesson you learned how to create your own stylish slideshow presentation. In the process, you've explored the Slideshow module and used the control panels to customize a slideshow template.

In the next lesson, you'll find out how to present your work in printed format, but before you move on, take a few moments to read through my recommended settings, and then reinforce what you've learned by reading through the review questions and answers on the last page.

My suggested settings for a slideshow

● **Note:** You don't have to follow along with this section. As you're getting into professional Lightroom user territory, you can see these sections as mere suggestions for what to do with your workflow.

This lesson was designed to take you through a tour of all of the features in the Slideshow module. It's important to note that while all of the features are there, you aren't required to use every one of them. In fact, when I create slideshows for myself, I often opt for a very stripped-down experience, but with some key changes to make sure that my branding is taken into account. I wanted to take a moment to share those changes with you here.

I tend to want my pictures to be the center of the discussion, so select the Simple template in the Template Browser. In the Layout panel, set the margins to 72 px. In the Options panel, set the stroke border to a dark gray (R=20%, G=20%, B=20%) and the width to 1 px, and make sure that the only thing selected in the Backdrop panel is a black background color. All Overlay panel options are deselected.

Where I do dedicate a little bit of time is adding intro and ending screens in the Titles panel.

If you are presenting a slideshow to a group of people or a client, you want to be sure you make the biggest impact out of the gate. I do not want my slideshow displaying the first image until I am ready to show it. I may want to introduce the project, or speak a little before it starts.

The Intro Screen area allows you to use an identity plate with your branding information. The easiest is to select Use A Styled Text Identity Plate. Here, I chose Helvetica Neue Condensed Bold for my font, and just typed in my company's name.

Once your identity plate is set up, you can use the Scale slider in the Titles panel to make the text bigger and fit the presentation. While the text is a good start, I want to personalize this even further.

If you are using Lightroom, there's a good chance you also have Photoshop available to you. I created a logo graphic in Photoshop with my signature (easy to create with a tablet and pen) and one text layer. I saved this graphic as a transparent PNG file (the color fill layer at the bottom is only there to show you how the white type looks).

Back in the Identity Plate Editor in Lightroom, select Use A Graphical Identity Plate instead. Then, click the Locate File button and select the PNG image.

The slideshow now has my own custom branding. Select the Ending Screen option and leave it set to black. Leave Add Identity Plate unselected. When it comes to presentation time, you can start the presentation and immediately pause it. This leaves your name or logo on the screen, and lets you introduce yourself or your work before you start the show.

Review questions

1 How can you change which template is used for the impromptu slideshow?

2 Which Lightroom slideshow template would you pick if you wished to display metadata for your images?

3 What options do you have when customizing a slideshow template?

4 How does tethered text help you design your layout?

5 What is the difference between saving your customized slideshow template and saving the slideshow you've created?

Review answers

1 In the Slideshow module, right-click the name of a slideshow template in the Template Browser and choose Use For Impromptu Slideshow.

2 The EXIF Metadata template, which centers photos on a black background and displays star ratings and EXIF information for the images, as well as an identity plate.

3 In the right panel group you can modify the slide layout, add borders and text overlays, create shadow effects for images or text, change the background color or add a backdrop image, adjust the durations of slides and fades, and add a soundtrack.

4 Tethered text is anchored either to the outside edge of the slide, which can be used to ensure that title text appears on every page in the same place, or to the image border, which ensures that photo-specific text will appear in the same place for each photo.

5 A saved custom template records only your layout and playback settings—it is like an empty container that is not linked to any particular set of images. A saved slideshow is actually an output collection—an arranged grouping of images, saved together with a slide layout, text overlays, and playback settings.

PHOTOGRAPHY SHOWCASE
ALAN SHAPIRO

"For me, every picture is a prayer."

For me, every picture is a prayer, each one different and heartfelt and important in its own distinct way. Each one about something to be thankful for, to be celebrated. Something to be corrected, or to be sorry for.

Every picture is a prayer about something that makes us feel big (in a small way). Or small (in a big way). Something that needs to be thought about over and over and over.

Or that needs to be shared. That needs to live on or needs to be heard.

For me, every picture is an acknowledgment, a reminder, a plea, a thank you. Something that makes us feel at peace, awed, inspired, incredibly profoundly moved. Part of something huge and magnificent and connected.

For me, every picture is a prayer.

And often a prayer that has been answered.

Amen.

www.alanshapirophotography.com
instagram.com/alanshapiro515

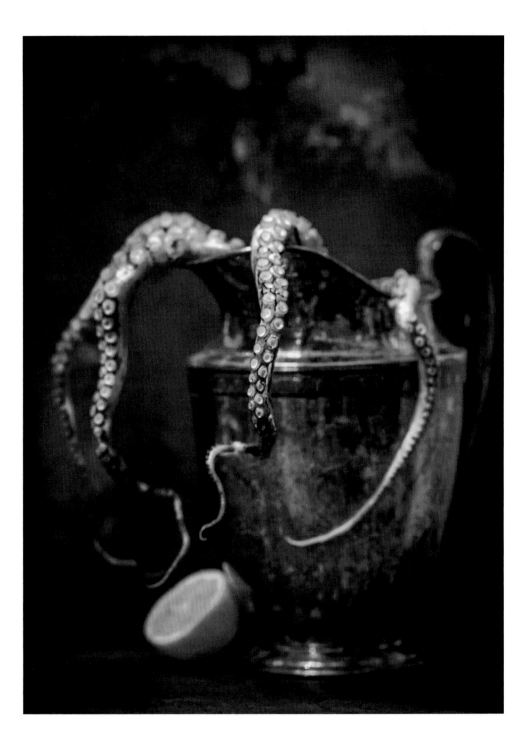

9 PRINTING IMAGES

Lesson overview

The Lightroom Classic Print module offers all the tools you'll need to quickly prepare your images for printing. You can print a single photo, repeat one image at different sizes on the same sheet, or create an attractive layout for multiple images. Add borders, text, and graphics, and then adjust print resolution, sharpening, paper type, and color management with just a few clicks. In this lesson, you'll learn how to:

- Choose and customize a print template, and create a Custom Package print layout.

- Add an identity plate, borders, a background color, and create captions from a photo's metadata.

- Save a custom print template and save your print job as an output collection.

- Specify print settings and printer driver options, and choose appropriate color management options.

 This lesson will take about 1 to 2 hours to complete. To get the lesson files used in this chapter, download them from the web page for this book at www.adobepress.com/LRClassicCIB2020. For more information, see "Accessing the lesson files and Web Edition" in the Getting Started section at the beginning of this book.

The Print module in Lightroom Classic makes it
easy to achieve professional printed results, with
device-specific soft proofing to help you produce
prints that match the color and depth you see
onscreen, and customizable layout templates for
anything from a contact sheet to a fine art mat.

Getting started

● **Note:** This lesson assumes that you already have a basic working familiarity with the Lightroom Classic workspace. If you need more background information, refer to Lightroom Classic Help, or review the previous lessons.

Before you begin, make sure you've set up the LRClassicCIB folder for your lesson files and created the LRClassicCIB Catalog file to manage them, as described in "Accessing the lesson files and Web Edition" and "Creating a catalog file for working with this book" in the "Getting Started" section at the start of this book.

If you haven't already done so, download the lesson09 folder from your Account page at www.peachpit.com to the LRClassicCIB\Lessons folder, as detailed in "Accessing the lesson files and Web Edition" in the "Getting Started" section.

1 Start Lightroom Classic.

2 In the Select Catalog dialog box, make sure the file LRClassicCIB Catalog.lrcat is selected under Select A Recent Catalog To Open, and then click Open.

▶ **Tip:** If you can't see the Module Picker, choose Window > Panels > Show Module Picker, or press the F5 key. If you're working on macOS, you may need to press the fn key together with the F5 key, or change the function key behavior in the system preferences.

3 Lightroom Classic will open in the screen mode and workspace module that were active when you last quit. If necessary, switch to the Library module by clicking Library in the Module Picker at the top of the workspace.

Creating a collection from the existing images

We've already imported and worked on so many images in this book, let's select 10 of them and place them into a collection for this lesson.

1 Click All Photographs in the Catalog panel, located at the upper left of the Library module.

2 Click the plus sign (+) button at the right of the Collections panel's header and choose Create Collection. Type **Images to Print** for the name. Make sure the Include Selected Images option is not selected, and then select Set As Target Collection.

● **Note:** If you ever want to change which collection is used as the target collection, simply right-click the collection in the Collections panel and select Set As Target Collection.

3 In the Toolbar, set the Sort order to File Name. Scroll through all the photographs looking for images that you believe are good candidates for printing. When you find the image you want to work with, press the letter B on your keyboard and it will be sent to the target collection we just specified. This gives you the freedom to look without having to drag.

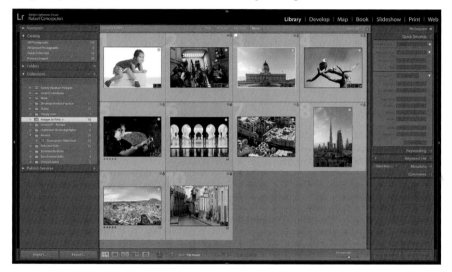

4 You can use whichever files you would like to print, but if you want to follow along with this chapter, you will need the following files: 2012_03_15_sabine_applebox-002.jpg, lesson05-001.jpg, lesson05-004.jpg, lesson05-008.jpg, lesson06-003.jpg, lesson07-004.jpg, lesson07-006.jpg, lesson07-023.jpg, lesson08-002.jpg, and lesson08-006.jpg. Then, click Print in the Module Picker at the top of the workspace to switch to the Print module.

About the Lightroom Classic Print module

In the Print module, you'll find tools and controls for each step in the printing workflow. Change the order of your photos, choose a print template and refine the layout, add borders, text, and graphics, and then adjust the output settings; everything you need to produce professional-looking prints is at your fingertips.

The left panel group contains the Preview, Template Browser, and Collections panels. Move the pointer over the list in the Template Browser to see a thumbnail preview of each layout template displayed in the Preview panel. When you select a new template in the list, the Print Editor view—at center-stage in the workspace—is updated to show how the selected photos look in the new layout.

You can quickly select and rearrange the photos for your print job in the Filmstrip, where the source menu provides easy access to the images in your library, listing your favorites and recently used source folders and collections.

You'll use the controls in the right panel group to customize your layout template and to specify output settings.

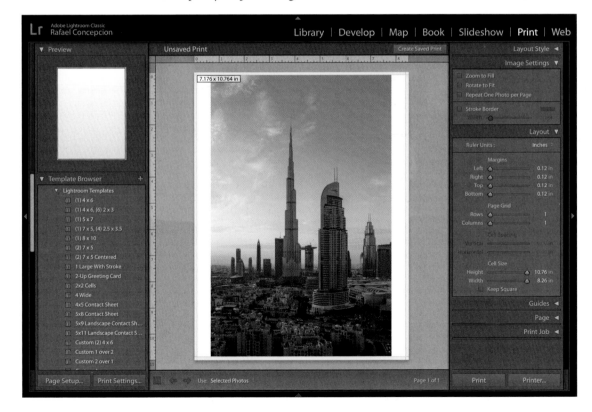

The Template Browser contains templates of three distinct types: Single Image/Contact Sheet layouts, Picture Package layouts, and Custom Package layouts.

The first set of presets (the ones that start with parentheses) in the menu are Picture Package layouts. They repeat a single image at a variety of sizes on the same page. The second set are Single Image/Contact Sheet layouts, which can be used to print multiple photos at the same size on a single sheet. They range from contact sheets with many cells to single-cell layouts such as the Fine Art Mat and Maximize Size templates. The custom layout templates farther down in the list enable you to print multiple images at any size on the same page. All of the templates can be customized; you can save your modified layouts as user-defined templates, which will be listed in the Template Browser.

Once you've chosen a layout from the Template Browser, the Layout Style panel at the top of the right panel group indicates which type of template you're working with. The suite of panels you see below the Layout Style panel will vary slightly, depending on which type of template you have chosen.

The controls in the Image Settings panel enable you to add photo borders and to specify the way your pictures are fitted to their image cells.

For a Single Image/Contact Sheet template, you can use the Layout panel to adjust margins, to adjust cell size and spacing, and to change the number of rows and columns that make up the grid. Use the Guides panel to show or hide a selection of layout guides. For a Picture Package or Custom Package template, you'll modify your layout and show or hide the guides with the Rulers, Grid & Guides panel and the Cells panel. The Page panel has controls for watermarking your images and adding text, graphics, or a background color to your print layout. In the Print Job panel, you can set the print resolution, print sharpening, paper type, and color management options.

About layout styles and print templates

The Template Browser offers a wide choice of preset Lightroom print templates that not only differ in basic layout but may also include a variety of design features such as borders and overlaid text or graphics.

Templates may also differ in their output settings: the preset print resolution setting for a contact sheet, for example, will be lower than the resolution set for a template designed for producing finished prints.

You can save time and effort setting up your print job by selecting the print template that most closely suits your purpose. In this exercise you'll be introduced to the different types of templates and use the panels in the right panel group to examine the characteristics of each layout.

1 In the left panel group, make sure that the Preview and Template Browser panels are expanded. If necessary, drag the top border of the Filmstrip down so that you can see as many of the templates in the Template Browser as possible. In the right panel group, expand the Layout Style panel and collapse the others.

2 Choose Edit > Select None, and then select any one of the images in the Filmstrip. The Print Editor view at the center of the workspace is updated to display the selected photo in the current layout.

3 If necessary, expand the Lightroom Templates folder in the Template Browser panel. Move the pointer slowly over the list of preset templates to see a preview of each layout in the Preview panel.

4 Click the second template in the Template Browser: (1) 4 × 6, (6) 2 × 3. The new template is applied to the image in the Print Editor view. Scroll up in the right panel group, if necessary, and inspect the Layout Style panel. You'll see that the Layout Style panel indicates that this template is a Picture Package layout. In the Template Browser, click the Lightroom template (2) 7 × 5. The Layout Style panel indicates that this is also a Picture Package layout.

5 Now choose the 2-Up Greeting Card preset template in the Template Browser. The Layout Style panel indicates that the 2-Up Greeting Card template is a Single Image/Contact Sheet layout, and the Print Editor view at the center of the workspace displays the new template.

6 In the Layout Style panel, click Picture Package. The Print Editor is updated to display the last selected Picture Package layout: (2) 7 × 5. Click Single Image/Contact Sheet in the Layout Style panel and the Print Editor view returns to the last selected Single Image/Contact Sheet layout: 2-Up Greeting Card.

You'll notice that different control panels become available in the right panel group as you move between the Single Image/Contact Sheet and Picture Package layout styles. Panels common to both layout styles may differ in content for each.

7 In the right panel group, expand the Image Settings panel. In the Layout Style panel, click Picture Package and expand the Image Settings panel again. Toggle between the Picture Package and Single Image/Contact Sheet layouts and notice how the options available in the Image Settings panel change.

You can see that the selected photo fits to the image cell differently for each of these templates. In the Picture Package layout (2) 7 × 5, the Zoom To Fill option is activated in the Image Settings panel so that the photo is zoomed and cropped to fill the image cell. In the Single Image/Contact Sheet 2-Up Greeting Card, the Zoom To Fill option is disabled and the photo is not cropped. Take a moment to examine the other differences in the Image Settings panel.

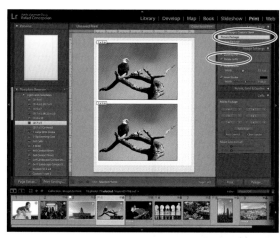

(2) 7 × 5 template 2-Up Greeting Card template

8 Select the Single Image/Contact Sheet layout style. Look at the page count at the right of the Toolbar below the Print Editor view: it reads "Page 1 of 1." Press Command+A/Ctrl+A or choose Edit > Select All to select all 10 images in the Filmstrip. The page count in the Toolbar now reads "Page 1 of 10." The 2-Up Greeting Card template is now applied to all 10 photos, resulting in a print job of 10 pages. Use the navigation buttons at the left the Toolbar to move between the pages and see the layout applied to each image in turn and the page count change as you move through the pages.

▶ **Tip:** You can also navigate your multi-page print document by using the Home, End, Page Up, Page Down, and left and right arrow keys on your keyboard, or choosing from the navigation commands in the Print menu.

9 For the last step in this exercise, collapse the Image Settings panel and expand the Print Job panel. You'll notice that in the Print Job panel, the Print Resolution for the 2-Up Greeting Card template is set to 240 ppi. Select the 4×5 Contact Sheet template in the Template Browser. The Print Resolution option in the Print Job panel is disabled and the Draft Mode Printing option is activated.

Selecting a print template

Now that you've explored the Template Browser, it's time to choose the template that you'll customize in the next exercise.

1 In the Template Browser, click the 4 Wide template. Later in this lesson you'll customize your identity plate, but for now, deselect the Identity Plate option in the Page panel to hide the default design.

2 Choose Edit > Select None. In the Filmstrip, select the images lesson05_004, lesson07_006, and lesson08_002. The images will be arranged in the template in the same order in which they appear in the Filmstrip. Drag the images inside their grid cells to reposition them as shown in the illustration below.

▶ **Tip:** By default, each photo will be centered in its own image cell. To expose a different portion of an image that is cropped by the boundaries of its cell, simply drag the photo to reposition it within its image cell.

▶ **Tip:** Lightroom automatically scales your photos in the print layout template to fit the paper size you have specified. In the Page Setup/Print Setup dialog box, leave the scale setting at the default 100% and let Lightroom fit the template to the page—that way, what you see in the Print Editor view will be what you'll get from your printer.

Specifying the printer and paper size

Before you customize the template, you'll need to specify the paper size and page orientation for your print job. Doing this now may save you the time and effort of readjusting the layout later.

1 Choose File > Page Setup or click the Page Setup button at the bottom of the left panel group.

2 In the Page Setup/Print Setup dialog box, choose the desired printer from the Format For/Name menu. From the Paper Size menu, choose US Letter > US Letter (macOS)/Letter (Windows). Under Orientation, choose the portrait (vertical) format, and then click OK.

Customizing print templates

Having established the overall layout of your print job, you can use the controls in the Layout panel to fine-tune the template so that the images fit better to the page.

Changing the number of cells

For the purposes of this exercise, we need only three of the four preset image cells.

1 If necessary, expand the Layout panel in the right panel group. Under Page Grid, drag the Rows slider to the left or type **3** in the text box to the right of the slider.

2 Experiment with the Margins, Cell Spacing, and Cell Size sliders—making sure to undo (Command+Z/Ctrl+Z) after each change. Select the Keep Square option below the Cell Size sliders. The Cell Width and Cell Height sliders are locked together at the same value. Deselect the Keep Square option.

3 The black lines you might see around the photos are merely guides indicating the image cell boundaries; they will not appear on your printed page. These guides are helpful while you're adjusting the cell size and spacing, but they'll be distracting when you add printable borders to your layout in the next exercise. If necessary, expand the Guides panel below the Layout panel and deselect the Image Cells option, then collapse the Layout and Guides panels.

> **Tip:** If you don't see the guides referred to in this step, select the Show Guides option at the top of the Guides panel and toggle each option to see the effect.

Modifying the page layout of a print template

Layout controls for Single Image/Contact Sheet and Picture Package templates

Depending on which type of print template you are working with, you'll find a slightly different suite of panels in the right panel group. The Image Settings, Page, and Print Job panels are available for all template types, but the controls for modifying the page layout differ. If you've chosen a Single Image/Contact Sheet template, you'll customize your layout using the Layout and Guides panels. For a Picture Package template, you'll use the Rulers, Grid & Guides panel and the Cells panel. For Custom Package layouts you'll also use the Rulers, Grid & Guides panel and the Cells panel—where you'll find a few minor differences from the options offered in the same panels for a Picture Package template.

Picture Package templates and Custom Package layouts are not grid-based, so they are very flexible to work with; you can arrange the image cells on the page either by simply dragging them in the Print Editor view or by using the controls in the Cells panel. You can resize a cell using the width and height sliders or simply drag the handles of its bounding box. Add more photos to your layout with the Cells panel controls or Option-drag/Alt-drag a cell to duplicate it and resize it as you wish.

Lightroom Classic provides a variety of guides to help you adjust your layout. Guides are not printed; they appear only in the Print Editor view. To show or hide the guides, select Show Guides in the Guides or Rulers, Grid & Guides panel, or choose View > Show Guides (Command+Shift+G/Ctrl+Shift+G). In the Guides panel, you can specify which types of guides will be displayed in the Print Editor view.

Note: The Margins and Gutters guides and Image Cells guides—available only for Single Image/Contact Sheet layouts—are interactive; you can adjust your layout directly by dragging the guides themselves in the Print Editor view. When you move these guides, the Margins, Cell Spacing, and Cell Size sliders in the Layout panel will move with them.

Using the Layout panel to modify a contact sheet/grid layout

Ruler Units sets the units of measurement for most of the other controls in the Layout panel and for the Rulers guide in the Guides panel. Click the Ruler Units setting and choose Inches, Centimeters, Millimeters, Points, or Picas from the menu. The default setting is Inches.

Margins sets the boundaries for the grid of image cells in your layout. Many printers don't support borderless printing, so the minimum value for the margins is dependent on the capabilities of your printer. Even if your printer does support borderless printing, you may first need to activate this feature in the printer settings before you can set the margins to zero.

Page Grid specifies the number of rows and columns of image cells in the layout. The grid can contain anything from one image cell (Rows: 1, Columns: 1) to 225 image cells (Rows: 15, Columns: 15).

Cell Spacing and **Cell Size** settings are linked so that changes you make to one will affect the other. The Cell Spacing sliders set the vertical and horizontal spaces between the image cells in the grid; the Cell Size controls change the height and width of the cells. The Keep Square option links the height and width settings so that the image cells remain square.

Using the Guides panel to modify a contact sheet/grid layout

Rulers are displayed across the top and at the left of the Print Editor view. If Show Guides is selected, you can also show the rulers by choosing View > Show Rulers (Command+R/Ctrl+R). To change the ruler units, click the setting in the Layout panel.

Page Bleed shades the non-printable edges of the page, as defined by your printer settings.

Margins and Gutters guides reflect the Margins settings in the Layout panel; in fact, dragging these guides in the Print Editor view will move the respective sliders in the Layout panel.

Image Cells shows a black border around each image cell. When the Margins and Gutters guides are not visible, dragging the Image Cells guides in the Print Editor view will change the Margins, Cell Spacing, and Cell Size settings in the Layout panel.

Dimensions displays the measurements of each image cell in its upper-left corner, expressed in whatever units of measurement you have chosen for the Ruler Units.

Using the Rulers, Grid & Guides panel to modify a Picture Package layout

Ruler Units lets you set the units of measurement just as you would in the Layout panel when you're working with a contact sheet/grid template.

Grid Snap helps you to position the image cells accurately on the page in the Print Editor view. As you drag the cells, you can have them snap to each other or to the grid (or turn the snap behavior off) by choosing Cells, Grid, or Off from the Snap menu options. The grid divisions are affected by your choice of ruler units.

Note: If you accidentally overlap your image cells, Lightroom will let you know by showing a warning icon (!) in the upper-right corner of the page.

Page Bleed and **Dimensions** work just as they do in the Guides panel for a Single Image/Contact Sheet layout.

Using the Cells panel to modify a Picture Package layout

Add To Package offers six preset image cell sizes that can be placed in your layout at the click of a button. You can change which of the presets is assigned to each button by clicking its menu triangle. The default presets are standard photo sizes, but you can edit them if you wish.

New Page adds a page to your layout, though Lightroom automatically adds pages if you use the Add To Package buttons to add more photos than fit on a page. To delete a page from your layout, click the X button in the upper-left corner of the page in the Print Editor view.

Auto Layout optimizes the arrangement of the photos on the page for the fewest cuts.

Clear Layout removes all the image cells from the layout.

Adjust Selected Cell lets you change the height and width of an image cell using sliders or numerical input.

Rearranging the photos in a print layout

Lightroom places your photos in the cells of a multiple-image print layout in the order in which they appear in the Filmstrip (and the Library module Grid view).

If your image source is a collection, or a folder without subfolders nested inside it, you can change the placement of your images in the print job by simply dragging their thumbnails to new positions in the Filmstrip. Rearranging photos in this way is not possible if either the All Photographs folder or Previous Import folder is the selected image source.

Deselect all of the images by clicking one of the other images in the Filmstrip. Once the images are deselected, rearrange the images into a new order, as shown in the illustration below. With the images reordered, select the three images by Command-clicking/Ctrl-clicking them.

If you enter the Print module with the Previous Import folder selected as the image source, it is impossible to reorder thte photos for your print job.

Creating stroke and photo borders

For our Single Image/Contact Sheet layout, the Image Settings panel offers options that affect the way your photos are placed in the image cells, and a control for adding a border. In this exercise you'll add a stroke border around each of the three images and adjust the width of the stroke.

Tip: You can change the color of the border by clicking the Stroke Border color swatch and choosing a color from the Color Picker.

1 Expand the Image Settings panel. For the 4 Wide template, the Zoom To Fill option is activated. This means that our photos are cropped in height to fit the proportions of the image cells.

2 Select the Stroke Border option, and then drag the Width slider to the right or type **2** in the text box to the right of the slider. For your reference, one inch is equivalent to 72 points (pt).

3 In the Layout Style panel, click Picture Package. In the Rulers, Grid & Guides panel, select the Image Cells option to see the borders of the cells. For a Picture Package template, the Image Settings panel offers two controls for borders. An Inner Stroke border is the picture package equivalent of a stroke border. The Photo Border control lets you set the width of a blank frame between the edge of each photo and the boundary of its image cell.

4 Experiment with the Inner Stroke and Photo Border settings.

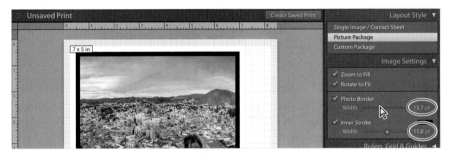

5 Deselect the Image Cell guides. In the Layout Style panel, click Single Image/ Contact Sheet to return to your modified 4 Wide template.

Customizing your identity plate

In the Page panel, you'll find controls for adding an identity plate, crop marks, page numbers, and text information from your photos' metadata to your layout. To begin with, you'll edit the identity plate to suit your layout.

1 Expand the Page panel, then select the Identity Plate option. The illustration at the right shows a preview of the default Identity Plate on macOS (your macOS user name); on Windows, the default is the word *Lightroom*. Click the triangle in the lower-right corner of the identity plate preview and choose Edit from the menu.

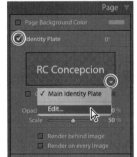

2 In the Identity Plate Editor dialog box, select the Use A Styled Text Identity Plate option. Choose Arial, Regular, and 36 point from the font menus. To change the text color, highlight the text in the text box to select it, then click the color swatch to the right of the font size menu, and choose

▶ **Tip:** If your text is too long to be fully visible in the text box, either resize the dialog box or reduce the font size until you've finished editing.

Using the Rotate To Fit option

By default, Lightroom will place photos so that they are upright within their image cells. The Rotate To Fit option in the Image Settings panel will override this behavior so that your photos are rotated to match the orientation of the image cells. For presentation layouts you would not wish to have images displayed in different orientations on the same page, but in some situations this feature can be very helpful and save on expensive photo paper too! The Rotate To Fit option is particularly useful when you wish to print photos in both portrait and landscape formats on the same sheet, as large as possible and without wasting paper, as shown in the illustration below.

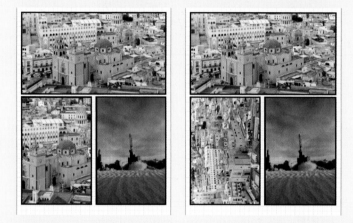

Another situation where you might choose to use the Rotate To Fit setting is when you are printing contact sheets. As you can see in the next illustration, Rotate To Fit enables you to see all the photos at the same size regardless of the image orientation.

a new color in the Color Picker. Select the text again, if necessary, and type **RC Concepcion Photography** (or a name of your own choice), then click OK.

3 In the Page panel, drag the Scale slider to the right so that the identity plate text is the same width as the image. You can also scale the identity plate by clicking it in the Print Editor view and dragging the handles of its bounding box.

▶ **Tip:** By default the identity plate will be oriented horizontally. This setting (0°) is indicated at the top right of the Identity Plate area in the Page panel. To re-orient your identity plate on the page, click the 0° indicator and choose to Rotate Onscreen 90°, 180°, or −90° from the menu. To move your identity plate, simply drag it in the Print Editor view.

4 Now you'll change the color of the identity plate. Select the Override Color option to set the color of the identity plate for this layout only—without affecting the defined color settings for the identity plate.

5 Click the Override Color swatch to open the Color Picker. For the RGB values, type in R: **55%**, G: **15%**, B: **5%**, and then close the Color Picker. The color of the text identity plate is now a deep, slightly desaturated rust red.

▶ **Tip:** If you see a hexadecimal value displayed in the lower-right corner of the Color Picker rather than RGB values, click RGB below the color slider.

6 In the Identity Plate pane, use the Opacity slider or type **75** in the text box beside it to set an opacity value of 75% for the identity plate. This feature can be particularly effective if you wish to position your identity plate over an image.

Printing captions and metadata information

In this exercise, you will add a caption and metadata information—in this case, titles for the images—to your print layout using the Page panel and the Text Template Editor.

1. At the bottom of the Page panel, select the Photo Info overlay option, and then choose Edit from the menu at the right. Most of the other options in the Photo Info menu are drawn from the images' existing metadata.

The Text Template Editor enables you to combine custom text with the metadata embedded in your image files and then save your edited template as a new preset, making it easy to add the same items of text information to future print jobs.

> ▶ **Tip:** You'll find more detailed information on the Text Template Editor in the sidebar "Using the Text Template Editor" in Lesson 8.

Descriptions of our lesson photos have been pre-entered in the Caption field of the images' metadata; you'll base your text captions on this metadata.

2. Choose Caption from the Preset menu at the top of the Text Template Editor dialog box.

3. Click to place the insertion cursor before the Caption token in the Example text box. Type **Print Portfolio:** (including the colon), then add a space between your text and the token.

4. Click to place the cursor after the Caption token in the Example box. Type a comma, and then a space, then choose Date (Month) from the second Numbering menu. If the Date (Month) token doesn't appear in the Example box, click the Insert button to the right of the Date menu to add it.

5. Add a space after the Date (Month) token, then choose Date (YYYY) from the second Numbering menu and click the Insert button if necessary. Click Done to close the Text Template Editor dialog box. The images in the Print Editor view are now captioned and dated.

Print Portfolio: Panoramic of the city of Guanajuato MexicoOctober 30, 2012

6 Click the triangles beside Font Size at the bottom of the Page panel and choose
 12 pt from the menu, then collapse the Page panel.

Saving your customized print template

Having started with a preset print template, you've created your own page design
by modifying the layout and adding borders, an identity plate, and caption text
to the images. You can now save your customized layout for future use.

1 Click the Create New Preset button (+) in
 the header of the Template Browser panel,
 or choose Print > New Template.

2 In the New Template dialog
 box, type [**Your Name**] **Wide
 Triptych** in the Template
 Name text box. By default,
 new templates are saved to
 the User Templates folder. For
 this exercise, leave the Folder
 menu set to the default User
 Templates as the destination
 folder and click Create.

3 Your saved template appears in the User Templates folder in the Template Browser panel, where you can access it quickly for use with a new set of images. With your new template selected in the Template Browser, select the last three images in the Filmstrip.

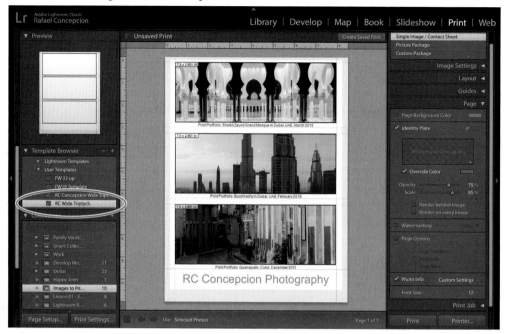

Creating a Custom Package print layout

▶ **Tip:** If you'd prefer to work without using a template, start by clicking Custom Package in the Layout Style panel, then click Clear Layout in the Cells panel and drag photos from the Filmstrip directly onto the page preview.

Every Single Image/Contact Sheet template is based on a grid of image cells that are all the same size. If you want a more free-form layout, or you prefer to create your own page layout from scratch without using any of the preset templates as a starting point, you can use the Custom Package option in the Layout Style panel.

1 Choose Edit > Select None, or press Command+D/ Ctrl+D on your keyboard. In the Template Browser, select the layout Custom Overlap × 3 Landscape from the list of Lightroom templates.

2 In the Rulers, Grid & Guides panel, select the Show Guides option, if necessary, then deselect all but the Page Bleed and Page Grid guides.

The images in a Custom Package layout can be arranged so that they overlap. The selected template includes three overlapping image cells spread diagonally over a fourth that occupies most of the printable page area.

3 Click to select the central image cell in the layout, and then right-click inside the selected cell. Note the menu options here: the first four commands enable you to move an image forward or backward in the stacking order.

4 For now, choose Delete Cell, leaving you the two corner cells and the large background cell.

5 At the bottom of the Cells panel, select the Lock To Photo Aspect Ratio option. Drag the lesson07_004 image from the Filmstrip into the smaller image cell at the upper right and the lesson07_006 photo into the larger cell behind it.

6 Click away from the large photo cell to deselect it, then re-select the image and use the controls in the Cells panel to set the Width to 9.5 in. The Height value is adjusted automatically, maintaining the photo's original proportions.

7 In the Cells panel, deselect the Lock To Photo Aspect Ratio option, then drag the handle at the top of the large cell's bounding box downward to set the height to 3 in (watch the slider in the Cells panel move as you do this). With the Lock To Photo Aspect Ratio option deselected, the image is cropped to fill the altered proportions of its cell.

8 Select the smaller image on the page and set both the Width and Height values to 4.6 in. Delete the small cell in the lower left, then hold down the Option/Alt key and drag the square-cropped image to produce a copy. Replace the photo in the copied cell by dragging the lesson07_023 image from the Filmstrip.

● **Note:** Depending on your printer, the printable (non-bleed) area may not be centered on the page, as is the case in these illustrations.

9 Drag the three images to arrange them on the page as shown in the illustration below. Be sure to center the arrangement within the printable area of the page; that is, inside the area defined by the gray border of the Page Bleed guide. To refine the way each image is cropped, hold down the Command/Ctrl key and drag to reposition the photo within the frame of its image cell.

Changing the page background color

1 In the Image Settings panel, select the Inner Stroke option. Use the slider or type over the current value to set the width of the stroke to **1.0** pt. Leave the stroke color set to the default white—the white stroke borders will become visible when you set a background color in step 4.

▶ **Tip:** To save on printer ink, you may prefer not to print a page with large areas of bold color or black in the background on your home printer, but when you're ordering professional prints this can be a striking choice.

2 In the Rulers, Grid & Guides panel, deselect Show Guides.

3 In the Page panel, select the Page Background Color option. Click the color swatch to the right to open the Color Picker.

4 In the Page Background Color Picker, click the black swatch at the top to sample it with the eyedropper, and then click the Close button (x) to close it.

The new color appears in the Page Background Color color swatch and in the page preview in the Print Editor view. If you need to make further edits to make sure they fit on the page, now is a good time to do so.

Configuring the output settings

The final step before you're ready to print your layout is to adjust the output settings in the Print Job panel.

1 Expand the Print Job panel in the right panel group.

From the Print To menu at the top of the Print Job panel, you can choose to send the job directly to your printer or generate a JPEG file, which you can print later or send out for professional printing. The controls in the Print Job panel vary slightly depending on which option is selected in the Print To menu.

2 Choose Printer from the Print To menu at the top of the Print Job panel.

Selecting the Draft Mode Printing option will disable the other options in the Print Job panel. Draft Mode Printing results in high-speed output at a relatively low quality, which is an efficient option for printing contact sheets or for assessing your layout before you commit it to high-quality photo paper. The 4 × 5 Contact Sheet and the 5 × 8 Contact Sheet templates are preset for Draft Mode Printing.

Note: The terms "print resolution" and "printer resolution" have different meanings. "Print resolution" refers to the number of printed pixels per inch (ppi); "printer resolution" refers to the capability of the printer, called dots per inch (dpi). A printed pixel of a particular color is created by patterns of tiny dots of the few ink colors available.

Soft proofing photos before printing

Each type of monitor and printer operates within its own *color gamut* or *color space*, which defines the range of colors that can be reproduced accurately by that device. By default, Lightroom uses your monitor's *color profile*—a mathematical description of its color space—to make your photos look as good as possible onscreen. When you print an image, the image data must be reinterpreted for the printer's color space, which can sometimes result in unexpected shifts in color and tone.

You can avoid these surprises by soft proofing your photos in the Develop module before you bring them into the Print module. Soft proofing lets you preview how your photos will look when they're printed; you can have Lightroom simulate the color space of your printer, and even the inks and paper you're using, giving you the opportunity to optimize your photos before printing them.

To activate soft proofing, open a photo in the Develop module and select the Soft Proofing option in the Toolbar, or press the S key on your keyboard. The background surrounding the image changes to white "paper" and a Proof Preview label appears in the corner of the work area. Use the view button in the Toolbar to switch between the Loupe view and a choice of before and after views.

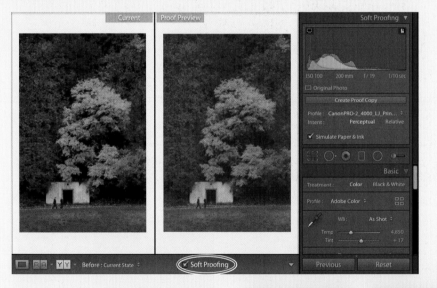

When you activate soft proofing, the Histogram panel changes to the Soft Proofing panel, which provides access to proofing options. The tonal distribution graph is updated according to the currently selected color profile. In the illustration at the right, the graph in the Histogram panel

corresponds to the Current image in the illustration above. The graph in the Soft Proofing panel reflects the comparative flatness of the Proof Preview.

To soft proof your photo for a different printer, choose another color profile from the Profile menu in the Soft Proofing panel. If you don't see the profile you want in the menu, choose Other, and then select from the list of installed color profiles in the Choose Profiles dialog box.

The Intent setting determines the rendering intent, which affects how colors are converted from one color space to another. The Perceptual rendering intent aims to preserve the visual relationship between colors so they look natural, though the color values may change. Relative rendering prints in-gamut colors as they are and shifts out-of-gamut colors to the closest printable approximations, retaining more of the original colors, though the relationships between some of them may be altered.

Once you've chosen a printer profile, you can activate the Simulate Paper & Ink option to simulate the off-white of real paper and the dark gray of real black ink. This option is not available for all profiles.

To check if your colors are in-gamut for the selected profile and rendering intent, use the buttons in the upper corners of the histogram in the Soft Proofing panel. Move the pointer over the Show/Hide Monitor Gamut Warning button on the left; colors that are outside your display's capabilities turn blue in the Proof Preview. Move the pointer over the Show/Hide Destination Gamut Warning button on the right; colors that cannot be rendered by your printer turn red in the preview. Colors that are out-of-gamut for both the monitor and the printer turn pink. Click the buttons to show the gamut warning colors permanently; click again to hide them.

Click Create Proof Copy to generate a virtual copy that you can adjust without affecting your master settings. If you start adjusting a photo while soft proofing is on without first creating a proof copy, Lightroom asks if you want to create a virtual copy for soft proofing or make the master image a proof.

The Print Resolution setting that is appropriate for your print job depends on the intended print size, the resolution of your image files, the capabilities of your printer, and the quality of your paper stock. The default print resolution is 240 ppi, which generally produces good results. As a rule of thumb, use a higher resolution for smaller, high-quality prints (around 360 ppi for letter size). You can use a lower resolution setting for larger prints (around 180 ppi for 16" × 20") without compromising too much on quality.

3 The Print Resolution control has a range of 72 ppi to 1440 ppi. For this exercise, type **200** in the Print Resolution text box.

● **Note:** The purpose of the Sharpening feature in the Develop module is to compensate for blurriness in the original photo, while Print Sharpening improves the crispness of printed output on a particular paper type.

Images tend to look less sharp on paper than they do onscreen. The Print Sharpening options can help to compensate for this by increasing the crispness of your printed output. You can choose between Low, Standard, and High Print Sharpening settings, and specify a Matte or Glossy Media Type. You won't notice the effects of these settings onscreen, so it's useful to experiment by printing at
different settings to familiarize yourself with the results.

4 If it's not already selected, choose Low from the Print Sharpening menu.

Using color management

Printing your digital images can be challenging: what you see onscreen is not always what you get on paper. Lightroom Classic is able to handle a very large color space, but your printer may operate within a much more limited gamut.

In the Print Job panel, you can choose whether to have Lightroom handle color management or leave it up to your printer.

Color managed by your printer

The default Color Management setting in the Print Job panel is Managed By Printer. This can be the easiest option, given the continuing improvement of printing technology, but will produce only satisfactory results. In the Print/Printer Properties dialog box (click the Printer button at the lower right), you can specify the paper type, color handling, and other print settings. On Windows, click Properties in the Print Setup dialog box to access additional printer-specific settings.

● **Note:** For Draft Mode Printing, color management is automatically assigned to the printer.

● **Note:** The options available in the Print/Print Setup dialog box may vary depending on your printer.

Color management controlled by Lightroom

Letting your printer manage color may be acceptable for general printing purposes, but to achieve high-quality results it's best to have Lightroom do it. If you choose this option, you can specify a printing profile tailored to a particular type of paper or custom inks.

1 In the Print Job panel, choose Other from the Color Management Profile menu.

You can choose this option when the profile you want isn't listed in the Profile menu. Lightroom searches your computer for custom printer profiles, which may be installed by the software that came with your printer or by you, if you downloaded the profile for the specific paper you are using.

2 Depending on your printer and paper stock, choose one or more printer profiles. In this illustration, a profile for the Epson Stylus Pro R800 using glossy

▶ **Tip:** The Include Display Profiles option at the bottom of the Choose Profiles dialog box enables you to load color profiles for devices other than printers. This can be useful when you need to save your images to a different color space for use on the internet.

photo paper has been selected. Each profile you choose will be added to the Profile menu under Color Management in the Print Job panel for easy access the next time you print.

Once you've chosen a printer profile from the Profile menu, the Rendering Intent options become available in the Print Job panel. The color space of an image is usually much larger than that within which most printers operate, which means that your printer may not be able to accurately reproduce the colors you see onscreen. This may result in printing artifacts such as posterization or banding in color gradients as the printer attempts to deal with out-of-gamut colors. The Rendering Intent options help to minimize these problems. You can choose between two settings:

- **Perceptual** rendering aims at preserving the visual relationship between colors. The entire range of colors in the image will be re-mapped to fit within the color gamut your printer is able to reproduce. In this way, the relationships between all the colors are preserved, but in the process, even colors that were already in-gamut may be shifted as the out-of-gamut colors are moved into the printable range. This may mean that your printed image will be less vivid than it appeared onscreen.

- **Relative** rendering prints all the in-gamut colors as they are and shifts out-of-gamut colors to the closest printable colors. Using this option means that more of the original color of the image is retained, but some of the relationships between colors may be altered.

In most cases, the differences between the two rendering methods are quite subtle. As a general rule, perceptual rendering is the best option for an image with many out-of-gamut colors and relative rendering works better for an image with only a few. However, unless you are very experienced, it may be hard to tell which is which. The best policy is to do some testing with your printer. Print a very colorful, vivid photo at both settings and then do the same with a more muted image.

3 For the purposes of this exercise, choose Relative rendering.

Tweaking printed color manually

Printed results don't always match the bright and saturated look of the colors you see onscreen in Lightroom Classic—even when you've spent time setting up the color management for your print job.

▶ **Tip:** The tone curve adjustments produced by the Print Adjustment sliders do not appear in the onscreen preview. You may need to experiment a little to find the settings that work best for your printer.

The problem may be related to your printer, the inks or paper stock you're using, or an incorrectly calibrated monitor. Whatever the cause, you can make quick and easy adjustments with the Brightness and Contrast sliders in the Color Management area of the Print Job panel.

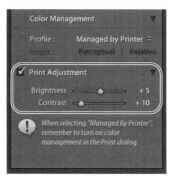

Your Print Adjustment settings are specific to the combination of printer, paper, and ink that you're using—they'll stay in place as long as you're working with the same output settings, and will be saved in the Lightroom catalog file with your custom template or saved print job.

Tip: Make sure you download the accompanying videos for this lesson, where you'll learn about a few more advanced options, including how to install an ICC profile for a specific paper type and how to use it to make a print. See the "Getting Started" section at the beginning of this book for how to access them.

Saving print settings as an output collection

Since you entered the Print module, you've been working with an unsaved print, as indicated in the bar across the top of the Print Editor view.

> **Unsaved Print** Create Saved Print

Until you save your print job, the Print module works like a scratch pad. You can move to another module, or even close Lightroom Classic, and find your settings unchanged when you return, but if you select a new layout template, or even the one you started with, in the Template Browser, the "scratch pad" will be cleared and all your work will be lost.

Converting your print job to a saved print not only preserves your layout and output settings, but also links your layout to the particular set of images for which it was designed. Your print job is saved as a special kind of collection—an output collection—with its own listing in the Collections panel. Clicking this listing will instantly retrieve the images you were working with and reinstate all of your settings, no matter how many times the print layout scratch pad has been cleared.

Tip: Once you've saved your print job, any changes you make to the layout or output settings are auto-saved as you work.

Depending on the way you like to work, you can save your print job at any point in the process—you could create a saved print as soon as you enter the Print module with a selection of images or wait until your layout is polished.

A print output collection is different from a normal photo collection. A photo collection is merely a grouping of images to which you can apply any template or output settings you wish. An output collection links a photo collection (or a selection of images from that collection) to a particular template and specific output settings.

For the sake of clarity: an output collection also differs from a custom template. A template includes all of your settings, but no images; you can apply the template to any selection of images. An output collection links the template and all its settings to a particular selection of images.

1 Click the Create Saved Print button in the bar at the top of the Print Editor

Create Print

Name: Print Portfolio

Location
☑ Inside:
Images to Print

Options
☑ Include only used photos
☐ Set as target collection

Cancel Create

view, or click the plus sign (+) button in the header of the Collections panel and choose Create Print.

2 In the Create Print dialog box, type **Print Portfolio** in the Name box to name your saved print job. Make sure that the Inside option is selected and its menu is set to your Images To Print Collection, then click Create.

> **Tip:** To add more photos to a saved print job, drag images to the print output collection in the Collections panel.

Your saved print output collection appears in the Collections panel, marked with a Saved Print icon to differentiate it from an image collection, which has a stacked photos icon. The image count shows that the new output collection contains three photos. The title bar above the Print Editor now displays the name of your saved print job, and no longer presents the Create Saved Print button.

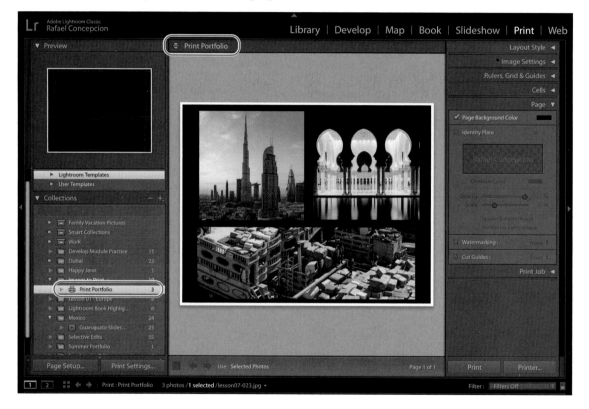

Printing your job

> **Tip:** If you don't need to verify your printer settings, click the Print button at the bottom of the right panel group or choose File > Print.

1 Click the Printer button at the bottom of the right panel group.

2 Verify the settings in the Print dialog box and click Print/OK to print your page, or click Cancel to close the Print dialog box without printing.

Clicking the Print button will send your print job to the printer queue without opening the Print dialog box. This is useful if you print repeatedly using the same settings and don't need to confirm or change any settings in the Print dialog.

344 LESSON 9 Printing Images

To achieve the best results when you print, calibrate and profile your monitor regularly, always verify that print settings are specified correctly, and use quality papers. However, there is no substitute for experience. Experiment with a variety of settings and options—and if at first you do succeed, consider yourself very lucky!

Congratulations! You've completed another Lightroom Classic lesson. In this lesson you learned how to set up your own sophisticated print layouts.

In the process, you've explored the Print module and used the control panels to customize a print template, refining the layout and output settings and adding a background color, text, borders, and an identity plate to your printed page.

In the next lesson, you'll look at ways to back up and export your Lightroom catalog and images, but before you move on, take a few moments to refresh your new skills by reading through the review questions and answers on the following pages.

Review questions

1 How can you quickly preview the preset print templates, and how can you see how your photos will look in each layout?

2 What are the three print template layout styles, and how can you check which type of template you have chosen?

3 How do you add custom text or metadata to your print layout?

4 For what purposes is Draft Mode Printing appropriate?

5 What is the difference between a Saved Print collection, a photo collection, and a saved custom print template?

6 What is soft proofing?

Review answers

1 Move the pointer over the list of templates in the Template Browser to see a thumbnail preview of each layout displayed in the Preview panel. Select your images in the Filmstrip and choose a template from the list; the Print Editor view shows how your photos look in the new layout.

2 Single Image/Contact Sheet layouts can be used to print multiple photos at the same size on a single sheet. They range from contact sheets with many cells to single-cell layouts. Picture Package layouts repeat a single image at a variety of sizes on the same page in cells that can be moved and resized. Custom Package layouts are not based on a grid; they enable you to print multiple images at any size on the same page, and even to arrange them so that they overlap.

 The Layout Style panel indicates whether a layout selected in the Template Browser is a Custom Package, Picture Package, or Single Image/Contact Sheet template.

3 Text can be added to any layout using a styled text identity plate. Custom text or metadata can be added to a Single Image/Contact Sheet layout using the Photo Info option in the Page panel. Choose from a menu of metadata options, or choose Edit to open the Text Template Editor for more options.

4 Draft Mode Printing results in high-speed output at a relatively low quality, which is an efficient option for printing contact sheets or for assessing your layout before you commit it to high-quality photo paper. The contact sheet templates are preset for Draft Mode Printing.

5 A photo collection is a virtual grouping of images to which you can apply any template or output settings you wish, whereas a Saved Print output collection links a selection of images to a particular template and specific layout and output settings. A saved print template preserves your customized layout and output settings but includes no images; you can apply the template to any selection of images.

6 Soft proofing is a way to check onscreen how your photos will look when printed, or output for use on the web. Lightroom Classic uses color profiles to simulate the result of printing to specific printers with particular types of ink and paper—or of saving your images to a different color space as you might do with pictures intended for the internet—enabling you to make the appropriate adjustments to your photos before exporting copies or committing to printing.

PHOTOGRAPHY SHOWCASE
AMI VITALE

"I use the camera to tell stories that connect people rather than simply emphasize our differences."

As a young woman, I was painfully shy and introverted. I found when I picked up a camera, it took the attention away from me and allowed me to focus on others. In the beginning, it was empowering. Later, it became my passport to meeting people, learning, and experiencing new cultures. Now it is more than just a passport. It's a tool for creating awareness and understanding across cultures, communities, and countries; a tool to make sense of our commonalities in the world we share.

Visual storytelling is the oldest form of communication. It began with cave paintings 40,000 years ago and today is still the most powerful way to communicate. Photography transcends language. It has this instant ability to connect people without language. You can look at an image and instantly feel something. I use the camera to tell stories that connect people rather than simply emphasize our differences.

There is a beautiful, universal truth everywhere, and if you peek under the veil, you'll find a wondrous commonality between us. I hope that in our travels, we all use our cameras not just as an extension of our eyes but also as an extension of our heart.

http://amivitale.com
instagram.com/amivitale

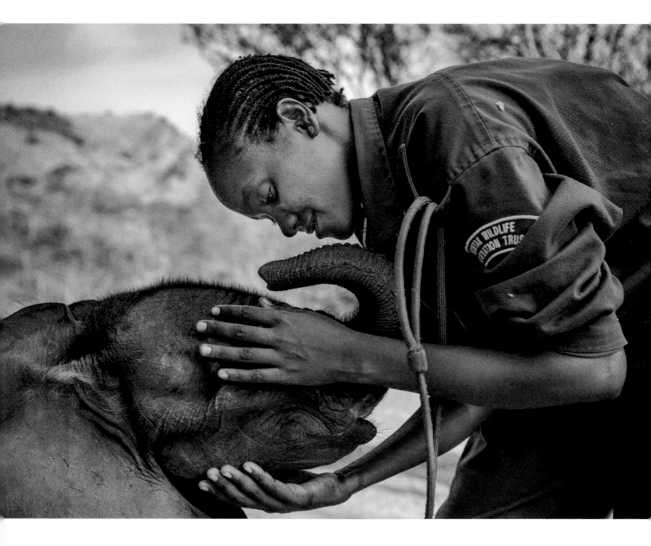

10 MAKING BACKUPS AND EXPORTING PHOTOS

Lesson overview

Lightroom Classic makes it easy to back up and export all the images and data connected with your library, streamlining your workflow and minimizing the impact of accidental data loss. You can create backup copies of your photos on external storage during import, make full or incremental backups of your photos and develop settings, or have Lightroom back up automatically. Export files in a range of formats, from images optimized for onscreen viewing to archival copies. In this lesson, you'll learn how to:

- Back up the catalog file and your entire image library.
- Make incremental backups and export metadata.
- Export photos for onscreen viewing or archival purposes.
- Export photos to be edited in another application.
- Use export presets.
- Set up automated post-export actions.

 This lesson will take about 1 to 2 hours to complete. To get the lesson files used in this chapter, download them from the web page for this book at www.adobepress.com/LRClassicCIB2020. For more information, see "Accessing the lesson files and Web Edition" in the Getting Started section at the beginning of this book.

Safeguard your photographs and develop settings against loss using Lightroom Classic's built-in backup tools. Back up just your catalog file or your entire photo library, complete with develop settings and copies of your master files. Export photos in different file formats for multimedia presentations or email attachments, for further editing in an external editor, or to be stored for archival purposes.

Getting started

● **Note:** This lesson assumes that you already have a basic working familiarity with the Lightroom Classic workspace. If you need more background information, refer to Lightroom Classic Help, or review the previous lessons.

Before you begin, make sure you've set up the LRClassicCIB folder for your lesson files and created the LRClassicCIB Catalog file to manage them, as described in "Accessing the lesson files and Web Edition" and "Creating a catalog file for working with this book" in the "Getting Started" section at the start of this book.

If you haven't already done so, download the lesson10 folder from your Account page at www.peachpit.com to the LRClassicCIB\Lessons folder, as detailed in "Accessing the lesson files and Web Edition" in the "Getting Started" section.

1 Start Lightroom Classic.

2 In the Select Catalog dialog box, make sure the file LRClassicCIB Catalog.lrcat is selected under Select A Recent Catalog To Open, and then click Open.

Adobe Photoshop Lightroom Classic - Select Catalog	
Select a recent catalog to open	
LRClassicCIB Catalog.lrcat	/Users/rc/Pictures/LRClassicCIB Catalog
LPCIB Catalog.lrcat	/Users/rc/Documents/LPCIB/LPCIB Catalog
RC Main Catalog-2.lrcat	/ - Personal/ - Lightroom Area
Lightwork Show LR Catalog.lrcat	/ - Syracuse/- Completed Projects/Lightwork Show LR Catalog
South Africa Print Show.lrcat	/ - Syracuse/ - Open Projects/South Africa Print Show
VIS Event Catalog.lrcat	/ - Syracuse/Resources/Vis Event/VIS Event Catalog
324.lrcat	/Users/rc/324

☐ Always load this catalog on startup ☐ Test integrity of this catalog

Note: Lightroom Catalogs cannot be on network volumes or in read-only folders.

[Choose a Different Catalog...] [Create a New Catalog...] [Quit] [Open]

▶ **Tip:** If you can't see the Module Picker, choose Window > Panels > Show Module Picker, or press the F5 key. If you're working on macOS, you may need to press the fn key together with the F5 key, or change the function key behavior in the system preferences.

3 Lightroom Classic will open in the screen mode and workspace module that were active when you last quit. If necessary, switch to the Library module by clicking Library in the Module Picker at the top of the workspace.

LRClassicCIB Catalog.lrcat - Adobe Photoshop Lightroom Classic - Library

Lr Adobe Lightroom Classic
Rafael Concepcion Library | Develop | Map | Book | Slideshow | Print | Web

Importing images into the library

The first step is to import the images for this lesson into the Lightroom library.

1 In the Library module, click the Import button below the left panel group.

▶ Folders +.
▶ Collections +.
▶ Publish Services +.
[Import...] [Export]

2 If the Import dialog box appears in compact mode, click the Show More Options button at the lower left of the dialog box to see all the options in the expanded Import dialog box.

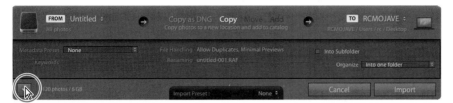

3 Under Source at the left of the expanded Import dialog box, locate and select your LRClassicCIB\Lessons\lesson10 folder. Ensure that all 20 images in the lesson10 folder are selected (checked) for import.

4 In the import options above the thumbnail previews, select Add so that the imported photos will be added to your catalog without being moved or copied. Under File Handling at the right, choose Minimal from the Build Previews menu and leave the Don't Import Suspected Duplicates option unselected. Type **Lesson 10** in the Keywords text box. Make sure that your import is set up as shown in the illustration below, and then click Import.

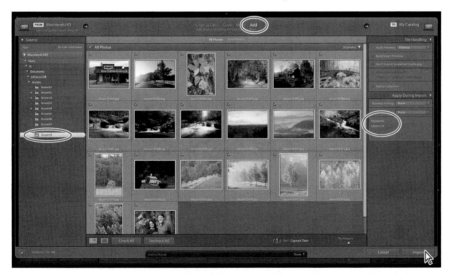

5 The 20 images are imported from the lesson10 folder, and now appear in both the Grid view of the Library module and in the Filmstrip across the bottom of the Lightroom Classic workspace. Create a collection called Lesson 10 and place the images in it.

Preventing data loss

The importance of a good backup strategy is often only understood too late. How much damage would be done if your computer were stolen right now? How many files would be irrecoverably lost if your hard disk failed today? How much work and money would that cost you? You can't prevent a disaster from happening, but it *is* in your power to reduce the risks and the cost of recovery. Backing up regularly will reduce the impact of a catastrophe and save you time, effort, and money.

Lightroom Classic delivers a range of options that make it easy to safeguard your photo library; as for the rest of the files on your computer, you really should have your own backup strategy in place.

Backing up the catalog file

The Lightroom catalog file stores a great deal of information for the photos in your library—not only the locations of the image files, but the metadata attached to them, including titles, captions, keyword tags, flags, labels, and ratings, together with all your developing and output settings. Every time you modify a photo in any way—from renaming the file during import to color correction, retouching, and cropping—all your work is saved to the catalog file. It records the way your images are grouped and ordered in collections, and records the publishing history, slide-show settings, web gallery designs, and print layouts associated with them as well as your customized templates and presets.

Unless you back up your catalog, you could lose hundreds of hours of work in the event of a hard disk failure, accidental deletion, or a corrupted library file, even if you do have copies of your original images stored safely on removable media. You can set Lightroom to initiate a regular backup of your catalog file automatically.

1 Choose Catalog Settings from the Lightroom Classic/Edit menu. On the General tab, choose When Lightroom Next Exits from the Back Up Catalog menu.

2　Click the Close button/OK to close the Catalog Settings dialog box, then quit Lightroom Classic. If you get a dialog box asking if you really want to quit Lightroom, click Yes.

3　In the Back Up Catalog dialog box, click the Choose button to change the folder where the backed-up catalog will be stored. Ideally, the backup should be located on a different disk than your original catalog file; for the purpose of this exercise you can select the LRClassicCIB folder on your hard disk. In the Browse For Folder/Choose Folder dialog box, select the LRClassicCIB folder as the backup directory and click Choose/Select Folder.

4　Make sure the Test Integrity Before Backing Up and Optimize Catalog After Backing Up options are selected. It's a good idea to keep these options selected whenever you back up your catalog; it would defy the purpose of a backup if your original catalog file was not in good working order. Click Back Up.

Each time you back up your catalog, Lightroom Classic will create a complete copy of the catalog file in the directory you specified, inside a new folder with a name composed from the date and time of the backup. To save space on your backup drive, you can either delete your older backup files or compress them. Catalog files compress very effectively; you can expect a compressed catalog to be as small as 10% of the size of the original. Make sure to decompress the file before attempting to restore your catalog from the backup.

Should your catalog be accidentally deleted or become corrupted, you can now restore it either by copying the backup file to your catalog folder or by creating a new catalog and importing the contents of your backup file. To avoid inadvertently modifying your backup file, it's preferable not to open it directly from the Lightroom Classic File menu.

● **Note:** Backing up the catalog file in this way does not make backup copies of the original image files or the preview images that Lightroom Classic displays in the workspace. The previews will be regenerated as your catalog file is restored from the backup, but you'll need to back up your original image files separately.

5　Start Lightroom Classic. In the Adobe Photoshop Lightroom - Select Catalog dialog box, make sure that the file LRClassicCIB Catalog.lrcat is selected under Select A Recent Catalog To Open, and then click Open.

6　Choose Lightroom Classic > Catalog Settings/Edit > Catalog Settings.

7　In the Catalog Settings dialog box, click the General tab and set your preferred backup frequency by choosing it from the Back Up Catalog menu.

8　Click the Close button/OK to close the Catalog Settings dialog box.

Exporting metadata

The catalog is a central storage location for all the information associated with every image in your library; exporting and distributing the catalog file's content is another strategy that will lessen the impact if your catalog file is lost or damaged. By saving the information from the catalog file that is specific to each photo to the respective image file on your hard disk—and keeping this exported information in sync with your catalog file, which can be done automatically—you have, in effect, a distributed backup of the metadata and develop settings for each of your photos.

When a photo has changes to its metadata that have not yet been saved to the original image file—such as the Lesson 10 keyword tag you applied to the images for this lesson during the import process—its image cell in the Library module's Grid view and the Filmstrip is marked with the Metadata File Needs To Be Updated icon.

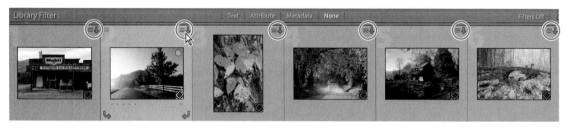

1 If you don't see the Metadata File Needs To Be Updated icon in the Grid view image cells, choose View > View Options. On the Grid View tab in the Library View Options dialog box, select the Unsaved Metadata option under Cell Icons. Click the Close button to close the Library View Options dialog box.

2 Select the first image in the Grid view. Right-click the thumbnail and choose Metadata > Save Metadata To File from the menu. Click Continue to confirm the operation; after a brief processing time, the Metadata File Needs To Be Updated icon disappears from the thumbnail cell.

3 Command-click/Ctrl-click to select the next five photos, and then click the Metadata File Needs To Be Updated icon in the image cell of any of the selected images. Click Save to update the image files on your hard disk.

After a brief processing time, the Metadata File Needs To Be Updated badge disappears from each of the image cells.

If you edit or add to an image's metadata in another application, such as Adobe Bridge or the Photoshop Camera Raw plug-in, Lightroom Classic will show the Metadata Was Changed Externally icon above the thumbnail in the Grid view. To accept the changes and update your catalog file accordingly, choose Metadata > Read Metadata From Files. To reject the changed metadata and overwrite it with the information in your catalog file, choose Metadata > Save Metadata To Files.

You can update the metadata for a batch of modified images—or even for the entire catalog with all its folders and collections—by selecting the images or folders to be updated and choosing Metadata > Save Metadata To Files, as you did in step 2.

You can use the Metadata Status filter in the Filter bar to quickly find those photos in your library with changes made externally to the master files on disk, any image with a metadata conflict—with unsaved changes made by both Lightroom and another application since the file's metadata was last updated—those with unsaved changes made in Lightroom, or images with metadata that is up to date.

For DNG, JPEG, TIFF, and PSD file formats—which have defined spaces within the file structure where XMP information can be stored separately from the image data—Lightroom writes metadata into the image file itself. In contrast, changes made to camera raw images are written into a separate XMP sidecar file that records the metadata and develop settings exported to the image from Lightroom.

Many camera manufacturers use proprietary and undocumented formats for their raw files, some of which become outdated as new ones appear. Because of this, storing the metadata in a separate file is the safest approach, avoiding the possibility of corruption in the raw file or loss of the metadata exported from Lightroom.

4 From the LightroomClassic/Edit menu, choose Catalog Settings. On the Metadata tab select Automatically Write Changes Into XMP so that metadata is exported automatically whenever a raw image is modified; the sidecar file will always be up to date with your catalog. Click OK.

However, XMP information exported in this way contains only the metadata specific to the individual images: keywords, flags, labels, ratings, and develop settings. It does not include higher-level data relevant to the catalog as a whole such as information relating to stacks, virtual copies, and settings used in presentations.

Backing up the library

In the first exercise you backed up your catalog file without any images. In the second exercise, you updated your images files with metadata and develop information from the library catalog. This time, you'll export your entire Lightroom Classic library: images, catalog, stacks, collections—the works!

Exporting images as a catalog

When you export your photos as a catalog, Lightroom creates a copy of the catalog file and gives you the option to make copies of the master files and the image previews at the same time. You can choose to export the entire library, or just a selection of your images, as a catalog. Exporting images in this way is ideal for moving your photos together with all the associated Lightroom catalog information from one computer to another. You can use the same technique to restore your entire library from a backup after a data loss.

1 In the Catalog panel, click All Photographs, then choose File > Export As Catalog.

Ideally, you should save your backup files to a hard disk other than the one that stores your catalog and the master image files—but for this exercise, you can save the backup files to your desktop.

2 Type **Backup** in the Save As/File Name text box, then navigate to your Desktop folder. Make sure the Build/Include Smart Previews and Export Selected Photos Only (if you selected photos first) options are unselected, and that Export Negative Files and Include Available Previews are selected. Click Export Catalog/Save.

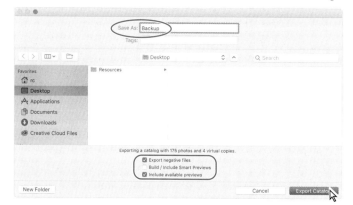

A progress bar is displayed at the upper left as the new catalog is being created; for such a small catalog, backing up should take only a few seconds. Lightroom copies the image files associated with the catalog to their new location as a background task.

3 When the export process is complete, switch to Finder/Windows Explorer and navigate to your desktop. Open the new Backup folder.

Note: You may see a different set of folders than is shown in the illustration, depending on which lessons you've already completed.

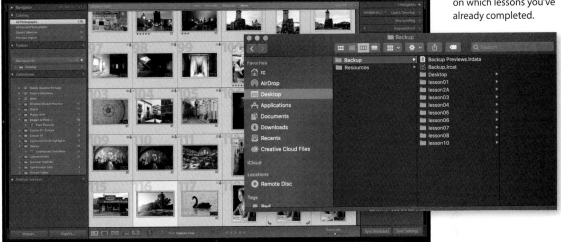

You can see that the folder structure nested inside the Backup folder replicates the arrangement of folders you see in the Folders panel. All the master images in your Lightroom Classic library have been copied into these new folders and the file Backup.lrcat is a fully functional copy of your original catalog.

4 In Lightroom Classic, choose File > Open Catalog. In the Open/Open Catalog dialog box, navigate to the new Backup folder inside your Desktop folder. Select the file Backup.lrcat, and then click Open. If the Open Catalog dialog box appears, click Relaunch. Lightroom will open the backup catalog.

5 Other than the filename in the title bar of the workspace, this catalog will be almost indistinguishable from your original work catalog. Only some temporary status information has been lost; for example, in the Catalog panel you can see that the Previous Import folder is now empty, as is the listing for All Synced Photographs. You can sync only one catalog from Lightroom Classic, so any synced collections in your work catalog will not be marked as synced here.

6 Some of your preferences have been reset to defaults that may differ from the choices you've made for your LRClassicCIB catalog. From the Lightroom Classic/Edit menu, choose Catalog Settings. Click the General tab in the Catalog Settings dialog box. You can see that the backup frequency has been reset to the default. Click the Close button/Cancel to close the Catalog Settings dialog box.

7 Choose File > Open Recent > LRClassicCIB Catalog.lrcat. In the Open Catalog dialog box, click Relaunch. If the Back Up Catalog dialog box appears, click Skip This Time.

Exporting photos

The backup techniques that we've discussed so far all produce backup files that can be read only by Lightroom or another application that is capable of reading and interpreting the exported XMP metadata. If you wish to send your work to somebody who doesn't have Lightroom installed on their computer, you'll first need to convert the images to an appropriate file format. This is comparable to saving a Word document as plain text or as a PDF document for distribution; some of the functionality is lost, but at least the recipient can see what you're working on. Your choice of file format will depend on the purpose for which the images are intended.

- To export a photo for use as an email attachment intended to be viewed onscreen, use the JPEG file format and minimize the file size by reducing the resolution and dimensions of the image.

- To export an image to be edited in another application, convert the photo to either the PSD or TIFF file format at full size.

- For archival purposes, export the images in their original file format or convert them to DNG.

Exporting JPEG files for onscreen viewing

For this exercise, you'll use a saved preset to edit the lesson images before you export them so that you'll be able to see at a glance that your develop settings have been applied to the exported copies.

1 Select the Lesson 10 collection in the Collections panel, and choose Edit > Select All. From the Saved Preset menu at the top of the Quick Develop panel, choose User Presets > Mandalorian.

2 With all 20 images still selected in the Grid view, choose File > Export from the menu. You can also right-click any of the images and select Export > Export, or click the Export button at the lower left.

3 Under Export Location in the Export dialog box, choose Specific Folder from the Export To menu, and then click the Choose button below it to specify a destination folder (*see illustration after step 4*). Navigate to your desktop and click Choose/Select Folder.

▶ **Tip:** If you are asked whether Lightroom should overwrite the information embedded in the image files, click Overwrite Settings.

4 Select the Put In Subfolder option and type **Export** as the name for the new subfolder. Deselect the Add To This Catalog option.

5 Under File Naming in the Export dialog box, select the Rename To option, then choose Date‑Filename from the menu.

6 Under File Settings, choose JPEG from the Image Format menu and set a Quality value of between 70% and 80%—a range that generally makes an acceptable compromise between image quality and file size. From the Color Space menu choose sRGB. The sRGB color space is a good choice for images intended to be viewed on the web, or in other circumstances where you are unsure what form of color management is used, if any at all.

7 Scroll down in the Export dialog box, if necessary, so that you can see the Image Sizing controls. Select the Resize To Fit option and choose Width & Height from the menu. Enter **1,500** for both width (W) and height (H) and choose Pixels from the units menu. This will proportionally scale each image so that its longest side is 1500 pixels. Our lesson images are all larger than this, so you won't need to select Don't Enlarge to avoid smaller images being upsampled. Set the Resolution to **72** Pixels Per Inch—although resolution settings are generally ignored for onscreen display. The reduction in file size is the result of reducing the total number of pixels that make up the image.

8 In the Output Sharpening settings, select the Sharpen For option, choose Screen, and set the Amount to Standard. Under Metadata, choose the Copyright Only option. Note the other options available under Metadata; even with the All metadata option selected, you can still protect your privacy by removing GPS location information. Deselect Watermark. Choose Show In Finder/Show In Explorer from the After Export menu under Post-Processing.

Note: To have Lightroom notify you by playing a sound when the export process is complete, choose a sound from the menu under Completion Sounds on the General tab in the Preferences dialog box.

9 Click Export, then watch the progress bar on the left side of the top panel in the workspace. When the export process is complete, your Export folder on the desktop will open in macOS Finder/Windows Explorer.

Using export plug-ins

You can use third-party Lightroom plug-ins to extend almost any aspect of Lightroom Classic's functionality, including the export options.

There are export plug-ins that enable you to use the Lightroom export interface to send images to particular online photo sharing sites and social networking sites, or even other applications; for example a Gmail plug-in enables you to create an instant Gmail message and attach your photos as they are exported.

Other plug-ins add search criteria to the Filter bar, enable you to automate and compress backups, help you to create photo-collages or design and upload web galleries, give you access to professional effects and filters, or let you work with Photoshop-style layers in the Develop module.

Click the Plug-in Manager button in the lower-left corner of the Export dialog box, and then click Adobe Add-Ons to browse online, where you'll find plug-ins from third-party developers offering additional functionality or helping you to automate tasks, customize workflows, and create stylish effects.

You can search the available Lightroom plug-ins by category, browsing for camera raw profiles, develop presets, export plug-ins, and even web gallery templates.

10 In Windows Explorer, show the Preview Pane or click Slideshow view to see a preview of the images in the folder. In the macOS Finder, select an image in Column view or in Cover Flow to see its preview. You can see that the Mandalorian preset was applied to these copies of the lesson photos during the export process. The copies are 1500 pixels wide and have much reduced file sizes.

11 Delete the images from the Export folder, then return to Lightroom Classic. With the 20 images still selected, choose Edit > Undo Mandalorian to revert all 20 images to their original colors.

Exporting as PSD or TIFF for further editing

1 In the Grid view, choose Edit > Select None, and then select lesson10_002. In the right panel group, expand the Quick Develop panel and choose Creative > Soft Mist from the Saved Preset menu.

2 Choose File > Export. In the Export dialog box, you'll notice that all your settings from the previous exercise are still in place.

Tip: To export more images using the same settings that you used for the previous export (and without calling up the Export dialog box) choose File > Export With Previous.

3 In File Settings, choose TIFF from the Image Format menu. When saving in TIFF format, you have the option to apply ZIP data compression—a lossless form of compression—to reduce the resulting file size. From the Color Space menu, choose AdobeRGB (1998).

▶ **Tip:** Choose your preferred external editor, file format, color space, bit depth, compression settings, and file naming options on the External Editing tab of the Preferences dialog box. In the Lightroom Classic work-space, choose Photo > Edit In, and then choose your preferred external image editing applica-tion from the menu. Lightroom will automat-ically export an image in the appropriate file format, open it in the external editor, and add the converted file to the Lightroom library.

When you intend to edit an image in an external application after exporting it, you should use the AdobeRGB (1998) color profile rather than the sRGB color profile. The AdobeRGB (1998) color profile has a larger color gamut, which results in fewer colors being clipped and the original appearance of your images being better preserved. The ProPhoto RGB color gamut is even larger, capable of representing any color from the original raw image. However, to correctly display images using the AdobeRGB (1998) or ProPhoto RGB color profiles onscreen, you need an image editing application capable of reading these color profiles. You'll also need to turn color management on and calibrate your computer display. Without taking these measures, your images will look bad onscreen with the AdobeRGB (1998) color profile—and even worse with ProPhoto RGB.

4 Change the image format to PSD. Choose 8 Bits/Component from the Bit Depth menu. Unless you have a particular need to output 16-bit files as part of your workflow, 8-bit files are smaller and compatible with more programs and plug-ins, but do not preserve fine tonal detail as well as 16-bit files. Lightroom actually operates in a 16-bit color space, but by the time you're ready to export images, you've usually already made any important corrections or adjustments that were necessary, so you won't lose much in terms of editing capability by converting the files to 8-bit for export.

5 In Image Sizing, deselect Resize To Fit and set the Resolution to 300 pixels per inch, to match the original image; to preserve all the image information for further editing, we wish to export every pixel of the source file.

6 Leave the Output Sharpening and Metadata settings unchanged. If you have Adobe Photoshop installed on your computer, choose that application from

the After Export menu in the Post-Processing options. Alternatively, choose Open In Other Application, and then click Choose to select your preferred image editor. Click Export.

7 Wait until the export is complete and the photo has opened in the external editor. The image has been exported with the Creative presets Soft Mist preset that you applied in the Quick Develop panel. Its dimensions are the same as those of the original image—7360 by 4912 pixels.

8 Quit the external editor, delete the file from the Export folder in the Finder/ Windows Explorer, and then return to Lightroom Classic.

Exporting as original or DNG for archiving

1 Navigate to the Develop Module Practice collection in the Collections panel and select lesson05_008, the picture of the bald eagle.

2 Choose File > Export. In the Export dialog box, under Export Location, deselect Put In Subfolder and simply export the image to the desktop.

3 In File Settings, choose Original from the Image Format menu. Note that there are now no other File Settings, Image Sizing, or Output Sharpening options available; Lightroom will export the original image data unaltered.

4 In the Post-Processing options, choose Show In Finder/Show In Explorer from the After Export menu, then click Export.

5 When the export process completes, the folder opens in Finder/Windows Explorer. In the Finder/Windows Explorer window, note that an XMP sidecar file has been saved together with the copy of the RAW image file, which was originally provided *without* an XMP file. The XMP file records changes to the image's metadata (the keyword you added at import) as well as its detailed editing history (the Quick Develop adjustments you made).

6 In Finder/Windows Explorer, delete both files from the Desktop folder, and then return to Lightroom Classic.

Using export presets

Lightroom Classic provides presets for commonly performed export tasks. You can use any preset as is or as a starting point for setting up your own.

If you find yourself performing the same operations over and over again, you should create your own presets to automate your workflow.

1 Navigate back to the Lesson 10 collection in the Library module. In the Grid view, select any of the images and then choose File > Export.

2 In the list of presets on the left side of the Export dialog box, choose For Email from the Lightroom Presets.

3 Examine the settings associated with this preset. With the current File Settings, an exported file will be an sRGB JPEG file with a Quality setting of 60 (%). Under Image Sizing, the exported image is set to be scaled down so that its longest side will be 500 pixels. Output Sharpening and Watermarking are unselected and the Metadata options are set to export copyright details only. Note that there are no export location settings or post-processing settings.

Lightroom will export the image directly to an email, so there are no export location settings associated with this preset. Post-processing options are also unnecessary—Lightroom automatically generates an email and attaches the photo, and your email is sent from within Lightroom, with no need to launch an email client.

▶ **Tip:** For more detail on exporting photos as email attachments, see "Sharing your work by email" in Lesson 1.

4 In the list of presets on the left side of the Export dialog box, click to select the Burn Full-Sized JPEGs export preset.

5 Note the changes in the export settings. CD/DVD is now selected in the Export To menu at the top of the Export dialog box, instead of Email (so, once again, export location settings are redundant). Under File Settings, the JPEG Quality setting has been set to 100 (%).

6 Scroll down to examine the rest of the preset options. Under Image Sizing, the Resize To Fit option is unselected, and the file will be exported with all of its metadata, except for People tags and GPS location information.

You can adjust any of the preset settings if you wish, and then save your custom configuration as a new preset by clicking the Add button below the Presets list.

Creating user presets

You can save your customized export settings as a new user preset. Export presets are always available from the File menu (File > Export With Preset), where you can start your export without opening the Export dialog first. Let's create a preset that will export an image suitable for posting to Facebook. The preset will save an image

to the desktop at 1400 pixels on the long edge, that has a JPEG quality of 85, and that uses the sRGB profile.

1 Navigate to your Lesson 10 collection and select the lesson10-001 image. Click the Export button at the lower left of the Library module.

2 To export the image, follow the settings outlined in the image to the right. The only settings that need changing are:

Top Export To: Hard Drive

Export To: Specific Folder

Folder: Desktop

File Settings: JPEG

Color Space: sRGB

Resize To Fit: Long Edge

Pixels: 1400

Resolution: 72 pixels per inch

All of the other settings can stay unselected.

3 Click the Add button at the lower left of the Export dialog box and give the preset a name—I am going to call this one "Facebook Export 1400px"—and click Create. Now that we have the preset set, click Cancel in the Export dialog box.

With the image still selected, right-click it, scroll down to Export, and you'll see the new Facebook Export 1400px in the list. This will make it easier to save pictures with just the right settings whenever you need them.

Using Multi-Batch Export

Imagine you have a series of images and you need to publish them to Facebook, make high-resolution exports to deliver to your client, make low-resolution versions to email to the client, and convert to DNG for your backup. Previously, you achieved this by creating a series of export presets and then doing each export separately, one by one. With the November 2019 release of Lightroom, you now have the ability to export one set of images with several different presets simultaneously—a boon to photographers' workflows everywhere.

In the Preset list on the left side of the Export dialog box, each preset has a check box in front of it. Simply click the check boxes for the presets you want to use, and when you click Export, Lightroom will export your images with all of the presets at once.

Congratulations! You've completed this lesson on backing up your Lightroom Classic files and exporting your images. You've learned how to use the built-in catalog backup feature and to save metadata to your files. You've backed up all your images by exporting them as a catalog, and exported them individually for viewing onscreen, for further editing, and for archiving. You have also used and created your own export presets. Before you move on to the next lesson, take a moment or two to review some of your new skills by reading through the questions and answers on the next pages.

Review questions

1 What are the two basic components of your photo library that need to be backed up?

2 How can you move a selection of images or your entire image library with all the associated catalog information from one computer to another?

3 How can you tell if any updated metadata have been saved to a file?

4 How would you choose between file formats for exporting your photos?

5 How do you create your own export preset?

Review answers

1 The two basic components of the image library are the original image files (or master files) and the library catalog file, which records all the metadata and the complete editing history for every image in the library as well as information about collections, user templates and presets, and output settings.

2 On one computer, use the Export As Catalog command to create a catalog file together with copies of the original images and the available previews. On the other computer, go to File > Open Catalog, navigate to your exported file, select the exported .lrcat file, and choose to open it.

3 In Grid view and in the Filmstrip, any images that have metadata to be saved will display the Metadata File Needs To Be Updated icon. You can also find any files that need to be updated by using the Metadata Status filter in the Filter bar.

4 The appropriate choice of a file format depends on the intended use of the exported images. To export images for onscreen viewing as email attachments, you'd use the JPEG file format and minimize the file size. To export an image to an external image editing application, you'd use PSD or TIFF and export the image at full size. For archival purposes, export the images in their original format or convert them to DNG.

5 Open the Export dialog box, change the settings to your liking, then click the Add button at the lower left of the dialog box. In the New Preset dialog box, name your preset, and click Create.

PHOTOGRAPHY SHOWCASE
KATRIN EISMANN

Photography has always been influenced by technological developments, and the current state of photography is one of inspiration, flexibility, and exchange. Images and knowledge overflow in an unlimited (some would say overwhelming) stream of social media feeds to catch a viewer's attention in a ricochet of noise and attention overload. But what is at the very essence of photography for each of us?

For me it is a childlike curiosity and the relishing of discovery, which can be as straightforward as Garry Winogrand's "I photograph to find out what something will look like photographed" to experimenting with a new lens or effect to needing to look at the same subject over and over again to actually see what is there. The best photographers ask questions and work with cameras and image processing to develop answers. In this process, the questions will shift, and the answers-in-progress will require honest assessment and introspection.

I see the world more clearly through a viewfinder, and every day that I carry a camera—be it a smartphone or a high-end full-frame piece of equipment—I am interacting with the world, and as I look out…I am actually looking within. Listen to your images and you too will discover new worlds that are all around us. Be curious, be brave, and enjoy the process.

www.katrin-eismann.com
instagram.com/katrin_eismann

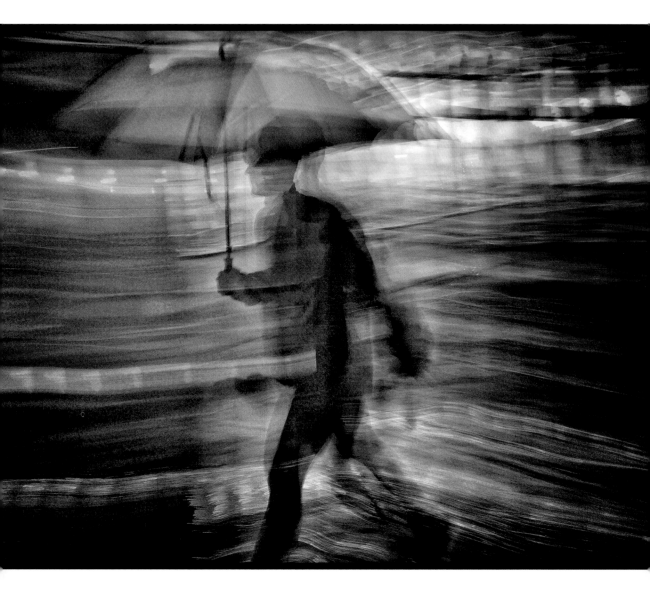

11 AN OVERVIEW OF MY WORKFLOW

Lesson overview

Now that you have a solid command of how to use Lightroom, you'll find that making and developing images comes quite easily. The harder part of the equation will be, what do you do when your computer fills up? Or what happens when you are using an external hard drive to store your images and it fills up? I often tell photographers that Lightroom is a program that organizes your images first and then happens to develop them. To truly master it, you'll need to develop a solid workflow strategy.

After teaching thousands of students online and in live seminars, I've learned that it's this part of the process that people find the most elusive. This lesson isn't intended to be a follow-along step-by-step guide, but more of a peek at how I organize myself. By walking you through my process and showing you the gear that I find the most useful, perhaps you'll get a better idea of how to get organized once and for all. In this lesson, you'll learn how to:

- Go from hard drive to external drive to network-attached storage (NAS) device, and how NAS devices can help with cloud sync.

- Use built-in tools for backup of external drives.

- Leverage virtual copies for offline use.

- Implement smart collections for essential tasks.

 This lesson will take 45 minutes to complete. There are no download files.

Evan is an amazing artist and athlete. Aside from playing guitar, he is on the track and field team at school—and preparing to go to college. We set out to try to make a portrait of him and he gamely came out for the scout shoot. As it turned out, all we needed was one light and a little bit of sun to make a heroic sports portrait.

Keep your computer clean

If there's one thing that I've noticed a direct correlation with, it's that the more free space I have on my computer, the better it works. Anytime my computer gets closer to only 10 or 20 GB free, I start losing a lot of its performance. My goal, then, has always been to manage my projects in a manner that leaves as much free space on my computer as possible.

If you look at the All Photographs folder in my Lightroom Catalog panel, you'll see that I have 321,825 pictures. (Don't worry, I'd guess that 321,800 of them aren't any good. I'm a bit of a pack rat.)

However, looking at my computer's desktop, you'll see that I have a little more than 300 GB of hard drive space free. This book is probably taking up about 100 GB of information, and I have a video project I'm working on that's about 150 GB. So in actuality, I probably have about 550 GB of free space on my computer on a 1 TB hard drive.

How do I keep that much space free on my computer while still having more than 321,000 images in my Lightroom catalog? The answer is my workflow strategy, which I call a hot, medium, and cold strategy.

Workflow overview: Hot, medium, and cold

Before we work through my workflow, let me explain the process from a 35,000-foot view.

Whenever I work on a shoot—whether it's a personal project, an assignment, or a commercial job—that project is known as a *hot* project. The project requires my near daily attention, and it will be the set of images that I am constantly going over in Lightroom every time it is opened.

Once the job is completed, the project moves into *medium* status. I may not need access to that folder of images all of the time, but there is a chance that I may be called on to provide something from it. Because of this, I move the job from the computer onto a removeable drive, and I use Smart Previews to manage it. That

drive moves around with me, and is backed up by the built-in features of my operating system (for me, it's Time Machine in Apple's Mojave operating system). Should I need to do any work on the images, I can work on them in Lightroom, and synchronize the changes when I plug the external hard drive into my computer.

After a while, that project will not be accessed as much and it moves into *cold* status. When that happens, I move the folder from the removable drive onto a network-attached storage device, or NAS. That NAS device lives in my home, and lets me have access to the images whenever I am connected to my home network. In a pinch, I can always keep the Smart Previews in my catalog, but even those get purged when the job becomes too cold. In an extreme case, I can always log in to my NAS device from a browser anywhere and do a download of a series of files should I need to.

Throughout this process, I use collection sets and collections to keep my work organized, and I try to be diligent about how I label the files, as well as the keywords that I apply to the images.

Let's pick apart the pieces now, one by one.

Workflow: Hot status

For the purposes of this demonstration, I have created a new catalog in Lightroom and am starting the import process with a recent shoot on my Nikon D850.

Importing the pictures

I made a couple of sports portraits of a graduating senior and will use that as our work project. We won't be developing any pictures, so we just need files to move across the process.

The key parts of the import are outlined here. In the Import dialog box's File Handling panel, the Build Previews menu should be set to Minimal, and no other options selected. In the File Renaming panel, I made a custom naming template that uses the Date (YYYYMMDD) token and a four-digit sequence separated by an underscore.

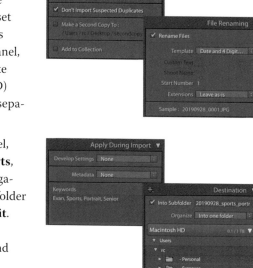

In the Apply During Import panel, I typed the keywords **Evan**, **Sports**, **Portrait**, and **Senior**, and I'm organizing all of the images into one folder called **20190928_sports_portrait**. While I don't need the keywords in the folder, I add them to remind myself of the shoot.

I create this folder on my desktop. Working on my computer, I treat my desktop as I treat my desk at home. If it is on my desk, it gets my attention and that is what I am working on for the day. Once I finish the job, it gets moved off my desktop and filed somewhere. Not having excessive files and folders on my desktop helps keep me focused, as I know *exactly* what I am supposed to be working on.

Iterative culling: picks and rejects

Now that the folder has been imported and is on my desktop, I immediately get to work culling the photos. The logic here is that, at this moment, you'll know exactly which images are the bad ones from the shoot (out of focus, underexposed, cut off body parts, etc.), so you should go through them and mark all of those bad ones as rejected. If, during this process, you see an image that is a 5-star image, mark it as such. The bigger point here is to get all of the images sorted and ranked before you start developing.

This also has a very practical purpose. Imagine you are doing a portrait shoot for a client and you promised them six pictures. You import the photos and notice that there are 90 pictures in the take. After going through the images, you can weed out a majority of the bad ones, and find six images to focus on immediately.

At this point, you can be done with the job. You found six images you can give to the client, so you can mark them as your picks, develop them, and move on to the next job.

There will be plenty of photography jobs that will require hours of work deciding the best pictures. Commercial photographer Joe McNally once told me, "There is food for the soul, and food for the table." Get the food for the table out as efficiently as you can so you can focus on the food for the soul.

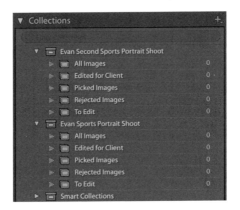

Collection sets and collections

Before I start dragging anything around in Lightroom, I make a collection set for the shoot and create collections inside of it. The collection set has the shoot name, while the collections are used for different selections of images from the shoot. All of my collection sets include the collections you see in the illustration at right.

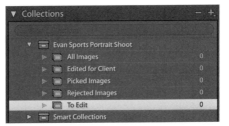

There is a Rejected Images collection in the collection set because, sometimes, clients ask that you don't delete any images. In those cases, I place all the bad images in the Rejected Images collection.

I organize my individual shoots in collection sets because it allows me to quickly find the images that I need. It also helps me organize future shoots with greater precision. For example, what if I did another shoot with Evan? Wouldn't I want to be able to quickly go through those images? I can make a second collection set for the second Evan shoot and keep it organized like the first one.

Note: Make sure you check out how to make collections and collection sets in Lesson 4.

Extrapolating this analogy, what if I wanted to group all the shoots that I do with Evan in one place? I could make a collection set called **Evan Napoli** and place the two collection sets of the shoots with him inside it. If I want to see all the shoots, I can click the main collection set. If I want to see individual parts of a shoot, I can click the individual collections in that shoot.

In this structure, I can see the picked images for each shoot in the individual collections, but what if I want to see the best of all of the shoots in one spot? I can create a collection named **Best of Evan** and have that collection live inside the main collection set. I can drag any images into it from anywhere and have access to the best of the best in one spot.

One final example: what if Evan is the start of my new sports portrait business? I can create another collection set called **Sports Portraits** and place the Evan collection set inside it. This structure allows me to collapse the Sports Portraits collection set, and all collection sets in it, showing them only when I need them.

The one thing that I can guarantee you in photography is that you will be making a lot of pictures. Developing a system to organize yourself like this may seem slow at first, but it is absolutely necessary as your inventory of images grows. I urge you to spend time reviewing this part of the process and developing your own system.

Note: In the accompanying video series, I share a couple more sample collection set breakdowns that I think could be helpful if you are a landscape, portrait, wedding, or documentary photographer. To find and download the files, see the "Getting Started" section at the beginning of the book.

With Previous Import selected in the Catalog panel, I press Command+A/Ctrl+A to select all of the images and drag them into the All Images collection. Then I use the Metadata filter in the Filter bar at the top of the Grid view to find the picked images, select all of them, and drag them into the Picked Images collection. I do the same for the rejects, dragging them into the Rejected Images collection. If there are images that I have flagged for editing, they are placed in the To Edit collection.

At this point, I start working on developing images in Lightroom.

Backing up your images

As I am working on one copy of the images on my computer, we need to start talking about the backup strategy here.

As an Apple user, I have all of the backups of my computer done to two separate external drives using Time Machine.

From the Apple menu, choose System Preferences > Time Machine. When you connect your external hard drive to your computer, you can select it as a backup disk and Time Machine will start the backup process to it.

This gives me one copy of the images at one location.

The drive that I use for the Time Machine backup is a G-SPEED Shuttle with ev Series Bay Adapters from G-Technology. I've had just about every drive under the sun, and I can say that the drives from G-Technology have always been pretty reliable for me. While you can use any of their desktop drives (their G-RAID are some of my favorites), I use this particular drive because it uses two Thunderbolt 3 connections. Not only does this drive let me connect my other Thunderbolt 3 drives, but the ev bays allow me to plug in my external hard drives, and I have immediate access to them at my desk.

A second one of these lives in my studio, and I plug into it whenever I am there to have a second backup at another location.

For Windows users, the closest thing I've seen to a backup for systems is Genie Timeline. While not exactly like Time Machine, it's pretty robust and it handles the process of keeping your computer backed up quite well.

In a perfect world, you should have your computer backed up in two separate locations. This solves the machine problem and keeps the hot shoot on my computer safe.

Workflow: Medium status

Now that the images have been organized and edited, the prints have been sent, and the samples have been sent to Facebook, it's time to start thinking about offloading your images to free up that space on your computer.

To do this, we will offload the hot project onto a removable drive. To make sure that we can work with the images disconnected, we will create Smart Previews. The goal is to move as much as we can off of the computer.

This is usually the part where photographers hear the collective record scratch and think to themselves, "Wait a minute, I want to be able to keep every picture that I've made with me, wherever I go, for however long I want it!" This is also the part where most photographers bail out of this process, and two years later, find themselves carrying a fleet of hard drives with no idea where any particular image is, let alone how to access them all. (This is an actual picture of a client's setup.)

Your need to access pictures diminishes over time

To convince you that you don't need to carry everything with you, I offer this example. If you look at your phone, there's a good chance that you took a picture with it not too long ago. There is also a good chance that you will go back to that picture pretty frequently over the next few days.

How long has it been since you've gone back to the beginning of all of your photos in your phone? Probably quite a while. Over time, we stop looking at the pictures of the past, and focus on what we are doing right now. We don't walk around with all of the pictures from our childhood with us; we know that they are safe at home (waiting for the right time to be brought out to embarrass us).

Your Lightroom collection should operate the same way. There are pictures that I look at daily, but over time, that need diminishes. The photos from that vacation I took seven years ago are tucked away on an external drive. I'll occasionally use them, but I don't need them with me.

If you can buy into this idea, you can save yourself a lot of headaches.

Creating Smart Previews

Before we move the folder to a removable drive, it's a good idea to create Smart Previews of your images. During the import process earlier in the book, we deselected the Build Smart Previews option in the File Handling panel. It's below the Build Previews menu.

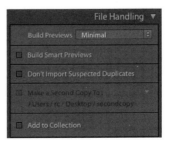

Smart Previews allow you to work on images without having the physical copy of them on the computer. Out of all of the preview types, they take up the most space, but they are a lot smaller than carrying the actual files with you. In Lightroom, you can make Smart Previews at any point in your workflow. Select the images you want to make Smart Previews for, then choose Library > Previews > Build Smart Previews.

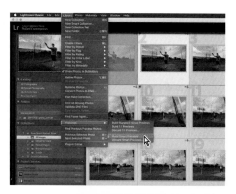

At the bottom of the Histogram panel, there is a symbol letting you know that a Smart Preview has been created for the active image.

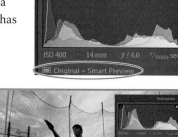

I purposely did not create a Smart Preview for the first image in the series to show you how this works. With this first image, you'll see under the histogram that there is no Smart Preview. I can go into the Develop module and make any changes—it's business as usual.

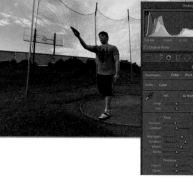

The moment that the image is moved somewhere other than its original location, Lightroom cannot make changes to it, the Develop module panels turn gray, and a File Could Not Be Found error is displayed. If you want to go back to the digital notebook analogy of Lesson 1, it is as if I moved all the pictures in my house, but never wrote down where I put them.

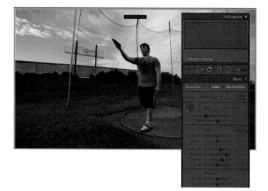

Without Smart Preview With Smart Preview

If an image is disconnected or moved from Lightroom with a Smart Preview, Lightroom continues to work with the Smart Preview alone, allowing you to make changes as you see fit. The moment that you relink or find the folder in question, Lightroom will take the changes and synchronize them with the original.

There are a couple of caveats to keep in mind when doing this, but we'll cover them a little later on. For now, we're ready for the move. Where do we move them to?

Selecting your external hard drive

The two qualities that I am looking for in a hard drive are that I want it to be dependable and I want it to be able to handle the rough and tumble of living in and out of my bag. If you're going to be carrying it around, you want it to be protected.

G-Technology makes a drive called the ArmorATD that has rain, dust, and crush resistance for up to 1,000 lbs. That is a good solution for mobile use.

I also use G-Drive ev RaW drives and protect them with an ATC case they sell that is crushproof, dustproof, and watertight. In the case, the drive can be connected via USB 3 or Thunderbolt.

I prefer these drives because when I get home, I can take them out of their cases and place them into a dock connected to my G-RAID, and they connect with the same cables I use at home. The dock is totally unnecessary, but is a welcome addition for me.

For as good as this hard drive is, though, it's important to keep in mind that in the end it is a spinning plate whose information is being read by a needle. Plug this drive in and go jogging or drop it and your results may vary.

Newer hard drives are being made from solid state memory, or SSD—the same type of memory that is used in your phone or tablet. With no moving parts to skip, I have started to upgrade to something like this to add another level of security. Looking at what gives you the most bang for the buck, I'm really enjoying the 1 TB Extreme Portable SSD from SanDisk. At the time of this writing, it's almost on par with a 1 TB USB 3 drive.

As an added bonus, if you are using a newer computer with Thunderbolt 3 or USB-C, the speeds of these newer drives are crazy. (I'm actually using one of these drives to run my whole computer's operating system, but that's another conversation for another time.)

Moving your images to the external drive

While you can use Lightroom Classic's Folders panel to move your images from one place to another, I prefer to use the file and folder management of my computer's operating system. Apple's Finder and Microsoft's Windows Explorer are things that we are already used to, so it makes sense to use them now.

Also, this gives us another set of skills that we can use later: the finding and relinking of folders.

Copy the shoot folder from the desktop (or wherever you were storing it) onto your removeable drive. I prefer to copy the images and verify they reached their new location before deleting the original files, rather than moving the files. You never know what might happen in the middle of that move. It's better to be safe than sorry.

Once the move is complete, right-click the folder on your computer and choose Move To Trash.

Relinking missing folders

If you look inside the Lightroom Develop module, you'll notice that the image is now relying on only the Smart Preview, although you can still edit it if you need to. Later, you'll need to relink these folders to Lightroom so that you can access your original files or update them. Here are the steps to remember to do that.

1 Find the image that's missing (or only has a Smart Preview).

2 Right-click the image and choose Go To Folder In Library.

3 Navigate to the highlighted folder in the Folders panel and confirm that there is a question mark on its folder. This means Lightroom cannot find the folder on your computer.

4 With the folder selected, right-click it and choose Find Missing Folder.

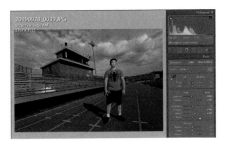

5 Navigate to the removable hard drive where we placed the folder, select it, and click Choose.

6 Your image is now relinked with your original. Your Smart Preview will sync all of your changes with the original image. If you did not have a Smart Preview created but were missing the folder, you should now have access to the Develop module with your files. All is well with the world again.

Relink subfolders faster with Show Parent

Moving to a bigger hard drive? Lost 100 subfolders? The process for the relinking of folders in Lightroom is one of the most useful things you will learn. Out of all the problems that I am asked about, this is the biggest one—bigger than how to develop pictures or how to make prints. I tell my students that I have clients from around the world that fly me in not to go to some cool exotic location and make pictures, but to sit in their basement and move files around on hard drives. It's a living, and I do get to see cool airports.

We covered relinking a single folder when you are using Smart Previews. Here are two more scenarios with related solutions.

In the first scenario, imagine you discover that a file is missing in Lightroom. You go to the folder in the Library module's Folders panel, and you realize that this image was in one of three subfolders of a parent folder. Does this mean that you need to update the folder location three times, one for each subfolder? Not at all.

In this scenario, you would select the parent folder, the folder that is holding all of the subfolders. This is the one you should use to find the missing image. By updating the location of the parent folder, all of the other subfolders (which sometimes can be in the hundreds) will automatically be updated.

Now imagine your 1 TB hard drive is out of space, so you move all of the images in it to a new 4 TB hard drive. What do you do when Lightroom can't find the images you need?

Right-click a missing image and choose Go To Folder In Library to find the folder of images that is missing from your computer. If you cannot see the name of the hard drive the folder resides on in your Folders panel, right-click the uppermost folder and select Show Parent Folder.

This should bring up the name of the external hard drive as a folder, a missing one that needs to be relinked. Right-click the external hard drive folder, and select Find Missing Folder from the menu.

Navigate to the new hard drive on your computer and select it. Don't select any of the subfolders; just click the Choose button at the lower right.

The locations of all of the subfolders inside the new drive will be updated, and you will save yourself hours of work relinking every single folder.

The key thing to keep in mind is that if there is a missing folder, look for a parent folder. If you can relink the parent folder first, you're always going to do less work and save more time.

Backing up your external drive

Once the images are moved onto the external drive, we need to make sure that they are included in our routine backup of the computer. If you are an Apple user and have committed to Time Machine, here's how to handle the very confusing yet useful dialog box.

Clicking the Options button in the lower-right corner of the Time Machine window will show you a list of connected drives that Time Machine is excluding from the backup process. By default, Time Machine will not back up your external drives unless you tell it to. Select the removeable drive in the list, and then click the

minus sign (−) button at the lower left of the list. Now your hard drive is excluded from the exclusion list (confusing, I know) and it will be backed up by Time Machine for you.

Workflow: Cold status

Now that I have spent some time with these images and edited them on a removable hard drive, I find myself accessing this project less and less. As our external drives are finite, I want to make sure that I am being smart about how I use that drive, and make sure that I am keeping all of the data that I am working on as safe as possible. In this section, we will move the folder from the external drive onto a network-attached storage device, or NAS device.

What is a NAS device?

A network-attached storage device is usually a collection of hard drives that are enclosed in a type of box. This box holds all of the drives in place, and via hardware or software, arranges all of the space for you to use it. (For the technologically inclined, it's a RAID configuration.)

Instead of being connected to your computer via a USB or Thunderbolt cable, this box is connected to the cable modem or router at your home. Just as a PC would use Windows as an operating system or Apple would use Mojave, the NAS has its own operating system to manage all of the features of storage on the system.

The NAS that I use is an 8-bay system from Synology similar to the one in the illustration at right. Synology has been rock solid in dependability, and plenty tough for the work that I do.

It's important to note that usually when you purchase your NAS, you also need to supply the internal drives that will go with it. I opted to use Seagate IronWolf NAS hard drives inside my NAS because they are designed to last a lot longer than a traditional hard drive. Do you have to get an 8-bay unit right off the bat? No, you can certainly

start with a much smaller unit. You can also leave some of the bays empty and fill them as your needs grow. The bigger point here is to get a NAS unit that you leave at your home, dedicated to holding all of your images in one location.

Moving your folder to the NAS device

Once I am ready to move the folder to my cold status, I power up my laptop and connect to my network (wired or wireless at home).

I plug in my external hard drive and navigate to the folder I want to move. Then I select the folder and copy it to the NAS device, usually into a folder that's labeled for that year. In a few minutes, all of the information will reside on the NAS device and I can delete it from my external drive.

Back inside Lightroom, I will get the same error as before that it can't find the file. At this point, I'll go to the Folders panel in the Library module and update the folder location to its new location on the NAS device.

Because I have Smart Previews turned on, anytime that I am away from my network at home, I can edit the images using the embedded Smart Previews on my laptop. When I reconnect to the network at my home, the NAS device will become available, and all of the changes that I made on the road will be synchronized with the originals that are sitting on the NAS device.

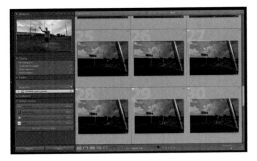

Accessing files on the NAS over the internet

While the NAS device allows me to access my files freely when I am connected at home, there are some rare occasions when I may need to access a file from a folder that is on the NAS device. What do I do?

Earlier I explained that the NAS device is essentially a box with hard drives, connected to your internet at home, and governed by its own operating system. In the case of my Synology NAS device, its proprietary system is called Disk Station Manager, or DSM. One of the great features of this is that it allows me to create a special connection back to my NAS unit at home that I can access via a browser or mobile device. If I need a file stored on it, I can simply log in from anywhere and download the file.

That said, the times I have needed to access something on it have been extreme situations. If you have a Smart Preview of a file in Lightroom, not only can you perform edits on it, but you can export a copy of the file for some general uses. As you can see in the illustration at right, exporting this Smart Preview as a JPEG at 240 ppi yields a file that is 2560 pixels on the long end—that's equivalent to just larger than 7x10 inches. Not bad.

Using smart collections for catalog cleanup

By now you're probably wondering why you wouldn't import every file into Lightroom Classic with Smart Previews turned on? They offer a lot to photographers, but you should keep an eye on them and use them sparingly. To keep track of them, I use smart collections. Let me explain:

During the import process, Lightroom builds a series of previews for you to use. You choose how large they are, with Minimal being the smallest size, then Standard, then 1:1 for when you want to zoom an image to 100%. The file size gets bigger with each preview choice, taking up more space on your computer.

Lightroom takes into account that the size of the preview impacts the amount of space a file takes on your computer by doing its own internal purging. In Lightroom's Catalog Settings dialog box, on the File Handling tab, the default behavior for Lightroom Classic is to delete the 1:1 previews (the ones that are the largest in the group) every 30 days. This is a good thing.

However, Smart Previews are theoretically bigger than 1:1 previews, as they allow you to edit them. Yet, in the Catalog Settings, these files that are bigger are not set to be deleted after a specific amount of time. We can import images with Smart Previews and in short order have a collection with much larger previews than we actually need, and with no way of knowing how many we have.

This is where smart collections come in handy. In my Lightroom catalog, I always keep two smart collections for cleaning out my catalog. The first one is pretty basic: it collects all the files that have the flagged status set to Rejected.

The next one is even more helpful. I have a smart collection that looks for whether the Smart Preview status of a file is set to True.

With that, I have a smart collection that lives in my Collections panel that is constantly scanning for how many Smart Previews I have. If I see that number get too large, or if I decide I no longer need to keep some for a job, I can select them in this collection and discard the Smart Preview by choosing Library > Previews > Discard Smart Previews.

That's the workflow, from start to finish!

Review questions

1 What tool is important when organizing images into a hierarchical structure in Lightroom Classic?

2 What is one benefit of working with Smart Previews?

3 How can you quickly relink a series of folders that were on one hard drive, but that have been moved to another hard drive?

4 How can a NAS device help you organize your growing library in Lightroom?

5 What is the importance of culling your images in Lightroom at the start of the import process?

Review answers

1 Collection sets are containers that allow you to store a series of collections inside of them. Collection sets can also hold other collection sets, allowing you to make an even more detailed structure for your shoots. By using collection sets, you have the ability to organize a large number of collections into a hierarchical structure that can make it easier to find the most important images in the Library module.

2 Smart Previews allow you to edit images that are not physically connected to your computer in Adobe Lightroom. Without using Smart Previews, images that are disconnected (i.e., stored on a removable hard drive or located on a NAS) would show no sliders as active in the Develop module, generating a missing file error. When using Smart Previews, Lightroom makes any changes to a low-resolution copy that temporarily resides on your computer, and syncs the changes to your original images once they are reconnected to the Lightroom library.

3 Right-click the highest-level folder in the Folders panel that you have moved and choose Show Parent Folder. Once the parent folder appears, right-click it and choose Find Missing Folder. You can then point Lightroom to the folder in its new location (the new hard drive). Once you select the new hard drive and click Choose, all of the subfolders will automatically be resynced with the Lightroom catalog.

4 A NAS device is a drive or series of drives that are controlled by a machine that is connected to your home network. The images on your NAS device will be available to you when your computer is connected to your home network (and through the internet, depending on the device), giving you access to all of your images in one place. Moving the images that are less frequently accessed to a NAS device allows you to free up space on your computer, making it perform better once it stores only more recently captured images.

5 In every photographic session, there are images that are successful and others that are not. Sorting through your images and flagging the unsuccessful ones allows you to focus your attention on only the images that you need, and shortens the amount of time that you need to spend developing the most successful images in your shoot. Exercising good culling strategies at the start of the import process speeds up your workflow and lets you get back to making even more images.

INDEX

SYMBOLS

> (forward arrow character), 4
/ (forward slash character), 5
1:1 previews, 78, 397
1:1 and 2:1 zoom settings, 104
8-bit vs. 16-bit files, 366
16-bit print output, 340

A

Adams, Ansel, 197, 239
Add image option, 67
Adjustment Brush, 226–228
adjustment pins, 229
Adobe Landscape profile, 187
Adobe Monochrome profile, 187
Adobe Neutral profile, 187
Adobe Portrait profile, 187
Adobe Raw profiles, 186, 187
Adobe Vivid profile, 187
AdobeRGB color space, 366
Ahmed, Zulfikhar, 46–49
Amount slider
 Detail panel, 203
 Effects panel, 242
 Graduated Filter tool, 223
Apply During Import panel, 67,
 68, 69, 382
aspect ratio, 34, 184–185
Attribute filter, 22, 152, 153–154,
 167, 169
audio for slideshows, 303–304
auto adjustments, 192, 211

Auto Align option, 248
Auto Crop option, 245, 250
Auto Import Settings dialog box,
 74, 76
Auto Layout panel, 267
Auto Leading button, 276
Auto Mask setting, 227
Auto Settings option, 248
Auto Tone Control button, 30
Autofill book feature, 267
Avedon, Richard, 197
AVI video files, 73

B

B&W panel, 240
Back Up Catalog dialog box, 357
Backdrop panel, Slideshow
 module, 296–297, 309
Background panel, Book module,
 274
backgrounds
 photo book, 273–274
 print layout, 336–337
 slideshow, 296–297
Backup folder, 361
Backup.lrcat file, 361
backups
 catalog file, 356–357
 example of creating, 385–386
 external drive, 393
 import process, 62
 library, 360–361

M

N

Contributors

Rafael "RC" Concepcion is an award-winning photographer, podcast host, and educator, and the author of seven best-selling books on photography, Photoshop, Lightroom, and HDR. He is digital post-production specialist and adjunct professor at the S.I. Newhouse School for Visual Communications at Syracuse University.

He is an Adobe Certified Instructor in Photoshop, Illustrator, and Lightroom, and worked with Adobe to write the Adobe Certified Expert exam for Photoshop CS6, Lightroom 4, and Lightroom 5. RC has more than 20 years of experience producing content in the creative, IT, and e-commerce industries. He has presented at seminars and workshops around the world. RC's production company, First Shot School, creates educational content and video productions for clients such as Intel, Dell, Epson, Nikon, Canon, Samsung, Nokia, Sandisk, Western Digital, G-Technology, Google, and Creative Live.

Production Notes

The *Adobe Photoshop Lightroom Classic Classroom in a Book (2020 release)* was created electronically using Adobe InDesign. Art was produced using Adobe InDesign and Adobe Photoshop.

References to company names in the lessons are for demonstration purposes only and are not intended to refer to any actual organization or person.

Team credits

The following individuals contributed to the development of *Adobe Photoshop Lightroom Classic Classroom in a Book (2020 release)*:

Writer: Rafael "RC" Concepcion

Compositor: Cindy Snyder

Copyeditor and Technical Editor: Cindy Snyder

Proofreader: Scout Festa

Indexer: James Minkin

Keystroker: Megan Ahearn

Cover design: Eddie Yuen

Interior design: Mimi Heft

Keystroker: Karyn Johnson

Adobe Press Executive Editor: Laura Norman

Adobe Press Production Editor: Tracey Croom

Typefaces used

Adobe Myriad Pro, and Adobe Warnock Pro are used throughout the lessons. For more information about OpenType and Adobe fonts, visit www.adobe.com/products/type/opentype.html.

Photo credits

Photographic images and illustrations supplied by Rafael "RC" Concepcion, Zulfikhar Ahmed, Joe Conzo, Katrin Eismann, Gregory Heisler, Tito Herrera, Sara Lando, Joe McNally, Alan Shapiro, Maranie Staab, Ami Vitale, and Adobe Systems Incorporated. Photos are for use only with the lessons in the book.

Special thanks

This book would not have been possible without the help, guidance, and support of some truly amazing people: Cristela, Jennifer, and Sabine Concepcion, Latanya Henry, Alvaro Misericordia, Ken and Elyse Falk, Kim and Denise Patti, Cindy Snyder, Meredith Payne Stotzner at Adobe Systems, Albert J. Fudger, Ladislav and Monika Soukup, and Karyn and Michael Allard. To my team at the S.I. Newhouse School of Public Communications at Syracuse University: Bruce and Claudia Strong, Dean Lorraine Branham, Dean Amy Falkner, Michael Davis, Hal Silverman, David Sutherland, Renée Stevens, Sherri Taylor, Seth Gitner, Ken Harper, Soo Yeon Hong, Olivia Stomski, Stanley Bondy, Donna Till, and Christi MacClurg. Thank you for all of your help and support.

This book is dedicated to Latanya Henry. You wear an incredible number of hats—business manager, wrangler, production supervisor, photographer, etc.—but the one I've come to value most is friend.

Conclusion

I want to thank you so much for spending your time learning Lightroom Classic (2020 release) with me. It has been an absolute pleasure to be able to share how to use this immensely powerful program with you. I hope that you've come to realize that the folks at Adobe have made this program simple, intuitive, and quite fun to get to know, in the hopes that it inspires you to go out and make the best pictures you can dream of.

If you are interested in learning how Lightroom Classic integrates with Photoshop, make sure you check out my other book in this series, *Adobe Photoshop CC and Lightroom CC for Photographers Classroom in a Book*, out now. Also, feel free to stop by Syracuse University for a chat!

Finally, I would love to see what kinds of images you are making, or be able to help you in any way that I can. If you'd like to stay in touch, please feel free to find me on Twitter, Instagram, or Facebook. My username everywhere is aboutrc.

You can see more of my work at www.aboutrc.com.

Now let's get out there and make some pictures!

NOV 2 6 2020